舉起鏡子迎上他的凝視

● 臺灣攝影首篇 ● 一八六九 ● 一九四九

Hold the Mirror up to His Gaze

the Early History of Photography in Taiwan (1869-1949)

目次

臺灣攝影歷經百餘年的發展已呈現了多元豐沛的樣貌，因此攝影既是珍貴的文化資產，也是獨樹一幟的藝術表現形式。然而，面對許多重要攝影資產面臨佚失的情況下，有感於早期攝影底片與作品保存不易並散見於民間，攝影文化及藝術的專責機構的建立便刻不容緩。有鑑於此，文化部於 104 年開始推動「國家攝影資產搶救及建置攝影文化中心計畫」，以攝影資產的調查研究、典藏、修復、口述記錄與出版以及設置攝影中心為重點工作項目；歷經多年努力促成「國家攝影文化中心臺北館」（以下稱「攝影中心臺北館」）的設立營運，更是此計畫極為重要的階段性成果。

攝影中心臺北館開館試營運展覽特別邀請策展人林宏璋教授，以國家攝影文化中心的典藏為核心進行研究，並推出「舉起鏡子迎上他的凝視－臺灣攝影首篇（1869-1949）」展覽。此展透過十九世紀、日治時期、國民政府遷臺的時序為軸線爬梳臺灣的攝影史，並重新思考臺灣攝影史論述與書寫方法。此展亦進一步探討攝影史如何從西方與日本殖民的帝國凝視，經由本土攝影家在技術上的掌握以及自我意識的覺察，逐漸發展出多元紛呈的獨特樣貌。特別的是，此次展覽透過當代藝術研究計畫的委託製作，從當代的觀點出發，為臺灣攝影的歷史脈絡創生另類的理解路徑，同時也展現當代藝術家反思歷史、進行辯證的豐沛創作能量。

「舉起鏡子迎上他的凝視」作為攝影中心臺北館推出的國內攝影史相關的首展，揭示了文化部致力於重新梳理、建構屬於臺灣的攝影史論述，以建構臺灣文化主體性的核心價值。也期待透過國家攝影文化中心的建立，強化相關研究收集、典藏、修復與展示等工作的動能，持續挖掘、保存、研究隱身於各處的珍貴攝影作品。亦希冀藉由多元展覽的策劃及攝影專著的出版，引領臺灣、乃至於國際的觀眾，以靈活且新穎的視角，觀看百年以來臺灣攝影家所累積的影像底蘊，同時也持續探尋並拓展當代攝影藝術拓樸發展的可能性。

館長序

梁永斐 · 國立臺灣美術館館長

文化部於 104 年推動「國家攝影資產搶救及建置攝影文化中心計畫」，在國立臺灣博物館與本館共同努力下，至今已典藏超過萬件以上的重要攝影作品。同時，國立臺灣美術館也致力於「國家攝影文化中心臺北館（以下稱攝影中心臺北館）」的開館籌劃任務，期使此中心成為臺灣攝影與影像藝術的展示推廣以及國際攝影文化交流的重要據點。

作為臺灣首個以攝影藝術為典藏、研究、展示和推廣核心的專責機構，攝影中心臺北館致力於透過策劃多元的展覽，進行攝影文化的推廣及討論，也藉此重新梳理臺灣攝影史論述。試營運的首檔國內展覽，特別邀請林宏璋教授以國家攝影文化中心的典藏為核心進行研究與策劃，推出「舉起鏡子迎上他的凝視－臺灣攝影首篇（1869-1949）」展覽。本展展出超過六百幀早期珍貴的臺灣影像，內容涵蓋十九世紀西方攝影家拍攝的臺灣風土、日治時期寫真帖、臺人寫真館記錄的常民生活、以及戰後臺灣第一代攝影家的作品。策展人由攝影技術史、殖民主義中觀看權力關係，以及從現代化進程等角度，探討二十世紀中期以前的臺灣攝影史脈絡。本展試圖以臺灣為時空座標的原點，理解攝影產業在世界文明史上的交錯關係，透過臺灣在地社會與歷史向度的書寫，思考去中心化的攝影史方法論。

本展除了梳理國家攝影文化中心的臺灣早期攝影典藏並呈現多層次觀點之外，也特別邀請九位（組）當代藝術家以自身的創作實踐回應本次的展覽命題，期望藉由「藝術研究」（Artistic Research）跨域且開放的特質，開展對於二十世紀東（南）亞攝影史、日治時期人類學攝影、女性攝影師視角追尋等議題的探問，並作為臺灣攝影史脈絡的補遺與延伸。展覽期間，攝影中心臺北館亦規劃相關論壇與教育推廣活動，邀請專家學者共襄盛舉，期盼開啟更多討論對話與思想交流的契機。此外，攝影中心臺北館得以順利開館，要特別感謝文化部文化資產局與國立臺灣博物館在建館籌備期間所奠定的重要基礎，亦要感謝所有協助本展的借展單位、團體機構所提供的對於「舉起鏡子迎上他的凝視－臺灣攝影首篇（1869-1949）」的支持，讓此展得以成功呈現。

照亮：舉起鏡子迎上他的凝視，或迎上自然

林宏璋・策展人

演得太過就失去了戲劇的本旨，從古至今，演戲的目的就是把鏡子舉起來迎上自然；讓美德顯示她的本性，讓醜態受譴責，讓時間的身體及替換顯示他的形式與印記。

—— 莎士比亞《哈姆雷特》[1]

前言

臺灣攝影歷史的書寫是一項敞開「不可能性」（impossibility）的寫作。首先，臺灣攝影的書寫主體必須透過歐美攝影史的研究方法、典範、經典等，進行歷史主體的解構與地區性的重構，這導致知識場域必定處在學科間彈性界定的範疇；再者，基於互為主體的學科論述，還得透過社會學、藝術學、哲學、美學等理論，在歷史基礎上建立知識場域。對應目前方興未艾的臺灣攝影發展研究，必須先體認到「臺灣」歷史主體的邊緣性，才能進行這項從零開始的書寫任務，而其起始點在於體認一種「未見」的敘事，在書寫中書寫。從此出發點走入論述實踐（discursive practice），是對既有知識生產機制（discursive institution）的挑戰與逾越；而這也是佳雅特里・史畢娃克（Gayatri Chakravorty Spivak）在〈下屬能否說話〉（Can the Subaltern Speak?）裡所要強調的：歷史書寫（historiography）正是從疑問中開啟的「不可能性」。[2]對應於攝影研究在影像主體化、科技主宰性、美學意識形態，乃至於大眾文化等潛藏的等級制中，必須讓「不能說話」者得以言語、得以發聲，並意識到邊緣歷史需透過主體意識開啟的時間空隙展開書寫；必須觀察散落於歷史黑暗角落的事物，並予以某種程度的「照亮」；必須聯繫並組裝那些幽微的關聯性，因為在時間的洪流中，稍縱即逝的歷史事物不會以同一均值的速度消逝，更不會以特定的組態呈現，它們之間的關係是多元且交錯的。如果適當點亮在不同歷史距離的事物，並重新聯繫中間的關係，就像米歇爾・傅柯（Michel Foucault）所言：「如星叢的照亮般，最為明亮的星星，未必是最為靠近的時空距離。」[3]

此次書寫及展覽的嘗試正是以臺灣作為時空座標原點，從邊緣性對於美學意識形態、技術史、帝國與殖民主義、現代化進程的一種「照亮」書寫。這不是給予均勻照明的歷史「全像」（gestalt），而是企圖尋找藏匿在黑暗歷史角落、糾結在一起的問題性（problematics）。隨著攝影的發展，它不僅僅是一種藝術表現的媒介，還是被規範之社會與美學意識形態的次序構成過程，並且因為它針對的是殖民屬地的人們、蘊藏了視覺性的馴化與反叛，以及在藝術系統中「合法性」建構等考量，而成為一種民主「中藝術」（middle-brow art）[4]的實踐。同時我們必須回到在地的社會與歷史向度，重新考察在這裡面的文化轉譯、產業關係之世界文明史，並且去思量其全球化的步調。這個源於臺灣攝影歷史的書寫，必須透過目前的攝影史方法論及主體問題性，再次解構去中心化的書寫。

攝影史的綜錯問題性

對於攝影歷史書寫，攝影史方法論及知識主體化的過程是重要的參考座標。由第一任美國現代藝術博物館（The Museum of Modern Art, MoMA）攝影部主任

博蒙特・紐霍（Beaumont Newhall）所撰寫的《攝影歷史》（The History of Photography）[5] 是目前第一本有系統、以時序編撰的「攝影史」書寫，同時也是當期許多攝影史寫作的原型。這部以歐美為中心的「攝影歷史」觀點，便是放在類似藝術史方法中強調的美學意識形態、風格轉變及典章（cannon）形成等重心。在其「典章化」的過程中，讓當時尚未確定為「高藝術」（high art）的攝影也成為美術館脈絡的一環。這部「攝影史」的建立與攝影博物館化息息相關，也與攝影藝術知識生產劃上等號。然而，當中大部分的攝影家來自歐美，僅有少數來自俄國，使得這部全像式攝影史如同當時絕大部分的藝術史一樣，仍是建立在歐洲中心主義（Euro-centrism）的論述之上。而隨著現代藝術建置為二十世紀新興、摩登的藝術機制（institutions），攝影也逐漸轉為現代藝術美術館化中不可或缺的一環。在二戰前後，許多攝影家，尤其是「美國農業部」（Farm Security Administration）所委任的攝影師，便憑藉著「攝影現代主義」成為這部攝影歷史的主角，攝影也自發明以來獲得「中藝術」的身分。持平而言，紐霍的攝影史是將攝影作為「高藝術」的一環，這往往是來自於其文化性、藝術性、作者創作價值及未經社會化的結果。而許多十九世紀到二十世紀初期的「攝影家」對於自身的創作身分以及媒材本身的自主性尚未自覺，這尤其在十九世紀的攝影對於繪畫風格、構圖、燈光、題材的模仿，乃至於自「畫意主義」（Pictorialism）中可見一斑。

然而不同於一般的「藝術史」，紐霍認為攝影史是科學發展與攝影藝術並行的脈絡研究。紐霍宣稱：「攝影是科學也是藝術，作為純熟手工的替代品到獨立藝術形式，從始至終這兩面是密不可分。」[6] 因此，在紐霍承認了技術作為攝影起源後，也說明了攝影的實用性質（純熟手工的替代品，特別是指肖像畫）。這部攝影史的起源是隨著光學被應用於透視學「暗箱」（camera obscura）開始，一直到 1839 年路易・達蓋爾（Louis-Jacques-Mandé Daguerre）與約瑟夫・尼業普斯（Joseph Nicéphore Niépce）發明的攝影定影技術成為歷史轉捩點（圖 1），自此攝影從技術轉為藝術；從模仿繪畫視覺語言的藝術「替代品」轉為具啟蒙意識、探求真理、自我覺醒的現代性藝術形式、風格與媒介。紐霍的攝影史透過藝術史方法論述、研究風格以及攝影美學的改變書寫，並開創了攝影史強調作品、作者之面向的趨勢。不過在以文化研究、社會學作為攝影發展的書寫中，這種強調「藝術性」、「原創性」的美學型態及論述欠缺「自反性」（self-reflexivity）的自我批判，使其聚焦在作品及藝術家創作本位的分析與詮釋，但往往忽略處在文化之間的邊緣性，以及技術、科學的持有問題，更無法反省平行於攝影發展的殖民主義世界史。紐霍的《攝影歷史》是一部「歐美中心」的「大敘事」（meta-narrative）攝影，這套敘述同時也「中性化」（neutralized）了藝術中心從歐洲轉換成美國的潛國家主義，壓抑了邊緣得以發聲的機會，輕忽了殖民視覺性的徵候，最終仍是「去政治化」的歷史話語。

其實早在紐霍攝影史完成前十年，華特・班雅明（Walter Benjamin）就完成了〈攝影簡史〉（A Short History of Photography）、〈機械複製時代的藝術作品〉（The Work of Art in the Age of Mechanical Reproduction）等文章，開始研究攝影在社會、文化的政治化意涵，並且基於美學的意義，賦予攝影具有重新定義藝術價值的「顛

覆性」，這包含原創性、本真性、天分等意義。最終呈現了「藝術政治」與「政治化藝術」的辯證，討論政治體制、社會性、美學意識形態交錯的歷史及社會觀，且呼應著電影所造成、大眾文化與菁英文化的區分。正如班雅明所說：「對於畢卡索繪畫的反感會造成對卓別林電影的好感……隨著藝術形式的社會意義的愈來愈低，大眾的批評及好惡的差別就愈大。」[7] 班雅明將攝影技術的發展定義為具有藝術位階，並且與群眾、社會有所關聯，進而回應了前衛藝術與戰爭的暴力美學：「人類異化的程度是如此之大，必須透過先毀滅自己才能達到其美學的樂趣。」[8]

另一方面，班雅明的寫作也引領出對於影像本體論（ontology）的論點，例如：憂鬱本質、剪輯的虛構情節、觀看方式的改變；而有關「靈光」（aura）的論點，更賦予獨特的個人和集體美感之現實經驗。班雅明在談論到尤金‧亞傑特（Eugène Atget）時，寫道：「照片把現實吸出其靈光，正如同從沉船吸出水一般。靈光到底是什麼？是時間、空間奇特的組合：又是不管多近都會感受到的距離之形式與表象。」[9] 班雅明體認到攝影作為一種人所創造之「物」的強大感受性，其「實擬性」（virtuality）遠遠超過「手操作」的藝術，攝影（以及其他複製技術）得以從真實性中攝取靈光，進而重組一種真實可能；這點當然與紐霍的攝影史觀點大異其趣。就這個意義進一步思考，班雅明的攝影歷史書寫提出了某種神祕主義美學政治的顯現，以及社會普及性作為藝術民主化之可能。這不是討論藝術家、作品風格的藝術史，而從意識形態建構中找尋攝影的未來性，是「發生學／系譜學」（genealogy）的歷史書寫。

然而，最為注重社會芸芸眾生的民主式攝影研究，莫過於皮耶‧布迪厄（Pierre Bourdieu）研究團隊在 1965 年出版的《攝影：中藝術》（Photography: A Midbrow Art）。布迪厄的社會學方法是從對於特定地區的拍照、相機及業餘攝影俱樂部研究，發展出攝影在日常生活的消費行為，進而察覺到大部分攝影，尤其是業餘攝影者們所追求的攝影，恰恰是介於精緻與粗俗品味、功利性與情感投射之間的藝術實踐，這些剛好是伊曼努爾‧康德（Immanuel Kant）美學經驗的反向，即「平凡感知」（common sense）。[10] 其中，布迪厄強調的文化習性（habitus）是在文化場域中累積及傳承、成為一種如潛意識般的傾向，而文化情感（ethos）則是作為凝聚特定團體內部的向心力。布迪厄的社會研究便著重觀察攝影在文化場域中的軌跡與發展。從這個意義上來說，攝影是一個全民參與的社會藝術實踐，但也往往是一種功利性與情感投射的品味與美感。儘管「高藝術」實踐在布迪厄的研究中缺席，但是他也指出社會大眾的攝影實踐必要性，以及社團、集會等民間組織形成對於攝影藝術價值的必要性。[11]

追隨布迪厄的書寫立場，也許就是艾倫‧瑟庫拉（Allan Sekula）在 1975 年寫作〈攝影意義的發明〉（On the Invention of Photographic Meaning）時的觀點。瑟庫拉專注於攝影在歐美「詮釋社群」（interpretative community）的發展，將其視為攝影現代主義的開端，回應了從夏爾‧波特萊爾（Charles Pierre Baudelaire）以降的現代性議題，進而賦予攝影意義。[12] 瑟庫拉肯定了在 20 世紀初阿爾弗雷德‧史帝格勒茲（Alfred Stielgliz）的「直接攝影」（straight photography）及路易斯‧海因（Lewis Hine）的「紀實攝影」（documentary photography）興起，

影像的社會性便是其媒材性具有的自主性。而攝影作為社會的「見證」與「先知」（seer），是具有自我意識的藝術實踐。

從紐霍的攝影藝術史、班雅明的新馬克思主義辯證史觀、布迪厄的反身社會學到瑟庫拉的詮釋社群等研究，框架著攝影社會美學的雙重意義：一方面，攝影是菁英們的高藝術，是具有美學意識、創造「生成」（poiesis）的藝術實踐；但另一方面，攝影是被一群不知名的「藝術家」默默實踐的社會實踐，而這對於前者有著巨大的影響力。在兩者之間發生的各種連動、辯證關係，是臺灣攝影歷史書寫必須關注的環節。而糾纏在這些「攝影史」論述的問題性，並重新回到「臺灣」座標進行書寫——包含攝影在臺灣的專業性與合法性賦予、技術科學的擁有者、社團組織的參與以及歐美中心主義的美學意識形態等問題——是形成研究「臺灣」攝影視角的書寫位置，並作為「書寫」本身的應變性（contingency）問題顯現出來。

文化轉譯的「攝影」及其不可翻譯性

攝影的起源，一般往往認定是從達蓋爾發明的「達蓋爾版」（Daguerreotype）開始。然而，這是善於經營的達蓋爾透過公部門的認定，以及歐洲社會引發「達蓋爾熱」（Daguerre mania）的風潮造就的認知。實際上，達蓋爾的發明並無促成第一張照片的誕生，甚至連「photography」、「photograph」等名詞的起源也歷經不少的轉變。早在 1826 年之前，尼業普斯便知道運用感光版畫技術，這也是最早的定影影像。1827 年，他便在自己家中窗戶拍攝〈在樂加斯的窗外景色〉（View from the Window of Le Gras）。這時候攝影的曝光時間非常長（從 8 個小時到數天都有可能），而尼業普斯則稱自己的攝影術是「Heliography」，其中「Helio」意為太陽；「graphy」意為書寫或素描。尼業普斯在 1833 年因病逝世以前，儘管已經發現並不是因為「太陽」才能夠顯影，但他仍然堅持使用「日光書寫」一詞。另一方面，目前通用的「photography」則意為光（photo）的書寫或素描（graphy），是出自英國天文科學家約翰・赫薛爾（John Herschel）在 1839 年 3 月 14 日於皇家學院（Royal Society）提出的《論攝影藝術；或將化學光線應用於呈現畫面之目的》（Note on the Art of Photography; or the Application of the Chemical Rays of Light to the Purpose of Pictorial Presentation），這也成為第一份使用「photography」字詞的正式文件。在這篇報告中，正像（positive）、負片（negative）、藥膜（emulsion）等現在通用的攝影術語已經開始使用。[13]其後，在寫給威廉・泰伯特（William Henry Fox Talbot）的信中，也特別強調不使用泰伯特偏好的「光生素描」（photogenic drawing）原因，是因為科學中的「photogenic」有別的用法。

雖然早在 1833 年，法籍巴西人艾爾邱・福羅倫斯（Hércule Florence）便在手稿中寫下「光的書寫，或是光線的印『像』」（*photographie, ou impression à la lumière*）等字眼，但這本私人筆記並未廣泛流傳。法國政府在 1839 年 6 月 15 日購買攝影專利法案時，尚未使用「photography」一詞，而是使用「光，素描保存的事物」或者是「達蓋爾處理法」（Daguerre Process）等字眼，可見當時「光的書寫」說法仍尚未普及。不過在查閱 1839 年 10 月期間的法國報紙（如《時報》〔*Le Temps*〕、《環球箴言報》〔*Gazette Nationale ou Le Moniteur Universel*〕等）後，

可以發現同年 8 月起便開始出現「photographie」字眼，但並未成為固定用法，而是與「光生素描」混用。對此，發明「光生素描」說法的泰伯特，一直到 1844 年的《自然的鉛筆》（The Pencil of Nature）裡仍然堅持交替使用「光生素描」與「光的書寫／攝影」這兩個字眼。而在引介這本攝影集時，他承認攝影一詞已經普及：「攝影一詞大家早就耳熟能詳，任何解釋都是多餘的。」[14] 根據報紙、報告、寫作習慣與用法進行推論，至少在 1839 年之後，赫薛爾使用的「Photography」一詞便開始普及與通用，不過在指涉個別方式時則會使用「達蓋爾版」，而比較不通用的用法還有將泰伯特所發明的正負片稱作「泰伯爾版」（Tablotype），或是命名為「科羅版」（Calotype，意即美麗的印象）。但是到了 1960 年代，隨著玻璃濕版（wet collodion）取代達蓋爾版之後，「photography」、「photograph」便成為攝影、拍照、照片的通稱。

與此同時，隨著歐美帝國殖民主義的發展，達蓋爾熱也開始延燒到亞洲各地。1844 年，于勒‧埃及爾（Jules Alphonse Eugène Itier）在中國和印度拍攝達蓋爾版；1853 年至 1854 年，馬修‧培里（Matthew Perry）准將黑船上的攝影師小伊利法萊特‧布朗（Eliphalet Brown Junior）亦拍下達蓋爾版。之後，在 1860 年代，許多歐美攝影師開始在中國和日本沿海城市開設照相館。然而，「光的書寫」並沒有在目前通用的中文「攝影」一詞顯示出來。中文的「攝影」和臺語發音的「liap-iann」或「翕，音 hip，意『吸』像」，似乎比較強調「影像」被相機「攝取」及「吸納」。雖然從墨子的《墨經》到沈括《夢溪筆談》中都有關於光學的討論，但是「影」（通「景」）與「像」的概念仍十分模糊，而「攝」一字在這些古籍中則未被提出。直到十九世紀，廣東籍發明家鄒伯奇受到《夢溪筆談》的影響，寫作短文《攝影之器記》，其中記載了「暗箱」技術。文中寫道：「余嘗製為攝影之器，以木為方箱，開孔置中高鏡（凸透鏡）。」這段文字顯示出暗箱用來繪製地圖、圖像的功用，但並非用於達蓋爾版的顯影、定影過程。1846 年，行至廣東的周壽昌撰寫《廣東雜述》，當中則提到了拍攝達蓋爾版：「一為畫小照法，人坐平台上，面東置一鏡，術人至日光中取景，和藥少許塗四周，用鏡嵌之，不令洩氣。有頃，鬚眉衣服畢見，神情酷肖，善畫者不如。鏡不破，影可長留也。」文中的「鏡」即為達蓋爾銀版，而「畫小照法」即為「攝影術」。在這篇文中並未描述攝影甫至亞洲之初，人們對於拍照、攝影的恐懼，將其形容成如「攝魂」一般。而另外一個「攝影」成為「光的寫作」的路徑，則有可能是轉借中文古籍的內容，把這些歐美名詞翻譯日文漢字（即日語借詞），如同政治、法律、經濟、藝術等名詞，並形成日本「蘭學」（蘭学／らんがく／Lan-gaku，意指荷蘭的學問）的知識系統。其中「攝影」一詞便有可能是透過日語借詞而成的翻譯，在日文中以「撮影／さつえい／Satsu-ei」或「撮影術／さつえいじゅつ／Satsu-ei-jutsu」；其中因為「撮」具有「摘取」、「拿」的意義，因此「撮」便通「攝」。

當然，日文裡「光的寫作」更常被用於「寫真」（写真／しゃしん／Sha-shin）。寫真原本是日本人從詩詞中擷取的漢字意義，取其文字與繪畫的描寫：「可憐俱是畫，誰能辨寫真。」（梁文帝《詠美人愛畫詩》）或「將軍善畫亦有神，偶逢佳士亦寫真。」（杜甫《丹青引》）在江戶時代興起的「蘭學」中，對歐美文化的學習與引介範圍從醫學、科學到政治、哲學等人文思想，也包含藝術、攝影

的研究。歐美知識的傳入與接納，是日本「脫亞入歐」現代化的重要原因。1799年，蘭學藝術家司馬江漢所著的《西洋畫談》提到：「東方畫作為鑑賞萬物無實之用，所謂繪畫若無法寫真，不足稱妙，亦不足稱畫也。」因此，「寫真」成為繪畫的美學準則，同時也在日文裡作為「畫像」、「肖像畫」的意義。「Camera Obscura」傳入之後，也被翻譯為「写真鏡／しゃしんきょう／Sya-shin-kyou」。而在 1839 年攝影技術發明之後的達蓋爾版，則是直接拼音「ダゲレオタイプ」，或稱為「影印」（印影／いんえい／Yin-ei）。達蓋爾版傳入之後，便在日本開始盛行。因為拍照多為肖像，「攝影」逐漸約定俗成地被稱為「寫真」。

透過考察「攝影」一詞與其文化轉譯，可以見到在歐美文化場域有著不同的文化意涵，也有著藉由命名人類首個機械複製藝術所賦予的寄望，無論是「日書寫」、「光生素描」或「光的書寫」等，都象徵其不同於之前版畫的人工複製。而在 1820 年代至 1840 年代，法國、英國開始出現的不同攝影命名方式，都蘊含著人、自然與藝術之間的關係（將會在下個段落發展這部分論述）。華語及日文的語言世界中，「攝影」與「寫真」之間則包含著文化轉譯中的「創造模糊性」（creative ambiguity），也包含著「光的書寫」在華語、日文的「不可翻譯性」（un-translatability）。實際上，這裡連貫地充滿了語言系統的「孔隙」（lacuna），無法在封閉系統達成一致意義化，而有如「多語」（polyglot）的巴別塔一樣。也許在這樣的「不可翻譯性」中，我們才能發現該文化語言系統的主體性正躲藏在其歷史文化脈絡中，而以一種「不可翻譯」的狀態保留下來。

然而，相較於語言系統的非一致性，攝影產業的資本在國際之間的流通，往往伴隨著殖民主義的腳步。從 1839 年起，攝影就是標準的全球化產業。日本在明治維新之後，攝影更成為現代化的指標。隨著達蓋爾版相館的開設、肖像照片的普及，以及明信片和印刷的流傳，讓日本國內的攝影風氣大開，同時也包含著日本攝影工業的興起（例如：富士、柯尼卡），以及寫真學校的創立（例如：1894 年「寫真講習所仮場」、1902 年「女子寫真傳習場」、1929 年「小西寫真專門學校」等）。十九世紀中後期開始，這些位處日本的攝影產業生產機制便緊緊扣著歐、美、澳等國家所開啟的產業鏈。日本政府也了解到攝影的實用性，而展開包含人類學、地圖、工程、軍事等各方面的應用，臺灣在這時便因風土踏查、軍事部屬的需要而成為日本的拍攝對象，並被納入其「視覺治管」（visual governmentality）的一環。

舉起鏡子迎上「他」的凝視

隨著 1839 年達蓋爾版的發明，歐美國家的攝影師開始進入東亞、東南亞拍攝。在日本，培里艦隊中的攝影師布朗拍攝約 400 餘張達蓋爾版，但因為一場大火導致目前僅存五張，[15] 不過有一大部分的照片皆已由艦隊畫師威廉·韓恩（William Hein）依其影像製成石板版畫。培里艦隊曾在臺灣活動，不少研究臺灣攝影史者均懷疑其曾經拍攝過臺灣。而自從 1858 年的《天津條約》以降，安平、淡水、打狗、雞籠轉為通商口岸，傳教士或商賈們也開始拍攝臺灣，但是到目前為止仍未發現任何有關臺灣的達蓋爾版，或者類似周壽昌的「畫小照法」、日本蘭學等文字記載。值得注意的是，達蓋爾版本身是沒有底片的單一版，而其表面則如同鏡面。達蓋爾版的拍攝、沖洗等必須經歷用汞蒸汽顯影「潛像」（latent image）

等繁複的手續，而其複製與印刷過程則必須仰賴畫師依照達蓋爾版繪製圖像。儘管有許多關於臺灣「攝影元年」的說法，但是這些「合理」懷疑都指向一個不爭的事實：攝影是歐美的帝國殖民主義朝向歐洲之外的政治、軍事、經濟權力一環，同時也是透過影像部署（deployment）涉入他者的知識，尤其是對應歐美在十九世紀於東亞、東南亞等地的殖民主義發展。臺灣最早期的影像——更正確地說是「拍攝臺灣的照片」，清一色都是從外部進入臺灣的影像。這些拍攝者的入境往往是從港口到內陸，其中有英國、法國、美國、日本等國籍的早期攝影家。凝視「臺灣」作為「他者」（other）的影像，這裡浮現出影像「視覺性」（visuality）的政治觀，且往往聯繫著技術科學／殖民帝國／歐美中心主義的「綜合體」。

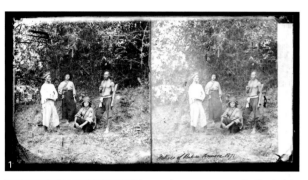

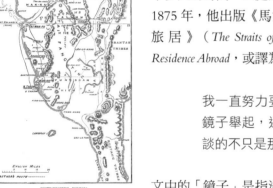

1860 年代末，「玻璃濕版」開始全面取代達蓋爾版。在這期間，約翰·湯姆生（John Thomson）已經在馬六甲、緬甸、泰國、越南、香港、澳門、中國等地拍攝數年。1871 年，由於之前拍攝大量漢人生活的照片，在馬雅各（James Laidlaw Maxwell）的建議與陪同下，湯姆生轉而拍攝臺灣原住民的生活（圖1）。儘管當時清朝官員希望湯姆生也能拍攝漢人生活，但湯姆生還是堅持拍攝「南島語系」（Austronesian）的人民及文化。在從高雄進入臺灣南部後，湯姆生在臺灣停留十多天的時間，四處運送著繁重的攝影器材及暗房，並拍攝了 50 餘張的照片。1875 年，他出版《馬六甲海峽、中南半島以及中國，或者十年的旅行、冒險及旅居》（*The Straits of Malacca Indo-China and China, or Ten Years' Travels, Adventures, and Residence Abroad*，或譯為《十載遊記》，圖 2、表 1）[16]。其中寫道：

> 我一直努力要跟讀者分享我所經驗的奇遇，但同時我一直小心翼翼把鏡子舉起，迎上「他」的凝視，……關於支那以及他們的人民，我要談的不只是那些留在中國本土的，還包括居住於我們殖民地的。[17]

文中的「鏡子」是指湯姆生用來凝視的相機「觀景窗」[18]，「他」指的是在維多利亞時代的倫敦讀者，句中的「他們」則是「日不落帝國」的殖民對象。湯姆生說：「透過照片的可信度能夠讓讀者貼近這些所拍攝場景。」[19] 因此，湯姆生的照片寫實並不是忠實、中性、無辜地觀看，而是呼應了西方文化和種族優勢的帝國凝視，在這個凝視裡顯示出的是維多利亞時代的歐美中心主義視點。作為專業攝影家的湯姆生，其收入來源除了出版照片、書籍之外，還必須爭取皇家地理協會（Royal Geographical Society）贊助。在拜訪亞洲之後，他還繼續拍攝了《倫敦街頭生活》（Street life in London）[20]，以街上的普羅階級社會邊緣人為主題。在《倫敦街頭生活》的開場中，他再度提及福爾摩沙，這個平行比較反映出湯姆生影像裡的中心到邊緣的等級制（hierarchy），裡面包含著帝國內外人民與社會邊緣人。在這裡，顯示出一種視覺性的採樣與分類，他者被轉化為「慾望物件」（desired object）。不過伴隨凝視的回望，主體、客體的位置替換，也反映出拍攝者與代表帝國中心讀者的「理想自我」（ideal ego）形象。因為拍攝「上像」（photogenic）的問題，正代表著拍攝者與被攝者間慾望的迴路內含

1. 約翰·湯姆生，木柵（今高雄內門）的原住民，福爾摩沙（臺灣），1871，約 10.5 x 21.5 cm，惠康收藏館提供（CC BY 4.0）| 2. 約翰·湯姆生在《馬六甲海峽、中南半島以及中國，或者十年的旅行、冒險及旅居》（1875）一書中描述其在臺灣十日內的拍攝相片的經歷，並提供南臺灣的地圖 | 表 1. 約翰·湯姆生在《馬六甲海峽、中南半島以及中國，或者十年的旅行、冒險及旅居》（1875）的附錄中還提供臺灣原住民族語言對照表，其中包括布農族、鄒族等族語的詞彙對照（右頁）

SHORT VOCABULARIES OF THE DIALECTS SPOKEN BY THE ABORIGINES OF FORMOSA.

TABLE I.

English	Pachien	Sibucoon	Tibolal	Banga	Bantanlang	Singapore Malay
			NAMES OF TRIBES			
Man	Lalusa	Lamoosa	—	Sarellai	Aoolai	Orang
Woman	Atlain	Maou-spingth	—	Abaia	Abaia	Prampaun
Head	Bangoo	Bangoo	Sapchi	Kapallu	Kapallu	Kapala
Hair	—	—	—	Ussioi	—	Rambut
Tooth	—	—	Nganon	—	—	Gigit
Neck	Guon-gorath	—	—	Oorohu	Oorohu	Leher
Ear	Charunga	—	—	Charinga	Charinga	Talinga
Mouth	Mussoo	Nipoon	—	Didisi	Muto-mytoo	Mulut
Nose	Ngoon-goro	Muttus	Nguchu	Coomonu	Ongoho	Idung
Eye	Ooraitla	Mata	Muchen	Macha	Macha	Mata
Heart	Takaru	Kanum	—	Kasso	Tookuho	Janteng
Hand	Ramucho	Tarima	Ramucha	Arema	—	Tangan
Foot	Sapatl	Ktlapa	Sapchi	Tsapku	Amoo	Kaki
Thigh	Bannen	Pinassan	Tangigya	Danoosa	Laloohe	Pauh
Leg	—	—	—	Tiboo-sabossa	—	Betis
Knee	Anasatoo	Khap	—	Pookuro	Sakaho	Lŭtut
Leopard	Lakotl	—	—	Likalao	Rikoslao	Animau Kambang
Bear	Chumatu	—	—	Choomatu	Choomai	Bruang
Deer	Putooru	—	—	Silappu	Caliche	Rusa
Wild hog	Aroomthi	—	—	—	Babooy	Babi-outan
Monkey	—	—	—	—	Mararooko	Monyet
Wild goat	Okin	—	—	—	Kehe	Kambing-outan
Fowl	Turhook	—	—	Turkook	Turkook	Ayam
House	—	—	—	Dami	Dami	Ruma
Chief	—	Titan-garchu	—	Tital-abahi	Tallai	Rajah
Bamboo	Baswera	—	—	—	Taroo-lahiroi	Bulah
Cassia	—	—	—	Tara-inai	—	Kŭlit Manas
Tea	—	—	—	Lang-lang	—	Daun Teh
Cooking pan	Kusang	—	—	—	Palangu	Kwali-Masak
Pumpkin	—	—	—	Tangu-tangu	—	Lãbŭ Fringgi
Fragrant	—	—	—	—	Anaremu	Wangie
Rice	—	—	—	—	Chiluco	Bras
Rice boiled	Oaro	—	—	Curao	Ba-ooro	Nasi
Fire	Apooth	Sapooth	Pooju	Apoolu	Apooy	Api
Water	Satloom	Manum	Choomai	Achilai	Achilai	Ayer
Ring	Tujana	Paklis	—	Tarra	Mata-na	Chin-chin
Ear-ring	—	—	—	Chin-gari	Ang-choy	Krabu
Bracelet	Pitoka	Push-tonna	—	Uliule	Issaise	Galang
Pipe	Katsap	Kaconan	—	Ang-choy	Ang-choy	Pipa
Gun	Taklito	Pavak-sapum	—	Guang	Guangu	Sanapang
Skin jacket	Nicaroota	Shiddi	—	Amalin	Carridha	Bajo-kulet
Cap	Sarapun	Tamoking	—	Tara-pung	Torra-pungu	Topie
Letter	—	—	—	Senna	Uraome	Surat
Smoke	Worlbooro	Khosalt	—	Uburon	—	Asap
By-and-bye	Chuden	—	—	—	Churana	Lagi-sabuntar
Warm	Machechu	—	—	Mechechi	Mechechi	Panas
Cold	Matilku	—	—	Matilku	Malilku	Sajuk
Rain	—	—	—	—	Maisang	Ugan

Note.—The Formosa vocabularies, with the exception of the Baksa Pepohoan, were supplied by Dr. Maxwell and the Rev. Mr. Ritchie, Formosa. The Baksa vocabulary was taken down by the author when among the Pepohoans.

「如何看？」、「如何被『看』？」、「如何被『被看』？」、「如何看『被看』？」等「互動」與「互被動」（interpassivity）的視覺意識話語。

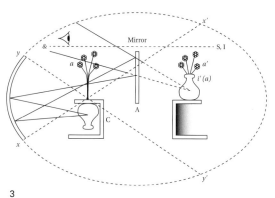

3

拉岡（Jacques-Marie-Émile Lacan）在其精神分析理論中提到，「理想自我」指的便是自我在想像慾求的影像關係之內。而在其凹透鏡實驗中（圖3），原本分離的花朵、花瓶，在「舉起鏡子」的某個特定視角，觀看主體（$）看向後面凹鏡的錯視視角，便會反射花朵在花瓶內之鏡像。這時候，平面鏡子作為大他者視閾，自我將在鏡子中同時看到自我影像，而那便是自我所慾望的形象。[21] 攝影正是拉岡鏡像主體的最佳範例，當中有著大他者與慾望客體的迴路，有著反射／折射／曲射主體和客體的「視覺驅力」（scopic drive）。舉起鏡子看到「他者」的凝視，這是十九世紀中期從外國人所拍攝的臺灣影像，內含著無窮盡的慾望主體（或者是被慾望主體）的互主體關係，並提出技術與殖民帝國凝視，以及觀看作為權力表現的架構。

在日治時代，日本學習歐美現代化的方式，不僅僅是在產業、工業及生產急起直追，對於影像控制更猶有勝之。當時嚴格控制照相館執照和攝影材料供給，而臺灣幾乎各個鄉鎮城市都有日本人開設的照相館，以及少部分由臺籍人士開設的相館。甚至到了戰爭末期，日本政府情報部開放「寫真師執照」。這些一再顯示出日本人小心翼翼將新學習到的攝影術作為國家體制的一部分，成為區分彼我的視覺化工具，同時也是標示出認同及差異的影像治理場所。與此同時，在拍攝日本人自己的時候，某種意義下的「自拍照」中往往顯示出「脫亞入歐」的西化衣著與打扮，而這也是當時日本「理想自我」的典型。在日治時期出版的《臺灣寫真帖》前幾頁，總是以軍政人物作為開場宣示；而當時皇太子裕仁的《行啟紀念》寫真帖或尋常日本的家庭相簿，也都充滿了現代化理想自我的形象（圖4）。

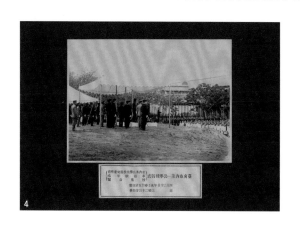

4

在「舉起鏡子迎上他的凝視」展演中，第一個語意空間的途徑在於揭示臺灣影像的「拍攝」、「被攝者回看」，以及「自看」等框架在自我與他者區分的慾望經濟學，並具體呈現在影像的佈置、安排與選擇上，這也包含了攝影與暗房技巧的表現。必須注意的是，因為臺灣照片的拍攝技術基本上是所謂的「第三代攝影」，以玻璃濕版與乾版（dry plate collodion）為主。這個時期的攝影與出版等息息相關，影像流通、交換和循環往往比之前的達蓋爾版來得更快，而商業經濟市場也更為緊密的結合。這些影像被「媒體化」成為一種形塑集體想望，以及成為經濟和文化運作的對象，攝影集（寫真帖）的出版就是一例。再者，「持照相機的人」選擇快門的動機和用意，是為了讓被拍攝的主體「上相」。而因曝光時間往往可以長達十數秒（主要為玻璃濕版），加上沖洗暗房處理必須馬上進行，長時間的準備導致必須預先構想構圖計畫等，當然大部分拍攝對象與拍照方式同樣也需事前考量。為誰、為何舉起攝影機的鏡子，將其收納為「被

3. 拉岡的凹透鏡實驗 | 4. 攝影者不詳，《皇太子臺南行啟紀念寫真帖》，1914-1915，紙質，22 x 30 cm，國家攝影文化中心典藏

竊的影子」（*Der Geraubte Schatten*）[22]，進而形成「鏡子」前後的主體反射、折射及慾望「錯視」（looking awry），這會是早期臺灣影像層層包裹的互主體網絡。

舉起鏡子，迎上自然／本性

湯姆生自陳，「舉起鏡子，迎上他的凝視」是要回應西方讀者，這裡的「他」便是殖民者之眼；然而湯姆生的句子又是參照莎士比亞《哈姆雷特》中「舉起鏡子，映出自然／本性（nature）」的台詞。「舉起鏡子」的宣告（enunciation），恰恰指向了互文閱讀的可能。在劇中，哈姆雷特王子為了要利用「戲劇藝術」追查弒父的「真相／真理」（truth），請演員忠實地扮演角色、自然呈現演技，而不要過度去扮演，這是劇中的敘述（diegesis）面。然而在「劇外的敘述」（extra-diegesis）中，「舉起鏡子，映出自然／本性」不正是莎士比亞透過劇中人的口白，自陳「戲劇」作為藝術反映「自然」之目的嗎？換言之，「舉起鏡子，映出自然」是莎士比亞自我的詩學宣告，並經由哈姆雷特王子的「藝術」找尋真理。在馬丁·海德格（Martin Heidegger）的哲學系統中，藝術是具有「開顯」真理（aletheia）的能力。那麼透過「攝影」，又會對藝術詩學宣告什麼真理呢？

作為機械複製的「人造物」，攝影是完全不自然的技術，而其最大的挑戰恰恰就是如何映照出自然自身。在這意義上，攝影已經去除了人工的「模擬」（mimesis）含義，而是成為擬仿（simulation）的要角。「要怎樣才能重塑如同精準數學一般的自然？」一直是攝影作為藝術表現媒材的潛在焦慮。尼業普斯稱自己的攝影術是「日光攝影」，稍後泰伯爾則稱「光生素描」或「自然繪製自身」（nature painted by herself）；而即便是現在通用的「光的寫作」等名詞，都強烈透露出對於這個媒材嚮往：從真實性擬仿中攝取自然的靈光。

1889 年，彼得·愛默生（Peter Henry Emerson）出版了《自然式攝影》（Naturalistic Photography），教導要如何拍攝比較「自然」的影像，而不是那些由僵硬線條、輪廓構成的機械複製圖像。他宣稱，最好的藝術是最接近人們眼睛所見到的內容，而非亨利·羅賓森（Henry Peach Robinson）或奧斯卡·雷蘭德（Oscar Rejlander）模仿繪畫題材、透視與構圖的「藝術攝影」（art photography）。愛默生從光學理論得到靈感，強調人眼是聚焦在中間視域，因此攝影就應該模仿人眼的呈現，而把鏡頭的焦距調整為稍微失焦的狀態，意即「柔焦」的效果。愛默生去除複製影像機械感的「自然式攝影」，曾經引發一陣風潮。然而在該書出版後兩年（1891），愛默生製作了一本題名為《自然式攝影之死》（The Death of Naturalistic Photography）的小冊子，撤回自己原本對於攝影美學的主張：「攝影的限制是如此之大，雖然它有時會帶給我們美學的樂趣，但應該是最低等的藝術，甚至比圖案設計還低。」[23] 愛默生對於攝影轉為氣餒的頓挫心境，其原因在於使用攝影呈現繪畫的表現形式，本身便是一個不可能的任務。

然而，史帝格勒茲認為攝影如同其他類型的繪畫、雕塑等藝術媒材，有著其獨特性及原創性。攝影不是「藝術的僕人，而是有獨特表現的特殊媒材。」[24] 對於原本攝影媒材的特性，史帝格勒茲在〈畫面攝影〉（The Photo-Secession）一文中援引了愛默生的文字，強調攝影的機械美感是「本性」（nature），而不需要

任何手工的「修圖」（retouching）。[25] 這個機械美感又以作品《三等船艙》（Steerage, 1907）最為顯著，伴隨著影像本身的壓縮和擠壓感，船板破壞了空間的透視，而在樓梯、桅柱、上下甲板劃分出不同區塊。史帝格勒茲認為攝影是隨著時代進步的藝術，這件作品便如同當時的「立體派」繪畫一般，也是「直接攝影」的代表作品。而在手持相機蔚為流行之際，他也為撰文替「手持相機」的美學說項。這便是攝影「現代主義」的開端，包括在二十世紀初的美國的「攝影分離派」（Photo-Secession）攝影家們，還有當時以弗雷德里克・艾文斯（Frederick Evans）為代表的、擁抱攝影獨特美學——「純粹攝影」（Pure Photography）等的攝影工作者。

攝影的現代主義，一方面是在媒材獨特性上的創作自覺，也是追求藝術的自主性。幾乎如同當時所有的「現代主義」藝術運動一樣，這時候的攝影亦有著自我意識的覺醒。史帝格勒茲便如此宣告自己：「我生在霍博肯（紐澤西），我是美國人，攝影是我的熱情，追求真理是我的執著。」[26] 這個持照相機的人，是一個「技術人」（homo techne），是能製造和使用工具的藝術家。攝影是科技與藝術互相依存合的「個人化」（individuation）實踐，因此其「自我意識」的向度會隨著與時俱進的技術或科技，轉為能夠表現時代精神的藝術。

在從莎士比亞、湯姆生到攝影現代主義的取徑中，臺灣現代主義逐漸萌芽的階段，恰恰就是「持照相機的人」開始對於媒材產生自覺意識，並藉由科技發起的自我覺醒運動。不論是專業的攝影家或者業餘的愛好者，在他們的作品中永遠有著「我是誰？」的主體自問。在「舉起鏡子迎上他的凝視」展演中，便試圖開展第二條語意途徑。透過擁有科技的藝術家「個人化」實踐，敞開臺灣特有的現代性道路與裂縫。在彭瑞麟、張才、洪孔達、鄧南光、李鳴鵰等人的鏡頭下，這批臺灣第一代攝影作品反映出「持攝影機的人」的觀看主體，是如何透過攝影推展其獨特的「半參與」社會實踐，以及是在「之間」的冷冽注視顯影出來的時代圖像。這是在傳統／摩登、遷徙／移民、他鄉／自家、殖民／後殖民等錯雜之際，為斷裂的文化位置所留下瞬間的影像。

文件、記憶與檔案病

攝影就是檔案。它一方面是面向自我的檔案化，另一方面也是朝向他者的論述化，而其目的在於保存人、事物於流逝中的「靈光」。作為時間性的存在，攝影是「外置記憶」（exosomatic memory）所留下的存在痕跡，透過觀景窗、照片將人、事、物去現實化，同時向當下、過去與未來敞開。在這部分，攝影是史帝格勒茲所言的「第三持存」（tertiary retention）典範。在政治面向，攝影更是一種象徵見證、持有證據的「文件性」（documentality）潛能。而之所以能夠抗衡「治理性」和「生命權力」對於記憶的抹除，則在於攝影是機械的藝術，而非是人工摹寫。

雅克・德希達（Jacques Derrida）在《檔案病：佛洛伊德的印痕》（Archive Fever: A Freudian Impression）[27] 一書中，提出檔案雙重意義的矛盾性：「是開始次序，也是戒令次序。檔案的概念藏護自身，這是對 Arkhé 名稱的記憶。檔案被藏在記憶中，卻也被遮擋於記憶之外。在論及檔案的同時，我們也同時忘記檔案。」[28]

檔案起源於希臘字「Arkhé」，是新的「開始」，但其另一個相反意義，則是在既有系統底下的「戒令」。德希達意指的「檔案病」（Mal d'archive; Archive Fever），正是要強調檔案本身所擁有的「矛盾」意旨。在這裡，檔案既不是在既有權力治理邏輯下的重複操作，也不是種種「差異」（difference），而是「又異」（différance）。「檔案病」存在著「地點」與「空間」性質，德希達分析，「檔案」（Arkheion）原意為官員的私人房子，而文件、檔案便在此累積、存放、次序及保護；因此它同時是私領域與公領域交集，而「家」正是檔案「決定住處」（domiciliation）的場所，是「檔案病」發生的原初場景。在精神分析理論系統中，「家」則是從伊底帕斯到閹割情節那裡，庫存潛意識原始操作的地方。此外，「詭譎」（unheimlich）理論的字源則是「非」（un）「家」（heimlich），意指熟悉與安適的「家」突變成為詭異、陌生和弔詭的場所。

「檔案病」是一種「矛盾」的書寫，是德希達依循著西格蒙德·佛洛伊德（Sigmund Freud）〈神奇書的筆記〉（Notiz Über den Wunderblock）[29] 一文中所提出有關書寫、認知與（潛）意識的記憶系統所發展的概念。「神奇書」（wunderblock）是一種可以重複書寫抹除的孩童玩具，其第一層書寫是清楚、可辨識以及可消除的；而其第二層則是書寫後的痕跡，是層層堆疊、不可辨認的印痕。在佛洛伊德的眼裡，「神奇書」的書寫正是映照了在知覺與藝術的記憶系統裡，是結合著「白紙」與「黑版」書寫載體的性質，而保留著書寫過後的印痕，潛意識的運作便是在失憶、回憶以及外置記憶之間選擇不同的記憶。這是一種位處充斥「力比多」（libido）的場所，可以塗改、銷毀、遲滯發生的書寫；而「檔案病」的書寫操作，便是夾在「死亡驅力」（death drive）的交錯混亂之中。

從這點來看，阿比·華堡格（Aby Warburg）的「記憶圖庫」（Mnemosyne Atlas）正是一種「檔案病」式的回顧人類視覺記憶影像論述。實際上，因為攝影術的發明（外置記憶），才使得華堡格的計畫得以可能。在 63 個黑色展板上，密密麻麻地佈滿從古希臘時期的藝術史作品開始，一直到報紙和雜誌上的無數圖像。華堡格將它們進行排列和重新組合，還穿插了地圖、照片、手稿等，而每個展板有如提出一個視覺命題。「記憶圖庫」為各個面板予以編號，藉此聯繫組成命題單元的主題。透過高密度、巨集方式累積的影像集合，「記憶圖庫」增強了影像的強度、密度與張力，更使當中的時間性有如班雅明所寓言的「彌賽亞時間」（messianic time），彷彿在須臾之間瞥見了歷史的全貌，而漫長的歷史被壓縮至最後一秒。伴隨著時間順序遭到切割、倒轉，檔案本身的結構性決定了其敘事的論述方式，看似「混亂」的非理性置放則暗示著等待未來展開的組合與脈絡，以及重啟一種多語意空間的可能。

德希達的「檔案病」和華堡格的「記憶圖庫」預示了時空重組的歷史性。這是「舉起鏡子迎上他的凝視」第三條途徑：透過把「彌賽亞時間」視覺化的展演技術，可以看見臺灣攝影史前百年高密度壓縮的狀態，這會是共時（synchronous）的歷史。藉由歷時性（diachronic）結構壓縮，攝影作為一種外置記憶與歷史記憶的強度將會展現出來。

藝術研究的介入、岔出及補充

在「舉起鏡子迎上他的凝視」中，同時也委託了「藝術研究」（artistic research）計畫介入這次展覽，作為展覽語意書寫脈絡的「補充」（supplement）。其作用如同「註腳」一般，作為展覽脈絡的岔出與補遺。其中，藝術研究的知識性質在於其「不可複製性」，強調的是展演、研究與知識過程的結合，以及在裡面誕生的感性認識論（epistemology）。每位獲邀的藝術家均提出明確的題目，並以「藝術研究」的獨特知識性進行介入，形成開放性的論述。這一方面是藝術研究行動創造論述能力的展現，另一方面也回應了地區和文化特殊性要怎樣轉譯為自身在地相關的詩學行動；這不同於當前人文藝術領域（如社會學、哲學、政治學、藝術史及文化研究）透過「標準化」、「可測量性」和「方法論」等論述的特徵，也不是以「接受者」（recipient）的角度去呈現議題。這些藝術研究計畫穿插在展覽中，並以時序、主題為軸線展開出來。

首先，張乾琦研究了湯姆生照片中的慾望向度，以這位蘇格蘭籍攝影家拍攝的「女人」作為對象，參照湯姆生在亞洲拍攝的路線和地區，並對照自己所拍攝的外籍新娘、女性作品，進而呈現出攝影工作者在這150年間的生產狀態改變，以及相對應的區域政治、生存狀態變遷。高俊宏的〈後像1871（行走、快拍與朗誦行動）〉，以湯姆生在臺十日的旅行日記為本，於「一日」之中重訪湯姆生的臺灣之旅，演繹英國皇家地理學會成員湯姆生「舉起鏡子迎向凝視」的路程以及150年間的人文地理變遷，結合在地文史學者游永福的考證，邀請參與者以講述表演（lecture performance）進行現地批判。

曹良賓則試圖回應英國人喬治·尤維達爾·普萊斯（George Uvedale Price）在1895年拍攝的〈北福爾摩沙的回憶〉（Reminiscences of North Formosa）寫真帖，利用文本分析的方法，理解這本具有商業廣告性質的寫真帖。當中的圖文關係影射了潛藏於背後的全球化經濟產業動向，並將其視角具體而微地聚焦在「臺灣烏龍茶」的農業、生態和經濟神話上。梁廷毓的〈槍砲、頭顱與骸骨〉則是討論在日本時期，臺灣原住民族的肖像、頭像及獵首習俗，而這也反映了日本時代對於原住民族的攝影（包含人類學者主導的調查）中，恰恰發展了一種關於首級拜物與殖民知識建構的「頭像學」。

在討論臺灣攝影的發展時，我們必須將臺灣的脈絡擴展至東南亞攝影及其產業、民間組織的發展上。莊吳斌的〈東南亞的攝影與華人性〉討論了東南亞華人的散播，以及藝文圈、照相館、民間社團組織（如沙龍攝影協會、業餘攝影俱樂部或攝影學會）等的狀態，大量蒐藏了從越南、泰國、馬來西亞、新加坡、印尼等東南亞華人的家庭相本。而菲律賓籍的希林·施諾（Shireen Seno）則討論菲律賓的殖民影像，其研究計畫〈摘取一朵花〉（To Pick a Flower）以「論述電影」（essay film）的方式呈現電影與攝影的辯證本質，在動態與凝結的張力之間思考影像「此曾在」（it-has-been）逝去，與其間的「存有魂有學」（ontology / hauntology）。陳敬寶的〈猶疑：彭瑞麟的兩種攝影取徑〉討論繪畫與攝影的辯證，延續著從波特萊爾到伊斯特雷克夫人（Lady Eastlake），以及從自然式攝影到畫意攝影的辯證，並以赴日學習攝影的彭瑞麟作為研究對象。他聚焦在彭瑞麟赴廣州擔任翻譯官的經

歷，以「臺灣人」的身分向中國、日本予以「回返凝視」（return of the gaze）。「鬼島踏查日記」（黃英嘉、游承彥）計畫則透過攝影師張才、小說家及電影人劉吶鷗與女攝影師陳麗鴻，試圖構建出上海這個遠東殖民帝國的交會點、「日屬臺灣人」經驗在異地流浪離散的經驗，以及回溯被殖民者的他者／自我的認同視點。陳飛豪的〈喜多舞台與日本能樂在臺灣〉研究計畫，則將時間點回返至西門町商圈、漢口街的大村武居酒屋，在二戰末期建立臺灣當時少見的能劇稽古舞台，從一個歷史邊緣特例中思索殖民／被殖民之間的傳統藝術從歌仔戲到能劇的復返脈絡。

以上委託製作的藝術研究，強調實踐、展演與知識的結合，以感性認識論作為行動研究，反映了在當前藝術領域之研究論述基礎，如藝術社會學、藝術哲學、藝術史及文化研究等人文思想，如何與藝術實踐的跨領域結合、展現其創作本身論述能力；另一方面，也回應地區及文化特殊性如何轉譯為創造行動之知識生產，自有藝術知識的政治面向，強調實踐的知識政治是「舉起鏡子迎上他的凝視」展演敘事的開放線索。

「開始」的攝影歷史書寫

從湯姆生在 1875 年陳述「迎上他的凝視」出發，我們試圖發展出「臺灣攝影」歷史書寫的思路，企圖照亮存在於文化史、殖民史等的歷史幽暗角落。儘管這裡幽明晦暗，但在給予不同程度照明的路途，總是一次次回到臺灣的座標原點上。從日光書寫、照相到攝影中間所發生的文化轉譯和技術發展沿革，展覽試著呈現從十九世紀到二十世紀之間文化概念轉移與不可轉移的進程，這涉及到攝影歷史的編撰方式、歷史哲學和社會學的問題性，及藉由「不」可能性組裝書寫的「可能性」，並進一步思考攝影的命名及其美學理想。憑藉著湯姆生書寫的問題性，展開了 1850 年到 1895 年之間的作為帝國凝視對象的臺灣攝影討論，並緊扣著十九世紀作為一個知識及科技爆發時代，攝影政治和經濟、他者與自我慾望折射和反射等互為主體的位置。而在臺灣影像的「第三代攝影」之中，不同於先前的達蓋爾版與泰伯爾版攝影，取代玻璃濕版的影像技術因為其移動性、知識／科學生產及媒體的流通與加速，造成攝影生產狀態的改變，並與全球化政治、經濟、文化、知識、軍事網絡產生聯繫。

當然，利用哈姆雷特的台詞「舉起鏡子，迎上自然／本性」詮釋攝影本身的藝術主體性，一方面是檢視攝影是如何像其他藝術一樣，總是回應著與「自然」的關聯，並從柏拉圖的「模擬論」一直延續到「浪漫主義」（Romaticism）的美學思想；另一方面，則是思考攝影作為「人造物」的機械特性，衍生出其自「自然式攝影」到現代主義的過程中，從頓挫到自覺的影像運動。尤其針對臺灣殖民現代性的問題，攝影如何轉化為自我意識的探詢，標註著影像實踐的原創性及解放，對於大他者權力構成回望，重新編纂自我／他者互主體的網絡，並形成一種自覺視覺性呈現。最終還包含了攝影作為檔案意義，以「回奏」（ritornnello）的方式呼應著傅柯與德希達不同之檔案概念，經由弗洛伊德的「神奇書」書寫狀態，聯繫到華堡格「記憶圖庫」高強度密度化的蒙太奇展陳，這是影像的「魂有存有學」（hauntological ontology），同時也說明了「檔案」以「病」、「症候」方式呈現的必要性。

在研究過程中，臺灣攝影的書寫展開必須藉由既有的「攝影史」、「歷史敘事」所存在的問題性，思考著這些問題之間的關聯性，並脫離歷史方法論（如傳記研究、風格研究）的既定因果關係，試著從問題裡面發展出多元決定論的歷史觀；也只有在這個基礎上，臺灣攝影史將會作為一種多重複雜性敘事的可能。透過技術史／（後）殖民史／文化史的基礎參照點，展覽回應了有關臺灣十九世紀至日治時期的影像發展，尤其是在 1895 年開始的日治時期。日本所操作的殖民政策，不同與歐美帝國的異質侵略方式，往往是存在著「雙重同化」（double-simulation）的操作：一方面要與歐美的文化、政治同化，另一方面又交雜了被殖民者的認同。而日本選擇把攝影翻譯成「寫真」，正是其文化特殊性的展現。同時隨著日本殖民政府了解到影像生產的重要性，不僅僅產生了有關攝影執照的限制，同時也造成只有少數臺籍攝影師出現的情況。而日治時代大量「寫真帖」的出版，正反映出日本式的視覺殖民性，其藉由影像馴化他者以及自我理想化的呈現。由於日治時期殖民政府在政治、文化、軍事、經濟的複雜部署，攝影成為了突顯與調度殖民視覺性中各種「可見性」的技術。同時吊詭的是，這般視覺性不僅僅反應了殖民者的慾望，也聯繫到知識生產及出版媒體的主要客體。從「治管影像」討論「凝視的反轉」的可能，呈現出攝影的社會「生產狀態」，同時也是社會關係（如民間的攝影社團）如何流動、消費、分佈，伴隨著影像之間的量、質辯證，進而討論了攝影在民主化與專業性之間的搖擺。

於遲來的國家攝影中心第一檔展覽進行書寫，如同德希達所強調的「檔案」雙重概念：既是「戒令」，又是「開始」。如何將「臺灣攝影檔案」「朝向未來」開啟，是「舉起鏡子迎上他的凝視」的嘗試，也是委託藝術研究案「複聲多語」（polyphony）的訊息。重新展開與強調風格的歐美攝影史不同的論述語境，意味著必須反觀知識系統的形塑，同時也是對於權力主體的質疑與抗議；重新檢視全球性技術與「光的書寫」發展的歷史成因，具體呈現在往返於鏡內、鏡外、鏡中且密集堆疊累積的影像中，進而掌握歷史「不可能」的全像瞬間。然而這僅僅是一個發起，無法窮盡書寫臺灣攝影史中包含的種種豐富向度，但如同德希達「檔案病」的發生場所——家，正是以「臺灣」為「家」的影像包含了種種的詭譎（uncanniness），而存在於「觀者別有所意」的觀看主體。

在這個「戒令」與「開始」時機點上，必要的後續研究需包含下面兩個面向：第一、研究「臺灣攝影」的同時，必須關注到共時、平行發展的「東南亞」、「東亞」影像。雖然攝影區域性研究在過去存在著文化、語言與政治之間的隔閡，但是早期攝影的發展，尤其在移民史與殖民史部分仍有著共同的歷史，印尼「督工攝影」（*Toekang Potret*）和新加坡日本移民開設的「照相館」就是其中兩個例子。因此發展攝影的地域性研究與田野方法，使其有別於歐美普遍的「攝影研究」，將會是未來研究的主要方向與課題，同時也是深入以「國家」為單位的攝影研究必定會遭遇的核心議題。第二、在典藏攝影時的文件性問題，這包括必須重新定義「檔案化」（archivalization）與「可檔案性」（archivability），例如攝影技術、工具、作品相關雜記與筆記、出版等等在遭逢「檔案病」時產生的困難。這是在第一個國家級攝影中心必須直接開始面對的問題，同時也是「舉起鏡子迎上他的凝視」框架在面對技術、殖民、文化史的互主體對話之外，對於「攝影的中心」發展之未來寄語。

1 筆者自譯，原文為：For anything so overdone is from the purpose of playing, whose end, both at the first and now, was and is, to hold, as't were, the mirror up to nature, to show virtue her own feature, scorn her own image, and the very age and body of the time his form and pressure. 見 William Shakespeare, *Hamlet*, London: Penguin Books, 2015.

2 Gayatri Chakravorty Spivak, "Can the Subaltern Speak?" *Can the subaltern speak?: Reflections on the History of An Idea*, ed. Morris, Rosalind, New York: Columbia University Press, 2010.

3 Michel Foucault, *The Archaeology of Knowledge and the Discourse on Language*, trans. Sheridan Smith, New York: Pantheon Books, 1972, p.129.

4 此概念由皮耶・布迪厄（Pierre Bourdieu）於《攝影：中藝術》（*Photography: A Middle-Brow Art*）中提出。見 Pierre Bourdieu et al., *Photography: A Middle-Brow Art*, trans. Shaun Whiteside, Stanford, CA: Stanford University Press, [1965]1996.

5 Beautmont Newhall, ed., *Photography, Essays and Images: Illustrated Reading in the History of Photography*, New York: The Museum of Modern Art, 1980.

6 原文如下：Photography is at once a science and an art, and both aspects are inseparably linked throughout its astonishing rise from a substitute for skill of hand to an independent art form. 見 Beaumont Newhall, *The History of Photography*, New York: The Museum of Modern Art, 1982.

7 Water Benjamin, "The Work of Art in the Age of Mechanical Reproduction," *Illuminations*：*Essays and Reflection*, trans. Harry Zorn, New York: Schocken Books, 1968, p.234.

8 Benjamin, "The Work of Art in the Age of Mechanical Reproduction," p.241.

9 原文如下：They suck the aura out of reality like water from a sinking ship. What is aura, actually? A strange weave of space and time: the unique appearance or semblance of distance, no matter how close it may be. 文中也指出複製技術銷毀獨特性的社會狀態。見 Walter Benjamin, "Little History of Photography," *Selected Writings*, Vol.2: 1927-1934, eds. Michael W. Jennings, Howard Eiland, and Gary Smith, trans. Rodney Livingstone et al., Cambridge, MA: Belknap, 1999, p.519.

10 在這個有關「平凡感知」或共識的意義上，布迪厄有著康德美學的影子。Bourdieu et al., *Photography: A Middle-Brow Art*, pp.77-79.

11 攝影的藝術位置，往往透過業餘之間的民間結社，成為其文化合法性的一環。日本現代主義攝影與臺灣的攝影發展，有著類似的進程。參考 Bourdieu, *Photography: A Middle-Brow Art*, p.103.

12 Allan Sekula, "On the Invention of Photographic Meaning," *Photography in Print: Writing from 1816 to the Present*, ed. Vicki Goldberg, New York: Simon and Schuster, 1981, p.452.

13 Steffen Siegel, ed., *First Exposures: Writings from the Beginning of Photography*, Los Angeles: The J. Paul Getty Museum, 2017, p.299.

14 原文如下：The little work now presented to the Public is the first attempt to publish a series of plates or pictures wholly executed by the new art of Photogenic Drawing, without any aid whatever from the artist's pencil. The term "Photography" is now so well known, that any explanation of it is perhaps superfluous. 見 William Henry Fox Talbot, *The Pencil of Nature*, Gutenberg Ebook: 2010, p.1. http://www.gutenberg.org/ebooks/33447，2020 年 8 月 1 日瀏覽。

15 根據布魯斯・艾利克森（Bruce T. Ericson）的研究，目前已知，火災後僅存的達蓋爾版有四張位於日本，另有一張藏於夏威夷的畢夏普博物館（Bernice Pauahi Bishop Museum）。見 Bruce T. Ericson, "BROWN JR., ELIPHALET Hannavy," in *Encyclopedia of nineteenth-century photography*, ed. John Hannavy, London: Routledge, 2013, pp.223-224.

16 在附錄中，還有臺灣原住民語言的對照表。見 John Thomson, *The Straits of Malacca Indo-China and China, or Ten Years' Travels, Adventures, and Residence Abroad*, London: Sampson Low, 1875, pp.543-544.

17 原文如下：I have endeavoured to impart to the reader some share in the pleasure which I myself experienced in my wanderings; but, at the same time, it has been my care so to hold the mirror up to his gaze, that it may present to him, if not always an agreeable, yet at least a faithful, impression of China and its inhabitants; and of the latter, not only as I found them at home on their native soil, but also as we see them in our own colonial possessions. 見 John Thomson, *The Straits of Malacca Indo-China and China, or Ten Years' Travels, Adventures, and Residence Abroad*, V. 中文翻譯亦參考約翰・湯姆生，《十載遊記：現代西方對古東亞的第一眼：麻六甲海峽、中南半島、臺灣與中國》，顏湘如、黃詩涵、黃逸涵譯，臺北：網路與書出版，2019，前言。

18 其實在當時並沒有觀景窗，拍照構圖與取景往往使用鏡子。

19 John Thomson, *The Straits of Malacca Indo-China and China, or Ten Years' Travels, Adventures, and Residence Aboard*, V.

20 John Thomson and Adolphe Smith, *Street Life in London*, London: Sampson Low, Marston, Searle and Rivington, 1877.

21 Jacques Lacan, *The Four Fundamental Concepts of Psycho-Analysis*, trans. Alan Sheridan, New York: W. W. Norton & Company, 1977, p.140.

22 Thomas Theye, *Der geraubte Schatten. Eine Weltreise im Spiegel der ethnographischen Photographie*, Berlin: Bucher C.J., 1998.

23 原文如下：The limitation of photography are so great that, through the results may, and sometimes do give a certain aesthetic pleasure, the medium must always rank the lowest of all arts, lower than any graphic art. 見 Peter Henry Emerson, *The Death of Naturalistic Photography*, 1891, p.197。

24 原文如下：Not as the handmaiden of art, but as distinctive medium of individual expression. Alfred Stieglitz, "The Photo-Secession," *Bausch and Lomb Lens Souvenir, Rochester*, New York: Bausch and Lomb Optical, 1903. Reprinted in Richard Whelan, ed., *Stieglitz on Photography: His Selected Essays and Notes*, NY: Aperture, 2000, p.154.

25 原文如下："Retouching," says Dr. Emerson, "is the process by which a good, bad, or indifferent photograph is converted into a bad drawing or painting." It was invariably inartistic, generally destructive of values, an always unphotographic, and has to-day almost disappeared. 見 Alfred Stieglitz, "The Photo-Secession," reprinted in Richard Whelan, ed., *Stieglitz on Photography: His Selected Essays and Notes*, p.154.

26 Alfred Stieglitz, *An Exhibition of Photography by Alfred Stieglitz: 145 prints, over 128 of which have never been publicly shown, dating from 1886-1921*, New York: Anderson Galleries, 1921.

27 Jacques Derrida, *Archive Fever: A Freudian Impression*, trans. Eric Prenowitz, Chicago: University of Chicago Press, 1996.

28 原文如下：Both in the order of the commencement and in the order of the commandment. The concept of the archive shelters in itself, of course, this memory of the name Arkhé. It's sheltered by and from this memory, which comes down to saying also that it forgets it. 見 Derrida, *Archive Fever: A Freudian Impression*, p.1.

29 Sigmund Freud, "Notiz über den Wunderblock ," *Gesammelte Werke: XIV: Werke aus den Jahren 1925–1931*, London: Imago Publishing, 1991, pp.3-8.

十九世紀中業，隨著複製影像技術的發明，攝影先後歷經了達蓋爾式銀版攝影（Daguerreotype, 1839）、紙基負片的科羅版（Calotype, 1841），以及濕版火綿膠攝影法（Wet-collodion Process, 1851）的時代。在字根意義上，攝影（photography）即為「光的書寫」。1860 年代，濕版攝影取代了以室內肖像為主的銀版攝影，攝影從室內攝影棚的限制中獲得解放，開始書寫著關於建築、自然、人物、戰爭的影像。雖然濕版攝影的曝光時間需十秒以上，且需要隨身攜帶暗房沖洗底片，濕版攝影的出現卻仍然讓攝影成為全球事業，相繼在香港、新加坡、廈門、馬尼拉等歐、美、澳之外的城市出現第一代相館，攝影者們也開始在世界各地拍攝未曾被顯影的地區。當時澳洲雪梨是全球玻璃底片的生產中心之一。伴隨著現代化與殖民主義的推進，攝影結合照相凹版印刷（photogravure）及銅版畫的出版，成為一個全球化的影像運動。

在 1860 年代，於亞洲頻繁活動的歐美攝影師展開拍攝福爾摩沙的計畫，如在廈門設立相館的「黑面朱利安」（St. Julian Hugh Edwards）、約翰‧湯姆生（John Thomson）及悉尼（S. Sidney）等，這些影像不僅代表了從外部進入臺灣的凝視，也代表了帝國以及知識的慾望折射。這些攝影師往往是從打狗（高雄）與雞籠（基隆）等港口進入臺灣內陸，尤其經年遊歷與拍攝東南亞與中國的湯姆生，更與馬雅各醫生（James Laidlaw Maxwell）一起進入茖濃、木柵等地拍攝原住民和自然景觀。這些早期臺灣的照片也出現在活躍於東亞、法裔美籍的李仙得（Charles W. Le Gendre）和必麒麟（William A. Pickering）等政治人物著作中，藉以宣稱自己擁有著地方知識，成為帝國勢力在軍事與政治上的延伸；法人於清法戰爭（1884）拍攝的軍事紀錄（包含戰俘照片等）亦具有軍事價值。而隨著全球資本主義興起，蘇格蘭人「獨先生」（John Dodd）在臺灣栽種烏龍茶，當時拍攝了製造茶葉的照片並集結成攝影集，則成為出口至歐美的商業用照片。

因此，十九世紀留下的臺灣影像往往具有權力與資本的註解；同時因為帝國勢力的擴張，使得臺灣攝影史與東亞、東南亞（香港、新加坡、印尼與菲律賓）的攝影發展有著強烈的連動關係。攝影保存著權力、帝國的生命政治部署痕跡，也將當時風土民情、建築景觀、生活方式以及生態環境定影；對於了解臺灣歷史和物質文化，特別是原住民與平埔族等原民性之探討，提供真實的線索及證據，這是在攝影作為文件持存而面向未來允諾的歷史契機。

曙光：關於早期臺灣攝影的幾個思考

蕭永盛

一幀題名〈影像岬，基隆港，福爾摩沙〉（Image Point, Kelung Harbour, Formosa）的老照片，[2] 刊載在《四十年前遠遊中國與日本海岸》（On the Coasts of Cathay & Cipango Forty Years Ago）[3] 一書中，而此書作者威廉・白克禮（William Blakeney）繪製於1858 年 6 月 20 日至 24 日期間的基隆港地形水文圖則折頁於旁邊。

〈影像岬，基隆港，福爾摩沙〉這張照片拍攝自基隆港入口西側外木山岬角，港口外的基隆嶼被框取在畫面的左上方，前景則是造形怪奇的風化石（圖 1）。

「無畏號」的臺灣探索
1858 年 5 月 28 日，英國測量艦「艾克頓號」（Actoeon）上的助理測量員白克禮接獲任務，命其至香港，加入著名英艦「無畏號」（Inflexible）前往臺灣。「無畏號」這艘軍艦，承載了鬱屈的記憶，與中國近代史葛藤糾纏。

1857 年 12 月 30 日，英法聯軍攻進廣州西門。31 日，廣東巡撫柏貴投降。1858 年 1 月 4 日，兩廣總督、內閣大學士暨欽差大臣葉名琛經英法聯軍全城搜捕後被俘，隨即被押上泊於黃埔的英艦「無畏號」。1月 5 日，「無畏號」駛往香港，在香港一泊 48 天。葉名琛在被俘之日，陸軍上校葛瑞勞克（Crealock）拍攝之他的肖像，日後成為廣州越呱畫室生產的《葉名琛肖像畫》的原型。

2 月 23 日，「無畏號」駛向英國殖民地印度，1858 年 3 月 12 日，船抵加爾各答港。三天後，葉名琛被押往「威廉炮臺」。一年多後，葉名琛絕食死於異鄉。1859 年春，英人歸其屍於廣州。

「無畏號」前往臺灣，是奉英國印度洋海軍司令麥可・西蒙（Michael Seymour）命令，尋找可能遭遇海難的英艦「克爾比號」（Kelpie）及其倖存者，並從事博物學探查、採集工作。著名博物學者、英國首任駐臺灣府副領事羅伯・史溫侯（Robert Swinhoe），以及英皇家植物園邱園（Royal Botanic Gardens, Kew）派出的植物採集者查爾斯・威爾福（Charles Wilford）都在船上。

史溫侯此時才剛離開由英全權大使額爾金（Lord Elgin）所率領、在天津脅迫清廷修約的中國特使團譯員工作，轉任英廈門領事館翻譯官。但博物學探查及尋訪近十年前失蹤的海灘船員，是表面看得到的一部份，真正的工作是因應臺灣開埠的先期調查。[4]

「無畏號」於 1858 年 6 月 8 日，自廈門駛抵臺南府北方的國聖港，之後朝南逆時鐘環巡臺灣一周，於 6月 29 日重回臺南，30 日經澎湖島後，於 7 月 1 日返回廈門。

此趟洋艦環繞臺灣之行，在臺灣近代史裡是少見之舉。「無畏號」經熱蘭遮城、安平、打狗、枋寮、車城、蘭嶼、綠島、蘇澳、基隆、和平島、淡水諸地。基隆

港則是「無畏號」泊港最久之地。

測量員白克禮花了五天繪製出基隆港圖。白克禮在他的回憶錄《四十年前遠遊中國與日本海岸》中說，這幀詳細的水文圖曾在 1858 年 10 月單獨印行出版。白克禮測量海灣港口期間，「無畏號」上的史溫侯等人除了在基隆周遭的煤港八斗子（Coal Harbour）等地勘察煤礦外，亦徒步至金包里，翻越七星山至北投進入臺北，並乘小舟溯基隆河至汐止、七堵。

1858 年 6 月，「無畏號」把臺灣繞著轉了一圈。白克禮繪製的基隆港地圖（圖 2），也詳細地將基隆裡裡外外丈量了一遍。內港的水文圖尤其較四年前美國海軍所繪細緻，地圖中幾處重要地標，如外木山（Image Point）、和平島（Palm Island）、八斗子則循國際貫例，沿用之前繪圖的命名。

IMAGE POINT 的來源：從培里艦隊說起

一部重要西文文獻[5] 告訴我們「Image Point」是在 1854 年 7 月 14 日由美國海軍上尉測量官喬治・普瑞伯（George H. Preble）和海軍官校畢業生準尉華特・瓊斯（Walter F. Jones）所命名的。這份稱為《官方版遠征記事》（The Official Narrative of the Expedition）的文獻，記錄了美軍培里艦隊的遠征之旅。[6]

1852 年，美國海軍部任命海軍準將馬修・培里（Matthew Calbraith Perry）為美國海軍東印度、中國和日本海域司令長官。同年，培里自維吉尼亞州搭蒸氣巡洋艦密西西比號出發到香港集結調度艦隊，培里陸續集結了五艘美國艦艇，並派遣他們至上海、廣州、澳門、長江等地賦予不同任務，而其中一艘砲艦「大皮箱號」（Saratoga）被派往澳門去接艦隊首席翻譯衛三畏（Samuel Wells Williams）[7]和他的漢學老師謝永川。

培里在他的日記[8] 寫到當年他時常閱讀有關中華帝國的多本書籍，而衛三畏擁有中國文化的知識，即是他受培里注目的原因之一。1853 年，培里邀衛三畏出任遠征隊首席翻譯。然而，培里在日記中也寫到衛三畏僱用的中文老師謝永川因長年吸食鴉片病逝船上，使艦隊陷入沒有中文翻譯員的狀態，必須等衛三畏自上海找一位合適的翻譯加入艦隊。

為什麼首席翻譯必須兩度聘請中文老師做助手？培里日記透露，原來當時衛三畏雖能做中文口語翻譯，卻不擅於書寫中文，由於書面文字在美國與琉球王國或與日本幕府的外交折衝是必要媒介，日方並無英語翻譯，美國艦隊也無日語人才，書信需藉荷蘭文或中文才能溝通。這種以第三方語言進行異文化交流、接觸的方式，呈現了一種特殊的風景。直到衛三畏找到第二位來自廣東的漢文老師羅森，在 1854 年初從上海搭船來到琉球加入培里艦隊，協助翻譯工作。

一直以來無論是在 1980 年代的中國攝影史書寫，或直到 2010 年有關臺灣攝影的源流探索，皆因輕率地編造與沿襲，將羅森誤認為是培里艦隊上唯一攝影師小伊利法萊特・布朗（Eliphalet Brown Jr.）的助手，但其實羅森的角色在有關東西學術研究中，很清楚地被認知為是一位學識淵博且擅於書畫的中國文人。

艦隊上的攝影師：達蓋爾銀版攝影術與早期印刷

談起艦隊上的攝影師布朗，他是放棄在紐約已有相當商業利益的先行達蓋爾銀版攝影師，也是培里從眾多應徵者中選中的兩位參加遠征艦隊的藝術家之一。

在《官方版遠征記事》第一卷有一份圖像清單，以石版畫（lithographs）與木版畫（wood-cuts）區隔。題名、地點、藝術家和頁碼都非常清楚，並對版畫的原圖性質特別交代。若有原圖來自達蓋爾銀版照片，便會標上「from a daguerreotype」。經過比對、檢視清單與內頁版畫細節，我們發現統計出培里艦隊上的攝影師布朗，至少提供了 30 幀以上的達蓋爾銀版照片給紐約的石版畫作坊 SARONY、ACKERMAN 和木版畫作坊 RICHADSON 等。在這些版畫的角落邊緣，我們可以找到「DAG」、「Dag」、「From a Dag」不同的銘刻，證實有數十幀達蓋爾銀版照片存在過的間接證據（圖 3）。

布朗拍攝於 1853 年與 1854 年的上百幀（有學者估計有 400 幀）達蓋爾銀版照片，現在只有六幀被保存下來，其中三幀是拍攝於北海道箱館的達蓋爾銀版照片，可以和兩張石版畫版一張木版畫作圖像比較（圖 4、5）。這三幀達蓋爾銀版照片是北海道攝影史研究者涉谷四郎於 1965 年重新發掘的。

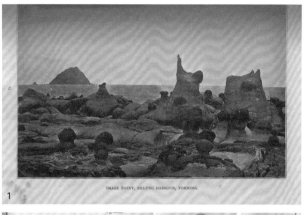

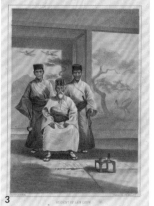

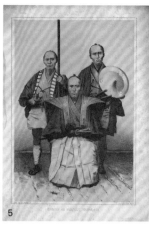

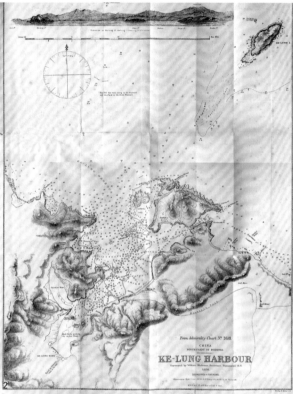

1. 影像岬，基隆港，福爾摩沙，國立臺灣圖書館提供｜ 2. 威廉‧白克禮繪製於 1858 年的基隆港地形水文圖，國立臺灣圖書館提供｜ 3. 琉球王國攝政總禮官尚大謨與他的兩位財務官，石版畫，布朗繪自他拍攝的銀版照片，1853 年，國立臺灣圖書館提供｜ 4. 1853 年 6 月，布朗於琉球泊村的寺廟前替當代居民與一名海兵拍照。海涅實景寫生，布朗繪圖，Ackerman 石版畫作坊，國立臺灣圖書館提供｜ 5. 遠藤又左衛門和隨從們，繪自布朗銀版相片的石版畫，1856。國立臺灣圖書館提供

第四幀是布朗在橫濱替通詞（翻譯員）名村五八郎拍攝的達蓋爾銀版照片，發現於 1982 年 6 月夏威夷博物館。名村的圖像出現在《官方版遠征記事》的第一卷，是一幀雙人肖像的木版畫。題名為〈名村，第三譯者，橫濱〉。這幀木版畫右下角刻有「E. BROWN. DAG.」，在清單上作者為 Brown，但沒有標示源自一幀達蓋爾銀版照片。布朗顯然在替幕府方面人物拍攝時，會拍攝多次。如此除了當作贈禮送給被拍攝的人外，艦隊此方才能另外留下幕府方面人物的達蓋爾銀版照片為日後所用。

第五幀現存的是布朗於 1854 年在日本所拍攝的達蓋爾銀版照片，是布朗在下田港替浦賀奉行與力（地方警備官）田中光儀拍攝的個人肖像。此幀達蓋爾銀版照片，在 1983 年 10 月由由田中光儀的後代於東京公開，布朗於培里艦隊大航海期間所拍攝的銀版照片原件，之後就沒有再聽聞有新的發現。

第六幀是下田奉行所支配組頭黑田嘉兵衛的銀版照片，發現於 2007 年，現寄存於日本大學藝術學部。[9]

從這僅存的六幀達蓋爾銀版照片實物，以及幾十張依據布朗拍攝的銀版照片做為模本的二次性圖像（刷色石版畫、木版畫、鉛筆畫），我們可以思考探究之處有許多面向。首先，是光學暗箱生產的影像和圖像印刷術之間的關係，圖畫（不論是描繪的、套印的或是雕刻的）在影像誕生後受到的影響和其演變也是課題之一。

于雅樂的《臺灣島之歷史與地誌》
現存的十九世紀臺灣早期的老件照片（vintage prints）為數有限，且散落在海內外數個公私立圖書館及私人機構中。國立臺灣圖書館臺灣學研究中心所收藏的《臺灣古寫真帖》[10] 計有 39 幀，乃 1942 年舊總督府圖書館向外求購後入藏。法國國家圖書館有一批來自《臺灣島之歷史與地誌》（L'île Formose Histoire et Description）[11] 一書作者法人于雅樂（C. Imbault-Huart）1885 年準備出書時作為原稿使用的照片（圖 6、7）。于雅樂的《臺灣島之歷史與地誌》這本書，在臺灣攝影史的研究中是重要的參考書籍；然而一些相關的研究對其部分資料有所誤讀，筆者在此提出。首先，此書的部份照片由愛德華茲（St.

Julian Hugh Edwards）的提供，但並不能因此推測照片皆為愛德華茲所攝。于雅樂於序言中表示：「臺灣島的風景照片，當然是很稀少的，刊載於此書的照片都由廈門的愛德華茲先生的好意而來。」[12] 于雅樂感謝愛德華茲的提供，而非感謝他的拍攝；這批照片中應是包含了愛德華茲所拍以及蒐羅而來的照片，並不是全由他拍攝。

書中有 17 幀未標示作者的凹版印刷照片及 11 幀版畫。當時因印刷技術的限制，凹版印刷照片成本較高，許多照片多以版畫的形式傳播，在這 11 幀版畫中，部分標有它們源自於照片（d'après une photographie）的註解，並有版畫鑴刻者 Ch Emonts 等人的簽名。這個時期的影像多可由照片與版畫之間的差異，推敲其圖片流傳的蹤跡。愛德華茲提供的影像不少於 28 幀，內含有兩幀約翰·湯姆生（John Thomson）所攝的作品。

此書另有一研究上的要題，在書中另外 12 幀照片裡，圖說皆標示「Phot. Berthaud, Paris.」。這 12 幀照片乃開業於巴黎及亞民（Amiens）的 Berthaud Studio 提供，然而一些研究者卻將其工作室之名 Berthaud 誤以為是人名。因《臺灣島之歷史與地誌》從未提及 Berthaud，倒是在書中提到 1874 年欽差大臣沈葆楨接受一位法國人貝托先生（M. Berthault）提供給他的類似巴黎四周要塞的藍圖，在距安平一公里半處建造了一座便於控制海灣的中國要塞。[13]

王雅倫《1850-1920 法國珍藏早期臺灣影像》[14] 一書及陳政三〈臺灣第一張照片誰拍的？〉[15] 一文中，都將「Berthaud」混淆為沈葆楨請來的工程技術者貝托先生，那些標有「Phot. Berthaud, Paris.」的 12 幀照片則被誤以為是一位技術人員業餘旅行時所拍攝。更有碩士論文將活躍於二次鴉片戰爭的中國及日本幕末時期的攝影師費利斯·比特（Felice Beato）也混淆成同一個貝托。

更重要的是，這些照片包括威廉·桑德氏（William Saunders）在澳門所拍攝的徐潤芝全身肖像照，此照片首次出版於 1876 年的《遠東雜誌》（The Far East）八月號第 38 頁，然而，于雅樂的《臺灣島之歷史與地誌》卻將徐潤芝的肖像標記為沈葆楨，在此留下

了歷史肖像照考證的難題……。[16]

《臺灣紀行》（Notes of Travel in Formosa）

近代西方涉臺外交事物史裡，法裔美國人李仙得（Charles W. Le Gendre）是一位爭議性的人物。日本早稻田圖書館收藏有出自李仙得的臺灣老照相簿《臺灣紀行：圖版》（Notes of Travel in Formosa: Plates），其中皆是保存相當完好的老件照片。直至 1865 年，臺灣才實質地完成通商口岸的開放，隔年李仙得——這位在臺灣老照片研究中相當關鍵的人物，被任為廈門領事並兼管臺灣的四口岸，並蒐羅了許多當時的臺灣照片，美國國會圖書館手稿室也藏有豐富的李氏相關文件及照片。收藏於早稻田大學圖書館的《臺灣紀行：圖版》[17] 老照相簿，即是李仙得送給日本高層極具現實參考價值的「禮物」，內容包括臺灣的茶業、石油、原住民等影像，具政治、經濟及軍事價值。這本老照相簿卷首有一「大隈氏藏書記」朱印，總計 89 幀尺寸不一的蛋白相紙臺灣影像，內含 43 幀約翰·湯姆生 1871 年春在臺灣南部拍攝的老件照片，這些照片應為約翰·湯姆生所沖印，是一手的影像資料，也是真正的老件照片，既非現代複印也未經修整。這 89 幀老件蛋白相紙的相片肯定不是李仙得帶去日本的全部，但此老相簿確實是臺灣學影像史料一處極重要的收藏。

1866 年起至 1872 年，李仙得任美國駐廈門領事。[18] 1867 年 3 月，美籍三桅帆船羅妹號（Rover）於屏東南灣七星岩觸礁，船員遭原住民殺害，他首次來臺與臺灣府文武官員及部落首領折衝處理善後事宜。此後，李仙得多次來臺且有攝影師隨行。其中以 1869 年偕同約翰·陶德（John Dodd）[19] 與必麒麟（W. A. Pickering）[20] 展開的那趟臺灣南北縱貫之旅，留下的多幀三人身影及臺灣十九世紀早期老照片最是珍貴（圖 8、9、10）。1872 年春，屏東射寮行是他最後一次來臺，李仙得 1874 年所寫的四卷本《臺灣紀行》[21] 中，首次明確提到此趟行程的隨行攝影師是廈門源發商行的李康沯（Lee Khong Tek），並有兩名助手與 27 名苦力同伴。

1872 年 10 月，李仙得外交仕途受挫，日本明治新政府出手拉攏，他於是獻計日本如何在臺灣東部和南邊海岸建立殖民地。此後他不僅帶走整套臺灣地圖，向日本正院（內閣）呈交多次備忘錄，還將質量可觀的蛋白相紙臺灣老相片帶到日本。

李仙得當年不僅接受日本政府提供的年薪銀洋 12,000 元待遇的外務省二等官職務，還介紹現職的美國海軍軍官協助侵臺日軍；他的異常舉動違背美國法律及《中美天津條約》之規定，美國北京代辦領事衛三畏就認為李仙得和海軍少校道格拉斯·克些耳（Douglas Cassel）甘心受日本利用妨害了中美和平關係，並辱沒了美國榮譽。

1874 年 8 月，李仙得回到初任領事的廈門計畫赴臺協助日軍。美國駐上海總領事喬治·西華（George F. Seward）得知後電報美國駐廈門領事恆德申（J. J Henderson）隨即將之逮捕。恆德申是以領事兼司法執行官的身分在美國海軍官兵的協助下逮捕了李仙得，李隨後由在廈門的洋商友人籌款交保；而後被押解至上海，雖然李仙得之後被釋放，卻終身未能再踏上臺島。即使如此，李仙得仍是日本出兵臺灣背後的真正「影武者」。

1874 年大隈重信 [22] 因為他的權力，得到了原本屬於李仙得的這 89 幀臺灣老照片。大隈重信出生於九州佐賀，早年在長崎學習蘭學，培里艦隊打開日本鎖國後，他也開始學習英學。史學家對他的功罪評價不一，1869 年他已經兼管日本新政府的外交和財政兩項要職，隔年更晉升當時日本政府最高官階的參議一職。1873 年征韓派政變後，他在明治政府內更顯得重要。1874 年 2 月，牡丹社事件，明治政府決定出兵臺灣。為安撫征韓派領導人西鄉隆盛，明治政府讓他的弟弟西鄉從道率兵征臺，擔任猶如遠征軍總司令的「臺灣事務都督」，然而大隈重信所任職的臺灣事務局總裁，卻是真正掌管出兵臺灣事務和財政的總負責人。也因為這實質的權力關係，使得李仙得將臺灣的老件照片交給大隈。《大隈文書》的〈生蕃討伐及統治意見書〉[23] 裡，我們可以看到李仙得如何赤裸裸地跟日本談及他自己和他介紹的美國海軍軍官、祕書、通譯之年薪月俸的金錢酬勞問題。

大隈作為近代日本的設計者之一，批評他的人指責他將日本帶向了軍國主義。日本侵略中國的開端，

Catamaran ou radeau en usage sur les côtes.

6.《臺灣古寫真帖》的竹筏影像，此竹筏尾端有一大清黃龍旗，木桶內坐著一位外籍海關檢驗員，另有三名左胸繡寫「臺灣關（府）」字樣的執法者，若此照片為臺南關（及當時臺灣府），則此照片可能在1865年臺灣府海關設立後所攝，照片尺寸 19 x 26 cm，國立臺灣圖書館提供｜7. 版畫出於于雅特《臺灣島之歷史與地誌》，國立臺灣圖書館提供｜8. 左側樟木桶貼著一張寫有「J. Dodd Petroleum Springs April 1865」（我陶德1865年4月在原油泉處）的紙張，國立臺灣圖書館提供｜9. 照片左起陶德、三名長槍護衛、李仙得，其餘三人。日本早稻田大學圖書館特別資料室典藏｜10. 臺灣南部某大榕樹下，有李仙得、必麒麟與陶德等人，日本早稻田大學圖書館特別資料室典藏

可以從 1915 年大隈任首相時對北洋政府提出的 21 項要求看到日本的野心。而 1872 年日本最初鋪設的鐵路「新橋－橫檳線」之開通，以及 1882 年創立早稻田大學（舊稱東京專門學校）則是他的正面功績。

大隈重信逝後，其後人分別在 1922 年和 1950 年將總計一萬二千餘件的文物、書信贈給學校當局。其中一冊皮革照相簿原屬李仙得所有，日後成為大隈藏書中頗為特別的文物。

牡丹社事件與其相關攝影史料

1895 年日本佔據領有臺灣，其遠因之一可以追溯至 20 年前的牡丹社事件。1871 年 12 月，前往琉球繳交年貢的宮古島官員在返航時因暴風與漂流至臺灣東南隅，多位宮古島人遭到排灣族高士佛社原住民殺害，此一不幸的事件成為 1874 年日本明治新政府首次海外出兵的口實。1874 年 6 月隨日本陸軍來臺的松崎晉二，是軍隊所雇用的攝影師，所拍攝的照片至今只出土了一幀〈灣島牡丹小女年十二歲〉的蛋白相紙小照片，一幀讓人感覺突兀、不舒服的照片。

1992 年秋，京都的寫真史研究家宇高隨生，將自己收藏的松崎晉二手稿《臺灣日誌》[24] 託付年輕輩研究者。之後才有東京大學教授木下直之和森田歷史寫真資料室負責人森田峰子對松崎晉二所作的研究。我們在此間接閱讀二則日誌：「9 月 7 日：據說是義大利人的攝影師，奉本國國王命令，得到日本外務省許可，乘神奈川丸到達此地。6 月 6 日：被叫去拍西鄉從道都督等人，攝影藥劑品質很壞加上有風，沒有拍成，非常困擾。次日再試著拍一次，水質惡劣，還是無法順利完成拍攝。臺灣真不是適合拍照的地方。路況很差，海邊砂地上立著的三腳架也不穩定，腳下不穩，一點風就讓暗箱動了，沒辦法好好拍照。加上一直有砂子跑進暗房來，沾在玻璃底片上。對攝影師來說臺灣真是無情難儀的所在。」

無法克服技術上的困難，難得留下這一張照片。少女被一隻從左邊冒出來的手強按著頭部，好讓松崎拍照成功。這位被稱作オタイ（Otai）的 12 歲少女，還被西鄉從道以教化蕃民的堂皇說辭，送往東京學習讀寫日語及日本的禮儀教養（shitsuke）達半年之久，期間以俘虜的身分，穿著日本和服，被帶往寫真館拍照。這張照片與被強迫移居至東京的琉球王朝貴族併置於同一頁發表於 1875 年的《遠東雜誌》第六卷的 204 頁。

當年如果李仙得順利自廈門前往臺灣協助日軍，且有攝影師隨行，以他熱衷蒐羅照片，並與包括活躍於廈門的愛德華茲氏、福州與廈門的悉尼（S. Sidney）、香港與新加坡的湯姆生、廈門的李康沙等人有過直接或間接的合作經驗，或許今天有關牡丹社事件的攝影史料就不致於如此貧乏了。

小結

新的歷史材料：1863 年，史溫侯於倫敦出版《福爾摩沙島札記》（Notes on the Island of Formosa），此書的第 113 頁貼著一幀蛋白紙照片。是筆者親自檢視過的老照片裡年代最早的，這幀蛋白紙照片年代應該不能早於 1858 年，不晚於 1862 年。

臺灣攝影起源的研究，如同藝術史裡繪畫的起源問題，充滿挑戰也難免含有猜想推測的時刻。福爾摩沙島上的攝影研究，正處在建構的進程中，島內海外厚藏堆疊許多尚待考掘的歷史材料；或只是一張玻璃濕版、一張蛋白照片、一本老照相簿、一輯早年的珂羅版印刷攝影書、一期攝影同仁團體期刊，或是一座老相館使用過的木製全景相機……每一次這些歷史材料有新的發現出土，為個人、公部門所收藏、保存修護、公開展覽，與被研究書寫發表，就是進一步充實豐富臺灣此地的物質文化史內容，有些時候還可能觸動我們土地承載的歷史記憶。

1 本文編輯自筆者於《攝影之聲》發表「臺灣攝影史系列」之〈從一張老照片說起〉及〈老相簿裡的歷史：考察臺灣 1860 年代的老照片〉兩篇專文，並進行部分改寫。見蕭永盛，〈從一張老照片說起〉，《攝影之聲》8 期，2013 年 3 月，頁 66-73，以及〈老相簿裡的歷史：考察臺灣 1860 年代的老照片〉，《攝影之聲》9 期，2013 年 5 月，頁 72-79。

2 2006 年 1 月 14 日，臺灣文史研究者陳政三先生投書《聯合報》，發表〈臺灣第一張照片誰拍的？〉一文，推測這幀照片極可能攝於 1858 年 6 月。對此推測，筆者持保留看法。

3 William Blakeney, *On the Coasts of Cathay & Cipango Forty Years Ago*, London: Elliot Stock, 1902.

4 臺灣開埠通商載於中國與列強間的條約，始於《天津條約》之規定。首先是美國全權公使列威廉（William B. Reed）與大學士桂良於 1858 年 6 月 18 日簽訂的《中美天津條約》，除五口岸外美國增開汕頭和臺灣這兩個通商口岸。6 月 26 日中英簽訂《天津條約》，英國向清廷增開臺灣、牛莊、登州、潮州、瓊州等五通商口岸。6 月 27 日，中法又簽訂《天津條約》，法國增開了臺灣、淡水、瓊州、潮州 登州、江寧等六通商口岸。兩次鴉片戰爭下來，中國就被迫開了 12 個通商口岸。舊五口中的廣州，此時等同被英法聯軍佔領。

5 見《奉美國聯邦政府命令，海軍準將培里統率下，執行於 1852、1853 和 1854 年，一支美國艦隊前進中國海和日本之遠征記事》（*Narrative of the Expedition of an American Squadron to the China Seas and Japan, Performed in the Years 1852, 1853, and 1854, under the Command of Commodore M. C. Perry, United States Navy, by Order of the Government of the United States*）三卷本之第二卷，頁 159。此書第一卷及第二卷書名同為《奉美國聯邦政府命令，海軍準將培里統率下，執行於 1852、1853 和 1854 年，一支美國艦隊前進中國海和日本之遠征記事》，培里為一卷所寫序言寫於 1856 年 1 月 1 日；第二卷序言寫於 1857 年 6 月 10 日。第三卷書名為《自這些獲得的材料做出的結論成果：先前遊於東方海域和返航母進其間，主要繪製於合眾國蒸氣巡洋艦密西西比號，自 1853 年 4 月 2 日至 1855 年 4 月 22 日，立基於黃道光實測報告》（Observations on the Zodiacal Light, from April 2, 1853, to April 22, 1855, Made Chiefly on Board the United States Steam-frigate Mississippi, during Her Late Cruise Eastern Seas, and Her Voyage Homeward : with Conclusion from the Data thus Obtained）。奉美國國會出版的華盛頓三卷本，實際出版於 1856（第一卷）、1858（第二卷）、1857 年（第三卷）。

6 《官方版遠征記事》共分三卷本，第一卷參考艦隊官兵的日記、筆記並使用藝術家寫生、畫稿、銀版照片製成版畫，另穿綴 89 張重磅刷色石版畫。此卷更記載「南安普頓號」（Southampton）1853 年 10 月 29 日經過臺灣時，觀測到距陸地十海浬處海底火山大爆發。第二卷內容為博物學繪圖，有鳥禽、魚貝、植物花卉等多幅精緻版畫；培里司令與船長間的官式信函、任務報告書、煤礦質地比較檢測報告、清人羅森所撰「日本日記」的英譯。1854 年 7 月，「馬其頓號」前往基隆探勘煤礦，任務主持人喬治‧瓊斯（George Jones）的報告書兩份；培里司令與船長喬爾‧阿伯特（Joel Abbot）間往返的數封信。第三卷編纂者是藝術碩士、海軍神職牧師喬治‧瓊斯，此卷有多幀大型地圖和黃道光天文觀測圖，船泊定位測量、海灣水道圖。普瑞伯和瓊斯所繪大型基隆港地圖即在此卷。

7 衛三畏（1813-1884）在 21 歲時接受海外傳道團體美國公理會（The American Board of Commissioners for Foreign Mission）派遣來到中國廣東，負責編輯中國境內早期西文月刊《中國叢報》（*The Chinese Repository*）或稱《中國寶函》。這份創刊於 1832 年 5 月至 1851 年休刊的《中國叢報》是漢學研究與中美關係史的重要文獻，衛三畏除了自 1848 年開始擔任主編，他在紐約出版的《中國總論》（*The Middle Kingdom*）也使他從此列身中國專家。1855 年衛三畏因為參與遠征艦隊的功績，被任命為美國駐中國公使館參事官，進入美國政府外交系統，晚年則在耶魯大學任教，成為美國先行代的漢學家。中美天津條約簽訂時，衛三畏即擔任美國全權公使列威廉（William B. Reed）的副使，臺灣（臺南府）則首次明載於開埠名單。

8 馬修‧培里（Matthew Calbraith Perry），〈遠征日本：培里艦隊司令私人日記〉（*The Japan Expedition 1852-1854 :The Personal Journal of Commodore Matthew C. Perry*），Roger Pineau 主編，Washington, DC：Smithsonian Institution Press，1968，第一冊廣東一節。

9 飯沢耕太郎，〈真的な物の見方と日本人の視学体験〉，季刊デザイン no.15 特集写真都市，頁 100。鳥海早喜，〈初めてダげレオタイプに写された日本〉，《レンズが撮られた外国人カメラマンの見た幕末日本一》，東京：山川出版，2014，頁 125。

10 《臺灣古寫真帖》共 39 幅，19 x 26 cm。

11 英博‧于雅樂（C. Imbault-Huart）原著，《臺灣島之歷史與地誌》（*L'île Formose Histoire et Description*），黎烈文譯，臺北：臺灣經濟研究室編印，1958。

12 寫於 1885 年，見于雅樂，《臺灣島之歷史與地誌》之序言，頁 xiii。

13 于雅樂，《臺灣島之歷史與地誌》，頁 178。

14 王雅倫，《1850-1920 法國珍藏早期臺灣影像》，臺北：雄獅圖書，1997。

15 陳政三，〈臺灣第一張照片誰拍的？〉，《聯合報》，2006 年 1 月 14 日，頁 A15。

16 沈冬，〈沈葆楨圖像考論：追尋祖先的容顏〉，《臺灣史研究》24 卷第 2 期，2017 年 6 月，頁 33-81。

17 《臺灣紀行：圖版》為早稻田所收藏的《臺灣紀行》圖版資料，共 63 頁，書籍大小為 39.3 x 31 cm。

18 雖然臺灣府與淡水分別在 1859 年與 1860 年開埠條約生效，各國卻未派遣領事來臺駐紮於開埠地，《天津條約》裡規定沒有領事館是不能開放通商的，臺灣的情況頗不尋常。西方列強都想一體均霑從臺灣獲得實際利益，初始表現得並不積極。英國最早在 1861 年派年輕的翻譯官史溫侯為駐臺灣府副領事，史溫侯只是副領事不能和臺灣道臺見面，只能向臺灣知府平等往來，外交文書僅能透過英國福州領事館轉呈，不能直達英國駐北京公使館。（見葉振輝，《清季臺灣開埠之研究》，臺北：標準書局，1985，頁 125-127。）史溫侯經過多年的爭取，英國才在 1865 年 2 月在打狗設領事館，並升史溫侯為領事。英國長老教會宣教師馬雅各（James Laidlaw Maxwell）也是在這一年長駐南臺灣傳布福音。1865 年臺灣才實際完成開放雞籠、淡水、臺灣府、打狗四口岸，並開設海關。美國則因 1861 年南北內戰，無暇關注臺灣的開埠，直到幫助北軍於內戰建功的李仙得被任為廈門領事並兼管臺灣的四口岸。

19 約翰‧陶德，英國蘇格蘭人。1864 至 1890 年活躍於臺灣鴉片、樟腦、茶葉市場。曾任多間洋行臺灣代理，並創立寶順洋行（Dodd & Co.）。曾聘李春生為買辦，設行館於艋舺、大稻埕、淡水、基隆、廈門及上海。1865 年陶德在苗栗發現石油，1869 年成功將臺灣烏龍茶行銷美國。1868 至 1874 年間因與李仙得的私交，代理美國駐淡水副領事。1884 至 1885 年的清法戰爭期間，曾將他的所見所聞發表於《香港英文報刊》（*Hong Kong Daily Press*）。

20 必麒麟，英格蘭水手。1862 年加入中國海關總署任檢驗員，曾在福州、打狗、臺灣府海關工作。1864 至 1870 年滯臺期間活躍於海關、洋行及原住民部落。因極佳的語言天賦曾協助李仙得與瑯橋諸番首領卓杞篤就保護難民人員取得口頭協議及作成文字備忘錄。因行事風格及商業利益引發 1867 年的樟腦收購戰事，是清官員的頭痛人物，並稱他是被清國海關革退的扦子手（tidewaiter）。

21 《臺灣紀行》2012 年原手記於臺灣由國立臺灣歷史博物館出版，見第 23 章，頁 311。此書收有長年研究李仙得的費德廉（Douglas Fix）所寫的兩篇文章〈An Annotated Listing of Photographs in Notes of Travel in Formosa〉（頁 418-425）及〈Photographic Views in Notes of Travel in Formosa〉（頁 xxxv-xlix）。

22 大隈重信（1838-1922）為日本的政治家與教育家，亦是明治維新的重要改革者，兩度出任日本內閣總理大臣（首相），並創立早稻田大學。

23 此為 1874 年 3 月 13 日李仙得致大隈之信，《大隈文書》亦收錄其他數篇李仙得的備忘錄。見大隈重信等，《大隈文書》，東京：早稻田大學社會科學研究所，1957。

24 《臺灣日誌》中記錄的時間為 1874 年 4 月 22 日至 10 月 18 日。

1985 年黃明川將他在美國留學期間收集的資料初步整理出〈臺灣攝影史簡論〉，這是第一篇嘗試整理臺灣攝影史的書寫。文中提到在 1985 年前後，往年無法見天日的臺灣早期照片被大量發掘：「可見臺灣存在著對早期歷史影像的飢渴，而這種飢渴無疑是長期與臺灣歷史斷隔累積而來，只因為文學運動，政治參與，民俗學術研究的熱潮，才使照片在歷史證據的地位上突然增亮了起來。」[2] 在解嚴前後興起重建社會記憶工程，使得收集歷史照片成為急迫的文化生產以及圖像記憶的指認。即便早在 1979 年由雄獅美術出版的《攝影臺灣》與《攝影中國》便意圖以攝影見證歷史變遷，然兩冊旨在呈現常民生活與建築的攝影圖書，在編輯期間卻多次被警備總部突襲檢查，使得在戒嚴時期的非官方歷史圖像生產與詮釋產出異常困難。如許綺玲所言，因為政治因素影響，遲至 1980 年代中期臺灣才醞釀出整理本地攝影史的環境條件。[3]

同年 5 月，由吳家寶主持、行政院文化建設委員會（今文化部）主辦的「百年臺灣攝影史料整理工作」啟動。「誰首先拍下臺灣」[4] —— 一個似乎能為歷史開端定調的問題，在早期臺灣的攝影史編撰工作中經常被提起。然在 1980 年代中期，諸多線索尚未尋獲的狀態下，許多的臆測只能依賴文獻。[5] 尋找攝影歷史的起點，如傑佛里‧巴欽（Geoffrey Batchen）所言，不僅是抽象的姿態，更是政治性的。因為原點的定位通常與國族主義的想像或歷史概念架構綑綁，選擇起點的座標也宣稱了抉擇的意圖所在。他

以攝影史學者米謝勒‧費佐（Michel Frizot）的《新攝影史》（Nouvelle Histoire de la Photographie）為例，該歷史專注於攝影影像的技術生產，因此什麼是「攝影」，以及攝影的本體性成為至關重要的問題。讓攝影史變成「技術」的「生產」的歷史，使得它排除了攝影諸多的實踐，甚至排除了攝影在歐洲之外（非技術原生地）如非洲、亞洲、拉丁美洲等地的實踐。因此，原點作為一個問題不能只是問從何開始，而是如何開始，這個「如何」顯著地框定了歷史建構的角度與政治。[6]

「是誰首先拍下臺灣」作為原點的提問，或者換句話說，「臺灣如何被拍攝」，使得臺灣攝影史的開端與「被攝者」的歷史纏繞。在臺灣早期攝影史的研究中，在觀看與被觀看關係的網絡裡，約翰‧湯姆生（John Thomson）很快地便佔據了開啟「攝影元年」的位置，[7] 甚至也有學者認為臺灣在十九世紀影像史的研究中依舊大約是由 1871 年湯姆生來臺南部拍攝為基點，向前或往後延伸。向前延伸者，學者們嘗試提出是否有嚴格考據，如有否參考文字敘述。[8] 即便，時至今日已有新的歷史考據將攝影的初始事件錨定於聖朱利安‧愛德華茲（St. Julian Hugh Edwards）先後在 1865 年至 1874 年間，往返於廈門與福爾摩沙島（以下福島）留下的攝影活動紀錄與影像。然，愛德華茲既在廈門開設照相館，也在西班牙領事館工作，並曾因走私勞工而被李仙得逮捕等多重角色與經歷，顯示他僅將攝影視為受僱於他人的營生工具之一，並未將自己塑造為攝影

作者，意即刻意地將拍攝的影像進行作者式的註記與發表出版。這使得愛德華拍攝的照片四散，如何辨認照片攝影者的身份也是個巨大的難題。[9]

1985 年開始對於攝影起點指認甚至攝影史的建構，顯然已不滿足於大量的照片作為歷史註腳與佐證，並使得觀者有種集體的、時代承繼者的敘事觀。「攝影需要屬於自己的歷史軌跡」[10] 意味著它對於本體式的起點有了提問的渴望，攝影即便對「捕捉真實」似乎有其與生俱來的能力，但它卻對「自我明證」稍顯無力，華特・班雅明（Walter Benjamin）在《攝影小史》（A Short History of Photography）裡提到攝影之於現實永遠呈現近似的、趨近的滑動狀態，需要以文字的銘刻確認它宣稱與指認它與真實間的關係。[11] 湯姆生的作品之所以能在 1985 年以來追索臺灣攝影起源熱之時迅速佔據攝影元年的位置，主要原因便是在攝影之際，他留下了可供考據、可供辨識的文字遺產。這文字印刻能賦予攝影影像精確的身分，足以避免研究十九世紀臺灣早期攝影最大困難：「有圖無字」[12] 加上無法為影像精確訂定年代與攝影者，或「有文無圖」——如 1854 年培里將軍曾令馬其頓號（Macedonian）艦長喬爾・亞伯特（Joel Abbot）率同軍需船「補給號」（Supply）至臺灣北岸探查煤礦，船上可能有攝影師同行但至今還找不到影像證據。[13]

湯姆生作品裡文字印刻可分成兩個層面：一是他在玻璃板底片上直接為攝影內容註記；二是他結束在亞洲之旅返英後多次出版和發表自己的旅行見聞。關於前者，湯姆生在拍攝玻璃版之後，會悉心的在玻璃板上刻寫拍攝地點、主題與年代。而在 1921 年他將全數底片賣給惠康收藏館（Wellcome Collection）之前，又以類似紙膠帶的媒材貼在底片上註記拍攝地點及年代，並為底片編號，悉心地將攝影檔案化（圖 1）。[14] 關於出版，當 1872 年湯姆生結束了他在中國與福爾摩沙總歷時共五年的旅行後，他把這趟旅行出成了五本遊記與攝影書。[15] 作為皇家地理學會（Royal Geographical Society）與倫敦民族學學會（Ethnological Society of London）成員之一，[16] 返回倫敦後，湯姆生亦持續地以講座形式、地理探險和人類學介紹為角度發表他在福爾摩沙的行旅（例如 1873 年於皇家地理學會發表的〈南福爾摩沙紀行〉

（Notes of a Journey in Southern Formosa）。文字的印刻不論是刻在底片上或是出版，皆讓湯姆生的照片成了可輕易被辨識的影像遺產。因此，有別於十九世紀大部分於福爾摩沙行旅的攝影者並未為影像精確註記或無意大量出版，湯姆生對於相片傳遞資訊的功能相當警覺，如他在 1891 年發表的〈攝影與探險〉（Photography and Exploration）提倡「攝影在科學，尤其是地理學逐漸重要的位置，以及提醒探險者攝影能保全的知識（the great advantages which a knowledge of photography secure）描繪他們行經的路徑以及記錄他們的觀察。」[17] 為了確保攝影帶來的知識功能，他在玻璃板底片上悉心註記被攝者的資訊，亦回應了攝影在十九世紀配合殖民與帝國的擴張所扮演的權力－知識－主體的三位一體功能。

如果，攝影史的建構與檔案印刻與詮釋的技術息息相關，除了此文一開始提到湯姆生在十九世紀的檔案印刻技術驅使他迅速成為臺灣攝影史一個可被辨認的初始事件，在十九世紀當前湯姆生又如何利用這種印刻技術為了帝國的檔案經濟貢獻了一己之力，在以下的章節，我將陳述湯姆生來到亞洲行旅的契機，以及他返國後進行出版的嘗試。

約翰・湯姆生個人生平

約翰・湯姆生 1837 年出生於蘇格蘭愛丁堡，父親經營菸草生意。愛丁堡在十九世紀時是科學實驗與攝影機具的發明重鎮。[18] 在 1851 至 1861 年間他在一家光學儀器公司擔任學徒，並在 1861 年成為蘇格蘭皇家藝術會（Royal Scottish Society of Arts）會員。在實習與修業期間湯姆生接觸了微型攝影（microphotography）。[19] 1859 年湯姆生的兄長搬到了新加坡並開始雜貨商的生意，而在 1862 年 25 歲的湯姆生也決定跟隨兄長的腳步到新加坡協助攝影工作室的生意，該工作室主要為歐洲商人拍攝人像、製造照片卡（cartes de visite）。工作室的收入成為他接下來四年在東亞旅行的經濟來源。[20] 在新加坡，湯姆生訓練了兩名中國人阿昆 (Akum) 及 阿洪（Ahong）為助手，他們成為湯姆生在亞洲旅行的重要夥伴。[21] 在新加坡定居後，趁地利之便湯姆生前後在麻六甲、蘇門答臘、檳榔島各地旅行。1864 年 約翰・莫瑞出版社（John Murray）翻譯了法國文學家

亨利‧穆奧（Henri Mouhot）的《1858、1855 與 1860 年在印度支那（暹羅）中部、柬埔寨與寮國的旅行》（Travels in the Central Parts of Indo-China (Siam), Cambodia and Laos During the Years 1858, 1859 and 1860）。 這本書啟發了湯姆生前往暹羅與柬埔寨拍攝吳哥窟，在 1865 年他抵達曼谷為蒙庫國王（King Mongkut，也就是拉瑪四世）、貴族與官員拍照。深知這批照片的商業價值以及強調所有權，湯姆生甚至要求國王不能把照片給任何其他攝影師看，以免被複製。[22] 從捍衛相片的流向與所有權的角度來看，可見湯姆生對於他身為攝影者有相當的自覺。在所謂著作權尚未存在的十九世紀裡，翻拍複製他人相片作為其他商業或收藏用途是相當普遍的現象，如美國駐廈門領事埃爾維爾‧格茲保羅（W. Elwell Goldsborough）一次致信北京上訴他與愛德華茲之間的官司，認為需賠償愛德華茲的拍攝費太過昂貴之外，進而指控愛德華茲提供的許多照片都是翻拍而來，作者並非本人，甚至憤怒的指出「難道您就沒有懷疑過，愛德華茲的這些沒有具體日期的照片很可能是對我的栽贓陷害嗎？」[23] 沒有具體的日期、照片身份難以判定，除了說明攝影的難以自我明證，也顯示了翻攝風氣的盛行。因此不論是悉心的在底片印刻拍攝日期，或控制照片的流向，這些與作者綑綁的檔案技術都讓湯姆生在東方的行旅獲得高度的辨識度。

湯姆生在 1866 年 6 月由新加坡返回英國一年，抵達英國不到兩個月他便積極地發表在東方的旅行報告。他先是在諾丁漢（Nottingham）的英國科學促進學會（British Association for the Advancement of Science）發表；同年 8 月 16 日在皇家地理協會亦發表關於柬埔寨與暹羅旅行的報告，11 月湯姆生便正式成為皇家地理學會的會員。此外，他亦參與了愛丁堡攝影學會舉辦的攝影展，展出他在柬埔寨的照片。而在 1867 年他也陸續把照片發表在大英攝影雜誌（British Journal of Photography）與倫敦畫報 （The Illustrated London News）。同年他更出版了第一本攝影集《柬埔寨遺跡：在地攝影系列》（The Antiquities of Cambodia: A Series of Photographs Taken on the Spot），並加入了倫敦民族學學會。配合出版，湯姆生的東方行旅為他帶來不少的名聲與迴響，循著同樣的模式：東方行旅、

攝影及再返國出版東方見聞，湯姆生有計劃性地將旅行攝影帶回英國藉由在各式機構發表的機會建立職業名聲。在英國短暫停留後，同年他便回到新加坡，並著手規劃 1868 年到中國的旅行。

福爾摩沙行旅

湯姆生在 1868 年定居香港，在十九世紀異國探險活動與西方的帝國擴張有著一體兩面的關係。在中國因戰爭帶來條約簽定，也保障了西方人在中國傳教、居住或商業貿易的權益。例如，鴉片戰爭後的「南京條約」（1842）開放了五個港口，並把香港割讓給英國殖民。1858 年 6 月，清廷與美國、英國、法國簽訂「天津條約」，臺灣正式開埠，開放了安平與滬尾（淡水）兩通商港口。雖雞籠與打狗（高雄）非條約規定的通商口岸，但因早有外商前往貿易，加上雞籠有煤礦，清廷便被要求也相繼開放該兩港口作為滬尾與安平的副港。因此，該四個港口在十九世紀留下了不少所謂的通商口岸影像 （treaty-port imagery）。 香港或其他貿易港口是與異國勢力的接觸地點，通常被形容為繁華、秩序與活力之都。湯姆生認為代表現代文明的電氣，如蒸氣船與電報即將改變中國古老的地景，特別是已經電氣化的維多利亞城市，更是西方文明的成就。[24] 湯姆生 1868 年在香港落腳，工作室就座落在商業銀行洋樓。他的部份收入來自為遊客拍攝紀念照，也開始在《中國雜誌》（The China Magazine）發表在東南亞拍攝的照片。1868 至 1869 年期間湯姆生在鄰近地區，像廣東、上海等地進行短距旅行。但在 1870 年，他決定離開自己的工作室一年遍遊中國。行經廈門時，湯姆生參訪了廈門醫院，一個在中國最重要的傳教站，同時也是福爾摩沙傳教站重要的聯絡窗口。在此，他遇見馬雅各醫生（James L. Maxwell），後者成為他在福爾摩沙行旅的重要嚮導。馬雅各於 1863 年被指派到福爾摩沙身職醫療傳教，根據《英國長老教會在南福爾摩沙的傳教手冊》（Handbook of the English Presbyterian Mission in South Formosa）[25] 記載，馬雅各於廈門接受 18 個月的語言訓練，於 1865 年 5 月由杜嘉德宣教士 （Carstair Douglas）陪伴抵達臺灣府設立傳教站。自此，西方醫學伴隨著「治療身體拯救靈魂」的概念於島上運行。[26]

馬雅各在臺的醫療宣教地區其實是湯姆生行旅路徑

的原型，湯姆生拍攝一系列平埔族人肖像也多取材自馬雅各的教區。當馬雅各在 1865 年開始於福島傳教，一開始的際遇並不順利，不得已的狀況下開始思考是否臺灣原住民比漢人更容易接受福音。於 1865 年 11 月他便與在打狗海關任職的必麒麟（W. A. Pickering）拜訪新港、崗仔林、荖濃等地，多次的拜訪都受到了熱烈的歡迎，藉此機緣馬雅各更確認了他前往平埔族區域傳教的想法。於 1867 至 1868 年他再與必麒麟進行多次南部山區的探訪，而在 1870 年前往平埔族生活的區域如木柵（內門）、拔馬社（左鎮）、崗仔林、阿里等地傳教，其中木柵因為有馬雅各家中平埔幫傭 Nhauh-a 與 Niu-i 的協助，傳教過程順利，[27] 短短二個月內教徒由 60 人驟升為 200 人，這幾個地區也建造了在地聚落的禮拜堂。在湯姆生於 1871 年在福爾摩沙行旅時，馬雅各已經在平埔族區建立十多個禮拜堂，平埔族人受洗者約莫 1000 多人。[28] 因此，湯姆生行旅的路徑已被兩種現代技術穿透：攝影與西方醫療。馬雅各作為英國基督長老教會第一位在臺宣教士，除了積極在臺灣建立傳教中心與進行醫療工作之外，不少平埔族群的肖像留影都透過馬雅各的引線牽針下產生。如，李仙得籌劃的《臺灣紀行》手稿文件裡幾張平埔族人肖像，據費德廉教授對照推測，可能受李仙得雇用的攝影師愛德華茲在 1869 年 1 月至 1870 年 2 月之間，在李仙得、必麒麟與蘇格蘭籍商人陶德（John Dodd）陪同下於馬雅各教區短暫停留時的拍攝。除了留下一張馬雅各一家的合照（圖 2），馬雅各的平埔幫傭，也是最忠實的教友 Niu-i 也神色自若地獨照入鏡（圖 3），並在《臺灣紀行》文稿中被標記為「Poppo woman, Baksa」，成為木柵平埔女性的圖示範例。[29] 因此，在馬雅各的教區內，（早期）攝影作為一種需要高度紀律身體的儀式（曝光時間依光照程度從數秒至一分鐘不定），隨著宣教醫療已在福島裡成為不算陌生的儀式。相較於湯姆生在中國拍攝遭遇的不信任甚至攻擊的困難，在福島的行旅除了爬山涉水的辛勞之外拍攝過程還算順利，其中馬雅各扮演重要的角色。

湯姆生旅行路徑為打狗、臺灣府（臺南）、拔馬、木柵（今內門一帶）、匏仔寮（寶隆）、甲仙、荖濃村、六龜里、木柵。他共在福島拍攝了約莫 61 張照片，[30] 拍攝內容主要分兩類：一為南部內山風景，二為平埔住民肖像，亦拍攝他們住屋環境與建造的禮拜堂。根據湯姆生的旅行日誌，他在 1871 年 4 月 1 日由馬雅各陪伴從廈門抵達打狗城，抵達時他先在李麻牧師的傳道所休息，聽聞島上強盜肆虐的消息，因此湯姆生延後訪問南部的原住民的行程，4 月 2 日一清早先到臺灣府拜訪道臺。在表明想看島上的原住民後，一位口操流利英文、據說是道臺姪子的男士警告湯姆生永遠接近不了這些原住民，只會被毒箭射中或在山中迷路。然湯姆生很清楚地闡明自己的目的在於「深入島的心臟尋找原住民」[31]，作為他在亞洲之行裡尚欠缺的原始（primitive）冒險故事。

休憩幾日後馬雅各與湯姆生決定在 4 月 11 日前往內地深山拜訪較偏遠的傳道所，馬雅各也希望能拓展新的傳教區域。離開臺灣府的首站便是拔馬，在接近山脈前他們雇用轎子與苦力搬運攝影器材。接近山脈後一行人便徒步在崎嶇泥濘山路前進，抵達拔馬首見的是平埔族人們前來迎接許久不見的馬雅各醫生。在此也有一間小教堂由一名平埔族教徒協助主持。隔日早晨他們前往木柵，到達時亦受到許多平埔族人歡迎。在傳道所過了一夜後，4 月 13 日便前往甲仙埔沿途攀爬陡峭光禿的山脊，他們也請了六位平埔族人擔任挑夫，到達了山頂他們一飽壯麗中央山脈被煙雲圍繞的景色。到達柑仔林村後短暫停留由一位基督教執事帶領，他們離開傳道所繼續前行艱辛的山路，到達匏仔寮村他們住在一名叫辛春（Sin-chun）的平埔族人家，於此湯姆生仔細描述他與族人們進餐，和飯後馬雅各看診的狀況。

4 月 14 日繼續前往甲仙埔，當晚住在馬雅各認識的老人阿僮家，他仔細形容平埔家屋居住環境，當晚也參與族內舉辦的歌舞慶典。4 月 15 日一行人前往 11 哩外的荖濃，經過湯姆生號稱今生見過最壯觀的景緻之一。因為將經過山地「生番」[32] 領域，阿僮派了一位攜槍年輕人與湯姆生同行，在路上山谷稍作停留拍攝美景。抵達在大河邊的荖濃村由平埔族人阿洪招待，4 月 16 日由阿洪的兒子帶領前往六龜，沿路上亦拍攝一些原住民部落與風景。當晚一行人在六龜借居在馬雅各舊識家中，湯姆生並熬夜準備硝酸銀液。4 月 17 日湯姆生花了大半時間趕路回木柵與拍照，精疲力盡之餘馬雅各還得趕在 4 月 18 日在木柵禮拜堂舉辦儀式。到達木柵後休息一晚，馬

1. 湯姆生在玻璃板底片上留下「平埔人家屋 福爾摩沙中國 平埔家屋木柵 Bak-su 福爾摩沙 1871 棚屋 福爾摩沙在地平埔族人 410」410 為他為玻璃板的編號，惠康收藏館提供（CC BY 4.0）｜2. 倫敦亞非學院檔案室所收藏的照片中，皆有註記被拍攝者的名字。此張照片為馬雅各夫婦、平埔幫傭與教友 (Thik, Niu-i)、漢人助手以及被稱為 Bun 的傳道吳文水之合照，圖片來源：The School of Oriental and African Studies, Missionary Collections (PCE BOX2, file2)｜3. 愛德華茲拍攝的木柵平埔族婦女，此張照片收錄於李仙得籌劃的《臺灣紀行》手稿文件，國家攝影文化中心典藏｜4. 約翰・湯姆生，戴著頭飾的平埔族女性，木柵（今高雄內門），福爾摩沙（臺灣），1871，惠康收藏館提供（CC BY 4.0）｜5. 約翰・湯姆生，平埔族女性，木柵，30 歲，福爾摩沙，1871，惠康收藏館提供（CC BY 4.0）｜6. 約翰・湯姆生，老婦人，廣東廣州，1869，惠康收藏館提供（CC BY 4.0）｜7. 約翰・湯姆生，平埔女孩，木柵，福爾摩沙，20 歲，1871，惠康收藏館提供（CC BY 4.0）｜8. 約翰・湯姆生，《中國及其子民》第二冊，珂羅版，1873，國家攝影文化中心典藏

雅各便在禮拜堂主持宗教儀式，而當日湯姆生也回到打狗，原本想往更南部的部落探險，因有戰事，而結束福爾摩沙之旅。

攝影集出版與檔案渴望

湯姆生在 1871 年 4 月遊歷福島後返回香港，他賣掉經營的照相館換取更充沛的攝影材料，以便前往中國上海、河北、天津、北京、漢口、四川、南京等地遊歷，他於 1872 年春天再返回香港將所有的玻璃片進行分類，最終選出 1200 塊玻璃版帶回英國。在同一年秋天回到英國後，他便積極出版在中國與福爾摩沙長達近五年的旅行。湯姆生在福爾摩沙拍攝的影像，在他的規劃下分為三本攝影與圖集出版，分別為《中國及其子民》（1873-1874）、《十載遊記：麻六甲海峽、中南半島與中國》（1874）（以下《十載遊記》）、《一具相機走中國》（1898）。[33]

《中國及其子民》是湯姆生最著名的攝影集，四卷本收入了兩百多幅照片，並附有鉛印文字隨圖說明，在 1873 至 1874 年由桑普森‧洛公司（Sampson Low）出版。在廣告裡此書主打「關於中國的傑作：攝影全來自作者的底片，由珂羅版的連續色調印刷製作（collotype/autotype），有個人觀察筆記」[34]，標榜攝影者的觀察與親身經歷的行旅，並由珂羅版的連續以呈現當時攝影最先進的技術呈現。[35] 此系列圖錄單本價值三鎊三先令，是昂貴的出版物。關於福島的影像在一、二冊出版，首兩冊分別印了 600 本，受到書評雜誌《畫報》（The Graphic）與《雅典娜雜誌》（The Athenaeum）高度評價。而以福島為開頭的第二冊評價更高「只有親眼目睹才能相信攝影可以呈現如此驚豔的效果。在圖像裡的輕柔與細節讓我們不禁想著只靠機械是辦不到的，……這些作品無疑的是完美的奇蹟，湯姆生先生很有資格冠上大眾施慧者（public benefactor）的頭銜。」[36]

《中國及其子民》嚴格來說並非遊記，而是一本以攝影為主、佐以文字解說的圖錄。福島的影像出現在第一冊最後一章「福島的山路」（A Mountain Pass in the Island），頁面左側的文字解說福島人口、簡短歷史與地理，右側則是在甲仙埔與荖濃間拍攝的山景。其他關於福島的章節則是「木柵的竹子」、「福爾摩沙的原住民」、「平埔家屋」、「平埔的

種類」（Types of The Pepohoan）與「近臺灣府的鄉間路」。此系列圖錄的文字以中立報導式口吻鋪陳，如「福爾摩沙的原住民」一圖說明：「圖錄的主題取材自木柵的平埔族……他們通常被認為半開化原住民中最先進的種類之一 (the most advanced types of those semi-civilized aborigines)」相較於其他遊記中經常出現的野蠻人（savage）字眼，此文體刻意呈現客觀中立的觀察角度，並以種族類型（racial type）——一種在維多利亞時期盛行的民族學攝影語言——進行拍攝，例如以正面、側面頭像與簡約空白的背景呈現肖像（圖 4、5），便是十九世紀民族學攝影的標準語言。[37]

《中國及其子民》銷售長虹，因此在 1874 年又乘勝加印另一本關於中國遊記的書籍《十載遊記》，並趕在 1874 年 12 月專攻聖誕節市場出版。《十載遊記》是關於湯姆生在遠東遊記的八開本，附有從湯姆生底片複製，J‧D‧庫柏（J. D. Cooper）製作的 60 張木刻版畫，一本書要價一幾尼（1 guinea = 1.05 英鎊，為英國在十七至十九世紀初通用的貨幣）。此書在 1875 年同樣獲得好評，如《倫敦新聞畫報》評論：「該書提供大量娛樂性的知識，讓中國的景色與人文如實與活生的呈現。」[38] 縱使在《雅典娜雜誌》的書評認為這本著作沒有太多新意。[39] 與《中國及其子民》不同，此書以長篇遊歷敘事為主，筆調生動且較具娛樂與渲染性，如在福爾摩沙一行還未上岸便在船上聽聞嗜血野人出沒的故事，或是在臺灣府見道臺時一再強調自己想深入島的心臟尋找原住民，卻被道臺警告其危險性。湯姆生在文初一再地將福爾摩沙形容為毫無法治之地，而隨著探訪馬雅各教區與平埔族人相處後，對其和睦與熱情的高貴性格亦多所著墨。此遊記清楚地說明遊歷路徑，並生動地形容沿途風景與遭遇。版畫在此作為文字的配圖，關於福爾摩沙的行旅只有一張行經荖濃村的留影與一張南臺灣地圖。

在湯姆生返回英國建立職業名聲多年後，於 1876 年翻譯法國化學家加斯頓‧蒂桑迪爾（Gaston Tissandier）的《攝影歷史與手冊》（History and Handbook of Photography）；在 1877 年出版著名的《倫敦街頭生活》（Street Life in London）；並在皇家地理協會擔任攝影指導。在 1898 與 1899 年他分

別出版了在世前最後一本攝影文集《一具相機走中國》的兩個版本：該書在 1898 年的出版由西敏寺：A·康絲坦布爾公司（Westminster: A. Constable & Co.）發行共 100 張圖版，而在 1899 年的出版則由倫敦及紐約哈潑兄弟（London and New York Harper & Brothers）發行共 114 張圖版。兩者選圖稍微不同，但文字皆與《十載遊記》的遊記大同小異只有稍微地簡化。兩本書「由半色調印刷法印製，可避免損失原作細節」[40]，新的印刷技術對於攝影遊記出版有著關鍵性的作用，半色調印刷的優點在於一次能將圖與文字共同印在紙面上，降低印刷成本。關於福爾摩沙行旅，比較特別的是在 1898 年的版本，湯姆生選用在中國拍攝的影像作為福島行旅的配圖，文字形容他參訪道臺庭院，以及離開臺灣府前經過漢人耕作田地與街景，然在這些文字旁，他皆以在中國拍攝的庭院與街景照片權充。顯然地在 1871 年福島行旅裡，漢人在福島的生活狀況並非湯姆生鏡頭下的興趣，因此鮮少留影，而在 27 年後因為出版的需要使他做出移花接木的決定。

由上述的三種出版可見，湯姆生擅長針對不同的讀者以及市場進行靈活的文體書寫以及選圖配置，將行旅的經驗重複印製出版。「出版的狂熱」像是避免記憶的褪去而以印刻技術託付於外部痕跡，某種程度上也回應了維多利亞時代的媒體特性，攝影作為一種新的觀看技術，尤其是英國威廉·泰伯特（William Henry Fox Talbot）脈絡下發展的科羅法（calotype process）提供了負相多重影像印製的可能，也讓讀者早習慣了由石版印刷、攝影、小說等混合體帶來對於殖民的、探勘式之於異地甚至是階級他者的觀看與理解。[41] 因此，伴隨著印刷品的流通，湯姆生亦回應了歐洲的讀者對於視覺資訊的渴求以及藉由攝影與世界連結的承諾，這樣的連結甚至是檔案式的渴望。德希達（Jacques Derrida）在著名的《檔案熱》（Archive Fever: A Freudian Impression）對於檔案的法理原則有著精闢的分析。在檔案的希臘文字源 arkheion 指的是一個家、住處、地址、行政官的住所或統治官。[42] 這居所也就是檔案的發生之地，亦是拓樸的與法理的交織之地，統治官在其管理的居所以其治理的權力將所見統一集中、指認、分類，一如返回倫敦的湯姆生將在福島搜集的資料與見聞在 1973 年於皇家地理學會進行發表一般，若

以拓樸（在航海用語裡指的是通航權力）與法理的交織之地的角度來看，我們便可以想像藉由帝國勢力的擴張以及通航的權力所觸及的異地，使得十九世紀維多利亞時代的讀者很難以不產生「帝國是一龐大檔案的想像」。[43] 在龐鉅的帝國家屋底下藉由紀錄、詮釋、認知他者的人情風土，外部的未知逐漸被收攏為內部的檔案知識，成為一系統性、單一且元素清晰又具理想配置的文體。

原始的類型

1860 年以來英國的人類學家，如湯瑪斯·亨利·赫胥黎（Thomas Henry Huxley）以及 J·H·蘭普里（J. H. Lamprey）建立了以攝影作為科學測量的系統，而正面與側面測量式的肖像是最為普遍拍攝他者人像的方式。湯姆生也在福島行旅利用了此種標準化的拍攝手法，這不僅讓他可以快速地建立與認知對象的關係，也讓大眾在熟悉的語言裡接收關於他者的訊息。因此，即便隨著十九世紀大英帝國勢力擴張，被觀察的對象與主題變多了，但認知的模式卻越來越可預期，換句話說，攝影者與讀者由於身處於同樣的社會與文化空間裡，熟悉以及可被接受的視覺訊息越來越趨同，人類學式肖像語法成為一種固定格式，裝載也置換著相異的臉孔。

湯姆生在臺灣拍攝了多組正面與側面的平埔族肖像，他們在白色或漆有墨竹裝飾的牆面前，也有女性拆掉頭巾前後的示意肖像，與他在中國拍攝的肖像類型不同，如在《中國及其子民》一書「勞動階級類型」（Types of the Labouring Class）的章節裡，他提到被攝者的社會背景與名字並賦予被攝者更多的性格：「珍……這位婦人依舊為了每日家務而繁忙：她很擅長刺繡，在有人生病的時候更是無價的醫療者。」[44] 而在拍攝她的側面肖像（圖 6）時，跳脫了人類學的拍攝方式，描繪了她整齊乾淨的髮型，更擺出近似沈思的姿態以右手輕輕地碰觸下巴，而另外一隻手支撐著手軸，拍攝了手部的皺紋給予更多關於生活的勞動或社會位階的細節。在福島拍攝的平埔族人卻緊緊扣合著近似人類學的測量語言，沒有提及被攝者的名字，僅以性別、年紀註記，在玻璃板一旁印刻的文字「平埔女孩 木柵 福爾摩沙 20 歲」讓被攝者直屬於族群之上的存在，呈現了服飾、髮式、臉部特徵扣合著人種類型分類的需求（圖 7）。而在

《中國及其子民》的「福爾摩沙的原住民」章節裡他更以「圖2、3與5是女性，6、7是男性平埔族人的頭」[45] 為拍攝肖像的註解，「平埔族人的頭」直接去除了被攝者的個體身份，而以人類學裡骨骼特徵取代（圖8）。如果在中國拍攝的肖像類型（type）是以社會階級呈現，那麼福島的類型便是以它的原初地位（primitive status）所指認，正如湯姆生所言，福島之行的目的在尋找「在這奇異島嶼中的野蠻人。」[46] 因此，湯姆生在亞洲的行旅中，福島之所以是必要的採集元素，便在於它的原初性，一種與現代碰撞後形成的概念，構成現代與前現代相對的光譜。在湯姆生的影像檔案中，中國正經歷現代化的過程，並逐漸被「文明之光」[47] 所照耀，而福島的原初性正是被它的自然山野、原住民肖像所呈現。更甚，這種想像成為湯姆生對於「原初典型」的參考值，而被用來形容倫敦街頭生活的吉普賽人：「在他未開發的狀態，不論是住在非洲赤道的沼澤中，或福爾摩沙的山裡，他皆欣然接受流浪」[48] 因此，福島的原初性成為他著名的《倫敦街頭生活》中呈現的都市遊牧民族證詞之一。

秘密協議／印刻／遺產／被視性（to-be-look-at-ness）

湯姆生在每次製作玻璃底片的成相後，皆以銳利的器具刻下關於被攝者的資訊，這樣的印刻與書寫避免了攝影的難以自我明證，甚至他回到英國後積極地出版發表，在過世前親自尋找將這批底片安全地保留的地方，在在顯示他有意識地將攝影印刻視作抵抗遺忘，進而可供流傳的遺產。這樣的影像遺產也影響了臺灣在攝影史上的自我指認。然撰寫以臺灣為地理範圍的攝影史，如許琦玲指出，似乎固著於一種普遍的迷思，亦即希望找到純正的、原真的、非異國的注目眼光。以自己人看自己人的自我指認似乎成為完成國族意識的必要任務。[49] 然，我認為上述的自我指認會失去一個重要的歷史層次，一種在殖民背景下臺灣的被視經驗。[50] 被視性是周蕾（Rey Chow）發展的概念，其目的是為了打破人類學的倫理困境，亦即在西方人類學記錄他者生活的模式下，建立了一種我們（被觀看對象）與他們（觀看對象）之間二元對立的堅固堡壘，因而導致無法細緻的考慮權力關係的動態。然我們需意識到，被視性極有可能成為主體化的一部分。因為我們觀看的照片的

前方已被攝影者的凝視佔據，因此，作為當代攝影史的詮釋者必然無可避免的需考量過往被「物化」與「被視」的經驗。

湯姆生的鏡頭確實也影響了臺灣自我再現的觀點，一種地誌他者的想像。例如，黃明川在〈一段模糊的曝光：臺灣攝影史簡論〉曾提到：「臺灣在世界攝影史上是不存在的地理名詞，不似中國大陸沿岸與日本，一接觸西方，即因政治利益與文化差距上的衝突，引來東窺的攝影師……在清代西洋人的眼光中，（臺灣）只是一個充斥著滿官、漢民、平埔族，與聽說會裸身出草殺人的『野蠻』的地方。」[51] 由西方凝視下的線索帶來認知的差異與區分，進而將臺灣視作中國、日本的他者，以不存在視作定位的起始。更甚，「被視性」在當代成為被觀看的渴望以及被含納在世界攝影史的地誌想像：「由於湯姆生在世界攝影史上的重要性，以及他長年以攝影和文字記錄東方的經驗，使得1871年拍攝活動造就臺灣的攝影史納入世界攝影史的範疇。」[52] 臺灣的攝影史是否真正的進入了全球攝影史的領域，依舊是一個需要被仔細檢驗的議題，然，上述引言裡的潛台詞卻透露了十九世紀「被視性」到了當今透過影像檔案再一次地被轉化成為（被）觀看的渴望，一種臺灣攝影史在全球攝影言論可視性的契機。如此複雜的觀看的慾望以及投射關係持續地產生動能，如湯姆生在《十載遊記》裡揭露的，攜帶相機在十九世紀的亞洲旅行彷彿：「持著鏡子對準他的凝視，為讀者呈現若不總是合意的令人愉悅的，但至少是對於中國與其子民忠實的印象。」[53] 在此，鏡子作為隱喻，反射的可能不僅是異地風土的忠實呈現，更是持鏡者（觀看者）與自己的凝視的對望，然這種多重纏繞的視覺作用力「在我〔們〕之前已經看了這個世界」[54]，並在我們逐漸失去看的能力之後，持續地尋找與它相望的對象。

1 本文經過多次修改書寫，部分文字修改自碩士學位論文 Chou Yu-ling, "Archival Inscription – John Thomson's Image Archive of Formosa in 1871." MA Thesis, The London Consortium, 2008。

2 黃明川，〈一段模糊的曝光：臺灣攝影史簡論〉，《雄獅美術》175 期，1985 年 9 月，頁 158-168。

3 許綺玲，〈臺灣攝影與「中國」符號初探——在不在：符號在哪裡？「中國」在哪裡？〉，收於劉紀蕙主編，《他者之域：文化身分與再現策略》，臺北：麥田書局，2001，頁 136。

4 黃明川，〈一段模糊的曝光：臺灣攝影史簡論〉，頁 165。

5 如，黃明川推測照相機登陸臺灣應不遲於 1852 年，因管轄東印度、中國、日本等海域的美國艦隊司令官培理（Matthew Perry）在 1852 年從琉球南下雞籠（基隆）調查雞籠附近含煤地層。該艦隊配有兩名銀版相機專家，但不確定是否有留下影像。見黃明川，〈一段模糊的曝光：臺灣攝影史簡論〉，頁 158-168。

6 Geoffrey Batchen, "Origins without End," Photography and its Origins, eds. Tanya Sheehan and Andrés Zervigón, New York: Routledge, 2015, pp. 68-71.

7 有類似觀點的論述如下：

吳嘉寶，〈1993 臺灣攝影簡史〉，《視丘攝影藝術學院》參考網址：https://www.fotosoft.com.tw/about-us/library/wujiabao-articles/essay/57-essay-05.html，2020 年 7 月 2 日瀏覽。

蕭永盛，〈臺灣寫實攝影的綱要系譜〉，《現代美術》74 期，1997 年 10 月，頁 19-27。

張照堂，〈光影與腳步——臺灣寫實攝影發展報告〉，《臺灣攝影年鑑綜覽：臺灣百年攝影 -1997》，臺北：原亦藝術，1998，頁 33-48。

莊淑惠，〈仍待開發與深耕，臺灣攝影藝術發展歷程與現況〉，《典藏今藝術》61 期，1997 年 10 月，頁 219-224。

8 林志明，〈十九世紀的臺灣影像：一些新線索及其解讀〉，收於余思穎等編，《時代之眼：臺灣百年身影》，臺北：臺北市立美術館，2011，頁 25-35。

9 關於愛德華茲的研究以費德廉（Douglas L. Fix）的文章〈陰影中的鏡頭：聖‧朱利安‧愛德華茲的福爾摩沙影像〉（Shots from the Shadows: The Formosan Images of St. Julian Hugh Edwards）最為詳盡。他與蘇約翰（John Shufelt）擔任主編的《李仙得臺灣紀行》一書裡對照並指認了 30 張（其中 9 張照片攝影者「可能」是愛德華茲）為愛德華茲拍攝的照片外，難以窺見愛德華茲作品的全貌。見費德廉，Shots from the Shadow: The Formosan Images of St. Julian Hugh Edwards，中央研究院臺灣史研究所、林本源中華文教基金會主辦，《臺灣研究在美國暨臺灣史新研究研討會（二）暨 2007 年林本源文化教育基金會年會》，2007，頁 19-21，以及費德廉、蘇約翰主編，《李仙得臺灣紀行》，臺北：國立臺灣歷史博物館，2013。

10 黃明川，〈攝影視覺與臺灣現象〉，《雄獅美術》183 期，1986 年 5 月，頁 86。

11 Walter Benjamin, "A Short History of Photography," Selected Writings, Volume 2, part 2, 1931-1934, trans. Rodney Livingstone and others., eds. Michael W. Jennings, Howard Eiland and Gary Smith, Cambridge, Mass and London: Belknap Press of Harvard University Press, 1999, p. 527.

12 王雅倫，〈由法國珍藏之早期臺灣影像探討影像資料館成立的必要性〉參考網址：http://ir.lib.ksu.edu.tw/bitstream/987654321/3829/1/，2020 年 6 月 30 日瀏覽。

13 高志尊，〈十九世紀臺灣早期攝影的先行者〉，收於陳永彬編，《凝望的時代》，臺中：國立臺灣美術館，2010，頁 32。

14 劉琇琪，《一八七一福爾摩沙顯影：John Thomson 臺灣攝影中的風景觀》，國立臺灣師範大學美術系研究所碩士論文，2008。

15 分別為《福州與閩江》（Foochow and the River Min, 1873）、《中國及其子民》（Illustrations of China and Its People, 1873-1874）、《十載遊記：麻六甲海峽、中南半島與中國》（The Straits of Malacca, Indo-China, and China, or, Ten Years' Travels, Adventures, and Residence Abroad, 1874）、《中國大地與中國人》（The Land and People of China, 1876）、《一具相機走中國》（Through China with a Camera, 1898）。

16 Elliott S. Parker, "John Thomson 1837-1921 RGS Instructor in Photography," Geographical Journal, no. 144, 1978, p. 456.

17 John Thomson, "Photography and Exploration," Proceedings of the Royal Geographical Society and Monthly Series, vol. 13, no. 11, Nov. 1891, pp. 669-675.

18 Judith Balmer, "Introduction," Thomson's China: Travels and Adventures of a Nineteenth-century Photographer, Hong Kong, Oxford, New York: Oxford University Press, 1993, x.

19 Joel Montague and Jim Mizerski, John Thomson: The Early Years in Search of the Orient, Bangkok: White Lotus, 2014, p. 2.

20 Balmer, "Introduction," xi.

21 Stephen White, John Thomson: The Early Years in Search of the Orient, New York: Thames and Husdon, 1986, p. 10.

22 Joel Montague and Jim Mizerski, John Thomson: The Early Years in Search of the Orient, pp. 18-35.

23 泰瑞‧貝內特（Terry Bennett），《中國攝影史：西方攝影師 1861-1879》，徐婷婷譯，北京：中國攝影出版社，2013，頁 180-181。

24 John Thomson, "Introduction," Illustrations of China and Its People, London: Sampson Low, Marston, Low and Searle, 1874, Vol. I.

25 Rev. William Campbell, Handbook of the English Presbyterian Mission in South Formosa, London, Edinburgh, Now York: F. J. Parsons, LTD., 1910, xiii.

26 李尚仁，〈謠言疑雲與帝國夾縫間：臺灣早期傳道醫療與民教衝突〉，《臺灣醫療四百年》，臺北：經典雜誌，2006，頁 52-57。

27 馬雅各，〈居家主日 1870 年 3 月 1 日〉，引自藍伯特‧凡‧德‧歐斯佛特（Lambert van der Aalsvoort），《福爾摩沙見聞錄：風中之葉》，林金源譯，臺北：經典雜誌，2003，頁 141。

28 Campbell, Handbook of the English Presbyterian Mission in South Formosa, xiv.

29 費德廉，Shots from the Shadow: The Formosan Images of St. Julian Hugh Edwards，頁 19-21。

30 蕭永盛，〈老相簿裡的歷史：考察臺灣 1860 年代的老照片〉，《攝影之聲》9 期，2013 年 5 月，頁 72-79。

31 約翰‧湯姆生，〈十載遊記：麻六甲海峽、中國與中南半島〉，《從地面到天空：臺灣在飛躍之中 1871-2006》，黃詩涵譯，臺北：信鴿法國書局，2006，頁 90。

32 用詞引自黃詩涵翻譯、顏湘如校稿，〈十載遊記：麻六甲海峽、中國與中南半島〉，頁 64。

33《中國大地與中國人》（1876）是推廣基督教知識而出版的文集，其中有少數湯姆生作品改編的木刻版畫。該文集以地理、歷史及宗教等目錄分析中國概況，內文提及福爾摩沙的部分相對稀少，也沒有與離島相關的影像，所以本文就不分析此書。John Thomson, The Land and The People of China, https://archive.org/details/landpeopleofchin00thomrich, accessed 16 September 2015.

34 Richard Ovenden, John Thomson (1837-1921) Photographer, Scotland: National Library of Scotland: The stationary office, 1997, p. 32.

35 John Hannavy, Encyclopedia of Nineteenth-Century Photography Volume 1, New York, London: Taylor & Francis Group, 2008, pp. 190-191.

36 Ovenden, John Thomson (1837-1921) Photographer, p. 32.

37 Mary Warner Marien, Photography: A Cultural History, New York: Harry N. Abrams, 2002, p. 39.

38 Illustrated London News, Saturday, January 16, 1875, p. 66.

39 Ovenden, John Thomson, pp. 34-35.

40 Thomson, "Introduction," p. 245.

41 Nancy Armstrong, Fiction in the Age of Photography-The Legacy of British Realism, Cambridge, MA: Harvard University Press, 2002, p. 77.

42 Jacques Derrida, Archive Fever: A Freudian Impression, trans. Eric Prenowitz, Chicago, London: The University of Chicago Press, 1996.

43 Armstrong, Fiction in the Age of Photography-The Legacy of British Realism, p.14.

44 Thomson, Illustrations of China and Its People, Plate XI.

45 Thomson, Illustrations of China and Its People, Plate XXIV.

46 約翰‧湯姆生，〈十載遊記：麻六甲海峽、中國與中南半島〉，頁 80。

47 "The light of civilization seems indeed to have dawned in the distant East; ….and already penetrating to the edges of the great Chinese continent." John Thomson, "Preface," in *The Straits of Malacca Indo-China and China*, London: Sampson Low, Marston, Low & Searle, 1875, vi.

48 John Thomson, *Victorian London Street Life in Historic Photographs*, New York: Dover Publication, 1994, p. 1.

49 許綺玲，〈臺灣攝影與「中國」符號初探──在不在：符號在哪裡？「中國」在哪裡？〉，頁 142。

50 Rey Chow, *Primitive Passions: Visuality, Sexuality, Ethnography, and Contemporary Chinese Cinema*, New York: Columbia University Press, 1995.

51 黃明川，〈一段模糊的曝光：臺灣攝影史簡論〉，頁 159。

52 劉家琪，《一八七一福爾摩沙顯影：John Thomson 臺灣攝影中的風景觀》，頁 7。

53 感謝策展人林宏璋在討論此展過程中提供以下參考資料：

Thomas Prasch, "Mirror Images: John Thomson's Photographs of East Asia," *A Century of Travels in China: Critical Essays on Travel Writing from the 1840s to the 1940s*, eds. Douglas Kerr, Julia Kuehn, Hong Kong: Hong Kong University Press, 2007, pp. 53-61.

54 Norman Bryson, "The Gaze in the Expanded Field," *Vision and Visuality-Discussions in Contemporary Culture*, ed. Hal Foster, New York: Dia Art Foundation, 1988, p. 92.

◆◆◆◆
聖・朱利安・愛德華茲

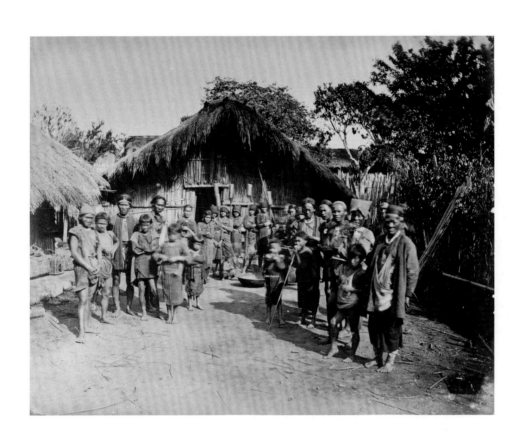

聖·朱利安·愛德華茲，運糖牛車，鄰近臺灣府，臺南，1869-1870，蛋清印相，19.5 x 24.3 cm，國家攝影文化
中心典藏 ｜ 聖·朱利安·愛德華茲，龍湖，南投日月潭，1875，蛋清印相，19.2 x 24.5 cm，國家攝影文化中心
典藏（右頁）

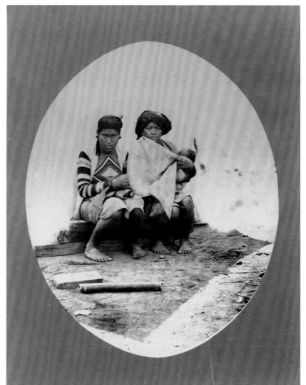

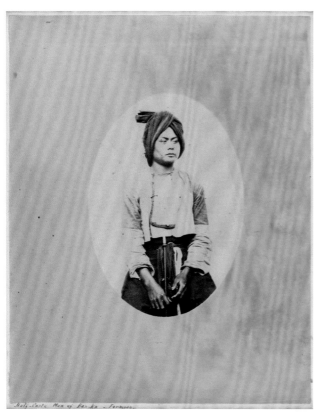

聖‧朱利安‧愛德華茲，萬金庄的平埔男子，屏東萬金，1869-1870，蛋清印相，25.3 x 20.2 cm，國家攝影文
化中心典藏 ｜ 聖‧朱利安‧愛德華茲，原住民婦女與小孩，邱苟（今苗栗出礦坑），1869，蛋清印相，22.8 x
17.6 cm，國家攝影文化中心典藏 ｜ 聖‧朱利安‧愛德華茲，大屯火山群，大屯山，1869，蛋清印相，25.3 x
20.2 cm，國家攝影文化中心典藏（左至右）

Volcano on Mt Jah-Ta-Kang (2270 ft. above sea) - N.E. of Tam-Suy - Formosa I.

聖・朱利安・愛德華茲（St. Julian Hugh Edwards, 1838-1903）生於麻六甲（英屬殖民地），母親有西班牙血統，因非裔美籍的父親而成為美國公民。1862 年，他移居廈門後從事多種工作以維生：開設攝影工作室、租房給美國領事館、擔任西班牙領事館的傭金代理等；1867 年曾被美國駐廈門領事李仙得（Charles W. Le Gendre）以非法開設移工與走私苦力為由逮捕。愛德華茲曾受英國駐臺副領事史溫侯（Robert Swinhoe）、李仙得、美國動物學家約瑟夫・比爾・史蒂瑞（Joseph Beal Steere）等人委託，拍攝廈門與福爾摩沙等地影像，成為最早記錄下臺灣影像的攝影家之一。根據史溫侯的遊記紀錄，史溫侯與愛德華茲 1865 年拍攝了萬金庄（今屏東萬巒鄉萬金）的排灣族原住民；1869 年愛德華茲亦陪同李仙得遊覽福爾摩沙，蒐集地方的人文風俗與地理資訊。經過多年調研，後來在明治政府番地事務局任職的李仙得集結書稿、地圖、相片、圖表、繪畫等資料，寫成《臺灣紀行》（Notes of Travel in Formosa），並以私人顧問的身分協助大隈重信，為日本併吞臺灣策略獻計。1874 年愛德華茲寄了多張廈門與福爾摩沙的相片給史蒂瑞，其中包括《新港文書》的翻攝文件。除了受雇成果，愛德華茲 1877 年亦曾在《遠東》（The Far East）雜誌刊登廣告以廣泛宣傳其作品，包括在廈門、福爾摩沙拍攝的風景，以及漢人與原住民肖像。愛德華茲將攝影作為副業之一，相片散見於十九世紀出版品，包含法國駐廣州領事于雅樂（Camille Imbault-Huart）的著作《福爾摩沙之歷史與地誌》（L'île Formose, Histoire et Description）。

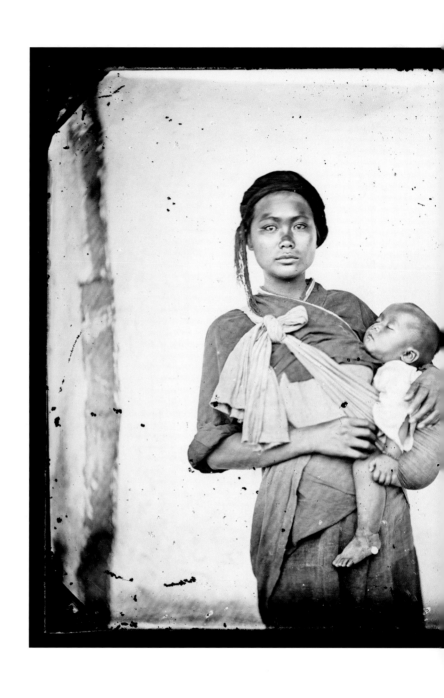

約翰・湯姆生

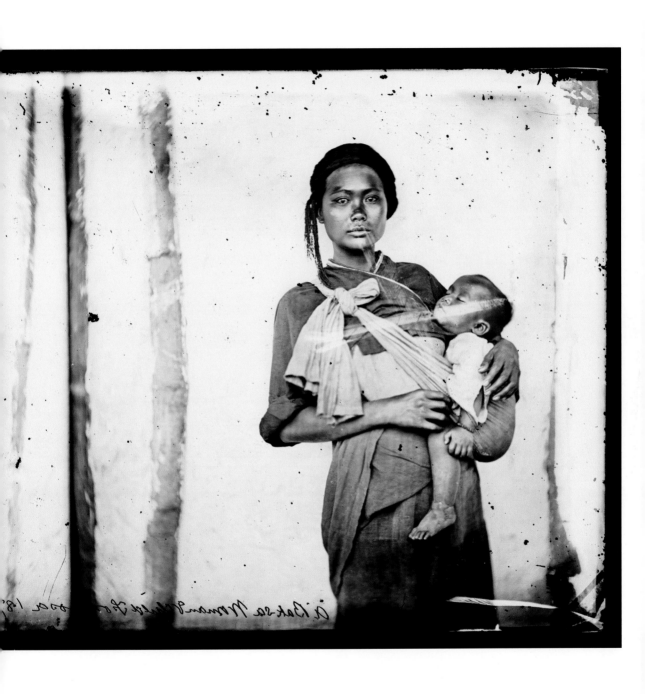

約翰・湯姆生，一位木柵（今高雄內門）女性與她的小孩，福爾摩沙（臺灣），1871，愛普生藝術微噴／含銀相紙，約 10.5 x 21.5 cm，惠康收藏館提供（CC BY 4.0）

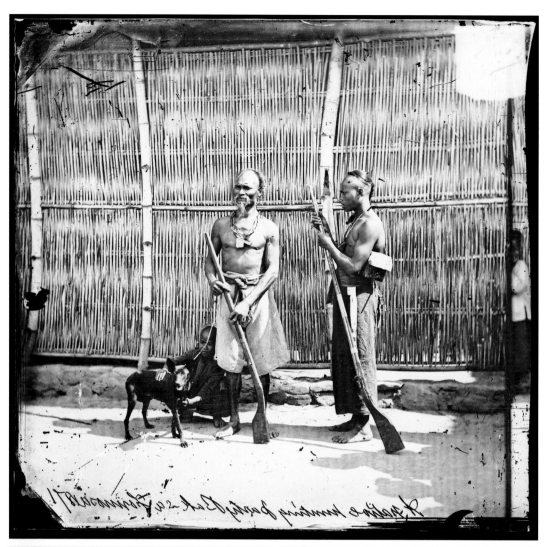

約翰・湯姆生，原住民的狩獵派對，木柵（今高雄內門），福爾摩沙（臺灣），1871，愛普生藝術微噴／含銀相紙，約 10.5 x 21.5 cm，惠康收藏館提供（CC BY 4.0）｜ 約翰・湯姆生，深泥巴坑，福爾摩沙（臺灣），1871；愛普生藝術微噴／含銀相紙，約 25.5 x 20.5 cm，惠康收藏館提供（CC BY 4.0）｜ 約翰・湯姆生，荖濃溪旁森林覆蓋的山丘，福爾摩沙（臺灣），1871，愛普生藝術微噴／含銀相紙，約 25.5 x 30.5 cm，惠康收藏館提供（CC BY 4.0）（上到下左至右）

約翰‧湯姆生（John Thomson, 1837-1921），生於蘇格蘭愛丁堡，曾於光學儀器公司擔任學徒，也在瓦特藝術學院（Watt Institution and School of Arts）夜間課程修業。1862 年，他投靠在新加坡製作鐘錶的哥哥，兩人一同開設相館。趁地利之便，湯姆生的行跡遍佈東南亞各地，並於 1865 年前往暹羅與柬埔寨；行抵曼谷時，他曾為拉瑪四世與皇室們留下著名肖像。隔年，湯姆生短暫返回英國後，出版了在暹羅與柬埔寨所攝作品，同時成為皇家地理協會（Royal Geographical Society）成員。1868 年，湯姆生移居香港開設相館，兩年後歇業以集中精力撰文與攝影，作為日後返英職涯發展的準備。湯姆生遍歷中國山河，1871 年經廈門時巧遇首位派駐福爾摩沙的傳教士馬雅各（James Laidlaw Maxwell），後者成為湯姆生 1871 年行旅福爾摩沙的重要嚮導。由於對原住民的強烈興趣，湯姆生隨馬雅各拜訪臺灣平埔族教區，行經打狗（高雄）、臺灣府（臺南）、拔馬（左鎮）、木柵（內門）、匏仔寮（寶隆）、甲仙、茇濃村、六龜里等地，留下許多珍貴影像。據統計，湯姆生在臺以濕版火棉膠攝影法（wet-collodion process）拍攝約 61 張相片，內容以風景、平埔族肖像為主。此拍攝手法雖迫使湯姆生須隨行攜帶沉重的相機與暗房，卻也幫助他產出精美細緻的作品。湯姆生卓越的拍攝技術讓他這段「遠東」行旅所出版的圖集與出版物在歐洲獲得廣大迴響；他所拍攝的福爾摩沙影像分別收錄於《中國及其子民》（Illustrations of China and Its People, 1873-1874）、《十載遊記：麻六甲海峽、中南半島與中國》（The Straits of Malacca, Indo-china, and China Or, Ten Years' Travels, Adventures, and Residence Abroad, 1874）、《一具相機走中國》（Through China with a Camera, 1898）等書。返回英國後，他與社會記者阿道夫‧史密斯（Adolphe Smith）合作出版《倫敦街頭生活》（Street Life in London, 1877），以圖文方式記錄邊緣族群的生活面貌，成為紀實攝影史的重要標竿之一。湯姆生在生前將在亞洲拍攝作品的玻璃版底片全數賣給英國藥商企業家亨利‧索羅門‧惠康爵士（Sir Henry Solomon Wellcome），現典藏於倫敦的惠康收藏館（Wellcome Collection）。

賴阿芳

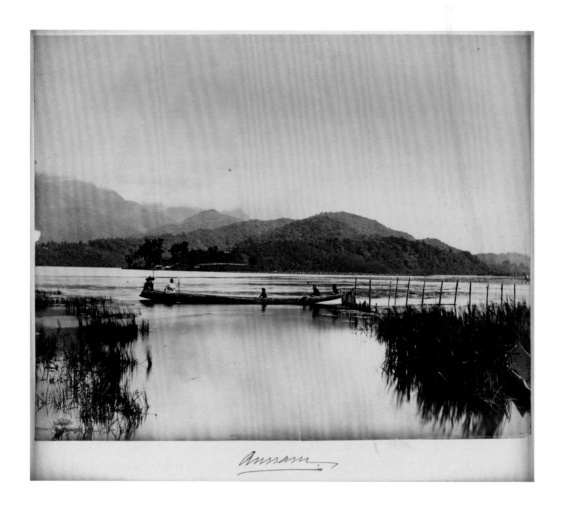

賴阿芳，安南（經考證為日月潭），南投，1875，蛋清印相，21.8 x 27.9 cm，國家攝影文化中心典藏 ｜ 賴阿芳，
集集峽谷，南投，1875，蛋清印相，27.3 x 21.5 cm，國家攝影文化中心典藏（右頁）

Formosa

賴阿芳，埔里社，南投，1875，蛋清印相，21.5 x 27.6 cm，國家攝影文化中心典藏

賴阿芳（Lai Afong, 1839-1890），又譯黎芳，20 歲始於香港從事攝影工作。據文獻推斷，他早年可能以學徒身分向西方攝影師學習攝影；並於 1865 至 1867 年間，在希爾維拉（*José Joaquim Alves de Silveira*）於皇后大道主持的攝影工作室擔任攝影師。《孖剌西報》（Hong Kong Daily Press）的廣告資料顯示，約莫 1870 年，他已開設私人工作室，執業項目除了拍攝照片卡（*cartes de visite*）外，也販賣中國各地如福州與閩江風景照。1870 年代的香港攝影業相當競爭，然賴阿芳卻小有名氣；同在香港執業的競爭對手約翰・湯姆生曾給予高度評價：「賴阿芳的某些照片表現出色，因藝術性構圖而著稱，就此來說，他是我旅中期間遇過的本地攝影師裡，唯一傑出的例外。」[1] 1875 年，賴阿芳旅行至福爾摩沙，並帶回一系列照片。從 1875 年 11 月 25 日的《北華捷報》（The North-China Herald）可以得知，他在福爾摩沙記錄下「未曾被拍攝的山景、湖、河流……以及美麗的鼓浪嶼居民。」[2] 為了增加工作室客源與維持聲望，賴阿芳不光聘邀埃米爾・瑞斯菲爾德（Emil Riisfeldt）與大衛・格里菲斯（David Griffith）等西方攝影師，吸引不信任中國攝影師技術的外籍訪客，也持續拍攝如參訪香港的俄羅斯大公阿列克謝・亞歷山德羅維奇（Alexei Alexandrovich）等外國使節或官員。賴阿芳攝影作品廣見於《倫敦與中國電報》等外文報紙，工作室則在他過世後持續經營至 1940 年。

1 John Thomson, *The Straits of Malacca, Indo-China, and China, or, Ten Years' Travels, Adventures and Residence Abroad*, New York: Harper & brothers, 1875, pp.188-189.
2 泰瑞・貝內特（Terry Bennett），《中國攝影史：中國攝影師 1844-1879 》，徐婷婷譯，北京：中國攝影出版社，2014，頁 276。

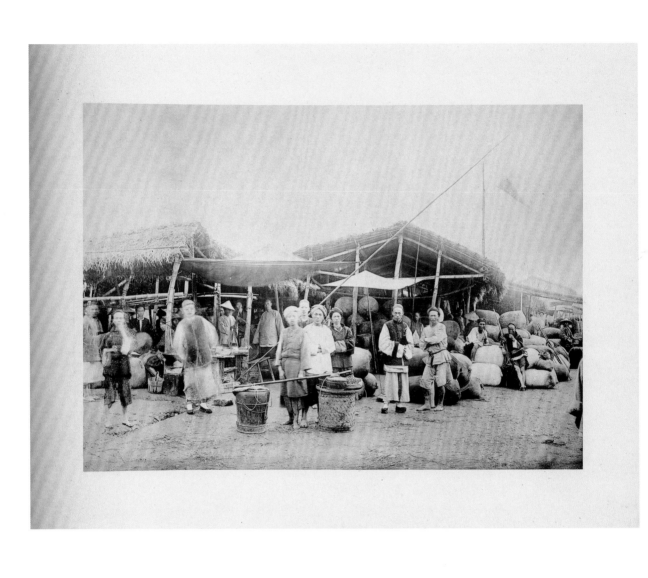

◆◆◆◆
《北福爾摩沙的回憶》
喬治‧尤維達爾‧普萊斯

茶葉順著水陸和陸路運送到市集，如今空無一人厘金稅站，曾經是人聲鼎沸的地方（《北福爾摩沙的回憶》圖版 IV 文字）｜ 大稻埕沿街可聽到一種別具古味的哼聲和喘氣聲，那是苦力蹣跚地踏出每一步所發出的聲音（《北福爾摩沙的回憶》圖版 V 文字，右頁）

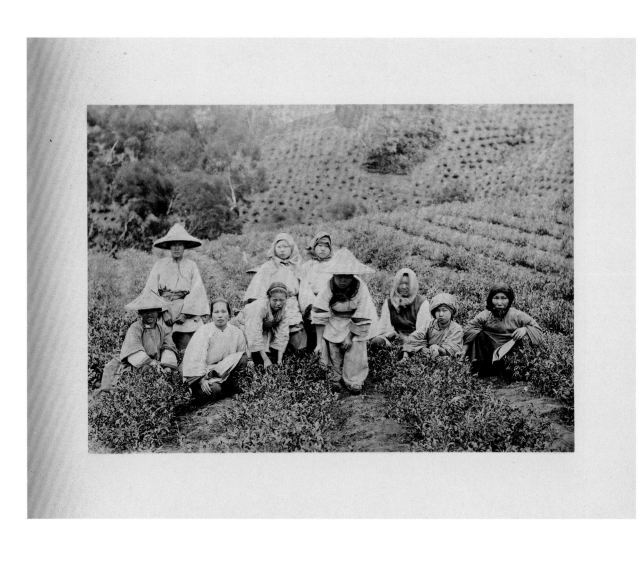

山丘上到處是採茶的婦女，她們帶著好奇的目光，抬頭看著路過的友善外國人（《北福爾摩沙的回憶》圖版Ⅰ文字）│ 婦女和兒童擠在採茶棚裡，揀出可用的茶葉，小巷和走廊上也到處是蹲在地上採茶的人們（《北福爾摩沙的回憶》圖版Ⅷ文字，右頁）

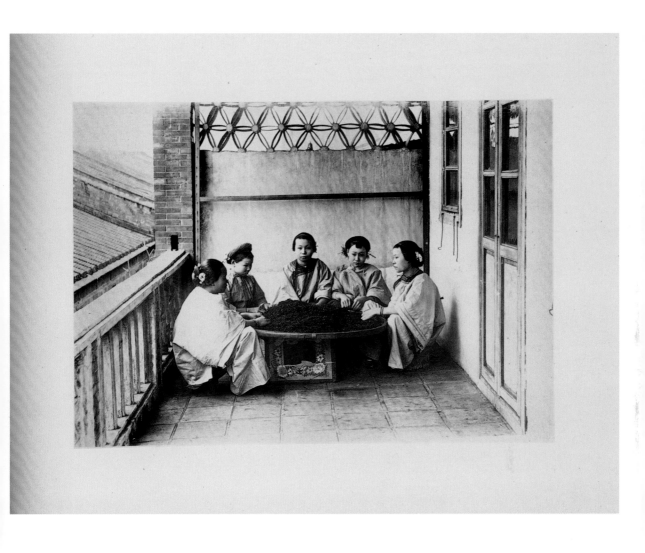

1895 年出版的攝影集《北福爾摩沙的回憶》（Reminiscences of North Formosa）
描述了淡水漢人製作茶葉的過程。書中影像由英國攝影師喬治·尤維達爾·普
萊斯（George Uvedale Price）以珂羅版（collotype）印刷，輔以優美文句說明，
是目前已知最早以「福爾摩沙」為名、出版流通的攝影集。書中一幅攝影作品
記錄了多名女子共同坐在狹窄房屋外的廊道，並圍繞著製茶用的軟篩的景象。
儘管這些女子或多或少正在搓揉茶葉，然而從她們手臂彷如靜止的姿態，以及
彼此間幾乎沒有互動的神情，不免讓人聯想，此幀相片是否為因特定目的而進
行的擺拍作品。類似影像頻繁出現於這本攝影集中。例如：男子肩擔著裝滿茶
葉的竹簍、裝扮採茶衣帽的女子們一齊蹲跪於山坡地的茶園等。他們對鏡頭投
以深沉注視的目光（同時也是正在閱讀此本攝影集讀者的位置），反而突顯攝
影師在拍攝過程中扮演的角色。這本記錄了製茶過程影像的《北福爾摩沙的回
憶》，同時體現當時茶葉市場的宣傳需求。

你看著我看著你

張乾琦

藝術研究｜單頻道錄像，25 分鐘｜2021 年

不知道約翰・湯姆生（John Thomson）是否曾經和他的拍攝對象約會過？

成年後的我一直是個在異鄉的異鄉人，為了影像創作橫跨整個地球。因緣際會下，約翰・湯姆生在十九世紀晚期曾到訪並且拍攝的亞洲地區，我可說全部（或幾乎）都行經過。

湯姆生的遠征可說是一場極度勇敢行動，源自常人無法超越的熱情；這還是比較保守的說法。在那個年代，要帶著一台笨重的木製相機、大型而易碎的玻璃板、背景材料以及有爆炸可能的化學物質旅行，簡直是一個無法言喻的挑戰。不論他的隨行團隊多麼龐大，光是這趟旅行本身就使他成為先驅者，而湯姆生的影像使他成為傳奇。

湯姆生可以說是探索這些亞洲地區（包含偏遠、人煙稀少的內陸地帶）以從事人文與地景紀錄的第一位攝影師。他的創作主題非常廣泛，然而我特別崇敬他拍攝「異國東方女性」（the exotic, oriental women）系列的手法。湯姆生的影像多半帶著凝望／窺伺的性質，或充滿撩人的意味，同時極具說服力又富有人性，甚至散發一股發人省思的親暱。隱身在布幕之後的攝影師在創作時腦海中究竟浮現了些什麼呢？而這些模特兒或許是第一次，也是人生中唯一一次，見到一位留著鬍子、戴著禮帽的白人男性，並為其擺拍。

150 年後，捕捉影像的裝置變得普及且便宜，但攝影過程的某些元素未曾改變：攝影過程永遠帶著期待與張力。一股神秘權力在一幅正式或非正式的肖像出現之前、成形當中，以及完成之後持續運作。一位攝影師如何看待他或她所要拍攝的對象；其對象如何看待自身；而這個對象又希望自己如何被觀看及拍攝，以及攝影師如何透過攝影的語彙詮釋眼前所見，即使是在影像能夠透過手持裝置產出的今日，這些情境依舊不變。

攝影師幾乎永遠都持有詮釋的話語權，但萬一就在湯姆生的濕版待乾之際，攝影師與模特兒之間無聲而充滿情感的凝視逐漸過火呢？他是否因為被拍攝對象堅定的目光而淹沒於慾望之中？你看著我看著你；我也看著你在看著我。

瀏覽大量湯姆生的女性肖像後，我相信這些影像不僅誕生於高度的專業，或許也帶有些許痴迷與衝動，或甚至在湯姆生危機四伏的旅途中引發一見鍾情的情愫。

湯姆生從未抵達印尼的伊里安加亞（西巴布亞），但我常想像，若是抵達該地，他會如何展開旅行和拍攝。1999 年，我因為一項《明鏡週刊》（Der Spiegel）的工作而來到伊里安加亞進行紀錄。和我同行的包含一位德國記者、一位嚮導、一位廚師，和八位赤腳的搬運工人，他們負責在為期兩週的叢林之旅中為我們搬運器材及行李。那裡的地景我前所未見，我們不是在攀爬，就必須匍匐前

進，而叢林的深處不是攝氏 40 度以上的灼人高溫伴以濕氣，就是無止盡的降雨，我的三台相機之中有兩台因此故障。我們沒有退路，只能痛苦地不斷向前。若是湯姆生，他會如何在這樣嚴峻的條件之中跋涉並進行攝影呢？

在危險的徒步旅行中，我們駐足村莊進行休養。我們可能是這些居民有史以來第一次接觸的外來者。村子裡的男人們除了遮覆陰部的葫蘆外什麼都沒穿，女人們則裸露著胸部，腰部以下繫著草裙。那些葫蘆永遠呈現 60 度上揚，但裸露的女人們卻呈現堅挺或鬆垂的差別，證實地心引力的神性力量。我們從未卸下心防，因為食人儀式直至 1980 年代早期仍時有所聞。我一直好奇為什麼那些村民總是四處嗅著那位德國記者。而後我才醒悟，那是起司的味道！湯姆生也曾經為自己的性命感到懼怕嗎？途中思念英國的家鄉菜時，他又拿什麼解饞呢？

湯姆生的肖像，不論正式或看似隨性的構圖，都創作於極度考究技術的情境。然而這些影像卻看來泰然自若，甚至是紀錄片式的存在。〈老婦人，廣東省廣州市〉（Old woman, Canton, Kwangtung Province）的肖像，就如同今日的當代肖像畫。

除了這趟遠征中的體能挑戰，我也好奇他是如何面對挫折的。他是否也像我一樣，飽受失眠、不安，或劇烈頭痛之苦？或是否曾經思念家鄉？是否曾感到寂寞？若是一對情侶的狂喜嗥叫穿越搖搖欲墜的牆壁而來，他該如何是好？

瀏覽湯姆生的影像時，我時常想起 2000 年代中期，為了〈囍〉（Double Happiness）計劃而在胡志明市拍攝到的那些年輕、害羞的越南女子。為了紀錄臺灣男人挑選妻子的過程，我安排了七趟越南之旅。那是個極其貶低女性的過程，她們彷彿被放置於一條快速生產線上。婚姻仲介公司從全國四處招募年輕的越南女子來到胡志明市，好讓成群的臺灣男人們審視。每位男子會付出一定的費用，並從隊伍中挑選適合的新娘。接著，不出幾天的會面，他們就成了一對對結了婚的夫妻！

在這七趟旅行中，我、那些臺灣人以及越南仲介，總共見到並且拍攝了不下千名越南女子。不用太久的時間，我們的雙眼開始感到疲憊、迷茫，且困惑，而心臟的跳動也不時沈重。在每一天結束之前，我們被招待前往當地的卡啦 OK，與經驗較為豐富的越南女子攪和。

湯姆生究竟有沒在旅途中思鄉呢？對我來說，只要是在路途中，就意味著我離家遙遠。而我時常感覺自己像是斷了線的風箏。經過多年的離家以及異地生活，我感到身體及心靈的脫節，彷彿處於半夢半醒間，總是承受著怪異的夜晚及惡夢。最終，隔著螢幕進行的對話依舊無法取代家中的肌膚接觸。

不知道約翰·湯姆生是否曾經和他的拍攝對象約會過？我不知道，但我考慮過。

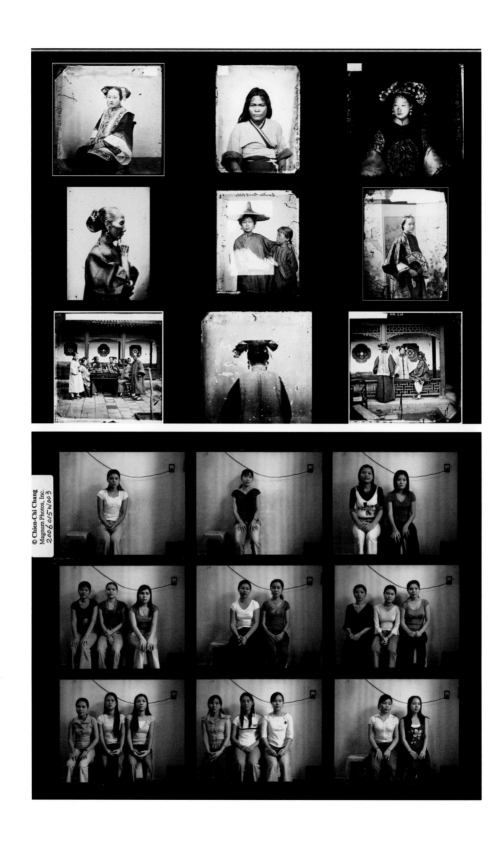

張乾琦，〈你看著我看著你〉擷取畫面，影像來源自湯姆生的肖像照，藝術家提供 ｜ 張乾琦，〈囍〉，胡志明市，2006（2006015W004），藝術家提供

張乾琦，1961 年生於臺灣臺中。1984 年取得東吳
大學學士學位，1990 年取得印第安納大學（Indiana
University）碩士學位。1995 年獲選加入馬格蘭攝影
通訊社（Magnum Photos）。張乾琦的創作呈現疏離
與連結的抽象概念。移民美國與奧地利的分歧經驗，
促使他在作品中探索人與人之間的牽繫。張乾琦有
著穩定的參展歷史，曾在威尼斯雙年展（2001）、
聖保羅雙年展（2002）以及紐約國際攝影中心三年
展（2002）展出系列作品《鍊》（The Chain），並
於新加坡國家博物館（2008）舉辦大型個展《雙重
性》（Doubleness）等等。

後像 1871（行走、快拍與朗誦行動）

高俊宏

藝術研究｜工作坊、單頻道錄像｜2021 年

以英國皇家地理學會成員，約翰·湯姆生（John Thomson）的《馬六甲海峽、中南半島以及中國，或者十年的旅行、冒險及旅居》（The Straits of Malacca, Indo-China and China, or, Ten Years' Travels, Adventures, and Residence Aboard，或譯為《十載遊記》）中的福爾摩沙（臺灣）旅記部分為本，攜手甲仙在地「湯姆生之路」研究者游永福，共同組織現地考察，重走湯姆生 1871 年 4 月啟程、當時被稱為「禁向之地」的路線。本創作呈現以手機快拍為主，從考現與批判地理學的角度，也從湯姆生當初攝影眼的後像與餘像出發，沿途行走、拍攝這條路百年後的城鄉變動與風土遷移。同時，沿途邀請參與者，以講演表演（lecture performance）的方式，在特定地點重新詮釋湯姆生的文獻。

約翰·湯姆生，木柵（高雄），1871，惠康收藏館提供（CC BY 4.0）｜
約翰·湯姆生，荖濃與甲仙埔間的山中峽谷及溪流，福爾摩沙（臺灣），
1871，愛普生藝術微噴／含銀相紙，約 30.5 x 25.5 cm，惠康收藏館提供
（CC BY 4.0）（左到右）

高俊宏，〈後像 1871（行走、快拍與朗誦活動）〉作品計畫圖，2021

高俊宏，藝術創作與論述者，國立臺南藝術大學博士，國立臺北藝術大學兼任助理教授。創作媒介主要透過身體、錄像、計畫型行動、書寫為介面。作品長期關注歷史、戰爭、生命政治、新自由主義、東亞、原民等議題。1995年起舉辦多次國內外個展、聯展與參與雙年展，並於香港、法國、英國等地進行駐村創作；作品曾入選與獲得數屆台新藝術獎。撰有《Bubble Love》、《家計畫》、《公路計畫》、《群島藝術三面鏡》、《拉流斗霸》等書，獲2016年金鼎獎年度非文學類圖書獎、年度最佳圖書獎。紀錄片《拉流斗霸》入圍第十二屆臺灣國際紀錄片影展。

翻閱《北福爾摩沙的回憶》

曹良賓

藝術研究｜單頻道錄像，20 分鐘｜ 2021 年

在瀏覽了國家攝影文化中心的典藏清單之後，我選擇以英國人喬治‧尤維達爾‧普萊斯（George Uvedale Price）所拍攝《北福爾摩沙的回憶》（Reminiscences of North Formosa）一書，作為主要的研究對象與創作起點。

這本在 1895 年出版的攝影集，包含了前言、12 張珂羅版影像、12 則簡短圖說與後記；主要內容為茶葉的種植、採收、處理、搬運、包裝、揀選、烘焙與保存等產製過程紀錄，拍攝範圍大抵在淡水和大稻埕等地的茶園、農舍、市集、騎樓（亭仔腳）與茶樓。

然而，除了臺灣茶的歷史與文化，這本看似輕薄的《北福爾摩沙的回憶》所牽連的議題其實頗為複雜。此計畫嘗試將此書問題化，將研讀過程中所遭遇的困境收束為幾組關鍵字，如圖書、檔案、分類、典藏、價值、視差等，並透過錄像的方式予以再現及轉化。期盼開啟觀者、書冊、機構之間的互動、想像與共創。

曹良賓，翻閱《北福爾摩沙的回憶》，2021，單頻道錄像，20分鐘，藝術家提供

THE tea still simmers on the charcoal fires and the bulking rooms shew no lack of tea, but the clarion notes of the bugle and the measured tramp of armed men proclaim the end of the old regime, and whatever the future may bring, one feels that the distinctive character of this little Port, that "go as you please" kind of air which constituted its only charm is now for ever buried in New Japan.

SEPTEMBER 1895.

喬治‧尤維達爾‧普萊斯，《北福爾摩沙的回憶》，1895，珂羅版印刷，
29 x 40 cm，國家攝影文化中心典藏

曹良賓，臺灣新竹出生，從事影像創作。美國紐約普拉特藝術學院藝術創作碩士。曾獲選文化部紐約駐村創作計畫、普拉特藝術學院獎學金、傅爾布萊特研習獎助金等。2015 年，出版首本攝影集《中途》，呈現旅美期間作為異鄉人在路上游移不定的身心狀態、疏離孤獨生活經驗下的城市景觀。近期創作計畫《Becoming / Taiwanese》，嘗試在轉型正義的視角下，凸顯國族認同、殖民歷史與價值意識之間的張力關係，並探索其中的社會和文化意涵。創作之外，亦致力於公共服務、藝文推廣並關注開放文化。2015 年，出版個人首本攝影集《中途》，並與友人共同發起「PHOTO TALKS」計畫，促進台灣當代攝影的討論。2016 年，成立「Lightbox 攝影圖書室」，致力於匯集整理臺灣的攝影出版物。期望以社會參與的方式，共建共享臺灣攝影，逐步朝向文化自主、知識自由的方向前進。

在玻璃乾版（Gelatin Dry Plate, 1871）獲得商業成功後，廣泛取代了濕版照片；前者不僅分離了拍攝及暗房程序，也讓曝光時間低於一秒（濕版曝光的 1/20）。自此，攝影的便攜性讓攝影者能夠捕捉到事物當下的瞬間及人物即刻的神情。而隨著攝影正式進入繼銀版、溼版之後的第三代技術，更構成邁布里奇（Eadweard Muybridge）在 1878 年發明「動態攝影」（zoopraxiscope）的必要技術條件。這時美國的喬治・伊士曼（George Eastman）在攝影產業獨佔鰲頭，除了得到乾版專利外，也在 1884 年發明了膠卷，在 1888 年以「你按下按鈕，其餘交給我們」（you press the button, we do the rest）的口號推出廉價手持相機，最終於 1892 年成立柯達公司。在半色調印刷（halftone）技術發明以後，攝影也廣泛運用在印刷出版，人類開始進入媒體影像社會的日常生活。

「第三代攝影」隨著日本殖民主義進入臺灣，松崎晉二曾拍攝具有軍事及戰略價值的照片（如牡丹社事件的影像紀錄所集結而成的寫真帖）；小川一真也於 1896 年出版《臺灣和澎湖群島的回憶》（*Souvenirs de Formose et des Îles Pescadores*）。「寫真」一詞作為攝影的日文翻譯，反應了從大化革新以來漢化的肖像美學觀。日本亦善用攝影的治理特質，使這項複製技術成為看待自我與被殖民他者的視覺化工具。不管是對於攝影工具、材料的掌握，或者是執照、證照的取得，乃至於照片流通、散播與傳遞等管道的控管，處處都存在著國家機器的箝制，特別是放在殖民者與被殖民者之間的權力關係上。日治期間，寫真帖、繪葉書，甚至是一般日人相館所拍攝的明信片，既是殖民政府政令宣導、視覺統御的技術，也是從明治維新以來「脫亞入歐」理想的自我顯影，反映出殖民地的權力影像。另一方面，伊能嘉矩、鳥居龍藏等人類學家的拍攝計畫，除了是知識化的樣本採集，也協助殖民政府加強對原住民的控制，劃分出「自我」與「他者」的區隔。

從日本人的視覺治管技術中，我們看到「殖民者」的影像製造，透過縝密的治管體系反映出「權力影像」。同時，當時權力試圖掩飾的痕跡也被予以保留、檔案化。換言之，這些影像一方面是在權力部署之下，屬於「被殖民者」的文件與證據；另一方面則是在這些照片「上相」（photogenic）的表面意義之下，被拍攝者不確定的返視與回望。那些無法成像、上相的無言抗議，在高舉「摩登」、「現代」的影像技術下，成為我們回望過往殖民歷史的檔案。

紳士寫真：臺灣日治時期的日本肖像攝影

周文龍（Joseph R. Allen）

1899 年某個意外涼爽的夏日，俱樂部的男士們聚集在位於臺北鬧區的總督府草坪上，準備進行一場槌球賽。槌球在近期與國際殖民文化的諸多配備一同引進本島。在地攝影師有田春香也在人群中，他開設的寫真館就在附近的北門街，店裡多的是最新的專業設備和材料，但今天他只帶了近期在廣島天正堂（Tenshodo）購入的柯達手持相機。他將相機對著兒玉源太郎總督，總督穿著時髦運動衣，臉上掛著蒙娜麗莎式的微笑，配合地擺出活潑的姿勢（圖1），驚人地一點也不像他在其他殖民時期相片紀錄裡的樣子。在為數眾多的相片裡，他總是著軍裝，非常嚴肅，胸前掛滿勳章（圖4、10）。雖然寫真師是專業人士，照片也在著名的小川寫真製版所製作，但影像蘊含的隨性與偶然性，顯然受到正席捲全球流行文化的抓拍（snapshot）類型所影響。他的姿勢，特別是笑容，預告了「柯達時刻」的年代。

攝影影像的存在條件長久以來一直有諸多討論，影像是否為被攝者的索引（index），一個用光和銀鹽相紙捺印的指紋？抑或，影像是在特定文化符碼之下所生產與被攝者神似的圖像，就如同其他肖像媒介？攝影影像的發明，遇上現代科學興起（以達蓋爾銀版攝影術為代表，亦即將暗箱得到的影像顯影在銀鹽塗面金屬上），讓攝影與理據世界頭一次結盟。它證明了被攝者在某個時刻確實存在，而在銀版攝影的範疇裡，主要為被攝者的人物肖像。然而隨著攝影術的普及，並且經過操縱、分歧化、理論化之後，其索引性質也面臨挑戰。部分而言，這也

就是羅蘭・巴特（Roland Barthes）所稱攝影的「隱含義的手段」：特效攝影、姿態、對象、上鏡頭、句法及審美處理。[1] 但更重要的是，周邊論述也有能力賦予影像特定重要性，最明顯的是權威式圖片說明得以控制影像的意義，此外照片也深植於從理據式到審美處理的社會論述裡。將一張照片從一個論述體系移到另一個論述體系會改變該影像的陳述，無論在肖像或其他類型皆是如此。

巴特在《明室》（*La chambre claire*）所假定攝影的「理據力量」[2]，約翰・泰格（John Tagg）則認為攝影具有偶然的本質。[3] 泰格認為在十九世紀後半葉，正是監視之意識形態與繁盛攝影媒介的交集時刻，攝影技術落入國家行政、執法單位、社會政策等機構的掌握，特別在歐洲和美國。在這麼一個遵從懲處的世界裡，祖父的肖像變成了嫌犯大頭照。詹姆斯・萊恩（James R. Ryan）從類似但更廣泛的脈絡來說明大英帝國的攝影構成，[4] 探索帝國思想之下攝影在軍事、人類學、休閒及教育方面的應用。可想而知，泰格及萊恩評述的攝影實踐之中，大半可見於日本明治時期的攝影文化，在時間和意識形態上恰與歐洲體制的境況重疊，然而攝影在日本及其殖民地亦有獨特的偶然性，尤其見於殖民肖像攝影以及寫真館系統。

歷史架構

攝影發展之初，技術及經濟的不確定性使得這項媒介僅用於有限範圍，然而到了十九世紀末，攝影實

踐已廣泛用在研究領域及通俗社交生活。尚・克勞德・勒馬尼（Jean-Claude Lemagny）與安德烈・魯伊萊（André Rouillé）寫道：

> 十九世紀最後十年，人類學、實驗醫學、心理學及社會學等新領域都已制度化，攝影也承擔更重要的角色，記錄多樣化的人類活動、風俗與生活方式。中上層階級上相館拍肖像，為他們的裙撐和高帽留下紀念，但在奧運重新被接受的年代裡，被認為時髦的紙板獨木舟、腳踏車和鄉村柵欄，取代了第二帝國和維多利亞中期的古建築柱及鍍金紙模裝飾品。[5]

日本帶到殖民初期臺灣的就是這個世紀之交的攝影術和觀念。

日治期間已發展出「第三代」攝影材料及程序，特別是賽璐珞底片問世以及半色調印刷術臻至完備，使得攝影這項媒材在日本殖民統治所佔的重要性遠超過早先的英國、法國及德國殖民政權。[6] 尤其肖像更為明顯，從攝影發明以來，肖像一直是攝影的經濟驅力。早期的肖像攝影，特別是達蓋爾版，快速加重並拓展了水彩及油畫肖像畫家的工作量。雖然這項技術尚未普及，但從皇族到無名小卒，只要花 25 分錢，人人都能在達蓋爾版工作室坐個 15 分鐘拍張肖像照。[7] 但達蓋爾版和肖像畫一樣，每張成品都無法複製，每一次拍攝須經過長時間曝光，而且只得一張影像。科羅法（calotype，又稱 talbotype）使用紙張負片，讓攝影師不再受限於工作室，並且得以複製出正像照片，但曝光時間長，影像模糊粗糙，使得被攝對象受限於靜物，大衛・奧克塔維斯・希爾（David Octavius Hill）製作的科羅版肖像則是重要的例外。[8] 直到火棉膠濕版攝影術發展成熟，能夠快速製作可供轉印的負片之後，才得以拍攝更生動的影像，並廣為散佈。現在人們總算能笑著拍張照片，然後把複本寄給親朋好友。這種潛力在肖像的領域透過名片式肖像而高度商業化，在 1860 年代造成一股熱潮，也催生了最早的相簿，第一個在日本成功發展的就是這種肖像攝影技術。[9] 接近世紀末，攝影經驗不僅是許多人的共同體驗，而且也不必在工作室或暗房來進行。快速簡捷的乾版法和底片為

攝影帶來新的流動性和便利性，正式肖像逐漸往抓拍演進。

最早拍下臺灣影像的日本攝影師，是 1874 年隨明治軍隊出兵本島東岸的松崎晉二，照片以笨重的濕版設備在現場暗房製作完成。嚴格而論，日治時期攝影則是以快速的乾版或底片製作，廣泛利用半色調印刷術再製，出現在書籍或報紙的排版頁面上。[10] 關於 1890 年代的技術提升，博蒙特・紐霍（Beaumont Newhall）寫道：

> 「半色調印刷術」這項重要發明達到完善的時機，適逢攝影技術革命，乾版、照相軟片、消像散鏡頭以及手持相機的出現，得以更快速、便利地製作負片，也能拍攝比以往更多元的主題。有了半色調印刷術，照片便能無限量出現在書籍、雜誌和報紙上。[11]

這項西方技術傳到日本之後，旋即傳到臺灣。早期從業者主要是著名攝影師及製版師小川一真，他於 1882 年到 1884 年在波士頓研修，學成後帶著攝影材料回日本，開設了好幾間寫真館，1889 年在東京創立小川寫真製版所，製作豪華的珂羅版（collotype），也製作較普及的半色調板。[12]

到了二十世紀初，歐洲殖民列強當然也擁有這項技術，但由於他們的殖民統治早在幾十年前甚至幾百年已經開始，因此殖民地基本狀況留下的紀錄並不多。肖像方面亦然，照片卡（carte de visite）熱潮主要的被攝者為王室及殖民地原住民，但這股熱潮出現在英國殖民統治的尾聲。歐洲與日本的殖民攝影有一基本不同之處：在日本方面，殖民與第三代攝影從帝國擴張初期就密不可分。事實上，凱倫・弗雷澤（Karen Fraser）認為，日本攝影從一開始就與明治維新與文化變遷有所連結。[13] 無論出自模仿或內部邏輯，日本早期攝影師的被攝者有王室成員，也有在地人，明治天皇著名肖像照在光譜的一端，另一端則是根植於早期人類學研究傳統的日本和臺灣原住民。[14] 不過，日本的肖像照絕不只這兩種可預見的人物類型，從皇室到原住民之間的社會階層很快就被納入其中。無論統治者或是被統治者，殖民地中

行業	業主姓名	名次/廣告頁	地址號碼
城內			
1. 寫真業	蘭昌堂/有田春香	149, 150	北門街 3/5
2. 寫真業	二雁館/齊籐南總	153	北門街 1/35
3. 寫真店	遠藤寫真館/遠藤寬哉	167, 166	府前街 3/11
4. 寫真店	淺井寫真店/淺井魁一	167, 165	府前街 3/9
5. 藥種商	資生堂藥館/中田銀三郎	174, 172	府前街 4/5
6. 寫真業	中島寫真店/中島喬木	181, 181	府中街 3/12
7. 寫真業	相川寫真館/相川清水	199, 200	文武街 1/39
8. 小間物, 雜貨	寫真攝影商/臼井兵吉	211	書院街 2/25
A. 寫真	惠良寫真店事：南進館	n.p.	文武廟街 56.
B. 寫真	有田春香	n.p.	北門街，cho 1
C. 寫真器械	樫村支店	1900/3/7, 6	北門街，cho 2
D. 寫真原料品	資生堂寫真部	1900/4/3, 8	府前街，cho 1
艋甲			
9. 寫真業	吉富吉次	221	西門外街 1/57
大稻埕			
10. 寫真業	增田寫真館/增田儔太郎	332	草店尾街 63
11. 寫真師	淺井寫真館/窪田洋平	343	義重橋街 35
12. 寫真業	有馬寫真館/有馬磯吉	343	義重橋街 36

表 1. 臺北市寫真業，1900 年｜1. 兒玉源太郎總督，1899 年夏。圖片來源：《寫真俱樂部－臺灣人物寫真帖》，1901。國立臺灣圖書館典藏｜2. 臺北寫真商家地圖，1900 年。地圖出處：改正臺北市街全圖，1901，合作者附註（第 10、11、12 為概略位置）。原始地圖由南天書局典藏｜3. 遠藤誠肖像照，臺北遠藤寫真館負責人，1900 年。圖片來源：《臺灣士商名鑑》，1900。國立臺灣圖書館典藏

上層階級的肖像照，在日本早期的殖民意識形態體制都佔有特殊位置，因為肖像照是攝影影像最能展現其權力構成的範疇。

日治時期的攝影工業

有關日治時期的臺灣攝影工業，無論當時或之後所留下的記載並不多，因此必須藉由第一手資料來調查。[15] 本文引用資料主要來自國立臺灣圖書館臺灣學研究中心，館藏包括臺灣總督府圖書館於 1946 年移交之 16 萬冊藏書，其中有好幾個類型的攝影紀錄。本文研究關注的為相簿（寫真帖）及各式工商名錄（名鑑或名錄），兩者都包含肖像照及其他相片，以及諸如敘述、附註、商業廣告等文字資料。報紙及其他當時的文件資料則作為補充資訊。

日治初期臺灣攝影工業主要是日本人的天下，這些人多與母國關係密切，有大量資料可佐證。[16] 例如現存最早以臺灣為主題的《征臺軍凱旋紀念帖》，就是仙台市著名的遠藤寫真館在 1896 年製作，由先前提過的小川寫真製版所負責製版，小川的名字列在出版資訊裡，也以拉丁文「K. Ogawa」出現在裡頭幾幀重要的影像上。[17] 由於殖民地初期的技術相對不發達，因此這本及其他早期寫真帖的部分或全本不意外是在日本製作。不過，到了 1899 年，已經開始有寫真帖在本島製作。《臺灣名所寫真帖》不只由《臺灣商報社》發行，掌鏡的寫真師石川源一郎也住在殖民地首都臺北市，不過製版及印刷依然在日本由小川一真寫真製版所負責。從這本商業導向寫真帖包含的廣告來看，證明了臺灣攝影逐漸發展茁壯，除了石川源一郎之外，另有五間寫真館刊登廣告（臺北三間、基隆兩間），還有一則以本島寫真為主的寫真帖廣告。1901 年出版之《臺灣土產寫真帖》雖由日本人監製，但以臺灣製作的名義發行，顯示本島攝影工業的快速發展。透過這個時期的出版品，我們得以描繪出臺北早期的寫真館系統。

1900 年《臺灣士商名鑑》共分兩卷，上卷刊登 178 位殖民地官員和商業人士肖像照及職等，下卷列出臺北工商名錄，包含其廣告。[18] 在討論這些肖像照之前，我想先從工商名錄及廣告梳理出相關資料，來畫出臺北寫真業商家地圖。名錄以商業地址來劃分地理位置，不以主題或商家名稱作為索引，此種排

列法在晚期的名錄才普遍使用。也就是說，要找出某個行業或商家，就必須掃遍 130 頁左右的完整名錄，每一頁從 12 個商家到一則廣告不一而足。因此，這是被動、地圖式的臺北商家紀錄，不算是實用的目錄。搜索與攝影工業直接相關的商家，可找到至少 12 個，包括寫真師、寫真館、寫真業、供應店（表 1 第 1-12）。除此之外，1899 年《臺灣名所寫真帖》刊有另外兩間臺北寫真館的廣告（表 1，A 與 B）。同時期的報紙還有在地寫真器械店的廣告（表 1，C 與 D）。[19] 綜合起來，世紀之交的臺北共有 16 個寫真商家（相應地圖見圖 2）。

名單雖不完整，但應算是 1900 年左右首都寫真業的實質代表，從業的主要為日本人，業界規模比起日本甚小。[20] 與當時日本殖民的模式一致，這些商家大多集中在城裡的中央區或西北區，但也有幾間散落在漢人居住區：一間在艋舺（岬），三間在大稻埕，後者有大量歐洲人口。

殖民初期的報紙以其他更實質方式描繪出早年寫真業的運作。例如在 1898 年的一則廣告裡，文武廟街惠良寫真店（表 1，A）寫說其駐店寫真師在香港學習攝影；[21] 別處提到一位惠良三太寫真師，[22] 據推測就是廣告裡提到的同一位。香港是中國早期攝影業的中心，與日本多有文化商貿之往來。[23] 一個月後，報上刊登廣島大型零售商天正堂的攝影器材廣告，插圖是剛發行的柯達手持相機和軟片，意味著本島開始出現業餘攝影師的客群。[24] 樫村支店（表 1，C）在 1900 年的廣告特別提及在地客戶，標榜販售特別為業餘者（素人）設計的器材。[25] 可惜由於時代變動，臺灣早期抓拍攝影留下的資料文獻很少，然而早年寫真館製作的正式肖像照，有些確實能感受到抓拍攝影的特質。

1890 年代晚期開始，透過半色調印刷術可以高效地在報紙印刷照片，這項技術於 1904 年首次出現在日本，[26] 之後一樣快速引進臺灣。1905 年 5 月 3 日，《臺灣日日新報》頭版登出一張兒玉源太郎總督與軍事顧問的照片，風格近似抓拍，是臺灣報紙第一次出現半色調印刷照片。[27] 7 月 1 日，該報登出第一張半色調印刷正式肖像照，被攝者是覆審法院院長鈴木宗言，在此之前，報上所有肖像照都是衍生自照片

的版畫，往後不到五年，《臺灣日日新報》的版面充滿照片，包括無數的肖像照。新聞照片的普遍、尺寸和風格，與臺灣肖像照特色的轉變息息相關。

由於缺乏這個時期的資料文獻，難以深入探究這些商家的商業活動，但仍可蒐集到零星訊息。例如，臺灣遠藤寫真館（臺北分店，表 1 之 3）的業務內容，可以從本館（1878 年成立於仙台）製作的一系列精彩作品來預測，作品內容包括創辦人遠藤陸郎以官方攝影師的身分，在 1891 年隨遠征隊前往千島群島，其弟遠藤誠則在 1892 年為明治天皇、皇后攝影，1895 年擔任征臺行動隨軍寫真師，1896 年製作《征臺軍凱旋紀念帖》。另一個弟弟遠藤寬哉，則是 1894 年中日戰爭之隨軍寫真師。[28] 遠藤寫真館的家族傳承，除了 1900 年《臺灣士商名鑑》之全版廣告，也見於 1912 年《臺灣實業家名鑑》收錄的遠藤寬哉簡歷。[29] 1900 年的廣告把仙台列為寫真館本店，另外三間分店位於臺北、臺南及中國。[30] 遠藤寬哉的簡歷列出，他從中日戰爭起開始擔任隨軍寫真師，1895年 8 月抵達臺灣，之後前往臺南（有可能是與在當地的遠藤誠會合）。遠藤寬哉在臺南待到 1896 年 5 月，之後隨軍隊返回日本。同年 12 月，他再次回到臺南開設寫真館，之後於 1899 年開設臺北分店。雖然 1900 年名鑑將臺北分店登記在遠藤寬哉名下，[31] 但名鑑裡收錄的肖像輯則將遠藤誠列為業主（館主）（圖 3），顯示兄弟倆一起經營臺北分店。根據傅月庵的研究，遠藤誠於 1903 年卒於臺南。[32] 另一份資料顯示，大哥遠藤陸郎跟著兩個弟弟遠藤寬哉及遠藤誠來到臺灣，1902 年開始一起經營臺南的寫真館，這或許是遠藤誠過世的時候人在臺南的原因。[33] 1911 年《臺灣商工人名錄》將遠藤克巳（可能是遠藤寬哉的兒子）列為臺北分店館主，寬哉還是負責人；身分未明的遠藤俊則列名在臺南分店。[34]

臺北的遠藤寫真館與殖民當局關係密切。1901 年臺灣神社設立，遠藤寫真館負責官方攝影，1910 年討番事業啟動，一樣由遠藤擔任隨軍攝影。著名的後藤新平擔任殖民政府民政長官時（1898-1906），最早期的肖像照之一（1899）就是由遠藤先生（遠藤誠或遠藤寬哉）所攝。此外，遠藤寫真館開設了很長的時間，臺北店到 1937 年仍有營業，店主為遠藤克巳，當時臺北市有 50 多家寫真業，遠藤是唯一也

出現在 1900 年原始名錄的一家。[35] 不用說，從這些單獨的參考點，無法全面性地了解遠藤寫真館以及它在殖民社會的角色，但足以一窺它如何融入了殖民政策體制，也能感受到遠藤寫真館以及寫真業在當年的活躍。

肖像輯

日治初期臺灣寫真館系統的出現最明顯可見的線索就是正式肖像照，這類照片通常都安排在該時期各式出版品的前幾頁，我稱之為「肖像輯」（portrait gallery）。1896 年出版，以圖文記錄日本征臺的《征臺軍凱旋紀念帖》立下了這個慣例。可以想見，收錄的肖像照都是軍事人員，從攻臺司令官北白川宮能久親王到其他指揮官及軍官，總共 25 個影像，橫跨七頁。這類肖像輯的短板，也出現在 1899 年的旅遊指南《臺灣名所寫真帖》，單頁的肖像照裡包括總督以及民政長官（圖 4）。總的來看，這兩個肖像輯都沒有特異之處，大部分照片依循當時的肖像照慣例為半身或四分之三身像，被攝者身著掛滿勳章的軍裝，表情肅穆，頭微微偏向一側，接近四分之三側面角度。不過，1896 年《征臺軍凱旋紀念帖》裡也有幾張例外。在初揭頁的照片裡，明治天皇和繼承人（未來的大正天皇）直視鏡頭，近乎威嚇的模樣，彷彿以自身威權來挑戰相機的威權（圖 5），後來這成為明治天皇最為人所知的姿勢，也為現代日本肖像照定調。[36] 另一張特例，是攻陷澎湖群島之後在戰地拍攝的軍官團體照，部分人物的姿勢較近似傳統東亞的「祖先畫像」式，面朝前的全身坐像，雙腿張開，可見於中國早期肖像畫。[37] 後面頁出現的臺灣重要抗日將領劉永福著官服坐姿照，就是採這種正式姿勢（圖 6）。照片雖由小川一真製，也採現代肖像照的四分之三側面傳統，但拍攝時間應該更早，頁面上方的毛筆題字「劉軍門永福小像贊」，稱讚劉在清法戰爭（1870 年代到 1880 年代）的軍事功績，照片應該是在那個時期所攝。日本人將照片重新下標為「元臺灣總督劉永福」，把劉貶至戰敗的被殖民者的位階。殖民時期的肖像照多見這類早期的肖像畫風，但也穩定朝著更新、更現代的風格前進。

1901 年《寫真俱樂部——名臺灣人物寫真帖》裡，肖像輯以特別華麗的形式出現，本帖收錄約 96 個人，

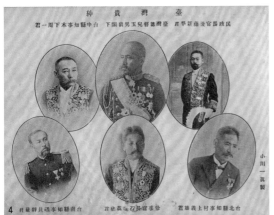

臺灣貴紳
台南縣知事木下周一君
臺灣總督兒玉男爵前閣下
民政長官後藤新平君
台北縣知事上村義上君
參事官長石丸君發藥君
台南縣事務知曙藤郡員行
4

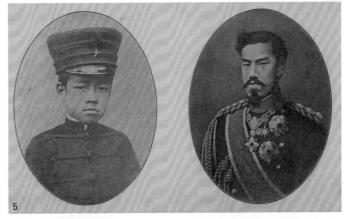

5

元臺灣總督劉永福肖像
EX-GOVERNOR-GENERAL RU-YUU-FOO.
6

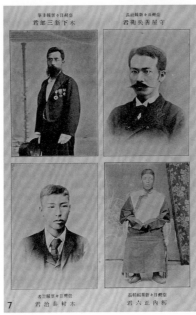

臺灣日日新報社主筆
木下新三郎君
臺灣新報社社長
守屋善兵衛君
宗灣日日新報記者
木村泰治君
宗灣日日新報社長
栃内正六君
7

遊獵中の添田博士
9

於夏門南普陀寺後長蔣官一行
8

4. 揭頁肖像輯，總督兒玉源太郎與民政長官。圖片來源：《臺灣名所寫真帖》，1899。國立臺灣圖書館典藏 | 5. 明治天皇與繼承人（未來的大正天皇）。圖片來源：《征臺軍凱旋紀念帖》，1896。國立臺灣圖書館典藏 | 6. 清代將領劉永福肖像照，日人在寫真帖裡重新標記為「元臺灣總督劉永福」。圖片來源：《征臺軍凱旋紀念帖》，1896。國立臺灣圖書館典藏 | 7.《臺灣日日新報》社長、主筆、記者及編輯（右上起逆時針）。圖片來源：《寫真俱樂部——名臺灣人物寫真帖》，1901。國立臺灣圖書館典藏 | 8. 後藤新平率臺北俱樂部成員前往中國南方旅遊團體照，1899 年。圖片來源：《寫真俱樂部——名臺灣人物寫真帖》，1901。國立臺灣圖書館典藏 | 9. 添田壽一郎扮演紳士獵人的寫真館肖像，照片標題為「遊獵中的添田博士」。圖片來源：《寫真俱樂部——名臺灣人物寫真帖》，1901。國立臺灣圖書館典藏

每頁四位，背面附上人物介紹與簡歷。所有被攝者都是隸屬於俱樂部的日本官僚或商人，只有一位不是。[38] 肖像照本身大多與預設相符，但揭頁的照片也有好幾張出人意表。

如同所料，肖像輯以高階軍事及民政長官起始，包括總督兒玉源太郎、民政長官後藤新平、臺北縣及臺中縣知事（見圖10），後續頁面羅列了各階層的殖民社會精英，以各種正式姿勢入鏡。肖像輯翻閱到四分之三處是殖民社會的商業界人士，有當時最重要的報紙《臺灣日日新報》成員，包括社長、主筆、編輯和記者（圖7）。其中兩張是標準的背景空白的胸像照（下方照片經過高雅的暈影處理），還有一張是中距離拍攝，搭配朦朧的寫真館背景。除了右下那張（詳後文討論），這些照片代表了世紀之交不同版本的標準肖像照，其特別之處，正在於這些照片完全以當時可見於全世界的殖民陳述來拍攝。

《寫真俱樂部——名臺灣人物寫真帖》展示的肖像照詳細記述了當時的殖民權位，仔細檢視可得到包括傳記、社會、意識形態方面的豐富資訊，不過，在此我想先討論排在肖像輯之前的六張不尋常的全版照片。其中三張是記錄俱樂部活動的團體照，最正式的一張，是後藤新平率領俱樂部精英代表團前往中國南方旅遊的照片（圖8）。成員模仿戰役軍事將領的姿勢，以後藤新平為中心，在廈門南普陀寺的臺階上合照，時間為1899年5月。照片是殖民權位的等級呈現，戴高帽穿制服的人佔據前排，穿西裝戴禮帽的在中間，最後面有穿僧袍的當地主人及一位「島民」（本島人）代表，據推測應是當時住在廈門的臺灣人。照片裡在（權位）光譜兩端的兩個人，沒有擺出標準姿勢。前排右二戴禮帽穿白長褲的紳士不看鏡頭，而是望向左邊上方，彷彿看著空中的飛鳥；跟其他淡定凝視著相機的人一樣，他的姿勢看起來也是刻意擺的。後方一位著僧袍的僧侶笑得燦爛，彷彿克制不住歡天的性情；也許他不知道拍肖像照的禮儀，也或許是因為他身在宗教團體，不受殖民現代性標準的束縛。無論如何，在這張照片、甚至整本寫真帖一片嚴肅表情裡，這個唯一的笑容，等於從對立面強調出當時肖像照的嚴肅特質。

其他全版照片讓人一窺幾位俱樂部成員的生活。這些照片也暗示了寫真師的存在，以及他的技術在殖民生活的角色。其中最後一張標題為「遊獵中的添田博士」，法學博士添田壽一郎是臺灣銀行總裁，這張照片可謂最符合俱樂部的姿勢：紳士獵人牽著獵鷸犬，手持獵槍，拎著一串鳥（圖9）。雖然沒有直接證據，但添田博士看似就是廈門團體照裡仰望天空的同一人，也許他正好在盤算遊獵的行程。[39] 如同其他殖民社會，打獵以及其他運動都是日本現代生活的一部分。[40] 萊恩指出，獵人在照片裡「持槍站在剛獵到的獵物旁邊」[41]，就是「殖民人物原型」的常見陳述。雖然這張照片在寫真館拍攝，獵物也比較小型，但這個描述符合添田博士的照片。

本寫真帖的頭兩張照片，不難想見即是兒玉源太郎和後藤新平，不過這兩張照片與本寫真帖裡或他處的肖像輯都大不相同。在這些照片裡，兩位都以「俱樂部文化」全面參與者的角色入像。後藤新平的照片還不算太異常，拍攝時間就是他率代表團拜訪廈門寺廟之時，他在照片裡一樣衣冠楚楚，戴高帽、著雙排扣外套、手持拐杖。但兒玉源太郎的照片就是本文開頭軼事裡提到的那張，與他正式肖像照所設立的規範相去甚遠。

寫真師

《寫真俱樂部——名臺灣人物寫真帖》收錄的絕大多數是寫真館肖像，這些寫真館的寫真師在專輯裡也明顯存在。96張照片裡，67張照片標出寫真師或寫真館，有些照片還包含其他歸類及附帶資訊。兒玉源太郎以槌球選手裝束示人的照片有著最完整的紀錄，不只標出寫真師和製版師，簡歷最後還詳盡列出拍攝經過：「參與總督府操場運動賽事，有田春香攝於1899年夏日」，我就是以這則註解寫下本文開頭的軼事。總督的正式肖像則是由另一位寫真師負責，僅僅簡單標記為「淺井先生」。這位應該是淺井魁（表1之4），他也是添田壽一郎獵人照以及寫真帖裡另外七張肖像照的寫真師。寫真帖裡總計52張肖像照及三則廣告，共標記了五位臺北寫真師，其他13位寫真師在日本。從寫真輯揭頁（圖10）就能感受到幅度之大，四張不同照片分別標記為淺井氏、遠藤氏、惠良氏、中島氏所攝（據推測為表1之4、3、A、6）。五位臺北寫真師中的兩位

佔了寫真帖大多數照片，標記為有田春香的有15張，包括一則廣告；中島喬木則是16張照片及兩則廣告。兩位寫真師與俱樂部的密切關聯，不只由照片的數量得證，還有寫真帖的封底影像。

精心製作的肖像輯以一張合成照片作結，影像的合成頗令人困惑（圖11）。中間「擺好姿勢」的抓拍照片裡的兩位殖民地人物，建築師田村佐太郎以及從日本來訪的作家村上浪六，坐在臺北城牆外軌道上的手推車，由兩名在地勞工推著前進。[42] 這是一張純然的「殖民」影像：在地臣民真真實實地負荷殖民統治者的重量，相當於呈現搬運工抬著轎子、載運外國人和行李穿越異國景色的許多殖民照片。照片裡兩位紳士戴著「在地」帽子遮擋熱帶陽光，成為他們的制式裝扮，但他們衣服的標記似乎也有等級之分。從家鄉來的訪客村上，衣著相對典雅潔淨（白襯衫、領帶、擦亮的長靴等），與在地居住的田村相較，後者的衣物似乎因為在殖民地環境穿著而磨損。村上彷彿尚未因訪臺而弄髒衣服，依然是來自東京的完美現代人。或許正因如此，背面才沒有他的資訊，因為他不是「本島人」。不必說，因為截然不同的理由，當然也不會有註記兩名勞工的資訊。

寫真師有田春香及中島喬木的肖像照，一右一左夾住中間的照片，兩張都是標準的寫真館肖像照，不同處理的複本出現在後文會討論到的1900年之名鑑（圖13，左上為中島喬木）。根據簡歷所述，中島於1896年抵臺，一開始在淺井寫真館工作，之後成立自己的店鋪（表1之6）；有田的情況類似，他在1897年來到臺灣，1898年成立自己的寫真館。兩位寫真師與中央的抓拍照關係不明，沒有歸類，也沒有註記。如此合成，代表照片是他們的作品嗎？如果是的話，這樣的選擇很有意思，暗示了攝影技藝的未來方向：新的小型相機所標榜的戶外「動態」攝影。不過，這張照片明顯是擺拍的。此外，此種對於素材的透明操弄，亦即巴特所稱的隱含義手段，[43] 以圖示方式將攝影師與他的技藝並陳。總結而言，這張合成自拍像（如果這樣的分析無誤）對於攝影師及攝影業提出的質問多過於解答，有待進一步探討。持續顯見的是他們勞動的大量成果：殖民仕紳的公開肖像。

商紳風格

行文至此回到1900年《臺灣士商名鑑》，探討其中的肖像照以及其他視覺內容。名鑑裡橫跨45頁的178張肖像，主題與風格都相當廣泛，揭頁一樣是兒玉總督與殖民官員的全版寫真，照片雖然是新拍的，人物姿勢與風格幾乎與1899年寫真帖如出一轍（圖3）；尾頁則有所創新，收錄三張臺灣人的照片，包括一位公民領袖及兩名商界人士（圖12）。公民領袖黃玉階是日治時期第一位領取漢醫執照的醫生，也是改革運動團體天然足會會長。照片裡他身著在地服裝，留著漢人必備的清式髮辮。兩位臺灣商人則呈現強烈對比，代表了面對殖民社會的兩種反應。也留髮辮的容棋年（圖12，左下）著在地服裝，在戶外以隨興風格入境，他盯著相機看，彷彿即便在洋行任職，也未適應現代生活。王志唐（圖12，右下）的寫真館正式肖像照就形成對比，他身著全套殖民者服裝，還佩戴了少許勳章，撇過頭不看相機，彷彿他期盼自己在未來的殖民現代社會出人頭地。

同一頁收錄了殖民者的肖像（圖12，右上）似乎是巧合，淡水的齋藤重友沒有列出頭銜或職業，彷彿降低殖民者地位就拉近了他與臺灣人的距離。但在比較齋藤與其他臺灣人的肖像照之後，可看出一些地位與種族標記。黃玉階和容棋年的照片當然最明顯，但即便是模仿殖民者的王志唐，也無法完全體現齋藤的殖民現代性。兩人衣著、姿勢、甚至雄性禿的模式幾乎相同，但齋藤濃密的八字鬍確立了他的種族及殖民位階。在早期的肖像輯裡，日本殖民領袖留著各式各樣的鬍子，例如1896年《征臺軍凱旋紀念帖》的肖像輯裡有23人、1899年旅遊指南《臺灣名所寫真帖》第一頁中的六人都留著八字鬍或鬍鬚（後者見圖4）。就連收錄階層更廣泛、包括好幾位年輕人的1901年《寫真俱樂部──名臺灣人物寫真帖》，之中也有超過三分之二的人留鬍子，而且幾乎所有高層官員都有留。同樣情形見於歐洲殖民者，可視為日本對歐洲殖民影像的模擬（臉部的制服），不過別忘了，至少在江戶時期之前，日本武士文化也有許多留鬍子的英雄。對於大多數被殖民的漢人臣民而言，這個形式的模擬因受種族所限而無法輕易做到，即使想學也學不來。他們可以剪掉髮辮，穿上各式各樣的殖民制服，以其他現代配件來打扮自己，但很少人留得出日式或歐式鬍鬚，

10. 殖民地長官肖像：民政長官後藤新平、總督兒玉源太郎、臺北縣知事村上義雄、臺中縣知事木下周一。寫真師為遠藤、淺井、中島、惠良（左上起順時針）。圖片來源：《寫真俱樂部——名臺灣人物寫真帖》，1901，國立臺灣圖書館典藏｜11. 合成照片，中左為建築師田村佐太郎，中右為作家村上浪六，右上為寫真師有田春香，左下為中島喬木。圖片來源：《寫真俱樂部——名臺灣人物寫真帖》，1901，國立臺灣圖書館典藏｜12. 1900年《臺灣士商名鑑》肖像照尾頁：公民領袖黃玉階、淡水居民齋藤重友、商人王志唐與容棋年（左上起順時針），國立臺灣圖書館典藏｜13. 臺北寫真師、寫真店主、技師肖像：寫真師中島喬木（左上），技師田中嶺月（右下）。圖片來源：《臺灣士商名鑑》，1900，國立臺灣圖書館典藏｜14. 1917年林茂生與妻子結婚照，後者著傳統日本和服。圖片來源：謝森展編著，《島國顯影》，1993，臺北：創意力文化，林宗人典藏｜15. 穿絲袍、戴傳統漢人學者帽的《臺灣日日新報》記者栃內正六。《臺灣士商名鑑》，1900，國立臺灣圖書館典藏

就連成年男子亦然。嘴上無毛使得他們看起來像「兒童」，殖民地的日本人就是家長。我將在本文最後回到模擬以及殖民者鬍鬚的問題。

1900 年名鑑裡的肖像照大多風格統一，與其他寫真帖標準一致，我想指出幾張帶有殘存風格或創新手法的偏離之作，但別忘了，在絕大多數傳統肖像裡，這些只佔一小部分。其一就是這些肖像照的場景設置，有些模仿舊時達蓋爾版及長時間曝光攝影術的傳統；班雅明（Walter Benjamin）曾嚴厲批評這種做法，認為擁有「靈光」（aura）與尊嚴的舊時肖像照被粗暴地商業化。[44] 第一代攝影術需要長時間曝光，意味著相機和被攝者在拍攝時間內都必須維持不動，早期至少要好幾分鐘。相機或靜物要維持不動很簡單，然而要拍攝肖像照，就要使用各種機械設備來支撐非常動態的人體。最實用的就是扶手椅，有的還配備隱形頭撐，使得被攝者的姿勢有如端坐在王座，恰巧反映了東亞的祖先正式畫像。桌子和矮柱可供被攝者倚靠而保持穩定，其他增加氣氛的物件也能順勢放入，例如書本、花瓶之類。微笑當然不行，無論就意識形態或實際理由而言。雖然這時一般快門速度已達到 1/25 秒，因此不需要採用這些手段，但這些肖像照裡頭，有幾張可明顯看到以上的舊慣例，曾經的必要現在成為流行（圖3）。在創新方面，有幾張照片展示了前衛的道具和姿勢，包括寫真俱樂部添田博士著獵裝率寵物狗的寫真館肖像照。除此之外，在一頁都是寫真館店主和員工的照片頁裡，有一張形式饒富趣味的自我呈現，一位沉思中的田中嶺月以側面入鏡，表現方式非常創新（圖13右下）。最後，殖民者服裝雖然佔大多數，名鑑裡仍有幾個人穿傳統日式和服，是為殖民模擬（colonial mimicry）之內的日本種族宣言。在早期攝影的脈絡裡，很難判斷這是舊慣例或創新的影響，和服有可能是引用傳統，也可能是以創新方式在現代國家陳述裡頭注入日本性。

隨著殖民政權朝現代邁進，日式和服也愈來愈只有在正式或日本性的特殊場合才看得到，後者主要是神道相關的活動。不只居住在本島的日本人是如此，殖民人口之中的大部分人，特別是都市精英，其中又以女性為大宗，都視和服為特殊場合服裝。這類模擬最驚人的例子，就是臺灣知識分子領袖林茂生

與妻子 1917 年的結婚照（圖14），這種場合會形成霍米‧巴巴（Homi Bhabha）在討論南亞及非洲殖民政權所提到之模擬的矛盾性，然而此處有一項要素，顯示這是具有東亞特色的模擬，也就是種族差異的重要性，以及面具的效力。巴巴評述殖民模擬為「期望成為一個改良過的、可以被辨識的他者，[45] 做為一個具有差異性的主體，幾乎一樣但又不太一樣」。[46] 他補充說明，部分因為歐洲殖民主義的高度種族化，因此他把「但又不太一樣」這句修訂為「幾乎一樣但又不是白種人」（譯註：not quite/not white）。[47] 種族與民族在日本殖民政策也扮演決定性角色，其中不乏殘忍的恐怖鎮壓手段，尤其針對臺灣原住民，但在所謂東亞同文和同化（文化）的政策方面，日本殖民修辭也淡化了種族差異。[48] 都會精英人口的某些照片似乎可見這類種族模糊的視覺形式，臺灣人雖然永遠無法真的「變成日本人」，但在照片靜止無聲的框架裡，有時卻可以「變得像日本人」。具備文化知識的人或許能解密林茂生的種族，但難的是解析他的新娘的種族。她究竟是友子（Tomoto）還是林（Ling）只有看圖說才知分曉。

種族模糊和殖民模擬在臺灣有時也出現奇怪的組合。1900 年名鑑裡某位人物就顛倒了標準的殖民慣例陳述：《臺灣日日新報》記者栃內正六穿絲袍戴傳統漢人學者帽，以漢人之姿直視鏡頭（圖15），可說是最奇特的自我呈現。其他殖民照片也有這類顛倒模擬的例子，例如尚‧蓋瑟（Jean Geiser）於 1870年拍攝的「穿阿爾及利亞服裝的歐洲夫妻」，[49] 但此處歐洲人模仿民族誌照片卻充滿反諷，因為他們很明顯是「扮裝」。在其他情境，當殖民者偽裝成臣民悄悄潛入殖民社會，顛倒模擬也有間諜活動的意味；英國殖民作家、探險家理查‧伯頓爵士（Richard Burton）就是以成功的顛倒模擬而為人所知。栃內的肖像照，似乎是顛倒了殖民模擬卻不帶反諷或托詞的例子，怎麼會這樣呢？

我在他處寫過日本殖民者面對臺灣臣民的曖昧文化關係。殖民統治精英想擁有臺灣漢人文化掌握的高價文化資本，特別是中國文人文化的部分，這在日本備受崇敬，享有象徵性的價值。[50] 此處，我認為栃內正六的肖像照可作為這種文化模糊的視覺化。雖然我們不可能知道栃內的意圖，但殖民區隔在這張

影像裡被模糊了。首先，他顯然選擇以這張肖像作為自我陳述，收錄在正式的殖民文件紀錄裡。第二，他的姿態完全不帶戲謔，服裝彷彿也是鄭重其事選擇的。同樣情況也見於他在 1901 年俱樂部寫真帖裡的肖像照（圖 7 右下），這回甚至更全面，他再度以漢人之姿入鏡，服裝和姿勢皆然，從頭到腳的清袍、帽與靴，「祖先姿勢」的張腿全身照。而且，兩張照片裡的栃內都沒有留八字鬍或鬍鬚，也就是日本統治精英最明顯的種族標記。[51]

種族與文化界限在栃內正六的兩張肖像照裡都被模糊了，而且是以東亞特有的方式。觀者或許會聲稱能看出栃內所屬的種族，但此處殖民統治者與臣民的區別，絕對不會比歐洲殖民攝影裡來得明顯。栃內有可能被當作王氏，但瓊斯很少會被當成王氏或古普塔氏。（譯註：日本人可能被當成漢人，但西方人很少會被看做是漢人或印度人。）另一個與服飾相關的明例，就是耶穌會成員也穿漢袍，但是「高鼻子和鬍鬚」使得他們與漢人族群明顯不同。[52] 整個日治時期裡，種族與文化的模糊有幾個趨勢可循，其中最重要的一個，就是日治之下的臺灣人民與日本統治者的肖像照來愈類似，都往現代男性身分認同的新標準邁進，這些改變明顯見於未來 30 年工商名錄的演進。

工商名錄的演進

隨著寫真帖的數量在整個日治時期激增，正式肖像輯失去以往的顯著地位，同時，商人和其他專業人士名錄變得愈發重要也更複雜，出現了幾種創新的變化。這些名錄是這時期的重要社交紀錄，除了大量的其他資料，工商名錄也是中上層族群公開肖像照的歷時性紀錄。在臺灣國立圖書館的臺灣總督府圖書館舊藏裡，除了 1900 年《臺灣士商名鑑》，另收錄至少 13 本臺北（或包含臺北部分）的工商名錄：1911、1912、1919、1927、1933、1934（上下卷）、1936、1937（上下卷）、1938、1943（上下卷）。

第一本名錄發行之後與接下來兩本（1911、1912）中間隔了十年，工商名錄的內容和類型形式有了重大改變。第一，這兩本收錄了許多臺灣人，1912 年《臺灣實業家名鑑》的臺北部分列出 200 多個臺灣人，相較於大約 300 個日本人。這本名錄也約略以地區來劃分（臺北、宜蘭、桃園等），但在每個地區之下列出個人，而不像 1900 年名錄是列出地址。雖然日本人（內地人）和臺灣人（本島人）是分開列表，但所有人的姓氏都以假名發音來排列，包括漢人姓氏。漢人姓名以日式發音，點出了兩種人口在語言學上的特殊複雜性，也明顯象徵了殖民層級。相較之下，1911 年《臺灣商工人名錄》先以職業分類，之後再列出地區和個人，日本人與臺灣人並列。舉例而言，日人與臺人專業寫真師在全臺共列出 34 位，其中 9 位在臺北基隆地區，[53] 因此這兩本名錄在不同方面比 1900 年版本更易於搜尋。

1912 年名錄對本文之研究特別有價值。這本名錄包含個人資料與影像，媲美 1900 年名錄下卷及 1901 年俱樂部寫真帖，涵蓋人物也廣泛得多。名單的內容與結構相當一致，一般包含個人照片及基本資訊（出生地、年齡、職業、商號地址、電話號碼），通常還有類似俱樂部寫真帖的個人簡歷，缺少照片的則由基本「名片」來代替（圖 16）。這時肖像寫真館在全臺已非常普遍，無論日人或臺人，中上層人士要拍肖像照都很容易，儘管如此，影像仍保留了清楚的種族區別，日本精英人士幾乎都是西裝領帶（偶見制服或傳統服裝）的半身像或胸像照，也有一些臺灣人物以這種方式入鏡，但絕大部分仍是「漢人」的舊時衣服和姿勢、著傳統服裝的全身照，有些還是古早的「祖先肖像」風格，名錄裡陳姓和林姓頁面可見風格涵蓋的範圍（圖 17、18）。臺灣人肖像照出現這麼多服裝風格，部分原因是涵蓋的人物一下子激增，這些人是在地商人階層，早期寫真帖和名錄並不收錄。影像陳述的範圍變大，反映了攝影業在本島拓展開來，並且捕捉到值得注意的文化與社會現象。

最引人注目的是，1912 年《臺灣實業家名鑑》收錄臺人肖像照密度高於日人肖像。如臺北地區 228 位「本島人」裡，有 137 位（60％）附肖像照，但列出的 372 位日本人裡，只有 160 位（43％）包括肖像照，這個趨勢在臺北以外的區域更加顯著。總計，名錄列出的日人為臺人的兩倍以上（1054 人與 427 人），但臺人有肖像照的比例是日人的兩倍，284 位臺人（67％）附上肖像照而不是名片，但只有 332 位日人（31％）附肖像照。從表面來看，這代表攝

16. 寫真館店主遠藤寬哉照片；其他兩個人以名片取代照片。圖片來源：《臺灣實業家名鑑》，1912，國立臺灣圖書館典藏｜ 17. 陳姓臺灣人列表。圖片來源：《臺灣實業家名鑑》，1912，國立臺灣圖書館典藏｜ 18. 林姓臺灣人列表。圖片來源：《臺灣實業家名鑑》，1912，國立臺灣圖書館提供｜ 19. 辯護士歐清石1934年及1937年肖像照。圖片來源：《臺灣人士鑑》，1934，1937，國立臺灣圖書館典藏｜ 20. 日本與臺灣紳士：橋本先生、近藤先生、陳先生、洪先生。圖片來源：《臺灣人士鑑》，1934，臺灣國立圖書館典藏

影專業雖然仍牢牢地（但不是僅僅）掌握在日人手裡，但寫真館的臺人客戶卻增加了。[54] 而且，如果寫真業其他項目如結婚照、家庭照、學生照等也展現同樣的統計數字，那麼增加的人數就更可觀，尤其以上的項目在日治晚期非常受歡迎。

這些數據可能代表什麼？殖民統治初期就有如此高比例臺灣人民的攝影影像陳述，顯然是日本殖民主義的特殊狀況，這是因為科技與工業都已到位才促成的。令人好奇的是為何會有這麼多臺人精英受到寫真館的吸引，是否因為肖像照代表的聲譽價值，使得臺灣商業精英希望被納入殖民商業系統？還是說，這個結果是來自兩邊人民固有的文化與階級差距：亦即臺人精英在臺灣社會佔的比例很小，以至於他們擁有足夠的資源投資在肖像照？或者臺灣人就是想「看起來像日本人」？就算理由如此，無論刻意與否，早期肖像照依然充滿了社會建構的種族象徵。

晚期的殖民趨勢

臺灣工商名錄的形式在往後數十年大約維持不變，但特定內容反映了殖民社會結構的改變，以本島寫真師人口統計為例可看見這些改變。1911 年，臺北地區九間寫真館都不是臺灣人經營，但到了 1927 年，22 間寫真館之中有五間由臺灣人設立；1936 年殖民寫真文化達到高點，臺北地區 51 間寫真館有 15 間列為臺灣人設立。[55] 1937 年名錄裡，臺灣人開設的寫真館比例稍微低一點（54 間之中的 14 間），寫真師張才以及其開設在大稻埕的寫真館第一次出現在名單裡，[56] 張才後來成為著名的「攝影三劍客」之一，從殖民時期到戰後 1945 年國民黨來臺，持續協助本地攝影圈成長茁壯，雖然一度也遭到中斷：太平洋戰爭最高峰時期，1943 年名錄裡臺北九間寫真館沒有一間由臺灣人設立。[57] 戰時的緊縮措施顯然改變了地方經濟，特別在奢侈消費及娛樂方面。1934 年的《臺灣人士鑑》於 1943 年再版，附卷的簡歷列表更看得出戰時的撙節，所有人都只有姓名等資訊，沒有影像。

公開肖像照的其他慣例發展，可從最早期到接下來數十年的名錄裡追溯得知。首先是臺灣商界和公民領袖的數量增加，也持續有很高比例的人附上肖像照，例如 1934 年《臺灣人士鑑》列出 93 位陳姓人士，81 位附上肖像（87%），而 39 位日本人之中只有 21 位附有肖像（54%）。早期名錄明顯可見的種族標記，以及舊慣例的肖像照拍法，隨著時間過去而漸漸減少，到了 1930 年代，無論日本人或臺灣人呈現的風格幾乎統一，大部分男人穿西裝打領帶，都是正面看鏡頭的腰或胸部以上影像。雖然還是有人留八字鬍，但早期殖民統治者特徵的濃密大鬍子已經很少見了。1901 年吉列（Gillette）公司發明安全剃刀帶動剃鬍的潮流，這個全球現象把刮乾淨的臉和青春及現代性做了連結，在接下來的數十年裡，特別是一次大戰之後，使得紳士剃鬍子成為慣例。這個做法在日治臺灣的附帶影響，就是讓臺灣與日本男性人口的影像陳述更接近。或許可以說，這個做法使得日本人在表象上模擬臺灣人，因為臺灣人本來就不太留鬍子，而日本人剃鬍的也愈來愈多。此外，後來的名錄也不再有東亞式或達蓋爾版式的全身入鏡照片，就連半身像都少見，影像裁切愈來愈多。

到了 1937 年《臺灣人士鑑》，肖像照裁切達到極致，大部分肖像切到只剩肩膀和頭，影像愈接近「嫌犯大頭照」（mug shot）的同時，也漸漸消去服飾的種族標記。一個明顯的例子是辯護士（律師）歐清石在 1934 年及 1937 年的肖像照，使用同一張照片，但後者卻明顯裁切（圖 19）。這點也與轉變中的身分認同之概念相符，從身體與服裝轉而移向心理與內在，臉部（特別是眼睛）成為個體之所在。類似而且可能還交互影響的就是電影裡的大特寫，這種鏡頭漸漸被用來傳達情感和親密的感覺。實際上，當身分認同不再是從「舞臺」投射出來的全身，肖像攝影就從原本的戲劇的陳述，轉變成具電影感的陳述。當時報紙使用肖像的頻率愈來愈高，也增強了這個趨勢。在早期報紙，見報的肖像照通常版面相當大，有時佔去八分之一頁面，但晚期因為影像激增而必須縮減尺寸，往往不到一個標準欄位的長或寬。就肖像而言，這代表了大頭照愈來愈受到注意。

晚期的名錄裡不免仍有受種族影響的照片，特別年紀較大的臺灣男性偶爾會穿中式絲綢外衣入鏡，但有時會佩戴殖民式勳章，另外再戴頂禮帽。[58] 相反情形也不時出現，例如來自屏東的臺灣年輕人謝權在

穿和服，留著細細的八字鬍。[59] 最後，名錄裡也開始
出現幾位女性的肖像。穿和服的陳進是在東京受教
育的藝術家，另一位在東京學醫、在臺北擔任眼科
醫師的陳石氏滿，則穿著西式女襯衫入鏡。[60]

在整個日治時期裡，雖然日本殖民者和日治之下的
臺灣人之間顯然有著真實存在的區別，但就視覺的
呈現，至少在公開肖像方面，演化出一種不尋常的
殖民模擬。這是「第三類」模擬，兩個族群接收「另
一個他者」的模式為己有：鬍子刮得乾淨的現代年
輕男子著西裝的嫌犯大頭照。此外，再加上兩個族
群之間較為模糊的種族差異，肖像照走向了某種模
式，使得橋本、近藤、陳、洪都被納入同一個影像；
他們實際上是「同類人」。陳終究無法成為橋本，
橋本也無法成為瓊斯，但在某些方面，陳和橋本都
有平等的機會成為瓊斯的模擬者。雖然還有其他標
記來維持殖民身分認同和區隔，例如個人姓名和口
語，但攝影肖像在視覺上的模糊性，外加其他社交
聚合（如從事文學或書法藝術者），更加混淆了作
為殖民統治基礎的文化區別。事實上在殖民晚期的
皇民化運動時期，住在大都市的人被迫改掉漢名、
語言和宗教，這些政策謀的是更進一步混淆文化區
別（陳至少可以在「名義上」成為橋本）。巴巴認
為殖民模擬「同時具有相像與威脅」的效應（at
once resemblance and menace）[61]，我認為他指的是模
擬行為所產生的最終差別（「過度／滑移」（excess/
slippage）），造成一種顛覆性的威脅，就是這個「又
不太像」在嘲諷殖民政權的任意性。從臺灣的公開
肖像照來看，這層威脅似乎來自另一個方面：日治
之下的臺灣人與殖民者共享「另一個他者」的模擬
模式，因此取得了與統治者同等的真實性，雙方「又
不太像」的方式是一樣的。

致謝
本文研究經費來自臺灣教育部提供之臺灣研究獎助
金，並感謝駐芝加哥臺北經濟文化辦事處。

1 Roland Barthes, "The Photographic Message," *Image, Music, Text*, trans. Stephen Heath, New York: Hill and Wang, 1977, pp. 20–25.

2 Roland Barthes, *Camera Lucida: Reflections on Photography*, trans, Richard Howard, New York: Hill and Wang, 1981.

3 John Tagg, *The Burden of Representation: Essays on Photographies and Histories*, Minneapolis: University of Minnesota Press, 1993, pp. 1–5.

4 James R. Ryan, *Picturing Empire: Photography and the Visualization of the British Empire*, Chicago: University of Chicago Press, 1997.

5 Jean-Claude Lemagny and André Rouillé, *A History of Photography: Social and Cultural Perspectives*, trans. Janet Lloyd, Cambridge: Cambridge University Press, 1987, p. 62.

6 我以「第三代」攝影術來區別乾版及膜料和火棉膠濕版攝影術的不同，後者取代了第一階段媒材的達蓋爾版以及科羅版。乾版技術在 1860 年代晚期研發出來，1890 年左右才達到夠快的曝光速度。柯達公司在 1889 年發明現代賽璐珞底片。半色調印刷術在 1880 年代發明，1890 年代開始被報紙採用。（Beaumont Newhall, *The History of Photography*, New York: Museum of Modern Art, 1964, pp. 86, 89, 139, 175–177.）有關這項技術的早期應用請參見拙作。Joseph R. Allen, "Colonial Itineraries: Japanese Photography in Taiwan." In *Japanese Taiwan: Colonial Rule and Its Legacy*, ed. Andrew W. Morris. London: Bloomsbury, 2015, pp. 25-48.

7 Ben Maddow, *Faces: A Narrative History of the Portrait in Photography*, Boston: New York Graphic Society, 1977, pp. 16–31 and Newhall, *The History of Photography*, chap. 4.

8 Newhall, *The History of Photography*, pp. 36–37.

9 Karen M. Fraser, *Photography and Japan*, London: Reaktion Books, 2011, p. 10.

10 木下直之提到松崎晉二的作品時說：「他拍臺灣的照片已散失。」（Naoyuki Kinoshita, "The Early Years of Japanese Photography." *The History of Japanese Photography*, eds. Anne Tucker et al., New Haven, Conn.: Yale University Press. 2003, p. 33）然而，他在牡丹社事件下拍的照片，有一小部分重印在 1915 年《臺灣寫真帖》以及詹姆斯・達飛聲（James W. Davidson）《福爾摩沙島的過去與現在》（*The Island of Formosa Past and Present: History, People, Resources, and Commercial Prospects: Tea, Camphor, Sugar, Coal, Sulfur, Economical Plants, and Other Productions*, 1903）原書第 127 頁對頁。沒有直接證據可得知他在當年征臺之役使用什麼設備，但他在隔年的遠征用的是火棉膠濕版（見 Kinoshita, "The Early Years of Japanese Photography", p. 33, fig. 8），因此可假設他在臺灣使用了濕版技術。

11 Newhall, *The History of Photography*, p. 175.

12 小川一真對日本攝影史存在著深遠影響，見 Kinoshita, "The Early Years of Japanese Photography", pp. 34-35，以及 Fraser, *Photography and Japan*, pp. 33–34；詳細提到小川使用的製版技術以及出版物完整清單，可見 George C. Baxley, "Kazumasa Ogawa: Japanese Photographer," BaxleyStamps.com, http://www.baxleystamps.com/litho/ogawa.shtml，and accessed July 22, 2014.

13 Fraser, *Photography and Japan*, p. 9.

14 「人類學式」的臺灣攝影在學術上相當受矚目，見許進發、魏德文，〈日治時代臺灣原住民影像（寫真）紀錄概述〉，《臺灣史料研究》第 7 期，1996 年 2 月，頁 19–44。Ka F. Wong（2004）提到，人類學家及攝影家鳥居龍藏以其拍攝的臺灣原住民寫真在近代民族誌佔有一席之地（Ka F. Wong, "Entanglements of Ethnographic Images: Torii Ryūzō's Photographic Record of Taiwan Aborigines (1896-1900)," *Japanese Studies*, 2004: 24(3), pp. 283–99; Torii Ryūzō's, *Etudes Anthropologiques: Les Aborigènes de Formosa*, Tokyo: Tokyo University, 1910, NTL call no. 0762 3; Torii Ryūzō's, *The Torii Ryūzō's Photographic Record of East Asian Photography*, Parts I-IV, Tokyo: University of Tokyo, 1990.）。萊恩寫過大英帝國殖民人口的人類學式照片，見〈Photographing the Native〉一章。

15 黃明川、張照堂、周文在文裡約略提到日治初期的臺灣攝影。見黃明川，〈一段模糊的曝光——臺灣攝影史簡論〉，《雄獅美術》175 期，1985 年 9 月，頁 159–168。張照堂，〈光影與腳步——臺灣寫實攝影發展報告〉，《映象與時代：中華民國國際攝影藝術大觀攝影藝術研討會論文專輯》，臺中：省立美術館，1992 年，頁 11–25。周文，〈以歷史的眼光鳥瞰臺灣攝影的發展〉，《臺灣美術》11 卷第 4 期，1999 年 4 月，頁 74–82。

16 Kinoshita, "The Early Years of Japanese Photography."

17 這些可能也是以高階的梅森巴赫（Meisenbach）半色調印刷術來製作，也是小川聞名的技術，見 Baxley, "Kazumasa Ogawa: Japanese Photographer."。小川去過中國，但從未造訪臺灣，不過他確實在 1896 年製作了一本臺灣寫真帖《台灣和澎湖群島的回憶》（*Souvenirs de Formose et des Iles Pescadores*），這些影像與《征臺軍凱旋紀念帖》沒有重複，見 Thomas H. Hahn, "Taiwan 1896," Thomas H. Hahn Docu-Images, 2009, http://hahn.zenfolio.com/p554924562 and accessed July 23, 2014.

18 《臺灣士商名鑑》臺北：にひふか社，1900，國立臺灣圖書館（以下簡稱國圖）索書號 0743-1。

19 《臺灣日日新報》1900 年 3 月 7 日，頁 6；1900 年 4 月 3 日，頁 8。

20 相對來看，東京在 1877 年已列出 116 位專業寫真師、14 間材料店。見 Kinoshita, "The Early Years of Japanese Photography," p. 24。早期寫真業為日本人的天下，唯二例外是臺中的林寫真館與鹿港的二我寫真館。林寫真館的店主林草向一位日本隨軍寫真師學習寫真，學成後在 1901 年設立寫真館；施強亦於同年開設寫真館。見張蒼松，《百年足跡重現——林草與林寫真館素描》，臺中：臺中市文化局，2003，頁 86；以及林煥盛，〈臺灣早期攝影發展過程中的鹿港「二我寫真館」〉，《臺灣攝影年鑑綜覽：臺灣百年攝影 1997》，臺北：原亦藝術空間有限公司，1997，頁 1-92-1-103。

21 《臺灣日日新報》1898 年 5 月 17 日，頁 6。

22 《寫真俱樂部——名臺灣人物寫真帖》，臺北：臺灣週報社，1901，國圖索書號 0743.3。

23 Claire Roberts, *Photography and China*, London: Reaktion Books, 2013, p. 27.

24 《臺灣日日新報》1898 年 6 月 15 日，頁 8。

25 《臺灣日日新報》1900 年 3 月 7 日，頁 6。

26 關於報紙使用半色調印刷術在西方的歷史，見 Lemagny and Rouillé, *A History of Photography: Social and Cultural Perspectives*, pp. 76-79 and Newhall, *The History of Photography*, pp. 176–77。日本的部分見 Kaneko Ryuichi, "Realism and Propaganda: The Photographer's Eye Trained on Society," *The History of Japanese Photography*, eds. Anne Tucker et al., New Haven, Conn.: Yale University Press, 2003, p. 187。

27 《臺灣日日新報》1905 年 5 月 3 日。

28 1896 年《征臺軍凱旋紀念帖》背面廣告描述了仙台寫真館的業務，封面印有寫真師遠藤誠的名字。見《臺灣實業家名鑑》，臺北：臺灣日日新報，1912，頁 99，圖 19。國圖索書號 0743-6a。遠藤寬哉之簡歷，詳述他擔任 1894 至 1895 年中日戰爭隨軍寫真師並造訪臺灣。

29 《臺灣實業家名鑑》，頁 99。

30 《臺灣士商名鑑》，頁 166。

31 《臺灣士商名鑑》，頁 167。

32 傅月庵，〈乙未戰役影像史料判讀上的一些問題〉，《臺灣史料研究》第 7 號，1996 年 2 月，頁 46。

33 資訊來自安・塔克（Ann Tucker），但她說陸郎在 1902 年設立寫真館。本文假設他是接手經營。見 Anne Tucker, Izawa Kōtarō, and Kinoshita Naoyuki, *The History of Japanese Photography*, New Haven, Conn.: Yale University Press, eds. 2003, p. 316。

34 《臺灣商工人名錄》，臺北：臺灣商工人名錄印刷所，1911，頁 265，國圖索書號 07901-23。

35 《臺北市商工人名錄》，臺北：臺北市役所，1937，頁 217-219，國圖索書號 07901/28a。

36 明治天皇肖像照的拍攝及流傳，與明治維新和現代性及國際社會接軌的企圖有密切關係，見 Fraser, *Photography and Japan*, pp. 37–40; Morris Low, *Japan on Display: Photography and the Emperor*, London: Routledge, 2006, pp. 10–15，最有名的一張是內田九一在 1873 年拍下。此處重印的看起來類似，但據推測是由遠藤寫真館製作，一樣廣為流傳。繼承人的照片則沒有在別處看過重印。

37 巫鴻描述過「中國姿勢」本質上存在的問題，因為這是早期在中國的西方攝影師以東／西、舊／現代的二元對立論述所創。特別有意思的一點，米爾頓・米勒（Milton Miller）在 1860 及 70 年代就是以這種姿勢來創作當時中國人的「祖先肖像照」。詳見 Wu Hung, "Inventing a 'Chinese' Portrait Style in Early Photography: The Case of Milton Miller," *Brushes and Shutter: Early Photography in China*, eds. Jeffrey W. Cody and Frances Terpak, Los Angeles: Getty Research Institute, 2011, pp. 69–89; and Roberts, *Photography and China*, p. 14 et passim.

38 我假定這裡指的俱樂部就是臺北俱樂部。見 Joseph R. Allen, *Taipei: City of Displacements*, Seattle: University of Washington Press, 2012, pp. 96–101。

39 寫真帖卷首插圖有添田以毛筆字題詩人杜牧（803-852）的詩句「清風故人來」，展現他文化生活的另外一面。（譯註：出自〈早秋〉第二行，原句為「大熱去酷吏，清風來故人」。）

40 這時期的報紙和其他出版品常刊登獵槍等設備的廣告，1906 年《兒玉總督凱旋歡迎紀念寫真帖》就有俱樂部舉辦的飛靶射擊比賽的照片。

41 Ryan, *Picturing Empire: Photography and the Visualization of the British Empire*, p. 99.

42 村上（1865-1944）使用筆名ぬの浦浪六，感謝 Maki Isaka 教授的驗證。

43 Barthes, "The Photographic Message."

44 Walter Benjamin, "Little History of Photography," *Walter Benjamin: Selected Writings, Volume 2 (1927-1934)*, ed. Michael W. Jennings, Cambridge, Mass.: Harvard University Press, 1999, p. 515.

45 Homi Bhabha, "Of Mimicry and Man," *The Location of Culture*, London: Routledge, 1994, pp. 85–92.

46 Bhabha, "Of Mimicry and Man," p. 86. Italics in original.

47 Bhabha, "Of Mimicry and Man," p. 87.

48 Ching（2001）對於這些政策的雙重性及內在矛盾有全面性的討論。見 Leo Ching, *Becoming "Japanese": Colonial Taiwan and the Politics of Identity Formation*, Durham, N.C.: Duke University Press, 2001。

49 Mounira Khemir, *L'Orientalisme: l'Orient des photographes au XIXe siècle* [Orientalism: Nineteenth century photographs of the Orient], Paris: Centre national de la photographie, eds. 1994, pp. 24–25.

50 Allen, *Taipei: City of Displacements*, pp. 102–103.

51 寫真輯 178 張照片裡只有 50 個人（幾乎都不是殖民首長）有剃鬍。

52 比較 Roberts, *Photography and China*, pp. 13–14, fig. 3 與 Wu, "Inventing a 'Chinese' Portrait Style in Early Photography: The Case of Milton Miller", p. 86, fig. 18。

53 《臺灣商工人名錄》，頁 265–267。

54 全臺共列出 33 間寫真館，7 間由臺灣人設立，6 間在臺中地區，可能是林草早期就在當地設立著名寫真館的影響。見張蒼松，《百年足跡重現——林草與林寫真館素描》。

55 《臺灣商工名錄》，臺北：臺灣物產協會，1927，頁 842-843，國圖索書號 07901-24b；《臺北市商工人名錄》，頁 223–225。

56 《臺北市商工人名錄》，頁 217。

57 皇民化運動達到高峰時期，人口審查的情況如何不得而知，或許有些臺灣寫真師已經改用日本姓名。

58 《臺灣人士鑑》，臺北：臺灣新民報，1934，頁 11-12，國圖索書號 RT 733.7 4307/1934。

59 《臺灣人士鑑》，頁 85。

60 《臺灣人士鑑》，頁 127、139。

61 Bhabha, "Of Mimicry and Man," p. 86.

□□□□□□□□□□□

《臺灣和澎湖群島的回憶》

小川一真出版，《臺灣和澎湖群島的回憶》，1896，珂羅版印刷，38.4 x 26.9 cm，國家攝影文化中心典藏

小川一真出版，《臺灣和澎湖群島的回憶》，1896，珂羅版印刷，38.4 x 26.9 cm，國家攝影文化中心典藏

《臺灣和澎湖群島的回憶》（*Souvenirs de Formose et des îles Pescadores*, 1896）是日本風景寫真先驅小川一真 1896 年出版的寫真帖，內頁作品攝影者不詳，但拍攝時間標註為同年 10 至 11 月。小川一真曾赴美學習攝影，1890 年代初期便開始發行具有美術風格的寫真出版品。其出版品多以西方讀者為受眾，因而特別以西方語言加註圖說文字；此本寫真帖便是以法語市場作為主要銷售標的。在《臺灣和澎湖群島的回憶》出版前一年，日本的現代化軍隊趁著甲午戰爭入侵臺灣，日後更逐步將臺灣納入其現代化國家的治理版圖。這導致寫真帖開頭處編排幾幀戰功卓越的軍事將領肖像，內頁也不時出現軍人身影，例如穿著整齊制服的軍人正在視察輕便軌道的影像。然而由於日本政府在彼時並未全面統治臺灣，使得這本寫真帖絕大部分內容仍呈現清領時期的風土民情，比方：以側拍角度捕捉漢人農夫透過黃牛拉耙的景象，及呈現當時淡水渡口和街道面貌的數幀相片。如此看來，《臺灣和澎湖群島的回憶》的無名攝影師並非以軍隊、戰事為拍攝主軸的隨軍記者，更不是記錄日本殖民建設的歌頌者，反而如同一名旁觀者，以純粹視角如實呈現漢人世界的傳統生活與社會樣貌。此一視角同時形塑出這本寫真帖的特色。

The Keelung Station. 　　　　（基隆要塞司令部御許可）　基　隆　停　車　場

基隆戶波煉瓦石造の二階建にてにり北臺停車場と大小同異なり塞�||偃禮貫鐵道の起點にしてと内地と最近の行程を有せるせ地打術終點まで二百四十八哩あり

The Official Residence of the Governor-General of Formosa.　　　臺灣總督府官邸

元正大る去りな物築建の式スンサーネル階二の用混材石瓦煉は造構てしに圓百三千七萬一十二費工綾年四十三し丁起年二十三法明り在に傍の門東城内城北臺

。りあ詩將軍玉兒め富に遲雅の泉林る設け類な水山の式地内邁廣赤内構てしに佳る頼望晚の上園りため改な舊に大し縱な耕修大り港大に年二りよ年

仁露雨皇天拜遙　　　舊依開菊野梅圖　　　春平太値轉砲戰　　　新可又雲風北朔

臺灣寫真會，《臺灣寫真帖第三冊》，1914-1915，紙質，22 x 30 cm，國家攝影文化中心典藏

（第二中隊）地陣砲臼及び砲山の中撃射護援進前兵步面方山コマナ社イシワラキムり&山頭幾

炎煙天に漲るトボコ社
The Toboko Village on Fire.

（海拔三千尺）り在に處の外圖方左つて向は所在駐官務吏蕃るたけ受な襲撃りせ歸に烏有てし燒全や今はき如の社本

Ready for the Tront. 搖動の族ンワイパ（五）

（蕃上春恆）裝の陣出に等草出び及鬪戰てみ組な隊が等彼

The Police Climbing the Precipices. 搖動の族ンワイパ（四）

す進前てぢ攀な崖嶮隊索搜

《臺灣寫真帖》是日治時代臺灣寫真會所出版的期刊。臺灣寫真會成立目的在於以鏡頭記錄當時臺灣各地風土民俗，從大正三年（1914）11月起，每月發行一冊，內容以照片為主，文字為輔，介紹全臺景點。第一期《臺灣寫真帖》的序言中，開宗明義地表明該期刊的出版旨在推廣觀光、力促國民教育。序言裡認為臺灣的奇山異水可與瑞士比擬，即便「受到西方人所注目的理蕃政策困難重重，但今年太魯閣討伐得有始有終，是值得被讚賞的……這個時期，盡可能地完善設備，就能夠做到發揚天賜之美、完善與他國的外交了。」由於《臺灣寫真帖》在大正三年太魯閣戰爭發生之後出版，除了宣揚理蕃功績外，亦拍攝臺灣各地山水與現代性建設，如《臺灣寫真帖》第一卷第一期的首張照片「吳鳳元輝廟之匾額」。臺灣總督佐久間左馬太親自主祭重修吳鳳廟時，特地頒發了「殺身成仁」匾額。這張照片的刊出便回應當時為了宣傳總督府推動的理蕃政策，進而在臺大力推崇吳鳳事跡。此寫真帖亦收錄彰化八卦山、臺中公園、赤崁樓等名勝古蹟之照片，作為推廣觀光之用。

攝影者不詳，《大正三年討伐紀念寫真帖》，1914，明膠銀鹽，紙質，13 x 18.7 cm，國家攝影文化中心典藏

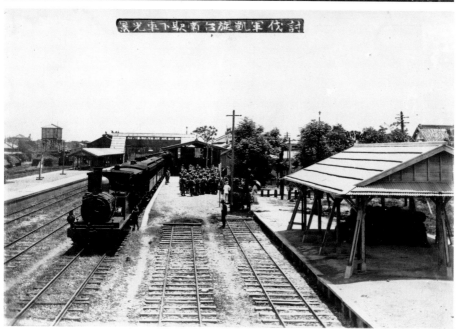

攝影者不詳，《大正三年討伐紀念寫真帖》，1914，明膠銀鹽，紙質，13 x 18.7 cm，國家攝影文化中心典藏

本件收錄之主要內容為軍事討伐相關影像，包含軍隊參拜神社、討伐軍凱旋光景、臺南陸軍練兵場等，為一軍事類寫真帖。從標註的年代，推論此為太魯閣戰爭相關圖像紀錄。太魯閣戰爭乃大正三年（1914）5月至8月，發生於太魯閣地區的戰役，臺灣總督府發動大軍征服太魯閣族，並進一步拓展對臺灣東部掌控。大正三年發生的太魯閣戰爭，是日本帝國為了能夠徹底掌控原住民居住區域，建立統治威信，並獲得山林樟腦、林木、礦產等自然資源，而主動展開討伐之有計畫的軍事行動，也是太魯閣族與日軍長期衝突的最後結局。其可上溯到明治29年（1896）12月，花蓮港守備隊新城分隊日軍侵犯太魯閣女子後，遭太魯閣族人殺死的「新城事件」；明治39年（1906）因採樟警備津貼發放糾紛，使日方與太魯閣族關係陷入緊張，後更爆發花蓮港支廳大山十郎等官民罹難的「威里事件」；明治42年（1909），原協助日軍「以蕃制蕃」鎮壓太魯閣族的南勢阿美族七腳川社遭受強力鎮壓的「七腳川事件」。太魯閣戰爭是日治時期最大規模的山地軍事鎮壓，戰爭前的準備期長達二年，歷經多次的探勘、觀測、描繪地圖，動用最多的軍、警、人伕，耗費最多的軍需，最長的運送補給線，作戰時間長達三個月之久。戰事的最後，日軍以優勢的武力迫使太魯閣族繳械歸順。戰事結束後，日本政府在花蓮港廳下設置新城支廳、內太魯閣支廳，並於海鼠山屯駐一步兵中隊，進一步拓展對東臺灣的統治。僅存之太魯閣族人被集體移住平地，然後打散分居到各處，另有部份族人被遷居至漢人居住區域，藉此來破壞太魯閣族部落的社會結構及傳統文化，並在各駐在所設立蕃童教育所，進行日本化教育。同時鼓勵發展定耕農業，設置蠶業講習所、苧麻講習所、農業講習所等，翻轉太魯閣族傳統經濟生活。

參考資料：
1 林進發，《臺灣發達史》，臺北市：民眾公論社，1936，頁178-215。
2 潘繼道，〈太魯閣事件〉，《臺灣學通訊》72期，2012年10月，頁14-15。
3 戴寶村，〈太魯閣戰爭百年回顧〉，《臺灣學通訊》82期，2014年7月，頁9-11。

詮釋資料參考自曾令毅－國家攝影文化中心109年度典藏品詮釋資料撰研工作計畫，臺中：國立臺灣美術館，2020。

臺南驛御着御泊所へ御進行

四月二十日〇二十三時五分

《皇太子臺南行啓紀念寫真帖》

攝影者不詳，《皇太子臺南行啟紀念寫真帖》，1914-1915，明膠銀鹽、紙質，22 x 30 cm，國家攝影文化中心典藏

攝影者不詳，《皇太子臺南行啟紀念寫真帖》，1914-1915，明膠銀鹽、紙質，22 x 30 cm，國家攝影文化中心典藏

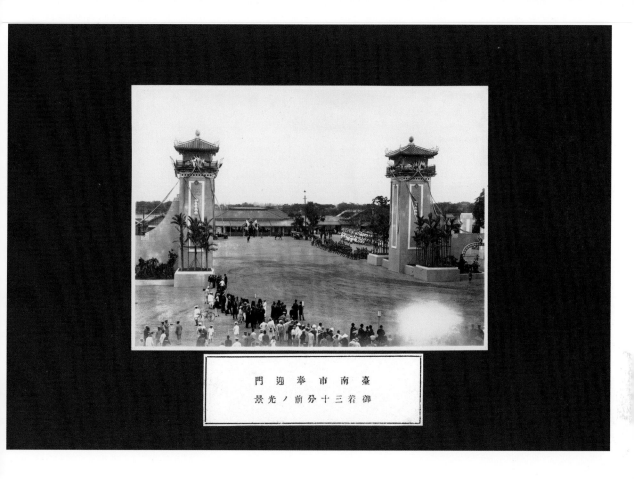

臺南市奉迎門
御着三十分前ノ光景

大正 12 年（1923）4 月 16 日搭乘御用艦「金剛號」的日本裕仁太子，抵達臺灣
進行 12 天的「東宮行啟」之旅，此行目的在於彰顯日本在臺治理績效，並希望
以日本為對象有效地進行招商投資與宣傳。對臺灣的本島人而言，自 1895 年日
本殖民以來，雖有多次皇族因不同目的造訪臺灣，但攝政皇太子的參訪是第一
次，除了透過高度儀式化的參訪隊伍建立帝國皇室的形象，對圍觀的觀禮者亦有
再度確認統治階級關係的作用，而這對臺灣總督府而言，也是空前絕後的盛會。
此次拜訪的行程停留幾個主要都市：從基隆登岸後，率續抵達臺北、新竹、臺中、
臺南、高雄、屏東、澎湖等地，參訪各州廳、學校軍事機關，以及殖產局或製糖、
製鹽的株式會社等，共計 62 處，各地舉辦的慶賀儀式也不勝枚舉。《行啟紀念
寫真帖》由臺北市役所出版，詳細記錄了裕仁皇太子巡查訪問期間的活動照片，
除了拍攝為了此行建構壯闊輝煌的建築體，如各驛站前的「奉迎門」，亦拍攝
皇太子受人民禮敬與夾道歡迎的畫面，如 4 月 18 日下午 4 時 50 分在總督官邸
前舉辦的 500 名臺灣各族原住民男女謁見，在「警務局理蕃課」宇野英種課長
帶領下，各部族代表齊向皇太子致敬的畫面。不論是儀式或列隊的視覺語言，
皆呈現帝國皇室的威儀，以及子民對帝國的崇敬與認同感。而此次展出的《皇
太子臺南行啟寫真帖》只收錄臺南部分行程，除了參訪臺南州廳，亦巡視位於
南門町的「北白川宮御遺跡所」、「總督府殖產局附屬鹹水養殖試驗場」、「臺
灣第二守備隊司令部」等地。

詮釋資料參考自郭雙富、王佐榮，《東宮行啟：1923 年裕仁皇太子訪臺紀念寫真帖》，臺北：蒼璧出版有限公司，
2019。

槍砲、頭顱與骸骨

梁廷毓

藝術研究｜單頻道錄像，23 分鐘｜ 2021 年

日本殖民初期，儘管獵首在各族原住民的文化和宇宙觀當中，自有一套生命禮俗及生態觀，但拍攝者透過事先安排與佈置，拍攝者對被攝者的動作姿態的編導，包含場景與人物動作，製造符合帝國所欲呈現的畫面。同時也會為了強化影像的視覺張力，將構圖與人物、物件、頭顱刻意的擺置，以「擺拍」形塑其野蠻的形象。因此，本次計畫以影像〈槍砲、頭顱與骸骨〉與書寫〈凝視的深淵－日治時期的原住民「頭骨架」、「頭顱」與「獵首」攝影〉切入主題，著重於殖民影像的再觀看、再反思，試圖逃脫殖民者給出的視覺形式與文字描述，回到一個生命形式、情感本體的影像閱讀。從日本人類學者森丑之助與鳥居龍藏在部落偷取頭骨的軼事談起，將頭骨作為標本的收集慾望，以及在拍攝原住民的獵首習俗時，野蠻化的影像再現與操作，連結上帝國理蕃征戰下的原住民頭顱特寫。將山地戰爭期間殺取的頭顱、奪得的頭骨，轉送體質、顱骨測量、檔案化、標本收存的研究供應鍊，反思帝國軍警治理與人類學知識之間的聯繫。

一方面，這些被去除身體的死者——原住民頭顱的攝影，開啟了臉龐與頭顱之間的辨認。死者的目光形成一種空的迴視，無分男女老少，每張臉龐的雙眼無神、眼皮明顯被擺弄，彷彿在看卻又不在「看」。而頸部的斷裂與異常的傷痕，逼顯著頭顱在視覺上的量感，讓人們對其生前遭遇湧現無盡的想像與深淵，甚至溢出以往對於殖民人類學攝影的批判論述。另一方面，當時的檔案亦記載數位被割去頭顱而死的日本軍警，或是受到槍傷的討伐隊員。然而，有趣的是，至今並未留下拍攝日本軍警傷亡者的相片，反而大量拍攝帝國征戰下的原住民陣亡者。為何不去拍攝被原住民殺害的日本軍警？拍攝被原住民獵首的日本軍警屍體，或是日本軍警的屍首分離，究竟意味著什麼？透過這個藝術計畫，我的研究也從此展開。這批原住民頭顱的攝影，是否藉由顱骨的病理學研究、頭顱影像與顱骨標本的對位，讓人的生前遭遇可以重新被想像？屍首分離的日本軍警，以往被視為帝國的屈辱、犧牲的忠烈之人，是否能在影像中重新打開更為複雜而膠著的歷史觀？這些都是本次計畫所關注的問題。

梁廷毓，〈槍砲、頭顱與骸骨〉，2021，單頻道錄像，23 分，藝術家提供

1

梁廷毓，〈槍砲、頭顱與骸骨〉，2021，單頻道錄像，23 分，藝術家提供

梁廷毓，國立臺北藝術大學藝術跨領域研究所碩士。創作主要結合地方調查與研究，以計畫性的藝術行動及複合媒體，關注鬼魂的概念如何涉及地理、歷史、記憶與族群關係等議題，並以動態影像集、死亡考察、鬼魂接觸、製圖、書寫的方式，進行現階段的藝術計畫。創作研究則以研討會、工作坊、文論的形式發表於文化研究、歷史學、人類學等相關領域之學刊與討論場合。

喜多舞台與日本能樂在臺灣

陳飛豪
藝術研究｜單頻道錄像、文件檔案｜2021 年

在臺北市西門町商圈的漢口街附近，有一間沿用日治時期房舍且被稱為大村武的居酒屋，店名取自這棟古宅日治時期主人的名字，是一位屬於日本喜多流派的能劇工作者，他當初也在此處建立了臺灣當時少見的能劇稽古舞台，[1] 時人稱為喜多舞台。

能樂在日治時期事實上是一個十分微妙的存在，作為日本重要的傳統表演藝術，能樂表演與欣賞自然是當時在臺日人常見的藝文活動。雖說能樂具有一定的美學高度，也與日本傳統政治具有一定連結，但相對於臺灣本土已具發展規模且大眾化的漢人傳統戲曲與現代化的新劇，在一定的門檻下，能樂大多限於當時的在臺日人族群，也因此喜多舞台的發現仍是一個尚待定義的存在：我們如何看待這段幾乎已塵封在臺灣歷史角落的日本傳統藝術脈絡？我們要如何重新探索這門古老表演藝術與臺灣過去帝國殖民史的關係？這是本計畫試著以喜多舞台為中心所開啟的提問與對話。

首先，本計畫的討論焦點是，根據作家西川滿的大河歷史小說《臺灣縱貫鐵道》中的書寫，曾經以能畫[2] 入選第一屆臺展的能畫家武部竹令（書中稱為武部竹次郎），其實也是一名喜多流的能劇表演者，他曾在 1895 年乙未戰爭從軍時期的臺北始政式中，擔任餘興節目能劇（仕舞）《八島》的表演工作。而這明顯看出能劇在日本古代與武士階層間的密切關係也延續到了明治時期帝國建立後的現代化軍隊。即使能劇用以教化臺灣人民的能力有限，它仍在各種國家慶典，如神社祭典與國際博覽會中出現，成了當時政權的文化符號之一。

另一焦點則是，殖民地臺灣因距離日本以男性為主的宗家中心較遠，因此由於性別限制，常被視為「業餘」的女性表演者，反而獲得了較多的表演機會。以喜多流來說，其設有喜多婦人會的組織，該流派的年輕女性能樂表演者三宅康子，便在當時臺灣重要宗教設施的建功神社的 1929 年大祭中，表演奉納能樂《月宮殿》。有趣的是，二戰日本戰敗後，全數在臺日人都被遣返，喜多稽古舞台也輾轉成為現今的大村武居酒屋。2020 年，身為灣生後代的能劇工作者岡部千枝女士組織新的臺灣喜多會，該會成員也幾乎以女性為主，並於 2020 年 2 月 9 日於大村武居酒屋舉行稽古表演會，應是此地 1945 年戰後睽違七十多年的能劇表演。

因此，這項創作計畫不僅邀請新臺灣喜多會於臺北始政式的地點臺北植物園內的欽差行臺重演《八島》，也於建功神社遺址所在的國立臺灣教育會館重演《月宮殿》，以性別置換與女流能樂回應強調男性傳承的能樂藝術與陽性帝國敘事，這類橫跨殖民歷史、地方記憶與性別意識的嶄新想像將如何成形，是本計畫試圖梳理與思考的重點。

1 具有基本能劇舞台功能，主要用於排練，但有時也做小型表演的設施。
2 日本畫中專門以能劇為繪畫主題的創作形式。

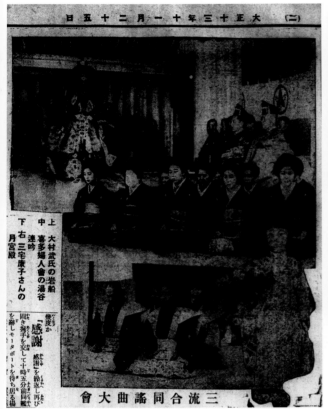

「武部竹令能畫作品：＜道成寺＞」，歷史檔案與輸出，30 x 30 cm（含框），
藝術家提供｜「喜多流稽古舞台落成慶祝謠曲會」，歷史檔案與輸出，30
x 30 cm（含框），藝術家提供｜「能畫家與能樂表演者雙重身分的武部竹
令（たけべ ちくれい）」，歷史檔案與輸出，30 x 30 cm（含框），藝術
家提供（左到右）

陳飛豪，〈2020 台灣喜多會大村武居酒屋稽古會：羽衣〉，2020，單頻道錄像，8 分 11 秒，藝術家提供｜陳飛豪，〈2020 台灣喜多會大村武居酒屋稽古會：櫻川〉，2020，單頻道錄像，3 分 45 秒，藝術家提供｜「喜多舞台現址的大村武居酒屋」，數位輸出，藝術家提供｜「喜多流稽古舞台現況」，歷史檔案與輸出，30 x 30 cm，藝術家提供（上至下左到右）

陳飛豪，畢業於國立臺北藝術大學藝術跨域研究所，現工作生活於臺灣臺北。擅長文字寫作，並運用觀念式的攝影與動態影像詮釋歷史文化與社會變遷所衍生出的各種議題，也將影像與各種媒介如裝置、錄像與文學作品等結合，探討不同媒介間交匯結合後所產生的可能性。曾參與 2016 年臺北雙年展、2017 年臺北國際藝術村「鑠條通」街區藝術祭，以及臺北當代藝術館與空總創新基地之「破碎的神聖」、2018 年關渡雙年展、2019 年臺灣當代文化實驗場之「妖氣都市：鬼怪文學與當代藝術特展」、2019 年首爾 loop alt. space「我們必然相遇」聯展。另於 2017 年於朝代畫廊舉辦個展「失效的神話」。

日治時期，由於複製技術是控管部署的治理對象及工具，攝影機具、儀器、底片及相紙等材料皆由殖民政府列管，臺人須排除萬難才得以設立自己的照相館。而二戰期間由情報科舉辦的寫真家登錄，讓日常生活的攝影實踐受到更嚴謹的管轄。透過日治時期的稅收資料，可以知道當時寫真館的營業仍以日籍人士（內地人）開設者為大宗，臺灣人開設的寫真館營業額不到日人十分之一。實際上，在日本政府鼓勵移民的政策下，日人除了在日本開設強調技職學能的寫真學校，也大量移民至東南亞各地開設照相館。

即便日人的殖民策略極為注重影音複製技術的運用及控制，卻無法阻擋複製技術中潛在的民主性，以及與時俱進的現代化腳步。布赫迪厄（Pierre Bourdieu）以「中藝術」（middle-brow art）的概念詮釋攝影作為文化中重要的一環，不僅僅是照相器材的選擇，同時也是因為攝影行為形成新的社會關係，成為觀察日常生活的文化指標。在日本時代，許多臺人寫真館的業者都是從日人寫真館學徒出身，或赴日參與寫真學校，如二我寫真館、林寫真館、張寫真館、金淼寫真館、明良照相館等。他們不光記錄臺灣現代化進程的容顏，也反映出日常生活的種種面貌，更促成以「中藝術」作為觸媒的社會關係，形成攝影的公領域，如攝影沙龍及攝影團體的組織。「寫真」在日文中同時是「肖像」的意思，是從「光的書寫」（photography）的語言轉譯，這說明了攝影與肖像在日本文化中的緊密關係，因此寫真學校大部分課程為肖像拍攝與棚內燈光運用。而在臺灣話中，「翕像」所代表的是相機吸（翕）入的影像。在臺籍人士所開設的寫真館中，肖像、結婚照、外拍、團體照成為標準的營業項目。於是，從拍攝題材的方式、擺拍與變裝的創意，以及強調從業人員在攝影、暗房與處理燈光的技巧，見證臺灣視覺文化的重要一環。戰後，隨著國民政府來臺出現的身分證照片需求，也產生了五、六個人一起拍攝「大頭照」的奇景。

在殖民影像「雙重同化」（double simulation）更加白熱化的同一時期，由於攝影設備相對普及，也開始有業餘的攝影人士進入影像生產的行列。這些影像在殖民者凝視的折射下，形成了臺灣進入現代化的視覺文化文件，也呈現了自我意識及朝向現代性的解放路徑。

像裡相外：臺灣早期「肖像相館」與地方社會的視覺文化

馬國安
譯者：李佳純

秋海下筆為余畫肖像，他之畫法與春源不同，春源是用四角格子安在寫真之上，漸次放大，故培火嫌其為非美術的也。秋海則不然，看人而畫，所畫比春源較像也。

—— 林獻堂，1931 年[3]

1931 年，林獻堂（1881-1956）51 歲大壽在即，曾於東京美術學校修業的張秋海（1898-1988）受委託為這位霧峰林家大家長製作肖像畫。霧峰位於臺灣中部，自晚清就是漢人居住地。能夠委託一位畫師作畫已是奢侈之事，林獻堂一次就請了兩位。這個主意來自他的友人蔡培火（1889-1983）及楊肇嘉（1892-1976）。[4] 他在日記裡提到，請第二位畫師張秋海，主要是因為朋友不滿意第一位畫師潘春源（1891-1972）臨摹照片的畫法，嫌其「非美術」。肖像畫師根據照片來作畫是當時常見的做法，雖然林獻堂還沒看到最後成品，還是認為「看人而畫」才可靠。對林獻堂和他的友人而言，這種肖像畫的風格，是肖像寫真「非美術」的影像所遠遠比不上的。他們心中對於肖像照和理想的肖像畫自有評斷標準，因此排除了肖像照，至少在林獻堂的眼中，從照片臨摹的畫像既不是美術，相似度亦非最高。

林獻堂和他的友人對肖像畫與肖像寫真「相似度」與「美術價值」的討論，是基於 1930 年代早期獨特的視覺文化脈絡。相館逐漸成為在全球崛起的中產階級最主要的圖像化方式，贊助人或顧客與相師的關係也愈趨成為所有人的共同體驗。近十年來，以肖像畫和肖像照為中心的圖像文化與圖像史研究終於開始受到東亞學界重視。在跨領域研究的視野下，「肖像照」以「肖像」作為其藝術類別，並以「攝影」作為其視覺媒介，開啟了學者對於視覺性與身分認同之錯綜關係的探查，也為當代東亞文化史帶來全新研究課題。[5] 首先，「肖像照」體現了攝影術與傳統肖像畫兩種視覺認知系統的交織碰撞，也因此模糊了「傳統」與「現代」的界限。我將以本文開頭的例子詳細說明在追尋圖像「真實性」的過程中，「傳統」與「現代」的概念是如何出現。

在十九世紀末、二十世紀初的臺灣，最早的畫／相館與早期中國的相館，有著十分密切的交流與傳承性關係。來自中國東南沿海城市一帶的肖像畫師／照相師，理所當然地成為以東南沿海移民為住民主體的臺灣第一代畫相館師承來源，前文所引林獻堂在日記中提到的潘春源，其師承雖不明確，但他曾在對岸美術學校學習人物肖像，也極可能曾以《芥子園畫譜》等晚清以來畫師習用的圖帖來自學肖像。[6] 潘春源除了自學也與中國的師傅偶有交流，是該地相當受敬重的廟宇彩繪師，但並非以肖像畫著稱。他與其他職業肖像畫師都必須在新時代的挑戰下努力生存。殖民統治下，他們一方面必須在宰制大眾傳播媒介的日本「寫真技術」以及美學概念中尋找自己的生存之道，二方面還得面對如林獻堂等顧客的質疑，這些顧客也同時在轉變中的地方社會尋找更新、更適合代表自己的影像。

最早由臺灣人設立的肖像相館在 1901 年開張，服務

項目已包括製作肖像照或炭精畫像。攝影師林草主持的「林寫真館」在該年設立，施強主持的「二我寫真館」則約於1920年代成立，兩間的製作技術及風格分別為日本及中國兩地肖像事業的延伸。師出日本人的林草（1881-1953）在臺中設立林寫真館；在香港習得攝影技術的施強（1876-1943）則在鹿港彰化開設了二我寫真館。[7] 臺中州是中部最有權勢的林氏宗族居住地；小鎮鹿港則曾經是重要口岸，十九世紀以來幾個最成功的紳商家族亦定居於此。臺灣文人及保正張麗俊（字升三，1868-1941）在日記裡稱讚施強為另一位文友製作的壽像：「其精神酷肖，畫法絕妙，比諸上杭畫師筆法，真不肯多讓云云。」[8] 他以上杭畫師作為理想的肖像畫師標準，意味著他熟知中國東南城市時興的肖像畫風，[9] 而且他並未把施強的畫作視為獨立的藝術品，而是對於中國視覺經驗文化場域中相館實踐的在地性模擬。另一方面，張麗俊同時也是林寫真館的顧客，但對「林寫真館」的攝影作品而言，這些視覺評論的語彙應已無法適用，因「林寫真館」專門提供攝影（寫真）肖像，是一「以光為筆」，提供「現代」視覺體驗的地方據點。於此，兩間寫真館體現了不同概念的圖像化及價值體系，並在此過程中形塑了在地觀點及視覺再現形式之間的複雜關係。

換言之，中國肖像傳統在被臺灣移民社會從業者承繼的同時，也面臨了日本殖民統治下另一種對「現代」圖像文化的想像，而所謂近代中國社會肖像傳統，一樣也是在以攝影術為代表的「現代」圖像文化的挑戰中面臨變革與轉化，值得一提的是相同的過程在兩岸都可見。近期關於現代中國視覺文化的學術研究指出，形塑現代中國「圖像現代性」的驅力必須從中國肖像文化開始分析。文學史研究者吳盛青從「自題小照」深入探討的研究指出，近代中國知識分子的圖像化自我不只是與「他者」或西方現代性的碰撞，更是中國文學傳統的重申，[10] 現代中國攝影的圖像性，特別是從肖像照的角度來看，必須與隨附的文字以及文化社經環境之文字／影像二元性一齊討論。隨著研究者開始了解肖像照在圖像文化研究的重要性，有關肖像照之製作、傳播及接納度的經濟社會關係，也逐漸進入學界的研究視野來探討其不同的中介性質。[11]

圖像與文化史學者重探肖像照作為中介文字與影像媒介的過程中，不但揭示了所謂「傳統／現代」或「西方／東方」二元對立式理解圖像傳統的問題性，同時體認圖像製作的跨國面向。因為作為圖像媒介的肖像照，其生產過程就是人們透過畫相館的平臺，扮演不同角色（或建構多重主體性）。本文分析的相館通常被賦予某種「地方」特色及文化功能，但它們在形塑圖像媒介的過程中所扮演的決定性角色往往被忽略。本文將說明，在地方文化傳統的轉變中，新的肖像相館產業也誕生於一個以二十世紀初臺灣地方社會為中心的視覺文化網絡中。然而肖像相館以「地域」和「傳統」納入地方敘述的同時，是如何與普及的圖像媒介同時發展成產業？還有，在中國與日本影響之下，臺灣相館如何生存，並且在面對殖民統治之時，成為地方仕紳及知識分子建構「能動性」（agency）的日常基地？所謂「能動性」，我指的不只是在全球化的印刷文化影響之下攝影媒介扮演的多樣化角色，也包括商業相館的顧客如何在全球化的地域空間裡，與相師互動而創造自我形象。相師與顧客探索攝影術如何重新框出圖像身分認同，以個人化的私人影像再現「真實」，也形塑了彼此的圖像意識。

本文從1930年代臺灣地方文人及相館網路，透過著名相師和顧客的軼事，來探討自我身分認同的形成及肖像照實踐之間的關係。除了概述中國的肖像歷史及其在二十世紀的演變，本文也會討論肖像相館與地方社會相互形塑的權力關係。既然肖像照所挑戰的是「傳統」與「現代」的界限，它與傳統肖像同質或異質的理由各是什麼？如果作為圖像媒介，它所中介的又是什麼？當我們重新思考並將畫／相館回歸到其參與互動而築成的公共空間，會得到什麼樣的新觀點？最後，本文從跨國面向的新角度來檢視殖民統治下的文化交流，盼能為進一步的研究助一臂之力，以了解「身分認同」的形成與概念既是個人，也是一種社群行動。

本文分為三部分：第一部分是東亞肖像相館的近現代史鈎沉，簡述圖像生產的傳承與斷裂如何產生並繼續影響地方社會，第二部分主要分析二我寫真館與鹿港地方宗族社會的關聯和互動，第三部分是觀察林寫真館及其如何融入，同時重新定義地方社會

中的「現代化」論述。本文認為，肖像照可以是物件、記憶的載體、甚至個人主體性與自我探索的紀錄，而像／相館，則是匯聚了人、物與記憶的獨特空間；在像裡，是提供背景的視覺奇境，在相外，卻是真實存在的視覺經驗基地。

肖像相館在東亞

肖像畫傳統在中國，絕非只有單一面貌，而其在現代社會中「傳統化」的過程，大約可以從清代說起。到了晚清時期，肖像畫可說是各階層人民最普遍共享的圖像文化經驗，隨著商業畫師的專業化以及石版印刷術（lithography）的發展，肖像畫製作變得前所未有地普及，規格也逐漸標準化。只有文字的《寫真秘訣》原本只是肖像畫學徒之間流傳的小手冊，後收錄於《芥子園畫傳》第四集，於十九世紀初公開流通。 1897 年時這本手冊更配上不同畫冊的肖像草圖，以石版印刷術重印於的《芥子園畫傳》。[12] 客制化的壽像和祖先像依然是文化菁英和有錢人家才負擔得起的奢侈品，但《芥子園畫傳》的出版，顯示了肖像的圖像經濟並不是上層階級的專屬經驗，肖像畫的技巧也變得更平易近人。顧客若負擔不起客制化的全幅肖像，畫師也有較便宜的「樣板」供選擇（圖 1）。這些樣板大多只包含著全套服裝的身體以及背景，顧客根據社經地位及美術品味選擇樣板，再要求畫師填入畫裡空白的部分，也就是臉。有了《芥子園畫傳》的臉譜教學，完成一幅樣板畫的成本與訓練都能夠壓低，因為畫師得以自行學習而無需受限於學徒制度（圖 2）。另一方面，商業化肖像的技術層面也漸漸比得上菁英畫師製作的文人畫，肖像不只成為傳統社會結構與家庭關係之紀念象徵，也是能在公共場域複製的圖像產物，可以廣為散佈並與其他更「現代」或更「真實」的圖像產物做比較。[13]

換言之，中國社會的肖像畫傳統在近現代時期已逐漸出現商業化面向，這些帶有「現代化」特色的發展，除了需要印刷術的普及、繪畫技巧與工具的轉變，其實更是基於轉型中的地方社會，知識份子與仕紳網絡對自我形象在公眾領域的新認知。也就是說，攝影術在肖像製作時的應用，是地方社會中對個人圖像的真實性或傳神的追求（truthfulness and realness）。到了 1900 年代，中國的肖像照（特別在

如上海等發展中的城市）已成為多功能產品，可以在公共場域流傳，或作為私人收藏，這種新的圖像媒介的發展被視為中國「圖像現代性」的重要象徵，[14] 一般認為中國像／相館納入攝影術，是促成中國現代化之圖像文化轉變的重要原因，但這個過程或所謂「前現代化」的來龍去脈尚未得到仔細的分析。造成這個歷史斷裂的原因，可能是缺乏早期像／相館業者或相師的資料文獻之故。在中國，攝影作為圖像再現與再製的技術，最早可見於文人圈與滿清朝廷，但把攝影介紹給大眾的是商業化相館，特別是位於香港等通商口岸的相館。

二我寫真館與鹿港宗族的公領域傳承

肖像製作與普及所形成的圖像文化空間，一直到二十世紀才在臺灣出現。林草和施強正式成為肖像相師的那個年代，臺北市已有不少由日本相師設立的相館，但根據現有資料，本島尚無肖像畫室。施強的二我寫真館應是第一代由臺人畫像師提供畫像服務的「肖像相館」，而林草的「林寫真館」則是第一代由臺人攝影師營業，專門提供攝影服務的照相館。

二我寫真館的故事據說要從施強隨著友人兼贊助人、出身鹿港宗族的陳懷澄（1877-1940）共赴香港說起。施強的叔叔是肖像畫師，在二我寫真館成立之前，施強原本隨叔叔學畫肖像。據稱他在香港學習攝影之後，在 1916 年左右回臺開業擔任肖像畫師及攝影師。寫真館的名稱由陳懷澄取名為「二我」，但此命名並非其原創，因為中國已經有同名的相館。[15] 雖然不確定是否為陳懷澄取名時的意圖，但「二我寫真館」以中文或日文漢字書寫，可解釋為同時提供中國式肖像畫及肖像照的地方。「二我」可能出自中國肖像畫流派「二我圖」，也可能是出自利瑪竇而後來被訛傳為描述攝影的一句名言。[16] 二我寫真館的名稱有雙重意義，也具有雙重功能。施強為肖像畫顧客提供「媲美上杭畫師」的成品，至於想拍照的人，他也有部分進口自中國的背景布和道具。綽號「強仙」的施強，很快就成為 1920 年代臺南－鹿港文化圈最受歡迎的肖像畫師／相師之一，當時剛興建完成的鐵路系統大大增加了流動性。施強以攝影專業技術成為早期臺灣重要的肖像畫師，但他的成功有一大部分歸因於他與中南部臺灣文人網絡

的連結，他本人也躋身文化菁英的圈子，受邀參加林獻堂舉辦的文化活動。當然，這一部分也要拜他的友人陳懷澄之賜，陳出身著名的南臺灣陳姓宗族，在鹿港經營著名的「慶昌行」商號。[17]

從二我寫真館在二十世紀初提供的雙重功能，不只能看出肖像畫與肖像照的微妙關係，也可見在地社會肖像文化傳統的轉變。施強的友人陳懷澄是地方仕紳領袖，因此他得以在當地文化社交中心的文武廟廂房開業，[18] 還有一個可能原因是施強的叔叔施屜為著名畫師，在施強開設寫真館前，他曾受文人之託製作廟宇彩繪，也製作壽像。臺灣進入日治時期之後，二我寫真館的功能也變得複雜。[19] 日治前十年裡，武廟的空間使用歷經窘迫的中繼狀態。武廟與文昌祠、文開書院三者形成連成一體的祠宇建築群，由當地文人資助營運，日治之後下令關閉，其原始社交功能也暫時停擺。由於殖民政府壓制漢文課程，文開書院的講課被迫暫停，而原本作為地方商界及宗教集會場所的武廟，在日人監督下遂成為非關宗教或文化的公共空間。施強和陳懷澄將廟外花園改成戶外工作室，廂房改為暗房，設立了寫真館，也讓這個地方暫時脫離殖民統治的監督。對於二我寫真館的顧客而言，武廟不但是理想的相館環境，更創造了有著縱使不夠「在地」，也富中國味的獨特造景。

究竟施強是出於商業壓力或個人興趣才開始提供攝影服務，這點我們無法判斷，因為這項圖像傳統的變革深植於鹿港變動的文化環境，同時形成二我寫真館與文武廟文化網絡千絲萬縷的聯繫。[20] 作為臺灣在地宗教及文化中心唯一的肖像相館，二我寫真館是轉型中的在地圖像文化之產物。它避開早期中國東南沿岸相館的商業模式，不以新奇的攝影或西方大師的技術來吸引顧客。比起施強當初學習攝影的香港相館，二我寫真館拍出來的相片也不是最「流行」的。同時期香港相館製作的肖像照以華麗的 3D 畫作為室內背景布，二我寫真館早期的肖像照則以書法題字來取而代之（圖 3、4）[21]，這種圖像風格也見於早期中國相館，不是只有二我寫真館才如此呈現，可見這很可能是早期鹿港仕紳偏好的個人風格。圖 3 及圖 4 皆以一對夫妻為拍攝對象，呈現風格較接近文人畫而非攝影影像。在陳藻雲的相片裡，後

方書法題字的詩句寫著：「志在琴棋詩酒間」，相片前方擺了一架古琴；其妻相片的詩句則寫著：「丫鬟侍側候添香」，她身邊的桌上果然放著香爐，未纏足打赤腳的年輕丫鬟則站在一側（傳統中國畫較常見的是母子）。這些影像呈現的可說是一種真實「紀錄」，但並非一位文人真實生活的體現，而是他理想生活方式或心態的投射。對陳藻雲而言，攝影媒介取代了肖像畫，把文人畫的圖像象徵系統轉入攝影而「傳達了精神」。

從精心佈置的道具都符合牆上詩裡描述的細節來看，相片背景可能是陳藻雲自己的安排。陳藻雲「詩意攝影」（poetry photography）的靈感可能來文人畫，但第一張以詩捲軸為背景的肖像照拍的是他父親鹿港商人陳祈（1842-1893），也就是陳懷澄同父異母的哥哥。陳藻雲出身慶昌行商號家族，他與父親都非科舉制度及第的文人，詩作也不多，僅見相片背景裡的兩首，然而父子兩人極為重視與文人雅士的交誼，更積極展現彼此的關係。唯一流傳下來、由後代所收藏的陳祈肖像照背景，就掛著福建進士黃貽楫（1850-1900）的書法帖。陳藻雲肖像照裡展現文學理想並自評的詩句，則是他請地方生員鄭鴻猷（1856-1920）所寫，鄭鴻猷是文開書院教師，同時也以賣字維生。

文人菁英請施強拍攝肖像照，不只是信任他在肖像畫方面的技術，也是因為他的社交及文化網絡吸引他們來到地方上的第一間肖像相館。施強的肖像事業雖然承自與文武廟素有淵源的叔叔，但他本人之後與文開書院教師蔡德宣結為親家，也和書院的贊助人交好。[22] 然而，施強和他的「顧客」是否把二我寫真館視為一門生意卻是存疑的。從施家收藏的施強作品來看，二我寫真館在 1920 年左右製作的影像大多受施強的親戚朋友所委託，1925 年之前，施強是鹿港唯一的相館業者，也是備受禮遇的肖像畫師傅（或臺語「sai-hū」），他對地方社會的重要性當不限於個人或家族肖像製作。文武廟一直是鹿港地區文人紳商集結交流之處，甚至在殖民時期的監視下依然是文人活動的重心。鹿港文人社群試著從日人手中取回文武廟的控制權時，施強的寫真館扮演了特別的角色。1914 年，在陳家及其他鹿港仕紳的請求下，日方長官同意讓祠宇建築群進行整修，文

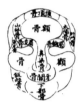

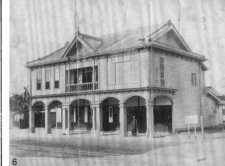

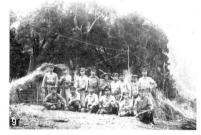

1. 樣板，圖片來源：廖瑾瑗，《背離的視線：臺灣美術史的展望》，雄獅圖書股份有限公司，2005，頁 69 ｜ 2. 臉譜，圖片來源：《芥子園畫傳：巢勳臨本》，頁 60 ｜ 3. 明治 37 年陳藻雲像，陳澤昭提供 ｜ 4. 陳藻雲妻楊氏妯像（左），陳澤昭提供 ｜ 5. 陳祈之肖像，李昭容，〈鹿港十宜樓及其後代考〉，《興大歷史學報》二十九期，2014 年 12 月，頁 36 ｜ 6. 臺中新富町林寫真館，林草拍攝，1918，林全秀提供 ｜ 7. 林草自拍照（雙重曝光），林全秀提供 ｜ 8. 林草與原住民沐浴合影，林全秀提供 ｜ 9. 日本官兵隊伍，林草拍攝，林全秀提供 ｜ 10. 山間遠征隊伍，林草拍攝，林全秀提供

開書院也重新開始招生。在 1920 年代中期走進文武廟，會看到鹿港學者鄭鴻猷在廟的一旁教授書法，施強則在另一廂房製作肖像影像。到了 1920 年，鄭鴻猷和施強都成為廂房的長期住客。[23] 文開書院唯一一張日治時期的相片也是施強拍攝的。在這個以保存傳統做法及知識傳播系統為目的的空間裡，施強的二我寫真館製作鹿港仕紳的肖像照，記錄並見證他們如何適應轉變的社會中，個人形象與圖像「再現」（representation）的關係。

陳氏夫婦把自己的影像與名家書法字並置在相片裡，創造了文人畫的效果；在陳藻雲的眼中，透過安排好的場景作為圖像產物，也為自己建構出中國／在地文人生活風格。先前提過，文人畫以畫中文字來描述畫中人的心境或自定的文化身分，從十七世紀以來的中國便自成一繪畫流派，並盛行於士大夫階層。陳藻雲的肖像照複製了這種畫風，同時調和了中式畫意象徵的主體性（亦即二十世紀鹿港的攝影寫實主義），以及「現代」圖像化定義之下公共空間中的個人。施強和他的顧客透過肖像照來探索自我陳述的方式，利用攝影來記錄被攝者的文化、社交及經濟地位，與之相對的是在全世界愈來愈常見的照片卡（carte de visite）。文人畫風格的肖像照成為二我寫真館的與在地文人的共同創作，顯示地方社會對於圖像再現的概念對於日治初期臺灣攝影圖像生產有著一定的貢獻。

林寫真館與作為現代化工具的肖像寫真

到了 1930 年代晚期，「二我風格」的畫／相館漸漸被時代潮流所淘汰，肖像照的價值或功能，如同之前所見相片裡懸掛的詩句，也重新被定義。林寫真館設立者林草與施強不同，他沒有傳統肖像畫的背景，但的確擁有林獻堂這位有錢的贊助人。林草從小被寄養在霧峰林家，他在 1901 年頂下日本師傅的相館開始自行經營，林獻堂及友人就是他最早的顧客。[24] 林寫真館經營的前十年裡，林草的身分比較類似林家的家庭相師，因為這時期留下的作品大多以林家成員及著名的「林家花園」為拍攝對象。1917 年他將相館遷移到日式風格的新房子之後，林寫真館開始吸引林家以外的顧客。這棟兩層樓的建築物有著西式門廊，屋頂採自然光，環境與二我寫真館非常不同（圖 6）。據林草之孫林全秀的記述，「林

寫真館」的主要創新特色，就是以現代攝影技術，「以光為筆」來創造全新的視覺體驗與作品。到了 1920 年代，林草成為成功的企業家，投資兼營新興事業如客車運務、製糖等，在南投一帶擁有超過 50 畝的甘蔗田。[25] 從各方面來看，相對於二我寫真館，林寫真館提供的服務堪比日人開設的寫真館。1921 年，櫟社（臺灣三大詩社之一）成員臺中文人張麗俊在日記裡寫道，詩社請他交名片式肖像作為出版詩集所用，他不得不跑一趟林寫真館。[26] 他還寫到另外一次為了特殊目的前往林寫真館，是為了中國大陸之旅而在 1911 年去拍了證件照。[27] 雖然沒有資料顯示日本人也光顧林草的相館，但合理假設他提供的服務與日本相師所提供的相去不遠。相對於施強的二我寫真館多是基於與顧客的人際網絡作為經營基礎，林寫真館則是透過提供「品質保證」能提供符合現代風格的影像來經營寫真館。「林草」這張著名的雙重曝光自拍照，就不只是林為招攬生意所拍（圖 7）。一方面，他向顧客展示相館能夠把傳統肖像轉變成現代風格的相片，另一方面，林草其實是透過這張新穎的作品，提供了一種思考自我肖像的新角度：透過攝影這項現代技藝，林草似乎是在邀請觀看者：如何透過圖像再現，展示自信的自我。

從林寫真館製作的早期影像來看，林草在 1910 年代地方社會扮演的角色可能不僅是成功的攝影師與企業家。林草的作品中有幾張日本士兵與原住民行經山區的相片，還有一張紀錄了太魯閣族人、林草本人和一名打赤腳的日本人一起在溪邊沐浴（圖 8）。根據林全秀先生提供資訊，林草曾參與殖民政府的山區遠征隊，他也曾在 1911 年到 1914 年之間受僱為隨軍寫真師。與日本宮內廳所藏、類似主題的遠征隊寫真帖比較後，可見林草的相片也是從類似的角度來拍攝（圖 9、10）。受僱為總督佐久間左馬太（1844-1915）的軍隊拍攝圖像紀錄，林草是當時極少數獲殖民政府委任類似任務的臺灣攝影師。[28] 這些相片以圖像證明了日軍討蕃事業的成功，這類官方隨軍寫真任務也是殖民論述裡關於攝影的「文明化」功能。攝影不但是一項工具，也見證了殖民統治的規訓權力。身為日本寫真師徒弟的林草顯然嫻熟作制式圖像紀錄的方式，才有機會受僱於政府，因此林草如何「受訓」以製作符合殖民標準的影像也是值得探討的議題。教導林草攝影技術的是 1895

年隨軍來臺的日本人森本，這可能是林草曾獲此項「訓練」的原因。[29] 在皇室收藏的寫真帖中，有關原住民影像、討蕃及景觀的寫真帖所採取的觀點大多出入不大，因每一本寫真帖都是日本政權成功理蕃的圖像「紀錄」。身為政府委任的相師以及商業相館的主人，林草成功建立了「現代化」相館，而在開設寫真館的臺灣人裡，林草是極少數被收錄在日治時期《臺灣企業家工商名錄》裡的一位。與施強相比，他是「台灣第一代的寫真家」，見證了「摩登」（或「毛斷」）與「現代性」成為地方文化圈口中關鍵詞的年代。也就是說，「林寫真館」的成功，反而正與「二我寫真館」成立的目的相反：因為「林寫真館」的經營宗旨，就是以異於中國圖像或視覺傳統要素的現代攝影技藝構築與過去肖像畫中，完全不同的嶄新個人—甚或是一自信的「自我」形象呈現方式。這種追求，或可說成是一種對「現代觀看方式」的探索。

「現代觀看方式」指的不只是殖民體制檔案影像資料對地方相師的影響，圖像真實度的現代知識也漸漸開始形塑地方相館的肖像製作方式。殖民體制收藏的原住民圖像紀錄可說是一種「技術」（technology），在林草等相師身上有某種規範功能，但這並不表示林草的相館使用的技術和殖民檔案相同。對於二十世紀初臺灣商業相館顧客而言，「技術」是影像風格轉變背後的重要驅力，但更重要的是一種新的敘事得以成立，並為新的圖像形式提供象徵性或祭儀性的面向。到了 1930 年代晚期，肖像畫快速退流行，絕大多數的畫／相館顧客轉而選擇到寫真館拍肖像照。

小結
殖民主義圖像文化是殖民圖像經濟的一部分，但在日治時期臺灣要退一步從傅柯（Michel Foucault）理論來解釋，才能解析殖民影像如何形成殖民體制的檔案資料，它不但是一門「技術」，也是從治理術得來的結果。[30] 根據本文分析，臺中林草的林寫真館與鹿港的二我畫／相館代表了日治臺灣攝影文化發展的兩個路線，但本文欲建立的不是「現代」與「傳統」之二元論點，而是「現代」觀看方式如何經過辯論、挪用、挑戰而成型，不只適用於視覺媒介，也適用在「技術」的論述。林寫真館及二我寫真館

的顧客多所重疊，但他們提供給顧客的不只是兩種照相形式選擇。兩個店家都有富有權勢的贊助人，也與地方社會來往密切，二我畫／相館被視為文武廟地區的祭儀式空間；林草的相館則提供了殖民統治之後才出現的現代寫真服務。施強師傅提供的肖像照服務所奠基的圖像標準，在過去被視為擁有最高的真實度，這類圖像象徵主義有部分面向保存在施強為顧客量身訂做的相片裡。另一方面，林草的相館依照西方（日本）圖像象徵主義來運作，從新興的圖像真實度來看，它以機器製作的真實應該比肖像畫的真實度更高。兩種不同圖像文化形式所體現的「社會價值觀」(social currency)，其價值來自於現代中國以及日治臺灣在二十世紀初期轉變中的知識論述。

1 本文所使用「肖像相館」一詞，專為指稱「提供肖像服務的像／相館」，是一功能性的描述法，現實中並無像／相館使用此稱呼。

2 本文原稿為英文，如中文翻譯之內容與英文有不同處，仍以英文為準。

3 林獻堂，〈灌園先生日記：1931 年 11 月 26 日〉，《中央研究院台灣史研究所台灣日記資料庫》。參考網址：http://taco.ith.sinica.edu.tw/tdk/ 灌園先生日記 /1931-11-26，2019 年 2 月 20 日瀏覽。

4 林獻堂，〈灌園先生日記：1931 年 11 月 26 日〉。

5 Luke Gartlan and Roberta Wue, eds., "Introductions," *Portraiture and Early Studio Photography in China and Japan*. London: Routledge, 2017, pp. 1–14.

6 謝世英，〈妥協的現代性：日治時期傳統廟宇彩繪師潘春源〉，《藝術學研究》三期，2008 年 5 月，頁 131–169。

7 「二我寫真館」其名「寫真館」看似是日語，但其實「寫真」一詞雖然在日語中專指攝影，卻並非全然的日語。自晚清以來，中文對攝影／照相並沒有統一的詞彙，小照、小影、小像、寫真、肖影等詞都曾用來指稱攝影，其中「寫真」此稱，其實亦是近代以前對肖像畫的指稱，在攝影術於十九世紀中葉傳入日本後被日人用以稱攝影，後又於二十世紀「回流」中國，因此近現代中文中的「寫真」一詞，與日語的「寫真」一樣，可說是一「跨文化」的詞彙。詳見 Yi Gu, "What's in a Name? Photography and the Reinvention of Visual Truth in China 1840-1911," *The Art Bulletin*, vol. 95, no.1, March, 2013, pp. 120–138。

8 張麗俊，〈水竹居主人日記：1908 年 1 月 23 日〉，《中央研究院臺灣史研究所臺灣日記資料庫》。參考網址：http://taco.ith.sinica.edu.tw/tdk/ 水竹居主人日記 /1908-01-23，2019 年 2 月 20 日瀏覽。

9 炭精肖像畫，又稱「擦筆畫」，為攝影傳入中國後，在民間興起的繪畫形式。二十世紀初，照相館於中國各城市設立；肖像照的出現，進一步刺激人們對紀念像的大量需求。由於早年攝影成本較高以及技術不便，模仿相片的炭精肖像畫應運而生，並逐漸普及。參考〈中國民間肖像畫〉，《漢聲雜誌》第 63、64 期，1994 年 3、4 月。

10 關於「自題小照」此題材跨越文字與圖像，含括攝影圖像與中國文學抒情傳統，以及圖像中隱含的中國文人建構自我現代性的相關討論，可見吳盛青，〈重層的自我影像：抒情傳統與現代媒介〉，《政大中文學報》26 期，2016 年 12 月，頁 31–74；亦可見氏著，〈相思之影：清末明初照相文化中的情感地圖〉，於同氏編，《旅行的圖像與文本：現代華語語境中的媒介互動》，上海：復旦大學出版社，2016，頁 127–158。

11 見 Gartlan and Wue, eds., *Portraiture and Early Studio Photography in China and Japan* 以及 Katherine R. Tsiang and Wu Hung, eds., *Body and Face in Chinese Visual Culture*. Cambridge: Harvard University Asia Center, 2005.

12 王概編，《芥子園畫傳：巢動臨本》，北京：人民美術出版社，1960。

13 嚴格來說，文人畫不算是一種肖像畫流派，其作畫主題可包括風景、花卉、人物。文人畫流派始於宋朝，參與的大多是士大夫畫家或藝術收藏家，理想的文人畫表現的是畫家或繪畫主題的內在境界及自身的清高文雅。元朝時開始出現獨立於文人畫與宮廷畫體系之外的職業肖像畫家，肖像畫漸漸地不再被認為是一種文人畫。見陳浩星，澳門藝術博物館等主編，《像應神全：明清人物肖像畫特輯》，澳門：澳門藝術博物館，2008。

14 中國「圖像現代性」一詞借自彭麗君的《哈哈鏡：中國視覺現代性》。藉由引用她的分析架構，我採納她所強調的影像實質化，以及觀者在觀察這些影像物件構成的實質世界時與物件之間的社交關係。「觀看的社交本質」則是彭麗君借自黛博拉．波爾（Deborah Poole）的概念，值得讚許的是彭麗君在分析不同圖像媒介對現代中國歷史文化的影響時特別注重脈絡。她提出現代中國印刷文化「追求真實」，是本文的理論基礎之一，但我感興趣的不是「傳統」與「現代」圖像文化的推論性界限，而是中國印刷文化帶來的影像物件實質化在 1930 年代臺灣具備的不同角色與功能。見 Deborah Poole, *Vision, Race, Modernity: A Visual Economy of the Andean Image World*, Princeton, N.J.: Princeton University Press, 1997.

15 最著名的是杭州「二我軒」，見 Claire Roberts, *Photography and China*. Hong Kong: Hong Kong University Press, c. 2013。

16 「二我圖」是一種畫中畫，文人肖像畫在宋代文人之間興起之後開始常見的類型。畫中人的肖像畫掛在屏風上，自己則在畫前休憩。最著名的包括劉貫道的〈消夏圖〉（藏於納爾遜－阿特金斯美術館〔Nelson-Atkins Museum of Art〕）。見李霖燦，〈是一是二圖和宋人著色人物〉，《中國名畫研究》上冊，臺北：藝文印書館，1973，頁 11–12。近期關於現代中國攝影的學術研究也注意到肖像攝影的「二我圖」，認為攝影雙重曝光的詭異效果對現代圖像文化有著一定的影響。見 H. Tiffany Lee, "One, and the Same: The Photographic Double in Republican China," *Portraiture and Early Studio Photography in China and Japan*, pp. 140–155. 有關利瑪竇被誤譯的文字，見方豪，《方豪六十自訂稿》二輯，臺北：臺灣學生書局，1969，頁 1270。（譯註：本頁內容提到，利瑪竇「交友論」稱朋友為「我之半，乃我第二我也。」乾隆時王應奎著《柳南隨筆》誤為利氏以「第二我」稱寫照。）

17 慶昌行及鹿港陳家之研究可參看李昭容，《鹿港意樓：鹿港慶昌家族史續探》，臺中：晨星出版，2011。

18 《寺廟臺帳·彰化郡》第五冊鹿港街一輯，約為 1910-1930，頁 538–539，中央研究院民族所圖書館典藏。

19 關於施強叔叔的簡介，見李昭容，《宜樓掬月意樓春：鹿港慶昌家族史續探》，頁 121–124。

20 根據林草之孫林全秀先生所提供資料，施強開始學習攝影或開設寫真館的原因，部分與當地鹿港士紳希望施強幫忙拍攝鹿港文化古蹟有關，因當時日殖政府的同化政策，使鹿港文人們開始擔心在地的文化傳統與史蹟將不保，認為留下圖像記錄有其必要。引用自林全秀，〈林寫真館與二我寫真館成立年代析疑〉（2019/11/6，未公開出刊資料）。

21 林煥盛，〈臺灣早期攝影發展過程中的鹿港「二我寫真館」〉，《臺灣攝影年鑑綜覽：臺灣百年攝影 1997》，臺北：原亦藝術空間有限公司，1997，頁 1-92-1-103。

22 林煥盛，〈臺灣早期攝影發展過程中的鹿港「二我寫真館」〉，頁 1-99-1-100。

23 《寺廟臺帳·彰化郡》第五冊鹿港區一輯，頁 538–539。

24 〈林草〉，《臺灣實業家名鑑》，臺北：臺灣日日新報，1912／13 年。

25 張蒼松，《百年足跡重現：林草與林寫真館素描》，臺中：臺中市文化局，2003。

26 張麗俊，《水竹居主人日記：1921 年 8 月 25 日》。

27 張麗俊，《水竹居主人日記：1911 年 4 月 5 日》。

28 1931 年《霧社事件討伐寫真帖》由另一間「ハセシ（林）寫真館」（林得富主持）拍攝和編輯。

29 〈林草〉於《臺灣實業家名鑑》。

30 傅柯關於科技、國家治理與自我及身體之理論散見其作品，在其演講記錄 "Technologies of the Self"（「建構」自我的技術）可見其一端。Michel Foucault, "Technologies of the Self." Lectures at University of Vermont Oct. 1982, *Technologies of the Self*, Univ. of Massachusetts Press, 1988, pp. 16-49.

□□□□□□□□□□□

施強

二我寫真館

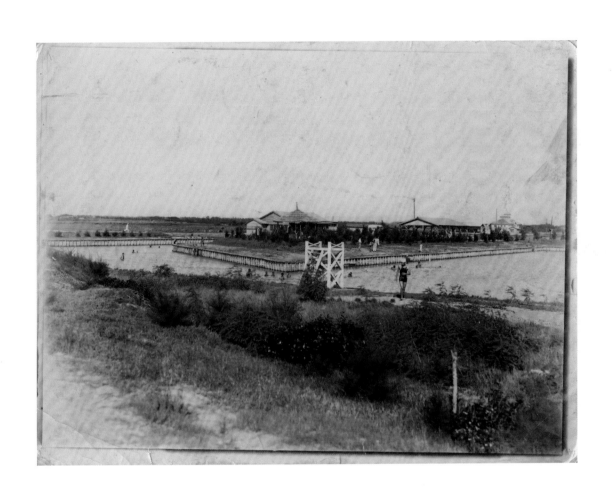

施能雨，蔡德宣公祭，鹿港，約 1944，明膠銀鹽、紙質，11.6 x 16 cm，國家攝影文化中心典藏 ｜施強、施吉祥、施能雨，鹿港海水浴場，鹿港，年代不詳，明膠銀鹽、紙質，12 x 16.5 cm，國家攝影文化中心典藏

施強（二我寫真館），男子合照，鹿港，年代不詳，明膠銀鹽、紙質，10 x 14.3 cm，國家攝影文化中心典藏 ｜ 施強（二我寫真館），鹿港辜家婦人坐像，鹿港，約 1935，明膠銀鹽、紙質，14 x 9.7 cm，國家攝影文化中心典藏（右頁）

施強（1876-1943）／二我寫真館，彰化鹿港。活躍於鹿港的攝影師施強乃日治時期首批開設寫真館的臺灣人之一。當地人稱「強仙」的施強早年以肖像畫師為目標，隨叔叔施厘習畫，後結識鹿港慶昌家族的陳懷澄，經其帶領於 1890 年左右赴港而初觸攝影術。在習得照相技術後，施強於鹿港文武廟（文開書院）廂房開設「二我寫真館」，將內部原作畫工作室改為寫場及暗房，戶外花園也轉為外拍場景。寫真館取名「二我」，意指現實世界的「我」，與透過鏡頭可見另一分身的「我」。憑藉早年肖像畫經驗，施強結合民間肖像傳統與商業攝影潮流，將被攝者全身置於傳統文人大宅的人工背景前，構圖講究，並營造書香氣息，吸引了許多仕紳家族、文人雅士上門，生意興旺。直到 1944 年，施強父子相繼逝世，二我寫真館方才歇業。當時的人們擔憂死於戰爭後終遭家人遺忘，或為留存生命的重要時刻，因此前往寫真館拍攝個人紀念照。此歷史脈絡下的二我寫真館，在二戰期間替當地居民留存大量影像紀錄。

□□□□□□□□□□
林草
林寫真館

林草（林寫真館），霧峰林家生活 - 日本軍警與林家合影，霧峰，1905-1910，愛普生藝術微噴／含銀相紙，林明弘提供

林草，霧峰林家生活 - 單車男子，霧峰，1905-1910，愛普生藝術微噴 / 含銀相紙，林明弘提供 ｜ 林草，霧峰林家生活 - 兒童肖像，霧峰，1905-1910，愛普生藝術微噴 / 含銀相紙，林明弘提供

林草（1881-1953）／林寫真館，臺中。林草是臺灣日治時期最早開設與經營寫真館的先驅之一。幼年時，父親將他寄養在臺中霧峰林家，日後結識森本寫真館店主荻野新町，習得攝影構圖、暗房沖洗、底片修整等技術，最終頂下師傅的寫真館，並於 1901 年改以「林寫真館」掛牌經營。除了攝影，林草亦兼營客車運輸、製糖等事業。林草拍攝時主要使用蛇腹型鏡頭的玻璃底片相機。他自 1905年起擔任霧峰林家非正式的家庭攝影師，記錄林獻堂等人長達四十年。1907 年，林寫真館另建新館，內部不單設有採集自然外光的活動式「採光罩」，還推出雙重曝光等技術招攬客人。種種創新之舉，使其成為當時最華麗的大型寫真館，也是所有臺營寫真館中生意最好、繳稅金額最高的。日治時期初期，只有日本官員和臺灣仕紳會請託寫真館攝影工作。林草另一個身分即是中部州廳首位委外臺灣籍攝影官，為官方文宣、政府活動、民俗慶典等進行例行記錄與隨行拍攝，甚至曾拍下總督身影，其底片留有各式各樣題材的影像內容。

◻◻◻◻◻◻◻◻◻◻

張朝目

張寫真館

張朝目（張寫真館），新錦雲戲劇劇照，約 1932，愛普生藝術微噴／含銀相紙，16.5 x 11.9 cm，國家攝影文化中心典藏

張朝目（張寫真館），張朝目四子攝於張寫真館，1934，愛普生藝術微噴／含銀相紙，16.5 x 11.9 cm，張文魁捐贈，
國家攝影文化中心典藏 ｜ 張朝目（張寫真館），張朝目重複曝光肖像照，1925-1940，愛普生藝術微噴／含銀相紙，
16.5 x 11.9 cm，國家攝影文化中心典藏

張朝目（1895-1964）／張寫真館，臺中豐原。日治時期，張朝目曾於 1925 年前往東京寫真學校就讀，返臺後，在豐原內埔庄當地開設「張寫真館」。他所拍攝的玻璃底片共有 80 餘多張留存下來，其中又以 1930 年代活躍於臺中地區的著名南管戲班「新錦雲」演員的攝影作品（時間約為 1932 年）最具代表性。張朝目這系列底片分別在寫真館與舞臺上完成拍攝。由於當時蛇腹式大型照相機靈活度較低，且玻璃乾版底片需花費約一秒時間曝光，戲班演員因而必須以固定擺姿以入鏡。縱使在 1930 年代，這批早期的臺灣戲劇影像仍屬極其罕見的民間攝影家「系列攝影」。

吳金淼
金淼寫真館

吳金淼（金淼寫真館），吳明珠肖像（吳金淼妹），楊梅，1935-1950，愛普生藝術微噴／含銀相紙，國家攝影文化中心典藏 ｜ 吳金淼（金淼寫真館），吳金淼自拍像，楊梅，1935-1950，愛普生藝術微噴／含銀相紙，國家攝影文化中心典藏（右頁）

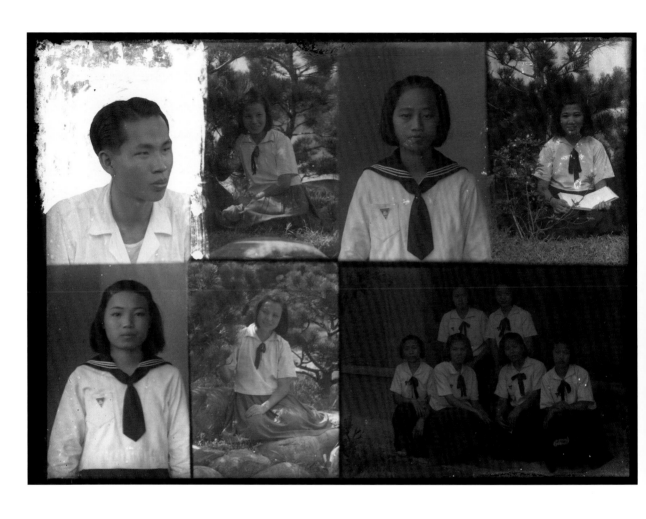

吳金淼（金淼寫真館），吳金淼寫真館拍攝肖像與身分證照，楊梅，1935-1950，愛普生藝術微噴／含銀相紙，國家攝影文化中心典藏 ｜ 吳金淼（金淼寫真館），中壢神社鎮座祭楊梅團扮裝行列紀念，楊梅，1935-1950，明膠銀鹽，國家攝影文化中心典藏（右頁）

吳金淼（1915-1984）／金淼寫真舘。桃園楊梅的金淼寫真舘於 1935 年取得營業
許可證，由哥哥吳金淼主掌攝影與彩繪上色、弟弟吳金榮負責暗房作業，妹妹吳
明珠、爸爸吳阿昌和媽媽吳鍾緞妹則協助其它工作項目。金淼寫真舘擅長以布景
與道具輔助擺出不同姿態的被攝者，再巧妙利用光線拍出別具特色又自然的影
像，吸引當地居民每逢年節前後特別至寫真舘拍照。除此之外，吳金淼也時常攜
帶笨重的相機設備前往戶外拍攝，其鏡頭大量記錄日治末期的地方生活樣態，包
括皇民化運動、出征歡送會、團體合照、婚禮喜慶及客家生活等，為楊梅留下許
多具有歷史意義與價值的重要影像，因而被稱為「楊梅攝影之父」。

吳其章（明良照相館），吳其章自拍像，地點不詳，1930-1940，明膠銀鹽、紙質，52.5 x 41.3 cm，
國家攝影文化中心典藏

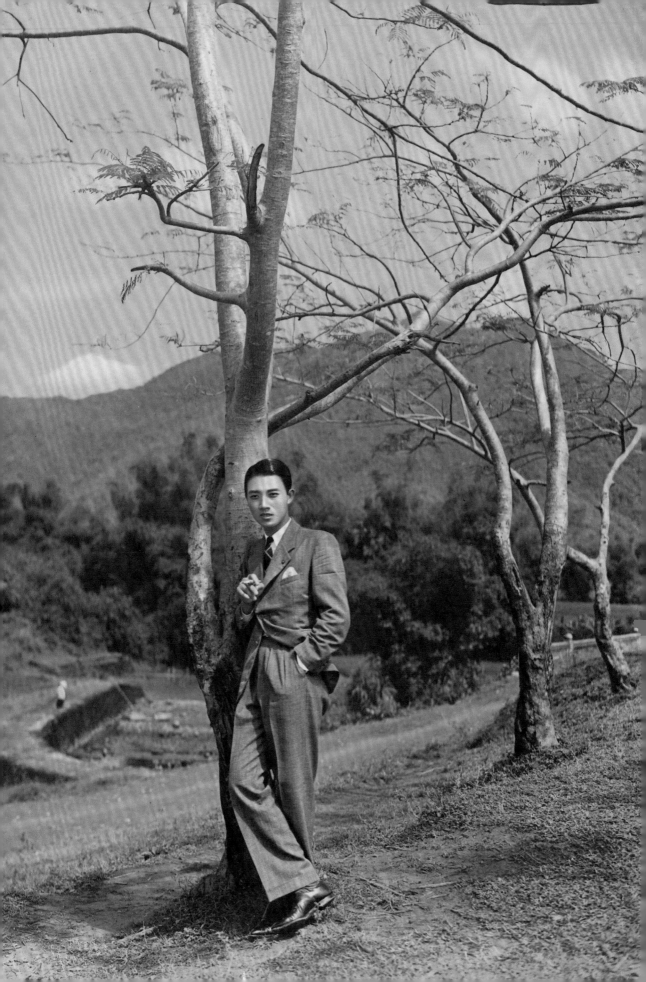

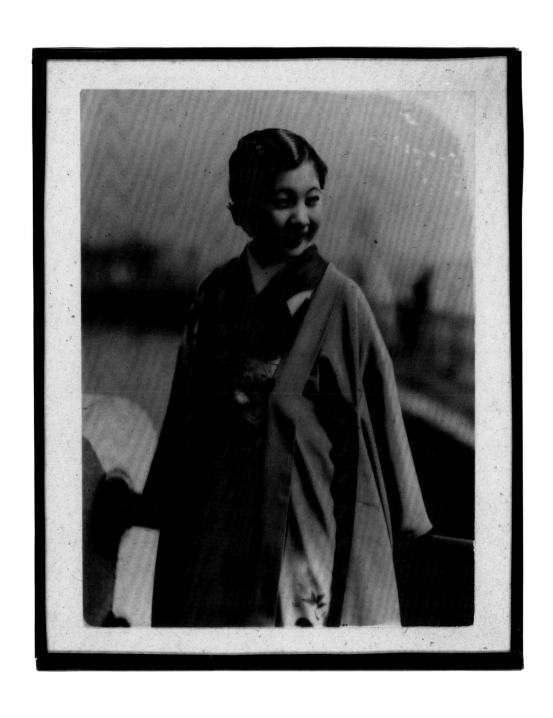

吳其章（明良照相館），和服女子，高雄美濃，1940-1950，明膠銀鹽、紙質，30.3 x 24.8 cm，
國家攝影文化中心典藏 ｜ 吳其章（明良照相館），河邊男子，地點不詳，1930-1940、蛋清印相、
紙質，9 x 8.7 cm，國家攝影文化中心典藏（右頁）

吳其章（1916-2001）／明良照相館，高雄美濃。吳其章是高雄美濃第一位從日本東京寫真學校畢業的照相師。有著繪畫天賦的他，最初跟隨吳昭華學習臨摹人像照的畫技，同時習得拍攝、暗房、修片等技術。1936 年留學日本期間，吳其章曾獲得校方攝影競賽第一名。返臺後在美濃開設的「明良照相館」，持續經營至其 1980 年左右退休，成為當地人的共同記憶。如同幾位臺灣早期攝影家，炭精擦筆繪畫的訓練亦影響了吳其章的作品。他甚至曾因擅長手工上色，獲得東京校方教師們的關注。此外，為了強化作品細膩度，吳其章還透過在正像玻璃版後方放入銀色紙板，發展出一種仿達蓋爾版攝影的玻璃版攝影術，其自稱為「金屬攝影」。雖然開設相館後便鮮少替人作畫，吳其章的鏡頭仍受肖像畫與祖先畫傳統的影響──不講求背景變化或象徵意涵，場景擺設也相對簡單，被攝者大多擇定位坐好。之後，吳其章逐漸擺脫正面構圖的侷限，開始近身捕捉人物神貌與動態，也為家庭成員留下不少生活紀錄。

□□□□□□□□□□□

黃玉柱
光華照相館

黃玉柱（光華照相館），湖邊小憩，地點不詳，1940-1949，明膠銀鹽手工彩繪上色、紙質，17.6 x 26.2 cm，國家攝影文化中心典藏

黃玉柱（光華照相館），綁蝴蝶結的少女，高雄鳳山，1945-1955，明膠銀鹽手工彩繪上色、紙質，14.8 x 20.5 cm，國家攝影文化中心典藏 ｜ 黃玉柱（光華照相館），戴手套的女子，高雄鳳山，1950-1960，明膠銀鹽手工彩繪上色、紙質，29.1 x 23.6 cm，國家攝影文化中心典藏（右頁）

黃玉柱（1920-　）／光華照相館，高雄鳳山。如同許多臺灣攝影家，黃玉柱早年亦隨炭精筆畫師習畫，並向曾是日人寫真館學徒的黃丁進學習攝影術。不久後，黃玉柱的家人投資黃丁進開設「日活寫真館」，黃玉柱也得以開啟學徒生涯；三年多後，黃玉柱改師從「石橋寫真館」的主持人石橋先生。為求精進，黃玉柱 20 歲時赴日求學於石橋先生的母校「東洋寫真學校」，後於 1941 年以第 20 期生畢業。太平洋戰爭爆發後，回到臺灣的他輾轉在同期生陳連科於南投開設的「南開寫真館」及日本人開設的「瑪莉寫真館」、「石橋寫真館」擔任寫真師與修整底片師傅。1946 年，黃玉柱終返故鄉鳳山，創立「光華照相館」，營業至今（2021）。日治時期的臺灣寫真館主要生意為拍攝各式肖像照，亦不乏婚紗照。由於早期拍照被視為人生大事，人們往往穿上最時髦流行的衣服，部分則特地選擇劇場裝扮入鏡，因此在彩色底片尚未發明前，具繪畫基礎的黃玉柱善用顏料進行手工彩繪、修整底片作為相館的特殊服務。

林壽鎰（林寫真館），花（中途曝光），桃園，1947，明膠銀鹽，紙質，24.3 x 29.5 cm，國家攝影文化中心典藏

林壽鎰（林寫真館），雙姝，桃園，1937，明膠銀鹽，紙質，15.3 x 11 cm，國家攝影文化中心典藏 ｜ 林壽鎰（林寫真館），三重曝光女子肖像，桃園，1930-1939，明膠銀鹽，紙質，13.6 x 10.1 cm，國家攝影文化中心典藏 ｜ 林壽鎰（林寫真館），雙重曝光男子肖像，桃園，1930-1939，明膠銀鹽，紙質，7.6 x 5.5 cm，國家攝影文化中心典藏 ｜ 林壽鎰（林寫真館），雙重曝光林壽鎰肖像，桃園，1930-1939，明膠銀鹽，紙質，7.6 x 5.5 cm，國家攝影文化中心典藏（左到右）

林壽鎰（1916-2011）／林寫真館，桃園。不同於早期臺灣攝影家大多家世良好，林壽鎰出身清貧，1929 年自國民學校畢業後，前往表哥經營的「徐淇淵寫真館」擔任學徒，習得攝影、炭筆、粉彩、水彩等技術；1931 年獨自來往基隆、花蓮一帶，以為當地人拍照和畫像謀生。1934 年，林壽鎰深感臺灣攝影的觀念與技術仍遠遠落於日本之後，遂決定前往東京銀座「日之初寫真株式會社」，以學徒身分積極鑽研各種人像攝影技術，是臺灣少數曾於日本寫真會社工作者。1937年返臺後，在故鄉桃園開設「林寫真館」。林壽鎰以肖像照見長，善用專業的燈光安排、景深控制、氣氛營造與人工上色等技術，作品細膩而動人。寫真館間的生意競爭日益激烈，林壽鎰除了從事人像拍攝委託外，也持續投入鑽研各種新型的照相技術與器材運用，以爭取來自不同領域的工作機會。二次大戰結束後，他持續經營寫真館，並參加攝影團體和比賽。

摘取一朵花

希林·施諾（Shireen Seno）
藝術研究｜單頻道錄像｜ 2021 年

我的母親以前總說，我們的餐桌和我年紀相仿。不知道那棵製成我們餐桌的樹被砍下時幾歲？我對於此類由自然世界轉變至人類社會的過程非常感興趣，像是一棵樹如何在被砍下之後重啟新的生命歷程。

我預計透過「錄像文章」（video essay）的形式，融合菲律賓美國殖民時期（1898–1946）的檔案照片，並藉此探索人類與自然膠著的連結，以及此一連結與帝國間糾葛不清的關係。

在搜集資料的過程中，我找到一張照片。照片裡的年輕新娘站在戶外，本應站著新郎的位子則由一盆植栽取代，周圍滿佈著不確定性。是不是新郎遲到了？或者因故無法出席？女子是否對於與男子步入婚姻不夠篤定，或者對婚姻本身滿懷質疑？又或許，女子不過是對於此一拍攝場景感到不自在，所以急著脫身？我想當時一定非常炎熱，而她穿著緊身婚紗，站在豔陽下。

後來，我又找到另一張類似的照片。一樣是一名女子站在戶外，身邊擺著一盆植物。我不確定女子是不是一名新娘，但她身穿正式服裝。這張照片中的女子並沒有注視鏡頭，而是微微側著，目光朝下望著泥地。她的容貌不甚清楚，但似乎看起來有些不適。女子的左手輕輕放在身邊小型盆栽的葉子上，彷彿盆栽是她的寵物或同伴，某種能夠提供慰藉的存在。

製作影像的過程中存在一種有趣的張力，這股張力能使片刻常駐，卻同時剝奪了那個片刻。如同我的一位朋友所說，製作影像就像是摘取花朵：花那麼美，讓人想要擁有它，但我們這麼做其實是在殺害它。相機使我們得以同時跨足生與死之間微妙的界線。

本作以植物與樹木為出發點，探索攝影及資本主義在菲律賓的根基與發展。

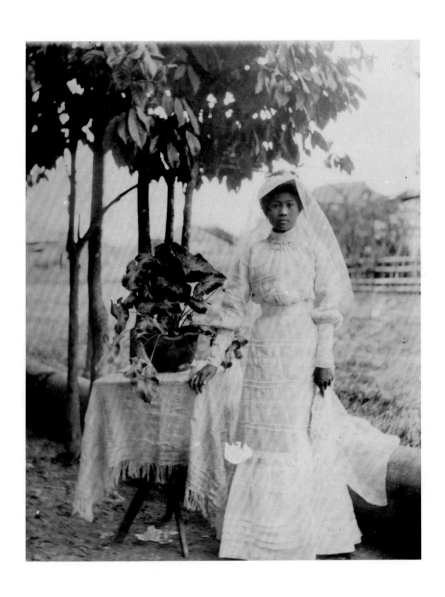

攝影者不詳，新娘，約 1906 -1910，E・莫瑞・布魯納家族（E. Murray Bruner Family）

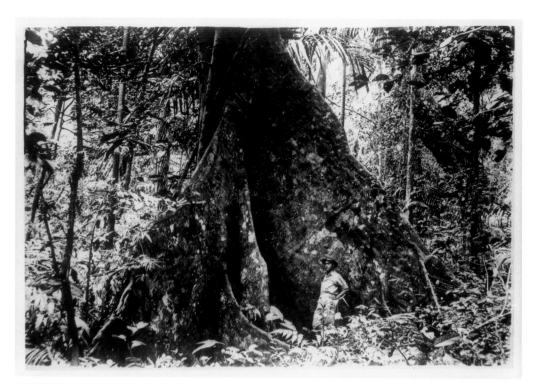

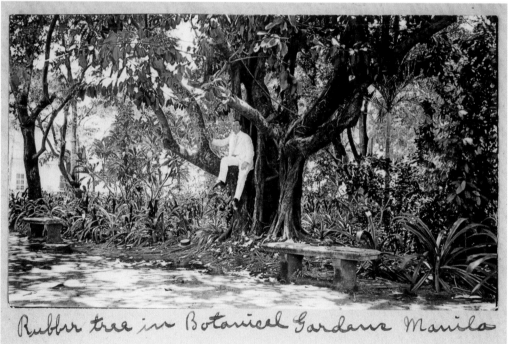

Rubber tree in Botanical Gardens Manila

紫檀樹，洛斯班尼奧斯（Los Banos），拉古納省（Laguna），1923-1924，
威斯康辛菲律賓影像典藏 ｜ 坐在橡膠樹上的男子，馬尼拉植物園，1907-
1916 ｜ 從樹上摘取椰子的男子，密西根大學，特藏研究中心，菲律賓攝影
數位檔案庫（上至下）

希林‧施諾（Shireen Seno），藝術家與電影創作者，作品聚焦記憶、歷史與影像創作，常探討「家」的概念；為 2018 年菲律賓文化中心「十三藝術家大賞」的獲獎人。施諾起初為拉夫‧達茲（Lav Diaz）的劇照師，後來執導了自己的首部電影《Big Boy》（2012），全片以超 8（Super 8mm）拍攝，以一名被父母要求「長高」的男孩為主角。施諾的第二部長片《成長的發聲練習》（2018）則描述一名女孩發現一支能夠翻譯緊張人們思想與情感的筆的故事。《成長的發聲練習》獲獎無數，並於紐約現代藝術博物館的「新導演／新電影影展」（New Directors/New Films）、泰特現代美術館的「藝術家電影企劃」（Artists' Cinema programme）以及東京都寫真美術館的「惠比壽國際影像祭」放映。施諾的策展經歷包括克里斯汀‧塔布列宗（Christian Tablazon）個展「以紋理而不是歷史來塑造世界」（And the World Thickens with Texture Instead of History）、飯村隆彥於馬尼拉的「圓形＋正方形」（Circle+Square），並與墨夫‧艾斯皮納（Merv Espina）共同為巴勃羅畫廊（Pablo Gallery）策劃十週年紀念展覽「指示說明」（INSTRUCTIONS），也搜羅研究有關菲律賓過去 30 年的實驗電影與錄像，策劃「共鳴追蹤（Kalampag）系統」。施諾與約翰‧托雷斯（John Torres）在馬尼拉共同經營致力於電影與藝術交流的工作室與創作平台 Los Otros。兩人近期於法蘭克福門廊美術館（Portikus Frankfurt）舉辦了首次個展，展出以〈多雲且可能下椰子〉（Cloudy with a chance of coconuts）為名的協作裝置，並策劃同名放映單元。施諾也是 Tito & Tita 的成員，這個影像與藝術群體的創作實踐涵蓋裝置、電影、攝影以及集體行動。此外，她同時擔任菲律賓藝術中學（Philippine High School for the Arts）的訪問教師。

在 1949 年之前，臺灣攝影逐漸形成專業化場域，不僅僅是因為寫真館在各地開設，更因為攝影作為文化場域的成形，如有赴日進入寫真學校的攝影工作者。媒體方面，如雜誌及報紙，也開始對照片產生需求。有關攝影的討論也不再侷限於技術，還包含著對攝影美學的研究。另一方面，由於影像的民主性，在業餘及專業人士的推波助瀾下，相機俱樂部和沙龍組織亦隨之成立。進入 1920 年代之後，135mm 相機的發明與膠卷開始普及，銀鹽相紙（gelatin silver print）成為主流，能動性及便攜性讓攝影成為一種掌握社會脈動的視像工具。在成熟的專業性及民主性的背景下，配合著平面媒體（如報紙、雜誌、書籍等）影像環境的普及，孕育出第一代臺灣攝影家的影像。

對應著歐美與日本的攝影創作，持著照相機的臺灣人，一方面有著十九世紀攝影沙龍所孕育的畫意攝影主義（pictorialism），另一方面也開始產出現代主義強調的寫實、機械及抽象美感的影像。如阿爾弗雷德·史帝格勒茲（Alfred Stieglitz）倡導的直接攝影及報導攝影對於社會題材的掌握，即便是前衛運動與構成主義（constructionism）的影像語彙，或是失去其美學政治的立場，也可以從影像形式的操作中察覺其端倪。在畫意攝影主義和現代主義之間兼容並蓄的風格有著殖民者凝視的折射圖像，成為臺灣印象運動開始萌發自我意識的觀察術，如同「攝影之眼」（photo eye）所形成的「攝影自我」（photo I）；這些具有創作意識的影像，同時也是典型現代主義對於自我意識的提問：「我是誰」。因此，攝影的影像問題被轉譯為「誰拍攝？」、「誰被拍攝？」、「如何拍攝？」的自我意識影像，在整個臺灣的社會場景之中映照出在地現實、傳統及人民的集體儀式，即使拍攝的場景不是臺灣，這個現代主義式的提問同樣反映了夾在現代性與殖民性的裂縫。在彭瑞麟、張才、洪孔達、鄧南光、李鳴鵰等臺灣第一代攝影作品中透射出「持攝影機的人」的觀看主體，是攝影獨特的「半參與」社會實踐，也是在「之間」的冷冽注視所顯影的時代圖像。

攝影不是：

＊彭瑞麟留給我們的習題

郭昭蘭

沉默的價值是什麼？無題事物，或者那些不求被命名的事物的價值是什麼？……如何確保意義的不確定性能夠被適當地傳達？沉默，及其帶來的曖昧性，在噪音主宰信息領域的今天，也許正是我們極度欠缺的。[1]

前言：苑裡與通宵

苑裡，距離彭瑞麟 1970 年代以後中醫執業的通宵只有五分鐘的車程，但我卻從來沒聽過他的名字，也不曾在我祖父輩的口中聽過「彭瑞麟」或者任何臺語「Suī-Lîn（瑞麟的臺語發音）」的聲音。[2]

2006 年左右，我開始隨機向家鄉苑裡的父執輩親友詢問：「苑裡有哪些藝術家？」除了想要貼近他們心中的藝術想像，也想藉機接觸那些早就在我家鄉以藝術的施為（performance）重複其日常時間的人。隨後，我被帶往 1932、1933 年獲臺展入選的邱金蓮女士通宵的家中；邱女士自從 1930 年代，恐怕再也沒提起畫筆[3]，客廳牆上一張與我祖父母的合照，意外將我祖父母與邱女士丈夫的同窗情誼聯繫起來，更說明當年的藝術施為已經長久消失在這裡，無人知曉。

2014 年當我知道彭瑞麟也住在距離我只有五分鐘車程外的通宵的時候，彭瑞麟成了與邱金蓮一樣的符號：兩位都是日治時代獲得「臺灣第一」般稱號的藝術家。但是就像邱金蓮早已消失在兩家人的記憶之中，彭瑞麟的故事，在通宵，也一樣無人提及。

我之所以思索著，何以我不能在更小的時候認識彭瑞麟，並不是因為對彭瑞麟的藝術在我生命中遲到的事實感到惋惜，而是嘗試了解，那個沒有被藝術家、藝術史所代表的沉默，究竟意味著什麼？其意義的不確定性是什麼？還有，沉默要如何發出聲音？

彭瑞麟的攝影並非終點：消失或出現

一直以來，我們因為彭瑞麟在 1928 左右年到 1940 年左右的一批攝影，將他定位在攝影藝術家的範圍之內，但是，與僅僅留下兩張膠彩作品的邱金蓮一樣，住在通宵鎮上的彭瑞麟，幾乎在戰後的臺灣，就再也沒有任何公開的發表。對於這個終止、這個消失，我們該如何看待？這是特定藝術或藝術家的退隱（withdraw）？還是藝術史在臺灣的無所作為？抑或是臺灣攝影史自身的缺席？同理，彭瑞麟再次在藝術舞台上的現身，又是在怎樣的驅力？是怎樣的心理促使我們必須從彭瑞麟以及彭瑞麟的攝影，抽取時代需要的見證之物？究竟，重新顯影的彭瑞麟要向我們說什麼？

這裡我想把彭瑞麟的研究問題看作對藝術史在臺灣的一個對照：彭瑞麟作為研究方法，而不只是研究對象。這裡的藝術史在臺灣，廣義的意指協助我即使在國小懵懂時期，仍能清楚說出洪通這位素人藝術家名字的童年，所映照的藝術世界中對於藝術實踐在傳播學上的效果與意義。那個時期即使再貧瘠，都會有像洪通這樣的英雄人物在傳媒中，提供大眾對於藝術家這樣的角色在社會的想像。藉此，我們或許可以同時將「凝視彭瑞麟的視線」與「彭瑞麟及其攝影」，兩

者首先孤立起來，避免將彭瑞麟及其攝影，僅僅簡單吸納進入藝術史在臺灣的分類標籤之中。

彭瑞麟在漫長的戰後之所以被遺忘，也許可以看作是臺灣美術教育中臺灣藝術史的缺席；另外一方面，當同時期的第一代赴日學習的西畫家，藉著省展中評審委員的身份，在學院內外繼續發揮影響力之際，日治時代的藝術攝影實踐，既沒有在後續勃興的藝術市場中引起漣漪，其史料的收集似乎也要等到解嚴前後，把藝術過往的敘述看做是廣泛歷史回溯中的一支時，才合法的進入了藝術史書寫的視線範圍。

彭瑞麟藝術歷史研究視線中的「不攝影」

> 林千郁：「他戰後就沒有再拍照了，你覺得可能會有什麼原因嗎？」
> 彭良岷：「沒有。」
> 林千郁：「因為他就把他的寫真館收掉了，然後就回到新竹了。然後也從你剛剛的描述裡面也有提到說，他還是會修一些照片，但是就沒有再幫別人拍照了？」
> 彭良岷：「沒有沒有。」
> 林千郁：「然後也沒有自己的創作，從現在的照片也完全都沒有這一段。」
> 彭良岷：「因為沒有那個設備啊，暗室什麼都不見了。」[4]

近來，有關彭瑞麟的研究，逐漸熱絡。最新的兩本重要專著有：2017 年北藝大學美術史組林千郁的碩士論文《近代攝影與繪畫交錯中的彭瑞麟》，與 2018 年由國家攝影文化中心執行、國立臺灣博物館出版、馬國安所撰寫的《臺灣攝影家：彭瑞麟》。後者以傳記學為基礎，提供彭瑞麟從繪畫到攝影、日本求學與得獎、徵召到廣東戰場，以至混合中醫專業生涯的傳記學式敘述。相對來說，林千郁的研究，除了藉著重新審視繪畫訓練為基礎的彭瑞麟如何走進攝影的世界之外，更將彭瑞麟攝影放在日本藝術寫真發展末期的環境對照，對於同時進行繪畫與攝影兩種媒材的創作路徑重新考察，進而將彭瑞麟定位為「繪畫與攝影交錯中」的藝術實踐者。相較於馬國安混合傳記學的方式，將彭瑞麟的攝影專論結束在未完成的「印畫法概說」這帶有「科技」

與「技術」想像的詞彙，[5] 林千郁的學術研究方法，給予我更多反思藝術歷史編撰法的參照視角。由於篇幅有限，我將主要從林千郁的論文出發，對話思考「彭瑞麟的不攝影」在歷史編撰學上可能的意義。

我想以「彭瑞麟的不攝影」來代表：一、彭瑞麟在漫長的戰後時期消失於攝影舞台視線的現象，以及二、彭瑞麟攝影的藝術史研究復甦所對峙的，那個被彭瑞麟的名義所代表的模糊曖昧對象。

林千郁在論文附錄的訪談資料中，對受訪家屬彭良岷夫婦問了一個重要的問題：「如果你父親在戰後也沒有這類〔攝影〕的活動的話，那他們是怎麼發現的？」彭良岷：「是文建會在徵〔臺灣攝影百年〕……我看到文建會攝影史，我就曉得如果講臺灣攝影史，我爸爸就一定有位置。」[6]

彭良岷先是在報上發現吳嘉寶主持文建會「徵臺灣攝影百年」[7] 的消息，進而由大哥彭良崑輾轉聯繫文建會，促成彭瑞麟的攝影實踐順利進入攝影史書寫的範疇。[8] 1989 年 2 月，吳嘉寶於《中華攝影周刊》發表〈被歷史遺忘的臺灣攝影先驅：彭瑞麟〉。五年後，蕭永盛接著在《臺灣攝影季刊》發表〈彭瑞麟：在時代的荒街獨行，一位臺灣攝影作家的肖像〉。[9]

林千郁將論文明確以 1945 年做為研究範圍結束的節點，論文附錄的「臺灣攝影大事記與彭瑞麟年表」，也結束在亞圃廬寫場（即亞圃廬寫真館）關閉的第二年：1945 年。儘管終結於 1945 年可能出於論文主題鎖定寫真館的設立，而將戰後彭瑞麟的家族攝影排除在研究範疇之外，但是終結於 1945 年似乎更意味者，作者對於日治時期攝影歷史化，所抱持的本質主義式的方法學預設：

> 從作品的紀年看來，彭瑞麟在 1938 年底〔自廣東戰場〕回到臺灣之後，除了家屬照之外，少有新的攝影創作。另外一方面從《商工人名錄》上的記錄，昭和 14 年（1939）亞圃廬寫場的經營者變為陳德銘，彭瑞麟似乎逐漸退出寫真館的營運工作。[10]

「彭瑞麟的不攝影」並不是林千郁論文的核心問題

招牌最初是阿波羅的裸像。其次改為日文片假名，被指為外來語而改為漢字，以後又被指為和音字，改為「瑞光」。

大東亞戰爭爆發後，為了加強防空設施，在櫥窗上張貼紙條。這是攝影社剛開時最早的櫥窗，上方相片中窗戶上的的紙條，也是當時所貼。[左]

此店於昭和二十年六月十日前後拆除，作為防空空地。[2]

昭和六年[3]十一月二十五日始借租於太平町本通大和洋行二樓。從頭到尾皆由陳德明、羅全獅等三人一手負責。雖受過當地同業驅擾，仍致力於啟蒙民眾。所在盡是些目光短淺之人，也有比城裡日本人還追求暴利的人。一年左右搬邊至右址，為了搭配老舊房子的顏色、在裝修上煞費苦心。為啟蒙民眾，在店內舉辦展覽，請研究製作特殊印畫，投稿於啟蒙民眾，四個人一起經營。而後詹德昌出的那陣子，呂慶梓與賴阿紅亦往來幫忙，在店內舉展度過難關。其中經營最苦的是酷暑和春節。自昭和十九年[4]十一月起休業。因作為防空台地而遭破壞，今全台灣的副會長引領島內三年。培養了一位西醫。回顧這十四年的歷史頗有收穫：成為北庄的會長，作為主要收入在賴阿紅送入師事於游有立送。德明退出後，想兼開醫院改善夏天的慘澹經營狀況，把醫學代銷費為職志，購入皇僕醫院，自己也以年收學費和代銷費為主要收入讀物。於是，想兼開醫院改善夏天的慘澹經營狀況，把醫學代銷費為職志，自師事於黃何立送。自昭和十九年十一月起本醫兼開醫院改善夏天，賴收取學費和代銷費讀物。自師事於游有立送，今全台灣的副會長引領島內三年。培養了一位西醫，在攝影界製造了許多大新聞。

曾想過若在士林有房子，就在阿波羅攝影社之外新增中醫社、X光放射線社和工藝社。有人覺得什麼都不無可能，也就覺得阿波羅三字以羅馬字書寫不佳，原為紀念恩師（石川老師和盧老師）和父親（香蒲）而改以漢字表之，但仍被覺得不妥，終改名為「瑞光」。二十九日未收到報紙。二十九日本島根遭空襲，五月二日夜記

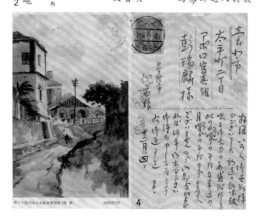

1 彭良岷註記：用意在減少空襲時產生的玻璃碎片；若在展示櫥窗上貼上如上方相片中窗戶的紙樣，則完全喪失展示的作用，因此在不違情形下，想出戰艦、探照燈、戰機等配置。既合月提定，又保持展示功能，且配合當時戰時氣氛。

2 譯者案：兩個月後，戰爭即結束。

3 譯者案：西元1931年。

4 譯者案：西元1944年。

翻譯提供：彭良岷

1. 彭瑞麟，〈私人相簿「回想的寫真」〉，1945，28 x 38 cm，彭良岷、彭雅倫提供。2. 彭瑞麟私人相簿「回想的寫真」中文翻譯。翻譯提供：彭良岷；翻譯內容經筆者修訂[14] 3. 繪畫中的彭瑞麟。藏於彭瑞麟資料庫 M4A5-A10 四號鐵櫃，編號 M4A9p98。彭良岷、彭雅倫提供。4. 倪蔣懷明信片（町裏），亞圃廬寫場時期，藏於彭瑞麟資料庫，檔案編號 M7RR1C2-1v82，彭良岷、彭雅倫提供。明信片內容翻譯：「倪蔣懷：基隆市；彭瑞麟：臺灣臺北市太平町二丁目 アポロ寫真館。內文：「敬復承蒙您多方關照。感謝您獻上詩歌興趣搭配鳴鼓。本周日（六號）下午以及下禮拜一（七號）下午的話，如果有空請出來，等候您大駕光臨。如右所示，靜候您的回信草筆。十二月四日」。譯文亦來自彭瑞麟資料庫

意識，反而是他設定研究範疇的界限，儘管如此，作者仍在論文中多次試圖推演彭瑞麟「不攝影」的現象與原因：

> 〔從〕彭瑞麟逐漸退出寫真館營運的時間點來看，前往中國擔任通譯為彭瑞麟攝影創作的轉捩點。彭良岷先生的描述中，提到彭瑞麟曾向兒女們描述在中國的戰爭情景，戰爭經驗可能是彭瑞麟減少攝影創作的原因之一。另一方面，從訪談中大致得知彭瑞麟在戰前即開始學習中醫，且在戰後考取中醫師執照，與其子彭良岷先生共同執業之外，還發表幾篇中醫的相關研究。藉此推論彭瑞麟自身的興趣可能從攝影轉向中醫，興趣的轉變也為彭瑞麟減少攝影創作的原因。此外，日本政府在戰爭期間亦箝制各類攝影活動，並在 1942 至 1945 年間實施寫真家登錄制，唯有登錄寫真家才可以在公共場合拍照，攝影活動大受限制。因此，缺乏材料以及政府控制亦為彭瑞麟減少攝影創作的原因。[11]

戰爭因素、寫真家登錄制及興趣選擇是作者對彭瑞麟在戰後減少攝影發表原因的推想。然而，有關彭瑞麟停止攝影的訪談與相關敘述，一直以來還存在著各種不同角度的歸因與敘述；除了受制於史料資源有限之外，每個不同的解釋也都代表著，敘述者對於不攝影與攝影，在藝術史編撰學技術與演繹上所代表意義的相異認知。

蕭永盛早在他 1994 年的文章中，已經具前瞻性地將此命題提取為至關重要的問題。他寫道：「彭瑞〔麟〕的攝影創作為什麼在 1938 年左右就猝然停止，是個極可深入研究的題目，不論是在攝影史上，或者是作者論上。在彭瑞麟心裡，他一生真正的志業仍是繪畫吧！而攝影是不是純美術呢？彭瑞麟顯然是持保留的態度……彭瑞麟的攝影創作活動嚴格地說，是在他拍攝了一系列風景攝影後就停止了。」[12] 蕭永盛的詮釋為後續的作者奠定了基礎，但此段文字也似乎間接將彭瑞麟後續竹東期間的攝影寫真館拍攝，排除在外。

史料方面，彭瑞麟 1945 年私人相簿「回想的寫真」中，在亞圃廬寫真館店面照片親筆提字的說明，則可能是將寫真館的關閉歸因於經濟因素的資料來源（圖 1，2）。

> 其中經營最苦是酷夏和春節，想兼開醫院改善夏天慘淡經營狀況……曾想過若在士林有房子，就在亞圃廬攝影社之外新增中醫社，X 光放射線社和工藝社。[13]

對於「不攝影」，蕭永盛曾指出「戰爭結束了他的事業，國民政府來臺後又莫明地被拘捕，二二八事件時結義兄弟遇害，為撫育七位子女接受高等教育，直至晚年生活一直窮困。」[15]

然而，彭良岷先生在 2016 年的訪談中，對此特別作出澄清表示：「我爸爸從來沒有為了賺錢，為了賺錢學中醫的事情」。[16] 換句話說，彭良岷儘管認為彭瑞麟可能出於經濟壓力而中斷攝影，但是並不認為其是出於經濟而改行中醫，也似乎不以為中醫的選項是取代攝影的關鍵。

最後，幾乎可以說是寫真館歷史當事人的林壽鎰，在簡永彬《凝望的時代：日治時期寫真館的影像追尋》中，以林寫真館創辦人的身分，將彭瑞麟的「不攝影」做出確認，同時也與日軍徵召作連結：「我的師父徐淇淵（1920 年在桃園經營寫真館，亦已亡故）亦是早期參加的研究者之一，據他們倆說當時在臺北，以臺灣人業者而言，『亞圃廬』不但價格最高，業務成績名列第一，更以新穎的技術和淵博的學理聞名東南亞，因此慕名而來學習攝影技術者相當踴躍，業餘者、內行者均有……不久彭是被日軍徵召至廣東，充當客家翻譯官，此時臺灣人突然失掉唯一的傑出攝影人才，至為可惜。」[17]

選擇權作為個人自由與個人性代表的侷限

事實上，自廣東戰場回到臺灣後，彭瑞麟曾於 1940 年擔任臺北區照相公會理事長，1941 年又擔任臺灣照相業聯盟副會長。即使在 1945 前後回到竹東，彭瑞麟仍然經營愛寶樂照相館，並保持每年帶著修正筆，環島拜訪學生指導修片的習慣。回到竹東的彭瑞麟經營過蔗園，後來進入學校教書，直到 1970 年退休。

彭瑞麟的確陸續在 1967、1968、1975、1980 及 1981年向日本雜誌《漢方的臨床》發表共六篇的文章；然而，直接以中醫的職業或者興趣的選擇說明彭瑞麟的「不攝影」，可能冒著將攝影僅僅看作一個職業選項，或者個人興趣嗜好的風險，阻礙我們照見特定攝影實踐背後更為廣泛的文化論述。

釐清各種對彭瑞麟「不攝影」傳記學的敘述後，這裡我想提出的是：如果我們把「攝影」視為「興趣」，以及假定彭瑞麟傳記學中後來的「中醫」取代了原先的「攝影」，其影響是什麼？

戰爭、經濟等外部因素之外，個人興趣、個人選擇是常見用以解釋藝術家的在各種選項之中作出判斷，進而顯現個人自由與個人性的途徑。例如，馬國安在文中便如此對比攝影與中醫之於彭瑞麟的意義：「攝影家彭瑞麟也許失去了更好的舞臺，但中醫彭瑞麟仍然砌而不捨，在中醫的研究領域中，成為了有一定分量的作者，光復後，彭瑞麟曾多次投稿日本的中醫研究期刊，認真的在中醫科學領域鑽研思考。」[18]

林千郁更以「彭瑞麟的選擇」來為他的論文作結。這裡的選擇呼應論文的核心題旨——繪畫與攝影的選擇。林千郁交代彭瑞麟如何在赴日之前即與畫家石川欽一郎往來密切，並因為石川的引介而進入東京寫真專門學校。由於日本東京學校期間所學習的藝術寫真逐漸由新興寫真取而代之，[19]彭瑞麟遂返回臺北。之後，彭雖然在 1931 年日日新報社舉辦個人寫真展，參與同年的竹東教育展，並於 1934 年在亞圃廬寫場發表作品，但是根據林千郁的描述，環顧周遭，臺灣「幾乎沒有藝術寫真的潮流下的作品，也沒有以創作為主的風景照。」[20]林千郁標題中的「選擇」，事實上也暗示了彭瑞麟的無可選擇——所謂的選擇，無非就是在無法選擇之下所進行的無選擇的選擇。

臺灣尚缺攝影方面的臺灣第一
如果創作舉措（施為）所迎來的是來自通過體制的標準取得認同，進而取得生命的意義與價值，那麼與其將彭瑞麟的不攝影看做是一種中斷，這裡我想試著提問，這個認同在往後不攝影的生涯中，究竟以怎樣的形式出現或者消失了？

彭良岷曾經表示，吳嘉寶來拜訪調查彭瑞麟之前，「我爸爸跟我談的都是畫圖的事情，很少講照相的事情」[21]，除了後來的漆器寫真，以及 1954 年左右打算讓藍蔭鼎協助推廣卻失敗的銀粉雪景技術。[22]彭太太（彭良岷之妻）也提到，彭瑞麟在定居通霄以後，「經常在四樓、三樓畫畫」，並留下這張畫靜物的工作照片（圖 3）。[23]

林千郁《繪畫與攝影交錯中的彭瑞麟》的確提醒我們，彭瑞麟與石川欽一郎的交誼，以及與包括倪蔣懷（圖 4）、洪瑞麟、李石樵、藍蔭鼎等第一代西畫家之間的往來。雖然在疏開以後，彭瑞麟越來越少機會聯繫繪畫圈的朋友如李石樵、藍蔭鼎，但是，1970 年代定居通霄以後，彭瑞麟仍幾度嘗試造訪李梅樹，甚至購藏洪瑞麟的作品。[24]最新公開的彭瑞麟私人檔案資料中，就留有洪瑞麟在 1979 年春之藝廊的「洪瑞麟：三十五年礦工造型展」彭瑞麟造訪的身影（圖 5），以及當時留下的剪報（圖 6）。

延續林千郁論文中將彭瑞麟定位於「近代攝影與繪畫交錯中」的位置，一批新近曝光的彭瑞麟個人遺物，也支持著這樣的看法。彭瑞麟完整的收集 1930、1933、1934、1935 年，也就是第 11、14、15 及 16 回帝展明信片；1935 年李石樵入選第二部會展的《編物》作品明信片；第 13 回春陽會展覽；1936 年的第六回獨立美術協會；1930 年第 17 回二科會，以及 1934 年第 21 回二科會等明信片。此外，1936年到 1941 年間彭瑞麟在日本《風景》雜誌發表了總共五篇的文章，除了文字之外，還包含攝影與手繪的風景。[25]1938 年受日軍徵召至廣東擔任翻譯官，他在吉岡少佐贈予的本子上，也留下數張廣東的風景（圖 7,8）。

我們回到藝術寫真的環境，了解到與繪畫共享著風景美學的攝影，對於像彭瑞麟這樣的攝影家來說，與這些繪畫同好的交誼，就是他的攝影環境與社會關係的連結。這個連結除了說明彭瑞麟在留日之前與石川以及繪畫的關係之外，也是 1930 年代攝影在日本的論述處境，藝術寫真與寫實寫真爭奪話語的環境中，傾向於藝術寫真的彭瑞麟向繪畫靠攏的事實。此外，將彭瑞麟的攝影簡單與繪畫分離，的確有其風險，畢竟，1930 年代紐約現代美術館仍存在

5. 1979 年彭瑞麟在春之藝廊舉辦《洪瑞麟：三十五年礦工造型展》留下的現場照片。彭瑞麟私人相簿，藏於彭瑞麟資料庫，編號 A9p84 至 A9p89。彭良岷、彭雅倫提供（依序為左上、左中、左下、右上、右中、右下）｜ 6.〈地底的靈魂——論洪瑞麟先生的畫〉剪報，中國時報第十三版，1979 年 6 月 26，藏於彭瑞麟資料庫。彭良岷、彭雅倫提供｜ 7. 彭瑞麟於 1938 年受日軍徵召至廣東擔任日軍翻譯官，此為當時彭瑞麟於廣東省惠州市境內的西湖畫下的景致。藏於彭瑞麟資料庫。彭良岷、彭雅倫提供｜ 8. 彭瑞麟於 1938 年受日軍徵召至廣東擔任日軍翻譯官，此為當時彭瑞麟於廣東省惠州市境內的西湖畫下的景致，畫面左側可以看見位於西湖旁的泗洲塔。藏於彭瑞麟資料庫。彭良岷、彭雅倫提供｜ 9. 彭瑞麟，〈閩式建築街景〉，彭瑞麟「藍色速寫本」。藏於彭瑞麟資料庫。彭良岷、彭雅倫提供

攝影是否藝術的爭議（儘管1939年紐約現代美術館，成立了第一個美術館中的攝影部門），東京的寫真美術館，也是等到1990年才成立的。

如果石川欽一郎在推薦彭瑞麟選擇攝影而不是繪畫的理由中，具有「臺灣尚缺攝影」的理由的話，那麼攝影的實踐在彭瑞麟生命中，就不該僅僅以個人興趣的選項被看待，需要進一步提問的問題反而是，這個在日本與臺灣之間所建立的藝術流通關係，在戰後又被怎樣的關係系統取代了？

王秀雄在〈臺灣第一代西畫家的保守與權威主義暨其對臺灣戰後西畫的影響〉中提到，儘管第一代西畫家透過長期任教學院與擔任全省美展評審，為國內繪畫世界投下巨大的影響，他們個人畫風大多多年不變。[26] 這個世代正是彭瑞麟同時期的藝術家。先不說攝影的技術與個人消費性攝影的演變，可能讓藝術寫真就算熬過其他外在因素，可能也會在下一波攝影技術潮流更迭中隕落，我們或許可以反過來問，彭瑞麟的不攝影向我們提問的是，那些被認為持續作畫的畫家，是否「繪畫」了？

如果我們將彭瑞麟的攝影，擲回1930年代的脈絡，攝影不僅尚未取得今天擁有博物館支持下的體制地位，無論是繪畫抑或是攝影，在日本與臺灣藝術體制的力動關係中，彭瑞麟的攝影似乎無法逃脫「臺灣缺少什麼」的結構性力量的支配。

如此一來，當戰爭結束，諸多日治時代畫家順利在新的政治條件下，以繪畫的名義建立權威之際，彭瑞麟這些消失在舞臺上，甚至被錯誤地以攝影之名而遭遺忘的繪畫施為，說不定才是沉默的非權威之聲。它們生長於前殖民地的美學條件，也與彭瑞麟的藝術寫真共享著風景繪畫的美學判準，卻在後續分立的媒材分類中，成為「非攝影」。這些「非攝影」過去充其量被拿來註記彭瑞麟的「不攝影」，如今應該要成為理解攝影家身體記憶與技藝的索引（圖9）。

如果藝術家的實踐值得我們以藝術史的名義加以回溯性的描述，那麼藝術家的不實踐，就值得被等量齊觀的關注與認識。如此，那個以藝術為名被刻寫註記的生命，在成為歷史的對象之際，其攝影背後

所銘刻的創作舉措，通過與「作」藝術的、「作」攝影的歷史相互對照，才能獲得與他同一時代生命條件共同分享的判準。這種判準不僅可能會透露給我們，何以某些藝術的生產在某些條件中被鼓勵並且持續在舞臺（藝壇）上上演，而何以某些舉措，必須以中斷，延續其生命；甚至，它可能回答我們關於我們無法親身參與的過往，以時代之名，以藝術人類學的視野，其探照所及的那些微不足道的生命為何？這時，我們才能說，我們正在避免剝削那些從藝術的過往（藝術史）來到我們面前的各式各樣的角色——如果剝削就是無可避免的話。

「沉默」的價值及其傳達

筆者之所以認為提問彭瑞麟「不攝影」的問題有意義，在於渴望從諸位作者對於不攝影的看法，還原今天從事攝影史研究者，究竟該以怎樣的關係結構來看待攝影在當時社會與今日社會間的文化翻譯與延異。

現在問題變成，我們究竟如何在不放棄藝術家生命史中詮釋資源的情況下，去理解藝術家的藝術生產，尤其他們的生命史總是與地方（區域）的脈絡纏繞在一起。我們要問的是，如果彭瑞麟要告訴我們關於遙遠他方的故事的話。究竟是以何種形式，而彭瑞麟又如何避免自己被同化進入一個均質的意志代理人？

如此我們稍稍將彭瑞麟的生命史，從聖徒傳式的英雄主義剝削中撥除開來，也從特定媒介的藝術通論中釋放出來，並賦予其生命必須被完整觀照的必要性。還原他生命政治條件的不得不然，幫助我們給予「不攝影」這個空白必須有的面貌。

1　Chiara Ianeselli, Reader #4: Silence, https://www.e-flux.com/announcements/324464/e-flux-reader-silence, accessed May 28 2020.

2　後來我才知道，彭瑞麟是竹東二重客家人，如果他有屬於臺灣方言的名號，也可能不是臺語發音的。

3　邱金蓮在第三高女（今臺北市立中山女子高級中學）時期自鄉原古統習得膠彩畫法，大家閨秀的相夫教子的優先性可以解釋她何以停止繪畫。

4　林千郁，〈近代攝影與繪畫交錯中的彭瑞麟〉，國立臺北藝術大學美術學系碩士班美術史組論文，2017，頁 140。

5　馬國安：「也許，彭瑞麟做為藝術家想尋求的，就是攝影做為藝術，與攝影做為『觀看的科學』之間，在現代世界裡的多重角色吧！」引自馬國安，《臺灣攝影家：彭瑞麟》，臺北：國立臺灣博物館，2018，頁 154。

6　林千郁，《近代攝影與繪畫交錯中的彭瑞麟》，頁 144。

7　正確名稱應為「百年臺灣攝影史料整理」計畫，由吳嘉寶主持，始於 1985 年。吳嘉寶，〈被歷史遺忘的臺灣攝影先驅：彭瑞麟〉，參考網址：https://web.archive.org/web/20090912102124/http://www.fotosoft.com.tw/book/papers/library-1-4023.htm，2020 年 5 月 10 日瀏覽。

8　根據吳嘉寶描述：「1986 年，筆者發起了以調查、研究、建構一本臺灣攝影史為前提的『百年臺灣攝影史料整理』計畫。這項計畫最早的原案，是前後持續五年的大型計畫。後來因為無謂的政治因素，無法獲得政府持續的經費支援，而僅執行一年就被迫終止。」引自林千郁，〈近代攝影與繪畫交錯中的彭瑞麟〉，頁 144。原文資料見吳嘉寶，〈臺灣的攝影教育 1930-1998〉，《視丘攝影藝術學院》，參考網址：https://www.tofotosoft.com/about-us/ 視丘線上圖書館 /wujiabao-articles/65- 台灣的攝影教育 -1930-1998.html，2020 年 5 月 10 日瀏覽。

9　蕭永盛，〈彭瑞麟：在時代的荒街獨行──一位臺灣攝影作家的肖像〉，《臺灣攝影季刊》第三號，1994 年 4 月。

10　林千郁，《近代攝影與繪畫交錯中的彭瑞麟》，頁 63。

11　林千郁，《近代攝影與繪畫交錯中的彭瑞麟》，頁 63-64。

12　蕭永盛，〈彭瑞麟：在時代的荒街獨行──一位臺灣攝影作家的肖像〉，頁 8。

13　引自彭瑞麟私人相簿「回想的寫真」，家屬收藏。

14　筆者於策畫臺北日動畫廊「旋轉歷史編撰法的爆炸圖」展覽期間，曾修訂譯稿內容。

15　蕭永盛，〈彭瑞麟：在時代的荒街獨行──一位臺灣攝影作家的肖像〉，頁 8。

16　林千郁，《近代攝影與繪畫交錯中的彭瑞麟》，頁 134。

17　林壽鎰，〈光復前後的攝影界〉，收於簡永彬主編，《凝望的時代，日治時期寫真館的影像追尋》，臺北：夏綠原國際有限公司，2010，頁 178。

18　馬國安，《臺灣攝影家：彭瑞麟》，臺北：國立臺灣博物館，2018，頁 154。

19　新興寫真為日本於 1930 年代興起的攝影風潮。不同於藝術寫真，新興寫真主張攝影不該依附於繪畫的美學，強調追求攝影機本身機械的特性，創造攝影獨有的視覺經驗。

20　林千郁，《近代攝影與繪畫交錯中的彭瑞麟》，頁 68。

21　林千郁，《近代攝影與繪畫交錯中的彭瑞麟》，頁 133。

22　簡永彬，〈彭瑞麟〉，收於簡永彬主編，《凝望的時代，日治時期寫真館的影像追尋》，臺北：夏綠原國際有限公司，2010，頁 259。

23　在林千郁的訪談紀錄中，彭良岷提到自己曾以 V8 記錄下父親作畫的過程。見林千郁，《近代攝影與繪畫交錯中的彭瑞麟》，頁 150。

24　林千郁，《近代攝影與繪畫交錯中的彭瑞麟》，頁 147-149。

25　根據彭瑞麟資料庫公開的史料，刊登於 1940 年 7 月《風景》雜誌上的〈新會城的古寺〉，以及 1939 年刊登於同名雜誌的「南支從軍」的〈惠州西湖〉，均是來自彭瑞麟的素描本。林千郁在彭瑞麟資料庫公佈前所發表的論文，曾經推測景致可能來自照片（見林千郁，《近代攝影與繪畫交錯中的彭瑞麟》，頁 63）。不過，我們仍無法確定素描本中的作品是否根據照片繪製而成。

26　王秀雄，〈臺灣第一代西畫家的保守與權威主義暨其對臺灣戰後西畫的影響〉，《臺灣美術發展史論》，臺北：國立歷史博物館，1995，頁 174-179。

朗靜山

郎靜山，〈春樹奇峰〉，1945，明膠銀鹽，紙質，46.5 x 37.0 cm，國立臺灣美術館典藏 ｜ 郎靜山，〈曉風殘月〉，
1945，明膠銀鹽，紙質，40.5 x 31.5 cm，國立臺灣美術館典藏 ｜ 郎靜山，〈瓶中春色〉，1957，明膠銀鹽，紙質，
47.0 x 35.5 cm，國立臺灣美術館典藏（左到右）

瓶中春色 SpringTime 1953 郎靜山作

曉來風景 SPRING FANTASIA 1945 靜山攝錄

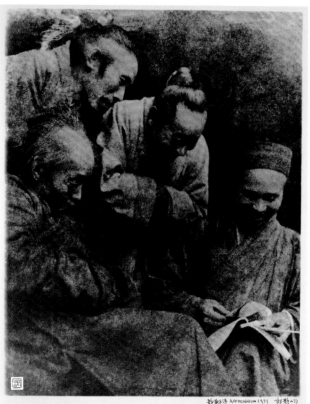

郎靜山，〈靜觀自得〉，1931，明膠銀鹽，紙質，40.5 x 31.5 cm，國立臺灣美術館典藏 ｜ 郎靜山，〈一女有所思（人體）〉，1924，明膠銀鹽，紙質，27.5 x 38.5 cm，國立臺灣美術館典藏 ｜ 郎靜山，〈金波泛筏〉，1930，明膠銀鹽，紙質，38.5 x 30.5 cm，國立臺灣美術館典藏（左到右）

郎靜山（1892-1995）生於江蘇淮陰，自幼喜愛傳統書畫，12 歲師從上海南洋中學的李靖瀾，習得攝影原理及沖洗曬印技術。1911 年，郎靜山在《申報》擔任廣告業務，視攝影為消遣；1926 年受聘為《時報》攝影記者，成為中國新聞界早期專業攝影記者之一；1931 年開設「靜山攝影室」，專門從事人像與廣告攝影。直到 1937 年七七事變爆發，郎家才遷往四川，郎靜山則往返於上海、昆明與重慶之間，一面從事新聞採訪，一面研究「集錦攝影」與創作。1949 年，郎靜山應美國新聞處之邀赴臺參加影展並定居。郎靜山以看似拼貼的集錦攝影聞名。他有意識地處理影像，構圖嚴謹，延續傳統水墨畫精神，隱約透出身為文人的傲骨風情。集錦攝影與諸多前衛主義的理念不謀而合，足見其先行與獨到；他視相機為畫筆，以攝影技巧保留傳統水墨氣韻，巧妙融合中國與西方元素，創造出一個無人踏足又獨屬自身的山水。此外，郎靜山也是中國拍攝裸女的先驅。與國外攝影家、藝術家交流頻繁的他，曾撰文比較西方攝影與中國美學的差異，亦曾與攝影史學家紐霍（Beaumont Newhall）會面，積極著手撰寫中國攝影史。郎靜山在美、歐、日、韓與東南亞等地皆享榮譽頭銜，顯現其攝影於國際地位之重要。

彭瑞麟

彭瑞麟，〈靜物之影中影〉，1930，三色碳墨轉染天然寫真印畫法、三原色自然色彩攝影法，15 x 10.5 cm，彭良岷
收藏 ｜ 彭瑞麟，〈太魯閣之女（漆金版）〉，1934-1938，漆金寫真技法，35 x 30 cm，彭良岷收藏（右頁）

彭瑞麟，日軍佔領後的廣州中山紀念堂廣場，廣州，1938，愛普生藝術微噴／含銀相紙，9 x 6 cm，彭良岷、彭
雅倫提供 ｜ 彭瑞麟，珠江今昔：中央大酒店一景，廣州，1938，愛普生藝術微噴／含銀相紙，9 x 6 cm，彭良岷、
彭雅倫提供（右頁）

彭瑞麟（1904-1984）生於日治時期新竹州（今新竹竹東），1923 年自臺北師範學校畢業後，分發至故鄉峨眉國小及二重埔國小任教；1928 年由石川欽一郎推薦進入「東京寫真專門學校」就讀；1930 年以三色轉染法創作的〈靜物〉入選當年「東京寫真研究會」的專輯；1931 年以第一名畢業於東京寫真專門學校，成為臺灣首位攝影學士與「日本寫真學士會」會員。同年 11 月，彭瑞麟在臺北市太平町（今延平北路）開設「アポロ寫真館」（Apollo 寫場，後以中文「亞圃廬」重新命名）。隔年，彭瑞麟創設阿波羅攝影研究班，積極推廣攝影教育，學生遍及全臺，為早年臺灣訓練出首批專業攝影人才。1938 年，彭瑞麟被日軍徵調至廣東擔任翻譯員，以隨身相機記錄許多影像。1944 年烽火連天，經營十四年的亞圃廬寫真館正式走入歷史，彭瑞麟回到故鄉後轉而專研中醫、為病人問診，也兼任美術教職。受日本教育影響，彭瑞麟風格獨樹一幟，尤以肖像寫真見長，且不論拍攝肖像、風景或靜物，甚至人體 X 光照，他的作品中皆隱約流露一股憂鬱卻優雅的美學氛圍。經營亞圃廬寫真館期間，他積極實驗十九世紀末多種攝影技法，盼能結合照相部門外的中醫部、X 光部，經營一個跨醫學、科學與影像的中心。在西方現代攝影思潮刺激之下，彭瑞麟 1934 年的「風景」系列則刻意模糊出如繪畫般的影像，頗有二十世紀初期畫意攝影（pictorialism）的味道，試圖以攝影模仿繪畫，持續遊走於兩者之間。數十年不斷精進、重新定位自己攝影身分的彭瑞麟，如同前衛的先行者，為臺灣攝影開啟重要大門。

鄧南光

鄧南光，〈山地族〉，1940，愛普生藝術微噴／含銀相紙，20.3 x 25.4 cm，國家攝影文化中心典藏 ｜ 鄧南光，〈出征前合影〉，1943，愛普生藝術微噴／含銀相紙，20.3 x 25.4 cm，國家攝影文化中心典藏（右頁）

鄧南光，〈戲棚下打拳頭賣藥膏〉，1935，愛普生藝術微噴／含銀相紙，20.3 x 25.4 cm，國家攝影文化中心典藏　｜　鄧南光，〈看戲〉，1935，愛普生藝術微噴／含銀相紙，25.4 x 20.3 cm，國家攝影文化中心典藏　｜　鄧南光，〈酒室風情〉，1940年代，愛普生藝術微噴／含銀相紙，20.3 x 25.3 cm，國家攝影文化中心典藏（上至下左到右）

鄧南光（1907-1971）生於新竹北埔，本名鄧騰輝，17 歲赴日求學，1929 年考入
日本法政大學經濟系，因參加校方寫真俱樂部而接觸日本近代「新興寫真」思潮。
1935 年返臺後，鄧南光於臺北京町（博愛路）開設「南光寫真機店」，經營期間
作為攝影愛好者的交流地，直至 1945 年因戰事而休業。戰爭結束後，他在臺北
衡陽路另立「南光照相機材行」，並與李火增等同組「萊卡俱樂部」。鄧南光活
躍於 1950 年代的攝影界：主辦「臺北攝影月賽」、創辦「自由影展」、擔任「中
國攝影學會」在臺復會發起人之一，也協助成立「臺北市攝影學會」。1960 年照
相機材行因營運困難而關閉，他進入臺北「美國海軍第二醫學研究所」，負責醫
學攝影工作。鄧南光常用小型相機以快照方式拍攝，長年記錄了時代變遷下的無
數在地風景，影像樸實精確，內容廣含太平洋戰爭時期的影像、家鄉北埔的農家
活動與歲時祭儀，以及為數眾多的家庭寫真與女子肖像。同時，無論太平洋戰爭
後的廢墟殘骸、二二八事件中的槍擊遺照，還是自己與蔣公像的合照，鄧南光的
攝影在在體現對臺灣動盪政治的關注，傳達他對在地影像的追尋；這些面對政治
抵抗的影像如儀式般地召喚屬於臺灣的本土意識。透過持續不輟且忠實描繪戰爭
前後的臺灣風貌，鄧南光不僅拓展影像語言的可能，也為傳統紀實融入現代思潮，
揉合政治隱喻、社會觀察，為臺灣攝影提供另一思考路徑。

洪孔達

攝影者不詳，洪旺隧，攝於臺南某寫真館，1909，愛普生藝術微噴／含銀相紙，10.6 x 8.2 cm，洪博彥捐贈，國家攝影文化中心典藏 ｜ 攝影者不詳，洪旺燧與洪興正父子合影，攝於臺南某寫真館，1909，愛普生藝術微噴／含銀相紙，10.7 x 8.2 cm，洪博彥捐贈，國家攝影文化中心典藏（右頁）

攝影者不詳，洪孔達熱衷桌球，約 1933，愛普生藝術微噴／含銀相紙，6.4 x 8.9 cm，洪博彥捐贈，國家攝影文化中心典藏

洪孔達（1912-2012）生於臺中，本業是婦產科醫師，卻長期投入攝影相關技術研究。他早年接受醫學專業知識培訓，後在臺中開設自己的婦產科醫院「洪婦產科」，但從中學開始，他開始接觸各式攝影與沖洗技術，並在行醫之餘，持續投入攝影工作。由於父親早逝的緣故，最初洪孔達的拍攝對象主要以母親、祖母等家人為主。1950 年代，他與好友吳鶴松、林權助、陳耿彬等人，成功地以印刷術為原理，研發出轉染法，製作彩色相片。同時，1955 年 12 月他們一夥 13 人倡議籌組「臺中市攝影學會」，翌年召開成立大會，希望藉此推動臺灣中部地區的攝影發展。由於洪孔達從事婦產科醫師的工作特性，他對當時以年輕女性為主的人體攝影不大感興趣。相對地，洪孔達最常被世人提及的作品當屬生態攝影。他將自己的關注焦點放在農村與大自然景致。甚曾花費長達三年的時間捕捉白鷺鷥的身影，成為臺灣第一位透過影像紀錄白鷺鷥生態的攝影師。另一方面，洪孔達曾前往當時還沒有多少人關注的泰雅族部落，試圖記錄當地原住民的狩獵與日常生活。

張才

張才，〈招牌〉，1943，明膠銀鹽，紙質，14.5 x 21.6 cm，國家攝影文化中心典藏 ｜ 張才，〈上海系列：洋婦人〉，
1942-1946，明膠銀鹽，紙質，27.3 x 38.8 cm，國家攝影文化中心典藏 ｜ 張才，〈上海系列〉，1942-1946，明膠銀鹽，
紙質，24.5 x 39.4 cm，國家攝影文化中心典藏 ｜ 張才，〈三洋婦人與中國男人〉，1942-1946，明膠銀鹽，紙質，34.6 x
22.4 cm，國家攝影文化中心典藏（上至下左到右）

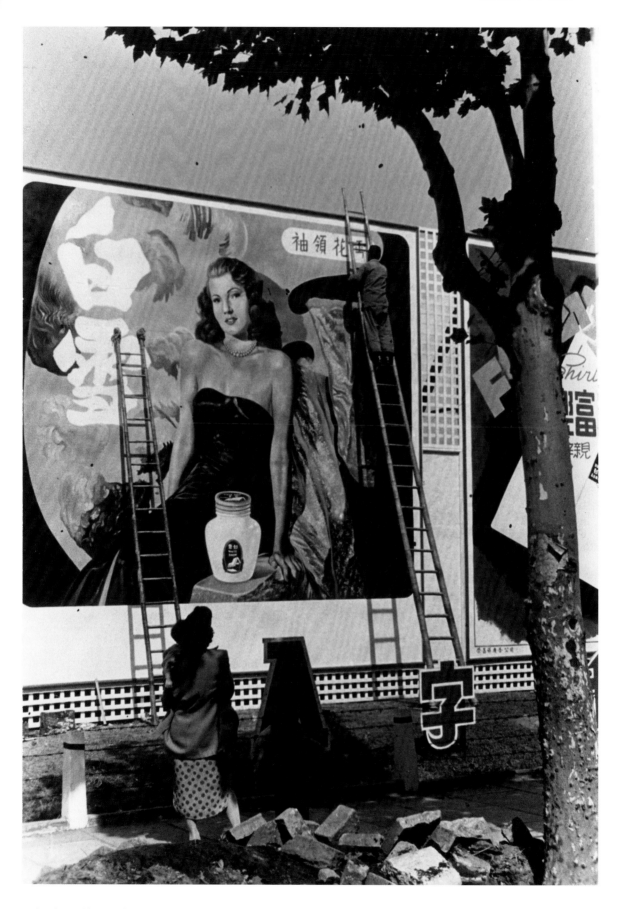

張才，〈白雪看板與太太〉，1943，明膠銀鹽，紙質，50.3 x 34.3 cm，國家攝影文化中心典藏

張才（1916-1994）生於臺北大稻埕，九歲時喪父，同年哥哥張維賢創立「星光演劇研究會」，年少時期多次參與劇團演出。為開展攝影之路，張才1934年赴日就讀「武藏野寫真學校」寫真科，後入「東洋寫真學校」半年的本科，1936年返臺後在太原路成立「影心寫場」。太平洋戰爭爆發後的1941年，張才舉家遷往上海，見證當時上海的興盛消亡。戰後1946年返臺，張才於太平町「山水亭」餐廳（昔大稻埕）開設「影心照相館」，1957年在延平北路成立「大新照相材料行」，從事彩色沖洗業務。張才的影像溫和卻冷靜，曾以異鄉人之姿側寫40年代上海社會境況。國民政府遷臺後，他參與臺大人類學原住民田野調查，拍攝許多原住民生活及慶典的影像，同時致力於記錄廟會及歌仔戲班百態，以其質樸卻敏銳的視角，透過影像詮釋潛藏於時代背後的複雜社會關係。張才的鏡頭直視社會最真實的一面，賦予影像某種超現實色彩，以冷靜漠然的畫面來降低主體意識，隱隱透露攝影家成長過程受無政府主義（Anarchism）的影響。經數十年執著與堅持，攝影家宏大且飽含哲學思想的內斂影像，留存了臺灣許多重要的文化場景。

李鳴鵰

李鳴鵰，〈香菸攤〉，1949，明膠銀鹽，紙質，25.5 x 20.5 cm，國家攝影文化中心典藏 ｜ 李鳴鵰，〈光復橋〉，
1947，明膠銀鹽，紙質，30.4 x 25.4 cm，國家攝影文化中心典藏（右頁）

李鳴鵰，〈第九水門〉，1946，明膠銀鹽，紙質，61 x 50.5 cm，國立臺灣美術館典藏 ｜ 李鳴鵰，〈光復橋下〉，1947，明膠銀鹽，紙質，23.2 x 28 cm，國家攝影文化中心典藏 ｜ 李鳴鵰，〈上林花大酒家女孩群〉，1948，明膠銀鹽，紙質，25.4 x 27.3 cm，國家攝影文化中心典藏（上至下左到右）

李鳴鵰（1922-2013）生於桃園大溪，七歲就讀大溪公學校六年制本科，14 歲時在叔叔廖良福經營的「大溪寫場」當學徒，養成攝影基礎知識及修整玻璃底片技巧，隔年赴臺北「富士寫真館」學習；1940 年前往中國嶺南美術學塾習畫，並在廣州與友人經營「大和寫真館」；1942 年自願入伍駐屯在廣州市郊的日本南支派遣軍，隔年遷居香港並擔任運輸業的日文顧問，隨後日本於戰爭中失利，李鳴鵰與多數臺籍人士一同受困當地集中營，1946 年才乘著英國政府租用的中國輪船返臺。25 歲返臺後，李鳴鵰於榮町二丁目（今臺北衡陽路）開設「中美行照相材料部」（後更名為中美照相器材行），迅速於臺北照相材料界崛起。1950 年代，他積極投入攝影會、講座、展覽及評審等工作；1951 年創辦戰後民間第一本攝影雜誌《臺灣影藝》月刊，刊載了許多攝影家作品、軟片應用技術及攝影評論等文章，同時致力推動臺灣攝影學會活動與影展。作為活絡臺灣攝影環境的重要推手，李鳴鵰戰後以深邃靜默的目光，關注人情風土、凝視常民生活，也積極捕捉生命面貌，影像題材多以鄉村生活、農家活動、女子容顏等為主。除了紀實攝影，他也積極吸收西方攝影美學，以編導方式將臺灣的時代影像擷取至鏡框中。李鳴鵰的影像真誠有情，重視光影變化，以獨特幾何構圖呈現所見的真實亦可見於其透視臺灣工業發展意象如水門、鐵橋墩等作品。

猶疑：彭瑞麟的兩種攝影取徑

陳敬寶
藝術研究 ｜ 2021 年

攝影必須回歸其真實任務，亦即作為科學與藝術的奴僕，並且是極其卑微的奴僕；一如印刷或速記，既不能創造也不能補充文學。讓它趕緊豐富觀光客的相本，並為眼睛恢復記憶所欠缺的精準；讓它裝飾自然主義者的書室，並放大顯微的動物；讓它甚至可以提供足以讓太空人確證其假設的資訊；簡而言之，讓它成為任何專業中需要絕對真實精確的人們其祕書與職員：這點沒有其他什麼可以比它做得更好。[1] —— *波特萊爾*

臺灣攝影家彭瑞麟，1928 年進入東京寫真專門學校，三年後以優異成績畢業。作為臺灣（在日本）正式研習攝影的第一人，彭瑞麟青年時期在攝影實踐與教育兩方面，均成就斐然；儘管作為石川欽一郎在臺北師範學校時期的得意門生，他早期其實以水彩畫作見長。

留日期間，即曾以「三色轉寫法」製作的彩色〈靜物〉作品入選「東京寫真會」的《研展畫集》，其時主要的攝影實踐，是古典紮實的肖像攝影。其風格明顯受到歐美「畫意主義」（pictorialism）轉傳至日本，被稱為「藝術寫真」的美學影響。

儘管有機會接受推薦到日本宮內廳拍攝皇室照片，或赴美繼續研習攝影；彭瑞麟在畢業後選擇返臺，旋即開設「Apollo 寫場」與攝影研習班。然而，彭瑞麟的攝影「創作」生涯，卻於 1938 年前後，約三十四歲之齡，在進行一系列近似「自然主義」（naturalism）風格的風景攝影，並再度短暫赴日習得「祕技」「純金漆器攝影」之後，「戛然而止」。1943 年，他開始學習中醫，重任教員，發表醫學論文，並於 1975 年成為日本東洋醫學會會員。

細究轉向之因，除了戰時及戰後的現實生活壓力，更核心的原因可能是，有著繪畫背景的彭瑞麟，一直在思考的「攝影與繪畫」問題。這可能也是在臺灣最早提出涉及攝影與（繪畫）藝術二者關係的質問：攝影發明之初，其作為藝術媒介的合法性，即受到像是波特萊爾這樣的重要評論家，提出嚴厲的質疑。以至於約 1885 年起，第一個自攝影內部啟動的國際性藝術運動「畫意主義」，必須向繪畫商借其形式、語彙及美學。1933 年，石川欽一郎在一封給彭瑞麟的回信中提到：

「你所思考的關於『攝影之美術價值』的問題，我想最終是歸結於攝影家如何克服科學技術的程度問題……對攝影作家來說，要創作出商業攝影或藝術攝影是他自己可掌握的……我建議你不要為上面這些事情煩惱……。」[2]

亦即，困擾著彭瑞麟的，固然是攝影作為商業與藝術之間的選擇，更有著他自己系所從出的日本攝影，上承自歐美「畫意主義」與「自然主義」，關於攝影是不是藝術或「純美術」（fine art）的提問。

有趣的是，其後彭瑞麟在二戰期間的際遇，卻他讓在醉心的「純美術」攝影之外，開展出全然不同的攝影面貌：1938 年，彭瑞麟被日軍徵調至已然成為佔領區的廣東，擔任通譯員。

他以隨身相機「近距離」拍攝日本軍人活動、演習、生活、碼頭移防的照片，並記錄了當時廣東日常的場景，包括反蔣介石遊行和軍用卡車上滿載婦女的影像。

相對「藝術攝影」之於彭瑞麟的意義：苦思攝影作為藝術媒介的定位，卻不得其解；1938 至 1941年間，他在廣東時期拍攝的照片，似乎卻成了他在「放棄創作」之後，在無心插柳的心態下，以根本未以「創作」待之的「隨拍」（snapshot）形式，「記錄」了一種臺灣攝影史上定位極為特殊的凝視：被殖民者，朝向殖民者的，回望。

1 Charles Baudelaire, *The Modern Public and Photography*, Alan Trachtenberg, editor, Classic Essays on Photography, New Haven, Conn:Leete's Island Books, 1980, p. 88.

2〈石川欽一郎私函〉，《臺灣攝影季刊》第三號，1994 年 4 月，頁 14。

彭瑞麟，風景寫真畫，新竹，約 1934，明膠重鉻酸鹽印相法，彭良岷、彭雅倫提供

彭瑞麟，移防中的日本軍人，中國廣東，1938，彭良岷、彭雅倫提供 ｜
彭瑞麟，軍人之一，中國廣東，1938，彭良岷、彭雅倫提供 ｜ 彭瑞麟，
著軍服自拍，中國廣東，1938，彭良岷、彭雅倫提供（上至下左到右）

陳敬寶於 1996 年就讀於紐約視覺藝術學院攝影系，
三年後以傑出成就獎獲得美術學士學位；2013 年畢
業於國立臺北藝術大學美術學系碩士班；目前，就
學於國立臺北藝術大學美術學系博士班。他在攝影
生涯的初始階段，就著眼於攝影藝術不同的面向。
陳敬寶以「片刻濃妝：檳榔西施」系列紀實肖像的
作品受到注目。他的「迴返」計畫，藉被攝者的文
件書寫，與擺拍式攝影來探討現實、真實與記憶的
微妙界域。「天上人間」系列則藉由拍攝與民宅比
鄰的小廟與墳墓，以「住屋」為隱喻，探討幽微的
生死學；同時將臺灣描繪為神、人與亡靈共居的土
地。近年來進行的「尋常人家」系列，則著重於描
繪記錄當代臺灣人居家生活的樣態。陳敬寶於 2008
年獲頒日本北海道東川賞海外攝影家獎，目前居住
並工作於臺灣新北市。

世界个人（Sè-kài ê lâng）

NIJ鬼島踏查日記（黃英嘉、游承彥）

藝術研究｜單頻道錄像，5 分鐘｜ 2021 年

關於攝影的研究，時常注重於「攝影師」及他們的「作品」。攝影者的典型原本有幾種，在日治時期的臺灣，可以看到如張才「見證者」、劉吶鷗「愛好者／浪蕩子」等較傳統攝影者類別的代表，我們希望再以（之前幾乎從未被研究的）陳麗鴻提出代表相館「商業類別」攝影師的重要性，再從一張當時雜誌中的飛機模特兒照片切入「被攝影者（如原住民女性）」同樣不可被忽視於攝影史中的地位，並連結至當代攝影技術與社會演變，嘗試以虛實交錯的訪談及電影手法，藉由整理攝影師典型與鏡頭之後被攝影的人與物，審視我們談論攝影的方式。

1943 年，陳麗鴻為了準備日本東洋寫真學校的入學考試，到臺北市一家照相館學習修片。畢業後，她先在松竹電影製片場實習、觀摩劇照拍攝，希望日後自己開設攝影館。隨著戰火蔓延，她回到臺灣，暫時在新店區公所工作。

1942 年太平洋戰爭爆發時，為躲避戰事，張才離開大稻埕的「影心寫場」攝影館，全家移居上海。他手持歐洲最新款照相機，遊蕩於世界列強在中國形成的半殖民地，有新穎、宏偉的城市建設，也見到街坊貧富差距的對照。

1940 年，劉吶鷗於上海遭到刺殺，留下一捲無聲家庭電影〈持攝影機的男人〉，題目向俄羅斯導演吉加‧維托夫致敬，拍攝滿州、廣州、東京與故鄉臺南的風景和生活。

本計劃以錄像裝置重構 1949 年之前，各式文獻對於三位日治末期攝影者的記載，分別探究三人對攝影的態度，及「日屬臺灣人」身份所帶來的特殊自由及限制，並穿越時空、性別，藉由一位當代臺灣攝影者的眼睛與身體，尋找當代世界中的陳麗鴻、張才和劉吶鷗所面臨相同、不同的挑戰，鏡照出攝影作為一種世界與永恆的語言，能夠穿越一切的可能性。

「Man of the world」，是波特萊爾延伸愛倫坡的想法，認為有一種人同時是「藝術家、世界之人、人群之人、兒童」，如果不能稱他們為哲學家，也許能稱為『描繪派的道德家』。這樣的人四海為家，群眾之於他們，就像水之於魚，這些人對『非我』永不滿足，他們的世界就像萬花筒。具有如此的觀看天賦已十分難得，如果還有表達能力更是天才，然而，雖然他們的靈感與觀察都來自群眾，卻不常被群眾接受。

"Man" of the (rest of the) world，無非是帶有父權與強權結構的，不過經歷時空變換，輾轉譯介成「世界之人」後，意義似乎更加開放而完整。2020 年，殖民與審查制度成為過去，攝影技術也由成本及技術程度較高的底片大幅數位化的臺灣，人民的血緣組成由原住民、漢人與各式新住民持續混合，身份認同仍然複雜，時局仍然動盪。不過可以確定，臺灣人從不只是日治時期畫報封面襯托新式戰機的原住民異國美女，一種國際權力競爭的性慾投射與籌碼。此刻，藝術家架起攝影機，詢問尚且年輕的陳麗鴻、張才與劉吶鷗，「你希望如何呈現自己？」

NIJ 鬼島踏查日記（黃英嘉、游承彥），〈世界个人（Sè-kài ê lâng）〉，
2021，單頻道錄像，5 分，藝術家提供

NIJ 鬼島踏查日記（黃英嘉、游承彥），〈世界个人（Sè-kài ê lâng）〉，
2021，單頻道錄像，5 分，藝術家提供

黃英嘉與游承彥在「NIJ 鬼島踏查日記」團隊以踏查、
研究、進行計劃型創作。2018 年參與森川里海濕地
藝術節，前往花蓮豐濱港口部落駐村，提出「眼淚搏
擊」計劃，梳理「儀式」於藝術與庶民文化的脈絡，
並反思藝術創作者姿態。相繼於港口 Cepo' 藝術中
心、關渡美術館、水谷藝術展出，並獲 2019 美術創
作卓越獎。

以更理想的姿態顯影：東南亞的攝影與華人性

莊吳斌
藝術研究｜檔案文件｜2021 年

攝影最初透過殖民主義進入後來被分割為東南亞的地域。當時的攝影師多半為白人男性，並藉由殖民統治進駐該區域。然而，殖民的機遇卻使原本視相機為惡魔的本土菁英們，得以運用攝影推展個人利益。殖民主義帶來的商機，吸引了十九世紀華人移民攝影師在該區域開設照相館（photo studio），並且／或是在當地生產攝影明信片。到了二十世紀初，他們遂成為照相館行業的主導者。根據人類學家凱倫·斯特拉斯勒（Karen Strassler）的研究，許多爪哇照相館都為廣東人所擁有。雖然廣東人看似主導東南亞攝影相館生意，部分著名的照相館亦由其他籍貫的華人攝影師所經營。最明顯的例子為瑯·阿努爾森桑索恩（Luang Anusarnsunthorn），這名混血富商在 1900 或 1901年後開設了清邁的第一間照相館，而他的其中一位祖先來自潮州。另一個例子是祖籍興化的黃傑夫（K. F. Wong），他 1938 年在古晉開設了著名的婀娜相館（Anna Studio），並在 1941 年於詩巫開了分店。黃傑夫也透過沙龍攝影成為享譽國際的攝影人。

畫意攝影（俗稱「沙龍攝影」）的國際風潮影響了該區域的藝術攝影實踐。從業餘攝影俱樂部或攝影學會的增生，可以看出此風潮的兩階段成長。第一階段發生在 1920 與 1930 年代，當時這些團體在殖民政權的支持下成立，成員主要是白人、當地菁英以及一些華族攝影愛好者。第二波成長於1950 及 1960 年代，去殖民化的浪潮將這些攝影組織的資源及領導權都轉移到了本國菁英的手裡。然而，攝影學會中最踴躍參與沙龍比賽的多為華裔攝影愛好者，其中不少人甫移民至此。藉由贏得區域內外的沙龍盛譽，他們為獨立不久的東南亞國家增加了在國際版圖上的能見度，自然引來國內菁英的注意。即使表面看來不帶政治性，當時許多華裔攝影實踐者自願或非自覺地藉由沙龍攝影涉入各種政治及社會文化活動，而各種政治勢力則藉此活動提出相異的國家願景與理念以互相競爭。

當年東南亞的沙龍攝影人參照的對象是被稱為「沙龍王國」的香港，因為香港攝影師從 1940 年代晚期開始就在世界各地的沙龍比賽屢屢獲獎。根據王梅香和李泳麒等學者的研究，冷戰時期不同的政治勢力藉由香港的特殊位置，透過各種團體和個人名義試圖滲透、影響海外華人。藉由為畫報提供圖片及稿件，或舉辦區域性比賽及展覽，香港和東南亞的沙龍攝影人無可避免地被捲入文化冷戰的角力中。

2004 年起，我著手書寫東南亞的攝影實踐。由於受訪者的慷慨捐贈，我獲得了一些研究相關的素材，包含小誌、攝影書、期刊、圖錄、展覽手冊等。2011 年起，我再藉走訪東南亞各地跳蚤市場及舊貨商，購買一些家庭相片、照相館雜物（像是照片、膠卷封套）與畫報期刊。漸漸地，我意識到我的研究和藝術創作正影響著我搜集素材的方式。2013 年，策展人阮如輝（Nguyen Nhu Huy）向我介紹了一位在胡志明市黎公橋街做舊貨買賣的潮州人，潮州人聲稱他的閣樓藏有 200 公斤的相片！他沒開玩笑。1975 年後，以及中越戰爭期間（1978-91），華人和越南人逃離越南時，並未帶上家庭相片，以致這些物件輾轉落入這位賣家手中；戰亂造成的棄置使得它們轉化為市場商品。雖然可能涉及潛藏其中的暴力，我購買並收集這些照片的目的在於重新想像這些素材最初產生

的背景緣由，以及使用時的轉化。在這位賣家的存貨裡，這些相片不一定都拍攝於越南共和國（1955-75，首都為西貢）。其中許多是在印度半島其他地區拍攝或寄出，甚至來自更遠的馬來西亞、新加坡、臺灣、中國、美國或歐洲等地。當然，戰亂離散並非這些華人家庭照片流入市場的唯一原因。我從朋友那裡得知，某些印尼華人拋棄他們在爪哇的老宅時，也把家庭照片棄置在原地，任人搜刮。

這個裝置作品展示了攝影相關素材與我近年田野調查的紀錄。攝影實踐與華人性（Chineseness）千絲萬縷的關係，自殖民時代到去殖民期間國族建構的過程中不斷演化。我用「華人性」一詞，來強調華人如何參與攝影實踐及影像在東南亞內外地區的生產、消費與傳播。同時，攝影實踐也被用來生產、呼應，甚至翻轉對於華人性的各種慾望。我用人類學家克里斯托弗‧品尼（Christopher Pinney）所說的「以更理想的姿態顯影（come out better）」，來突顯攝影人與被攝者之間交錯的慾望。他們的慾望又與國家利益糾纏，形成一種協作與對抗的動態關係，最終形塑了東南亞的國族性，以及其多元的攝影實踐。

莊吳斌，〈以更理想的姿態顯影：東南亞的攝影與華人性〉，2021，檔案文件，藝術家提供

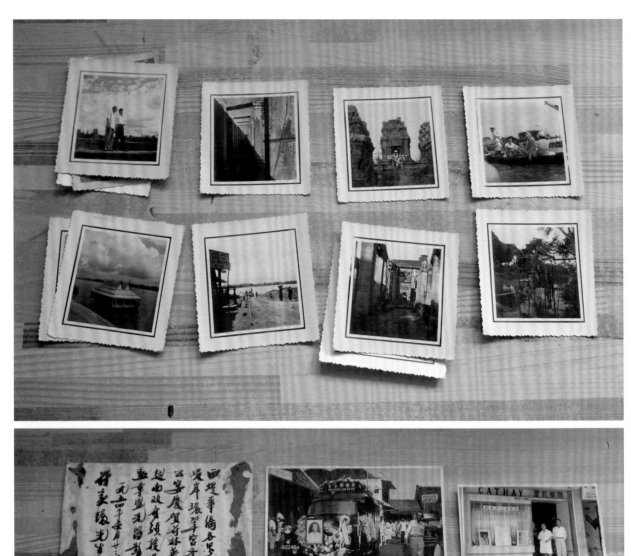

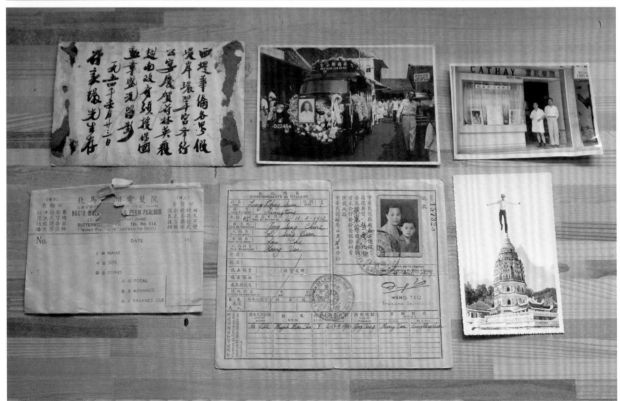

莊吳斌，〈以更理想的姿態顯影：東南亞的攝影與華人性〉，2021，檔案
文件，藝術家提供

莊吳斌，撰稿人、策展人及藝術家。他的寫作和策展計畫聚焦東南亞和香港的攝影實踐。研究主軸包含：攝影和「華人性」（Chineseness）的關係、期刊和攝影書作為書寫攝影史的場域、攝影與民族主義和冷戰之間的關連性。藝術創作則試圖以攝影和文字勾勒東南亞如何體驗不斷變動的「中華性」。莊吳斌於 2010 年獲荷蘭克勞斯親王基金頒發研究獎助金，並於 2017 年獲頒新加坡圖書館李光前研究基金，2019 年更獲得香港何鴻毅家族基金中華研究獎助金計畫的資助。他曾獲多個機構邀請參與駐村研究計畫，當中包括印尼萬隆科技大學（2013）、香港亞洲藝術文獻庫（2015、2018）以及關渡美術館（2017）。莊吳斌是《環亞攝影評論》（*Trans-Asia Photography Review*）的編委會成員之一，亦於 2015、2017 和 2020 年的清邁攝影節擔任特約策展人。從 2017 年起，莊吳斌與香港攝影空間「光影作坊」合作，策劃以東南亞攝影為題的計畫。出版品包括 2016 年由新加坡國立大學出版的《東南亞攝影概論》、2018 年由新加坡國家圖書館出版的 *Shifting Currents: Glimpses of a Changing Nation*。

Acknowledgements

感謝誌

我們對於下列個人以及機構團體表達誠摯的謝意，因為他們的慷慨支持及合作，促使本展得以圓滿且順利的完成。

We would like to express our sincere gratitude towards the following individuals and organizations for their generous assistance to the realization of this exhibition.

借展單位 Lenders to the Exhibition
國家電影與視聽文化中心 Taiwan Film & Audiovisual Institute
國立臺灣歷史博物館 National Museum of Taiwan History
林明弘 Lin Ming-Hong
徐宗懋 Hsu Chung-Mao
彭良岷 Peng Liang-Min
彭雅倫 Peng Ya-Lun
鄧世光 Deng Shih-Guang

特別感謝 Special Thanks
大塚麻子 Asako Otsuka
王信 Wang Hsin
李昭容 Li Jhao-Rong
林翊婷 Lin Yi-Ting
林志明 Lin Chi-Ming
惠康收藏館 Wellcome Collection
陳澤昭 Chen Ze-Jhao
堀川理沙 Lisa Horikawa
國立臺灣圖書館 National Taiwan Library
黃寶蓮 Huang Pao-Lian
蕭永盛 Hsiao Yong-Seng
魏德文 Wei Te-Wen
克勞汀・盧奧 Claudine Rouhaud
日德・艾蘭 Ella Raidel
陳維德 Eugene Tan
羅賓・蒙羅 Robin Munro
烏特・梅塔・鮑爾 Ute Meta Bauer

Contents

Minister's Foreword

Minister,
Ministry of Culture
Lee Yung-Te

With over one hundred years of history, Taiwanese photography has become a precious cultural asset exhibiting a great diversity of expression and unique artistic concerns. Yet at this moment, many important works of photography are in danger of being lost. The preservation of early films and photographs is a challenging task. Numerous important works have been scattered among the public, and the pressing mission of establishing a professional institution for photography and photographic culture has become a race against time. For this reason, the Ministry of Culture in 2015 launched the "National Photographic Asset Rescue and Development of a Photographic Cultural Center Project," which calls for the establishment of a center for photography, which will be devoted to research, collection, restoration, historical documentation and publications on Taiwanese photography. After many years of effort, a major milestone in this project has been reached with the establishment of the National Center of Photography and Images (NCPI).

During its trial operation period, the NCPI has invited curator and Professor Hongjohn Lin to present the exhibition *Hold the Mirror up to His Gaze: the Early History of Photography in Taiwan (1869-1949)*, which undertakes new research on the center's permanent collection. The exhibition presents the history of Taiwanese photography through various historical epochs, beginning in the 19th century then moving on to the Japanese colonial period and finally the relocation of the Nationalist Government to Taiwan. It reinspects the way in which the history of Taiwanese photography has been composed. The exhibition further examines how Taiwanese photography developed its own diversity and unique characteristics and how local photographers, through their skillfulness and self-awareness, where able to distinguish their visions from photographs produced according to the colonial gaze of Western and Japanese colonialists. Most importantly, this exhibition also presents alternative contemporary perspectives towards the history of Taiwanese photography through commissioned works from several contemporary Taiwanese photographers, who here use their creativity to reinterpret the past.

As the first exhibition of the NCPI to focus on the history of Taiwanese photography, *Hold the Mirror up to His Gaze* manifests the Ministry of Culture's efforts to clarify historical discourses on Taiwanese photography and further construct core values of Taiwanese culture. We anticipate that the establishment of the NCPI will mobilize and encourage work related to research, acquisition and collection, restoration, and exhibition, thereby allowing the discovery, preservation and research of other valuable works. Furthermore, we hope that by organizing exhibitions and publishing texts on photography, those from Taiwan and around the world will be able to appreciate fresh and inspiring viewpoints on the rich century-long culture of photography in Taiwan. At the same time, we hope to continue to explore and expand possibilities for contemporary Taiwanese photography through this new institution.

Director's Foreword

Director,
National Taiwan Museum
of Fine Arts
Liang Yung-Fei

The Ministry of Culture initiated the "National Photographic Asset Rescue and Development of a Photographic Cultural Center Project" in 2015. Through the joint effort of the National Taiwan Museum and National Taiwan Museum of Fine Arts (NTMoFA) there are now over 10,000 works in the collection. NTMoFA is also dedicated to arranging the opening of the National Center of Photography and Images (NCPI) with hopes that the institution would become a major hub for exhibiting and promoting Taiwan photography and image art as well as a site for international cultural exchange.

As the first institution dedicated to the collection, research, display, and promotion of the art of photography in Taiwan, the NCPI aims to encourage and promote discourses on photography through a diverse programme of meticulously curated exhibitions. For the first exhibition during the Center's trial period, the NCPI has invited Professor Hongjohn Lin to curate *Hold the Mirror up to His Gaze: the Early History of Photography in Taiwan (1869-1949)*, an exhibition which centers on the collection of the NCPI. The display includes over 600 treasured early photographs of Taiwan, with themes ranging from Taiwanese culture, the Japanese Colonial Period, daily life as captured by Taiwanese photographic studios, and works by the first post-WWII generation of Taiwanese photographers. The curator, tracking the trajectory of modernization, inspects power relations from the perspective of the history of photographic technologies and explores the historical context of Taiwanese photography before the middle of the 20th-century. Taking Taiwan as an historical reference point, this exhibition attempts to investigate the intertwined relationship between the photography industry and the history of world civilization, reflecting on methods of decentralizing the history of photography through writings on social and historical developments in Taiwanese society.

This exhibition not only provides an organized account of the collection of early Taiwan photography at the NCPI through richly-layered perspectives; it also invites nine artists and artist groups to elaborate on the theme of the exhibition through their practices. These new projects aim to examine topics including the history of 20th-century (South) East Asian photography, anthropological photography during the Japanese Colonial Period, and the perspective of female photographers. They are possessed of interdisciplinary qualities and an openness of artistic research and attempt to act as a supplement and extension the history of photography in Taiwan. As part of the exhibition activities, the NCPI has also arranged panel discussions and educational events on related topics, inviting professionals and academics to engage in further discussion. Furthermore, the NCPI owes thanks to the Ministry of Culture's Bureau of Cultural Heritage and the National Taiwan Museum for helping to provide a firm foundation during the museum's preparatory period. In addition, the center would also like to give thanks to all collaborating institutions and groups that have worked together in this exhibition. Their support has made *Hold the Mirror up to His Gaze: the Early History of Photography in Taiwan (1869-1949)* possible.

Illumination: To Hold the Mirror Up to His Gaze, or to Nature

Hongjohn Lin

For anything so overdone is from the purpose of playing, whose end, both at the first and now, was and is, to hold, as 't were, the mirror up to nature, to show virtue her own feature, scorn her own image, and the very age and body of the time his form and pressure.

—*William Shakespeare, Hamlet* [1]

To write the history of Taiwanese photography has to confront an impossible task. First, to write about the history, one must begin with Western cannons, models, and research methods in order reconstruct the local subject. The history of Taiwanese photography can only exist as a flexible category situated between existing disciplines as an interwoven field of knowledge. As such, one must apply ideas from sociology, *Kunstwissenschaft*, philosophy, and aesthetics to implement its historical basis. To begin the project from its nascent stage, one must first realize that history is in itself marginal. From this starting point, one must recognize an "unseen" narrative in embarking upon a discursive practice which challenges and surpasses the existing institutions. As Gayatri Chakravorty Spivak states in "Can the Subaltern Speak?" historiography is an impossibility born out of doubt. [2] As one confronts discourses on the subjectification of photographic images, technopoly, aesthetic ideologies, and even the hidden hierarchies underlying mass culture, one must allow the silence to be voiced and recognize that a marginal history can only be written from the in-between space of consciousness. Therefore, the undertaking requires observation and a degree of "illumination." One must connect and organize subtle nuances, for in the torrent of time, the ephemeral moments of history do not disappear at an even rate, nor are they presented in specific combinations; their correlations are intricate and varied. When the moments of history are illuminated and appropriately aligned, as Michel Foucault said, they "shine, as it were, like stars, some that seem close to us shining brightly from afar off, while others that are in fact close to us are already growing pale." [3]

This exhibition aims to establish Taiwan as a historico-geographical reference point, a marginal space from which to illuminate on aesthetic ideologies, histories of technologies, imperialism, colonialism, and modernization. This is not an attempt to present the panorama of history with an even lighting, but rather an attempt to probe dark historical corners and seek out the problematics embedded therein. In the 19th century, photography has neither been just a medium for artistic expression, nor has it been fully normalized for the construction of social and aesthetic ideologies. Rather, since it has been directed towards colonial subjects, it contains visual evidence of domestication and resistance and, for the legitimacy of the art system, photography has come to function as a kind of democratic "middle-brow art." [4] At the same time, in order to view the photographs of this exhibition, we must return to the original historical context to re-examine effects of the cultural translation and the production relation. In so doing, we may also reconsider the pace of globalization in that earlier time. The genuine history of Taiwanese photography should take into account these existing methods of historiographies and the troublesome subjectivity in order to present a new discourse, which is both deconstructed and decentralized.

Photography and the Problems of Writing its History

As we look back on the history of photography, we may pay special attention to the historical methods of its construction and the subjective experience of knowledge. The first systematic chronicle of "photography's history" was *The History of Photography* by Beaumont Newhall, the first curator of the department of photography at The Museum of Modern Art (MoMA). The volume became a prototype for many subsequent writings on photography. Centered on perspectives from Europe and the US, *The History of Photography* was organized according to a semi-art-historical method, which emphasizes aesthetic ideologies, stylistic categories, and the formation of a canon. By undergoing such a process of "canonization,"

photography, which had not yet been admitted as "high art," was able to enter the context of the museum. The establishment of the "history of photography" is tightly connected with photography's "museumization" and can be equated with the production of knowledge of photography as art. Most of the photographers discussed in Beaumont's history were European, with a few from Russia. As a result, this history of photography is like most histories of art of that time, in that it was based on Euro-centric discourse. With Modern Art came as the newly founded establishment of art institutions, and within this process of museumization, photography became a necessary component of any museum of modern art. After World War II, many photographers, especially those under the commission of the US Farm Security Administration, were identified as purveyors of a new "modernist photography" and thus became the major figures of this movement. Photography was socially recognized as a "mid-brow art." However Newhall's historiography is to render photography as a "high art," the unique product of cultural sensibilities, artistry, and notions of value created by an individual artist. Yet many photographers of the 19th century and early 20th century had yet to become aware of the autonomy of the medium and their identity as artists. This was evident among the pictorialist photographers of the 19th century, who imitated painting in style, composition, lighting, and themes.

In a departure from conventional "art histories," Newhall however believed the history of photography to involve developments in science as parallel to those in aesthetics. Newhall argued, "photography is at once a science and an art, and both aspects are inseparably linked throughout its astonishing rise from a substitute for skill of hand to an independent art form." [6] Once Newhall acknowledged photography's origin in technology, he went on to explain its practical applications (such as a substitute for manual technical skills, especially in portrait painting). His history of photography finds photography's origin in the period between the *camera obscura*, a machine which used the science of optics to enable a viewer to see perspective, up to the historical moment in 1839 when Louis-Jacques-Mandé Daguerre and Joseph Nicéphore Niépce invented techniques for fixing a photographic image to a surface, thereby transforming photography from a technology into an art form. Photography thus went from a surrogate for painting to a modern art medium possessed of the qualities of an enlightened consciousness, the exploration of truth, and the awakening of the self. Newhall's history of photography applied the art historical method of building a discourse based on stylistic trends and evolving aesthetics, and also emphasizing the unique identities of both works and artists. However, in more recent developments in cultural studies and sociological discourses on photography, such theories of aesthetic style, with their emphasis on "artistry" and "authenticity," have come to be seen as lacking a self-reflective or self-critical stance. Newhall's focus on analysis surrounding the work of art and the artist who produced it led him to overlook problems related to marginal cultures and the question of who actually controlled technology and science. By the same token, Newhall was unable to reflect on photography's parallel historical developments, namely the global history of colonialism. His history of photography is a meta-narrative of Euro-centric photography, a narrative that is at the same time imbued with an implied nationalism of declaring a shift in the art world from Europe to the US. As such, it suppresses opportunities for marginal voices and ignores visual representations of the colonies. As a historical discourse, it is completely depoliticized.

Ten years before the completion of Newhall's *The History of Photography,* Walter Benjamin raised the question of photography's political implications in his essays "A Short History of Photography" and "The Work of Art in the Age of Mechanical Reproduction." Through an examination of aesthetics, Benjamin declared photography to be endowed with a "subversive" character that would redefine artistic values, including originality, authenticity, creativity, and genius. He concluded with dialectic on "political art" and "politicized art," which discussed historical and social formation of mechanical reproduction art of political systems

and aesthetic ideologies. In the advent of the cinema, he uncovered similar issues, especially in the distinctions the cinema raised between popular culture and elite culture. Benjamin observed, "The reactionary attitude toward a Picasso painting changes into the progressive reaction toward a Chaplin movie...The greater the decrease in the social significance of an art form, the sharper the distinction between criticism and enjoyment by the public."[7] Benjamin defined photography's technical developments as worthy of aesthetic discussion, saying they were inextricably linked to popular culture and the general public. He noted that photography even echoed avant-garde art's aesthetics of war and violence, writing, "Its self-alienation has reached such a degree that it can experience its own destruction as an aesthetic pleasure of the first order."[8]

In a separate vein, Benjamin's writings also discussed the ontology of the photographic image, which included the way it was able to fabricate stories through editing and how it changed in our ways of seeing. On the topic of "aura," he brought forth the unique aesthetic experiences of reality of both the individual and the collective. Discussing the photographs of Eugène Atget, for example, Benjamin wrote, "They suck the aura out of reality like water from a sinking ship. What is aura, actually? A strange weave of space and time: the unique appearance or semblance of distance, no matter how close it may be."[9] Benjamin recognized that photographs, though made by men, had the powerful sensibility of "objects," and that their degree of "virtuality" far surpassed that of "handcrafted" art. He proposed that photography (and other technologies of reproduction) had the capacity to extract aura from reality and then construct new and different possible realities—an argument far removed from Newhall's analysis of photography and its history. Going even further, Benjamin's discussion of the history of photography proposed various possibilities, including a mysticism of political aesthetics and photography's wide, pubic dissemination as a means of democratizing art. This is not an art history of artists or artistic styles, but one that rather begins from ideological structures of art to tell the destiny of photography. Benjamin's writing is a historiography of genetics and genealogy.

Photography: A Middle-brow Art, published in 1965 by Pierre Bourdieu and his research associates sees photography as a democratic means for the masses. Bourdieu's sociological method set out to examine photography, cameras, and amateur photographers in certain specific regions in order to establish photographic activities as a part of consumer behavior in everyday life. He discovered that most photography, especially amateur photography, is an artistic practice situated precisely between refined and vulgar notions of culture, between utilitarian purposes and emotional projections. This may be common sense, but it is also precisely the opposite of Immanuel Kant's concept of aesthetic experience.[10] In particular, Bourdieu placed emphasis on cultural habits (*habitus*), which within a cultural field accumulate and inherit information, becoming like subconscious tendencies. Culturally conditioned emotions (*ethos*) meanwhile act as a sort of centripetal force, which brings about cohesion within particular social groups. Bourdieu thus focused on photography's historical trajectory and development within various cultural contexts. From this perspective, photography becomes an art practice in which all members of society may participate, though its tastes and aesthetics can only be seen to range from the purely utilitarian to broadly shared emotions. The concept of "high art" is completely absent from Bourdieu's analysis; he merely points out that photography by its very nature must exist as a mass activity, and the necessity that clubs, associations, groups must ascribe photography to its artistic values.[11]

The work to best following up Bourdieu is probably Allan Sekula's 1975 essay "On the Invention of Photographic Meaning." Sekula focused on the development of an "interpretative community" within Western photography, saying that by responding to issues of modernity raised since Baudelaire, photography gained its meaning and could thus be identified as the starting point of photographic Modernism.[12] Sekula conferred affirmation upon early 20th century photographers,

from the "straight photography" of Alfred Stieglitz to the "documentary photography" of Lewis Hine. With these photographers, the social character of their images stemmed from the autonomy of the medium. Photographers were now "witnesses" and "seers" of a society, and photography became a fully self-consciousness art form.

From Newhall's history of photography, Benjamin's neo-Marxist historical materialism, Bourdieu's reflexive sociology, and Sekula's theory of an interpretative community, we may build a quadrant in which photography carries its social aesthetics in different signification. On one hand, photography may exist for an audience of elites as a form of high art, an art practice endowed with aesthetic meaning and *poiesis*, "coming into being." On the other, photography is a social practice silently conducted by a multitude of anonymous "artists," who nonetheless exhibit a powerful influence towards their elite counterparts. To write a history of photography in Taiwan, one must account for the dialectical relationships and intersections between these two groups. Yet the discourse of the "history of photography" is always presented with certain problematics, as we must return to "Taiwan" as a reference point for its writing. These problematics include issues of how photography existed as a professional practice, how it was regulated by authorities, who held control of its science and technology, which segments of society engaged in it, and how it was bound up with Euro-American centric aesthetic ideologies. By addressing these questions directly, we may attain a position in which a true history of Taiwanese photography can be told by the local, and further reveal the impossibility of the "writing" itself.

On the Cultural Translation of Photography

Most would agree that photography began with Daguerre's invention of the Daguerreotype. However, this notion is in part the result of the clever management of Daguerre's legacy by various public institutions and the "Daguerre mania" which spread across Europe. In fact, Daguerre's invention did not bring forth the birth of the first photograph. Even words such as "photography" and "photograph" have earlier origins and underwent numerous transformations. Niépce had knowledge of photographically engraved printing plates in the 1820s and produced the earliest fixed photograph image. In 1827, Niépce produced the photograph *View from the Window of Le Gras*. The exposure time at this stage was very long—ranging from eight hours to several days—and Niépce named his technique "heliography," from *helios*, meaning "sun," and *graphein*, meaning "writing" or "sketch." Before Niépce's death in 1833, he had discovered that photographic images were not in fact produced by the sun, yet he still preferred using the term "heliography" to refer to his process. The commonly-used term "photography," which literally means writing (-graphy) of light (photo), was proposed by British astronomer John Herschel in his paper, *Note on the Art of Photography; or the Application of the Chemical Rays of Light to the Purpose of Pictorial Presentation*, which he presented at the Royal Society on March 14 1839. It is the first document in which the term "photography" is employed according to its current common usage. Also appearing in Herschel's report were other photographic terms commonly used today, including "positive," "negative," and "emulsion."[13] Some years later, in a letter to William Henry Fox Talbot, Herschel explained that he chose "photography" over Talbot's preferred term "photogenic drawing," because "photogenic" carried a different meaning in other scientific fields.

Although as early as 1833, Hercule Florence, a Frenchman living in Brazil, used terms such as *"photographie, ou impression à la lumière"* (photography, or an impression of light) in his notes, his personal notebook was not widely circulated. When the French government purchased a patent for the photographic process on June 15, 1839, the term "photography" was not used in the patent. What was used instead were terms like "light, events preserved by sketches" and "Daguerre Process." One can see that "writing with light" (i.e. photography) had not yet come into common usage. In French newspapers, including *Le Temps*, *Gazette Nationale*, and *Le Moniteur Universel*, the term *"photographie"* begins to appear from August 1839, but then word did not yet have a

fixed usage and was used interchangeably with "photogenic drawing." Talbot, who first proposed the term "photogenic drawing," used both "photogenic drawing" and "photography" in his 1844 book *The Pencil of Nature*. In the introduction, Talbot noted that the term "photography" had already become popularized, writing, "The term 'Photography' is now so well known, that any explanation of it is perhaps superfluous."[14] Based on a survey of commonly used terms in newspapers, reports, and other writings, Herschel's term "photography" became widespread no later than 1839, though "Daguerreotype" continued to be used when referring to Daguerre's particular photographic method. Other less frequently employed terms included "Talbotype," denoting the positive and negative photographic processes invented by Talbot, and "Calotype," meaning "beautiful impression." By the time daguerreotypes had been replaced by the wet plate photographic process in the 1860s, "photography" and "photograph" had become the generic terms for picture-taking and the images created through photography.

Around the same time, Western colonialism spread the fad for daguerrotypes throughout Asia. In 1844, Jules Alphonse Eugène Itier produced daguerreotypes in China and India. Between 1853 and 1854, Eliphalet Brown Junior, a photographer on the ship of commodore Matthew Perry, also produced daguerreotypes. In the 1860s, a number of European and American photographers opened photography studios in the coastal cities of China and Japan. The concept of "writing with light" was not however transferred into the Chinese translation of "photography," *sheying*. The Chinese term's literal meaning emphasizes the "intake" or "absorption" or "capturing" (*she*) of an "shadow" or "reflection" (*ying*). This is similar to its counterpart in the Taiwanese dialect, *liap-iaan* (攝影). Although some discussion of optics appears in the texts of Chinese philosophers, including the writings of 4th century BCE philosopher Mozi and then in the 11th century in *Dream Pool Essays* by Song Dynasty scholar Shen Kuo, pictograms used to refer to an "image" were only vaguely defined, and the idea of "capturing" an image was not to be found. In pre-Modern Chinese, the vocabulary used to refer to images includes *ying* (影) which was used interchangeably with *jing* (景) "scene" or "view," as well as *xiang* (像), meaning "picture," "image" or "likeness." The contemporary term for a "photographic image" is a combination of these two characters, *yingxiang* (影 像). In the 19th century, Cantonese inventor Tsou Pai-Chi took inspiration from *Mengxi Essays* (夢溪筆談) when he wrote the short article "Notes on Photography Equipment"(攝影之器記) which describes his own attempt to build a *camera obscura*. Tsou writes, "I attempted to make a tool for capturing images using a wooden box with a hole cut for the placement of a converging lens." As he goes on to describe how the camera obscura functions, he includes drawings and diagrams. But he does not mention any processes related to exposing, developing or fixing an image, as in a daguerreotype. In 1846, a regional official named Chou Shou-chang (周壽昌), mentioned daguerreotypes in his *Miscellaneous Stories of Guangdong* (廣東雜述): "One way of making a small picture, one would sit on a platform, facing a mirror placed to the east, the technician would capture the scene from the sunlight, a small amount of solvent was applied to the surface, the image placed atop the mirror finish, and sealed so air could not seep in. A moment later, the face and clothing of the subject appears with features that have a high resemblance to the sitter, and it exceeds any painting. For as long as the mirror remains undamaged, the image will remain for a long time." The "mirror" referred to in this passage is a daguerreotype, and "way of making a small picture" refers to photographic technique. We may also note that this text makes no reference of any fear among local people towards having their pictures taken, nor that they worried that the camera was an instrument for "capturing the soul." Another etymological path of the Chinese term *sheying* in evolving its meaning from "image capturing" to "writing with light" derived from Japanese, which borrowed the classical definitions of Chinese characters in translating newly imported, modern concepts from the West. Common examples include words such as politics (*zhengzhi*), law (*falu*), economy (*jingji*), and art (*yishu*). Their importation

into the Japanese language came according to a system known as *rangaku* (蘭學), literally meaning "knowledge from the Netherlands" and by extension "knowledge from the West." The Chinese word *sheying*, or "image capturing," was probably a borrowing of the Japanese term *satsu-ei* (撮影) (photography) or *satsu-ei-jutsu* (撮影術) (photographic technique). As both these Japanese words imply "to capture" or "to obtain," their literal meaning is closest to that of "capturing an image."

We should also note that in Japanese, an even more common term for photography is *sha-shin* (写真), "writing reality." This term finds its origins in classical Chinese poetry and incorporates the meaning of both "writing" and "painting." In *Poem Praising the Beauty's Love for Painting* (詠美人愛畫詩), Emperor Jianwen of Liang Dynasty (梁文帝) wrote, "However, these are merely depictions, who can tell reality from its likeness (写真)?" And Du Fu, in *Ode on a Painting to General Cao* (丹青引), wrote, "The spirit has flown through the general's stunning painting skill, and he would only paint portraits (写真) for a genuine literati." *Rangaku*, which rose during the Edo Era, encompassed Western knowledge on medicine and science, humanities such as politics and philosophy, and also art and photography. The influx of Western knowledge was a key to Japan's modernization and its "importation of Europe to Asia." In 1799, On Western Paintings by rangaku artist Shiba Kokan wrote, "The purpose of paintings in the East is the appreciation of the intangible qualities of objects. Therefore, if a painting does not capture the inner reality, it would be far from outstanding and cannot count as painting at all." It is an example of how *sha-shin*, or "writing reality," had previously been considered as an aesthetic principle for painting and portraiture. When the *camera obscura* was introduced in Japan, it was also translated as *sha-shin-kyou* (写真鏡，しゃしんきょう), or "mirror for writing reality." The daguerreotype, invented in 1839, was translated phonetically after its English pronunciation, *dagereotaipu*. Sometimes it was also referred to with the characters *yin-ei* (影印), meaning "the printing of an image." Once the daguerreotype was introduced, it spread quickly throughout all of Japan. Since most photographs were portraits, "photography" gradually became synonymous with *sha-shin*, and so "writing reality" also came to mean "producing a photographic portrait."

By examining the term "photography" and cultural translations across different cultures, we can see how the term carries different connotations in various Western countries. Yet in all of them, we find names that cast certain expectations towards the first mechanically reproduced art form. "Heliography," "photogenic drawing," and "writing with light," i.e. "photo-graphy," all describe an artificial technique of reproduction, which distinguishes itself from earlier forms of printmaking. From the 1820s to the 1840s, many different names for "photography" appeared in France and the England, but all embodied relationships between humans, nature, and art (the next section of this essay will elaborate on this idea further). In Chinese and Japanese language cultures, the translation of "photography" into *sheying* (capturing images) and *sha-shin* (writing reality) involves varying degrees of "creative ambiguity," as in Chinese and Japanese, it was simply impossible to make a literal translation of "photography" in the sense of its original meaning of "writing with light." Language systems are in fact filled with such lacunae, or gaps, such that these individual linguistic systems are unable to achieve consistent meanings from one to another, much like the polyglot from the Tower of Babel. Perhaps it is owing to this kind of "un-translatability" that within each cultural-linguistic system we can find a unique subjectivity, a sort of national or cultural character, which embedded the syntax within its own system. The "un-translatability" among these various forms of the term "photography" carries the cultural subjectivity, which in turn protects and preserves them.

While transfers between language systems may have exhibited certain inconsistencies, photography as an industry marched around the world in step with the global capitalism initiated by colonial empires. From 1839 onwards, photography becomes a prime example of a globalizing industry. In post-Meiji Japan, photography was seen as an indication for modernization. With the opening of daguerreotype

studios, the popularization of portrait photography, and the widespread circulation of postcards and printing, photography in Japan flourished. This period also saw the start of Japan's photographic industries (equipment manufacturers such as Fuji and Konica) and the establishment of colleges of photography (the Photography Training Center in 1894, the Photography Training Center for Women in 1902, the Konishi Professional School of Photography in 1929, and many more). From the mid-19th century onwards, Japan's photographic industries became integrated into a global industrial chain, well connecting to those in Europe, the US and Australia. The Japanese government also realized photography had numerous practical applications, and found uses for it in anthropology, cartography, engineering, and the military. It was during this period that Taiwan, owing to the needs of geographical surveys and the establishment of military posts, became a subject for Japanese photography. As such, later with anthropologists' photos, Taiwan came under Japan's regime of "visual governmentality."

To Hold the Mirror Up to His Gaze

Following the invention of the daguerreotype, photographers from Europe and the US started traveling to East Asia and Southeast Asia to take photographs. In Japan, Eliphalet Brown Jr., a member of the Perry Expedition, took over 400 daguerreotypes, though only five of these remain, as the rest were destroyed in a big fire.[15] Most of Brown's images however survive as lithographs, which were adapted by the fleet painter William Hein. Perry's fleet visited Taiwan, and many researchers on the history of Taiwanese photography speculate that photographs of Taiwan were taken during that visit. Following the 1858 Treaty of Tientsin, four trade ports were opened in Taiwan—Anping, Tamsui, Takao, and Keelung—and missionaries and businessmen might take photos of Taiwan. Little have there been discoveries of such daguerreotypes, Chou Shou-Chang's "small pictures" nor documents relating to Japanese *rangaku*. It's worth mentioning here that a daguerreotype is a single sliver plate with a mirror-like surface imprinted with an image, not transferred or printed as with the negative process. Exposure and developing of the image was a complicated process. The plate had to be pre-treated, exposure produced an (invisible) latent image, and this image was developed with fumes of mercury vapor. As a unique print, any subsequent reproduction was done by hand, with a draftsman copying the image and reproducing it as a woodcut or lithographic print before the 1870's. Although many researchers speculate on the plausible beginning of Taiwan's first photographs, their findings all point to an inconvenient truth: outside of Europe, photography and its industry was a part of colonial expansion of Western imperialism with the deployment of political, military, and economic power. Furthermore, photography was conceived as a means of obtaining knowledge of the other, and this is especially true of 19th century Western colonialism in East Asia and Southeast Asia. Early images of Taiwan, or more accurately, "photographs that were taken in Taiwan," were nearly all done by foreign visitors. These photographers from the UK, France, US, and Japan mostly traveled from ports to the inland areas as a visual intrusion. Their photographs gaze at "Taiwan" as "otherness," and the colonial visuality is embedded with interests of technology, imperialism and Euro-centrism.

In the late 1860s, collodion wet-plate process had replaced daguerreotypes. John Thomson's photography from this time includes pictures taken in Malacca, Myanmar, Thailand, Vietnam, Hong Kong, Macau, and China. These include a significant quantity of images of the lives and customs of Han Chinese, and in 1871, Thomson began photographing Taiwan's indigenous people at the suggestion of James Laidlaw Maxwell, who accompanied him on his travels. Although the Qing officials wanted Thomson to include images of the Han Chinese, Thomson also insisted on taking pictures of Austronesian peoples and cultures (fig.1). Thomson arrived in southern Taiwan at Kaohsiung and stayed in Taiwan for 16 days, traveling with heavy cameras and darkroom equipment and taking over 50 images. In 1875, Thomson published *The Straits of Malacca Indo-China and China, or Ten Years' Travels,*

1 John Thomson, Natives of Baksa, Formosa [Taiwan], 1871, approximately 10.5 x 21.5 cm. Credit: Wellcome Collection. (CC BY 4.0)

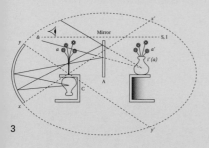

2

	NAMES OF TRIBES					
English	Pachien	Sibucoon	Tibolai	Banga	Bantanlang	Singapore Malay
Man	Lahua	Lamoosa	—	Sarellai	Aoolai	Orang
Woman	Atlain	Maau-spingth	—	Abala	Abala	Prampaun
Head	Bangoo	Bungoo	Sapchi	Kapallu	Kapallu	Kapala
Hair	—	—	Ngaoon	Uaaloi	—	Ramhut
Tooth	—	—	—	—	—	Gigit
Nock	Goon-gorath	Nipoon	—	Oorohu	Oorohu	Leher
Ear	Charunga	Muttoo	Nguchu	Charinga	Charinga	Talinga
Mouth	Musaoo	Kanum	Muchen	Didisi	Munu-myxooi	Mulnt
Nose	Ngoon-goro	Tarima	—	Cosmonu	Ongoho	Idung
Eye	Oomitih	Klatpa	Ramucha	Macha	Macha	Mata
Heart	Takaru	Pinasaan	Sapchi	Kaaso	Tookuho	Janteng
Hand	Raanocho	—	Tiangigya	Arema	—	Tangpn
Foot	Sapatl	—	—	Taapku	Amoo	Kaki
Thigh	Bannen	—	—	Danoosa	Laloobe	Panh
Leg	—	—	—	Tiboo-saboaa	—	Betis
Knee	Anasatoo	Khap	—	Pookuro	Sakaho	Lfttut
Leopard	Lakoti	—	—	Likalao	Rikoniko	AnimauKambang
Bear	Chumutu	—	—	Choomam	Choomal	Bruang
Deer	Putooru	—	—	Silappu	Caliohe	Rusa
Wild hog	Aroomthi	—	—	—	Babooy	Babi-outan
Monkey	—	—	—	—	Mararooko	Monyet
Rice	Okin	Turhook	—	Turkook	Kehe	Kambing-ootan
Fowl	—	—	—	Danil	Turkook	Ayam
House	Baswera	Titan-garchu	—	Tiral-sabahi	Danil	Ruma
Chief					Tallai	Rajah
Cassin				Tara-inni	Taroo-lahirui	Bolah
Tea	Kuaang			Lang-lang		Kfilit Manas
Cooking pan					Palangu	Daun Teh
Pumpkin				Tangu-tangu		Kwali-Masak
Fragrant					Anaremu	Labil Fringgi
Rice				Curao	Chiluco	Wangie
Rice boiled	Ozaro	Sapooth	Pooju	Apoofu	Ba-ooro	Bras
Fire	Apooth	Mumum	Choomai	Achilai	Apooy	Nasi
Water	Satiloon	Paklia		Tarra	Achilai	Api
Ring	Tujaoa			Chin-gari	Mata-na	Ayer
Ear-ring		Push-toana		Ululle	Anag-choy	Chin-chin
Bracelet	Pitoka	Kaconan		Ang-choy	Isaalse	Krabu
Pipe	Katsap	Pavak-sapum		Guang	Ang-choy	Goling
Gun	Takltito	Shiddi		Amalin	Guang	Pipa
Skin jacket	Nicaroota	Tamoking		Ttara-pung	Carridha	Sanapang
Cap	Sarapna			Seama	Torro-punge	Bajo-koulet
Letter		Khosalt		Uburon	Unaome	Topie
Smoke	Worfkooro					Asap
By-and-bye	Choslen				Chunana	Lagi-sabantar
Warm	Machechu			Mechechi	Mechechi	Panaa
Cold	Matilku			Matilku	Mafilku	Sajuk
Rain					Maisang	Ugan

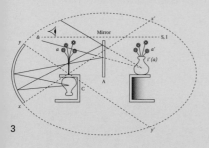

3

2 John Thomson's *The Straits of Malacca
Indo-China and China, or Ten Years' Travels,
Adventures, and Residence Aboard* (1875)
contained the photographs from ten days
of travel through Taiwan. I Form 1 John
Thomson's *The Straits of Malacca Indo-China
and China, or Ten Years' Travels, Adventures,
and Residence Aboard* (1875) also contains
a chart comparing indigenous languages,
including the vocabulary of the Bunun, the
Tsou, and other groups. I 3 Lacan's concave
mirror experiment. Image source: W. W.
Norton & Company

Adventures, and Residence Abroad (fig. 2, form 1).[16] Addressing the reader, he introduces his volume as follows:

> I have endeavored to impart to the reader some share in the pleasure which I myself experienced in my wanderings; but, at the same time, it has been my care so to hold the mirror up to his gaze, that it may present to him, if not always an agreeable, yet at least a faithful, impression of China and its inhabitants; and of the latter, not only as I found them at home on their native soil, but also as we see them in our own colonial possessions. [17]

In this passage, the "mirror" refers to the viewfinder of Thomson's camera,[18] while "his gaze" indicates the gaze of a Victorian reader in London. "Its inhabitants" refers to the colonial subjects of "The Empire on Which the Sun Never Sets." Thomson stated: "it may present to him, if not always an agreeable, yet at least a faithful, impression of China and its inhabitants."[19] In fact, the point of view of Thomson's photographs can never be neither faithful nor agreeable, which represents an imperial gaze with all of its implications of Western cultural bias and racial hierarchies. In Thomson's photographs, we may detect the Victorian Euro-centric attitude that regards a society is hierarchically constructed. As a professional photographer, Thomson derived income from publishing photographs and books, and he also received some sponsorship from Britain's Royal Geographical Society. After his voyages through Asia, Thomson went on to publish *Street life in London*,[20] which centers on lower classes and social outliers in British society. In the book's introduction, Thomson makes a mention of Formosa. By making a parallel comparison between London street urchins and Formosan aborigines, we can see Thomson's photography reveals the hierarchical relationship from a society to the world, and how this periphery includes both those excluded from the empire and those who exist in the margins of its own society. In this approach, we find Thomson taking and classifying visual samples in a process by which the other is transformed into an "object of desire." However, when in Thomson's photographs, this "other" returns his gaze, the positions of subject and object become reversed, and what is revealed is the "ideal ego" of the photographer and his implied readers, or more broadly, of the self which sits at the center of the colonial gaze. Because a photographer always desires a photogenic subject, there will always exist a political economy of desire between the photographer and the photographed: How can we see? How can we be seen? In the interpassivity of desire there is always the visual evidence well kept in photography.

Jacques Lacan mentioned in his psychoanalysis that the "ideal-I" refers to the self within the image relationship with the imaginative desire of the self. In his concave mirror experiment (fig. 3) to depict the relations between the subject and the gaze, when the flower and vase, which were originally separated, are viewed with the mirror held up to a certain angle, the viewing subject ($) looks toward the virtual image at the back of the concave mirror, which presents the reflection of the flower in a vase. The plane mirror becomes the main visual threshold of the Other, while the subject will also see the image in the mirror, which is the image of the "ideal-I." [21] Photography is a perfect example of the mirror subject in its extensive inclusion between the Other and the desired object, involving the "scopic drive" that reflects and refracts a curved image of the subject and object. Here in Thomson's photographs together with the most of Taiwan's photographs in the 19th century, to hold the mirror up to the gaze of "the other" in turn show to the "ideal I" and ego ideal , which involves the intersubjectivity amid the subject of desire (or the subjected desire), presenting the technological and imperial gaze, as well as the structure of seeing as an expression of power.

While Taiwan was under Japanese colonial rule, Japan adopted Western modernization approaches that led to rapid advancement in terms of industry and production as well as the use of images. At the time, photography studio

licenses and the supply of photography materials were under strict control, and there were photography studios with Japanese owners in almost every town and city, as well as a few that were opened by Taiwanese owners. By the late years of World War II, the intelligence department of the Japanese government started issuing "photographer licenses." All these measures indicate how the Japanese cautiously viewed photographic information as a part of the state system and as a visual tool for differentiating between the self and the other for a military purpose. Photography allowed for a type of image governance that marked out identity and difference. At the same time, photographs taken of Japanese sitters were in some ways a form of "selfie." Subjects wore Western fashions, and the images displayed the Japanese desire to "depart Asia for Europe," which is the typical "ideal-I" of Japan at the time. The first few pages of *Taiwan Shashin Cho* ("Taiwan photo albums") mostly display pictures of the military or politicians. Crown Prince Hirohito's album of photographs Imperial Visit and various family photo albums of the Japanese were filled with images of the modernized Japanese, the "ideal-I" of Asian Empiricism (fig. 4).

In this exhibition, *Hold the Mirror Up to His Gaze*, the first leitmotif lies in the economy of desire within the distinction of the self and the other in the frameworks of "photographing," "the photographed," and "self-seeing," while also including the expression of photography and the history of technology. It's worth noting that because photography techniques in Taiwan were essentially "third-generation photography," so the display mainly consists of the implements of collodion wet-plate and dry plate processes. The photography during this time was mostly connected with fields such as publication. The circulation and exchange of images was faster than in the era of daguerreotypes. As such, photography became more intimately connected with the commerce and the market economy. Images were transformed into media and became a tool for shaping collective aspirations and the object of economic and cultural operation. The publication of photographic albums is one example. Moreover, the "man with a camera," by showing the photogenic aspect of the photographed subject, tell the motive and intension of how the subject wants to be seen. Since the exposure time may reach over 10 seconds (long exposure was a limitation of the collodion process) and that dark room developing is required to be carried out immediately, extended preparations made it necessary for aspects such as composition planning. Of course, most photography objects and photography methods require extensive planning beforehand. For whom and for what are we holding the camera mirror up to so that "the stolen shadow" (*Der Geraubte Schatten*)[22] becomes the subjective "looking awry" of desire? This is the network of mutual-subjectivity that is archived in the early images of Taiwan.

To Hold the Mirror Up to Nature

Thomson stated that "to hold the mirror up to his gaze" was a response to Western readers. "His gaze" refers to the eye of the colonizer. However, Thomson's statement was inspired by a line from Shakespeare's Hamlet: "to hold, as't were, the mirror up to nature." The pronouncement "to hold the mirror up" precisely encourages an intertextual reading. In the play, Prince Hamlet investigates the "truth" of his father's murder by way of the "theatre arts." The play asks the actor to enact the role faithfully and present the acting skill naturally without over-acting. This is the "diegesis" aspect of the play. However, in its "extra-diegesis," isn't Shakespeare's statement, "to hold, as 't were, the mirror up to nature" a statement that "theater" offers a reflection of "nature" through art? In other words, "to hold, as't were, the mirror up to nature" is Shakespeare's personal poetic statement and searches for truth through the "art" of Prince Hamlet. In Martin Heidegger's philosophy, art has the ability of *aletheia* in making the truth that is concealed. In that case, what will be the poetic "truth" of photography?

As an "artificial product" of mechanical reproduction, photography is a technology that is completely unnatural, and its biggest challenge is to show nature as the rest

4 Photographer Unknown, *Photo Album of the Crown Prince's Visit to Tainan*, 1914-1915, 22 × 30 cm. Collection of National Center of Photography and Images

"natural" media such as a painting and a sculpture. Since 1839, photographers have always tried to avoid the artificial aspect of mechanical simulacrum. "How can nature be re-constructed from artificial mechanical reproduction?" has always been an underlying anxiety for photographers. Niépce called his photographic technology "heliography," while Talbotypes were called "photogenic drawing" or "nature-painted-by-herself." Even terms in use today, like "photography" (writing with light) convey deep aspirations towards the medium for simulating the aura of nature from the truth.

In 1889, British photographer Peter Henry Emerson published *Naturalistic Photography*, which advocated ways of making more "natural" images rather than the mechanical images of rigid lines and contours with mathematic precision. Emerson stated that the best photographs are those closest to what meets the eye, and not the "art photography" proposed by Henry Peach Robinson and Oscar Rejlander, whose works attempted to approximate painting in its themes, perspective, and composition. Emerson took inspiration from optics and emphasized that since the human eye concentrated on the middle field of the vision, photography should imitate what is seen; therefore, he adjusted the lens to be slightly out of focus, creating an aesthetic blurry effect. Emerson's "naturalistic photography" eliminated the mechanical qualities of his images, and his style gained popularity. However, two years after the publication of *Naturalistic Photography* (1891), Emerson wrote another pamphlet titled *The Death of Naturalistic Photography*, retracting his claims concerning photographic poetics. "The limitations of photography are so great that, through the results may, and sometimes do give a certain aesthetic pleasure, the medium must always rank the lowest of all arts, lower than any graphic art," he wrote.[23] Emerson's disillusion towards photography stemmed from the fact that using photography to show painting's expressions was a contradictory poetic statement in itself.

Alfred Stieglitz however believed that photography held the same potential for uniqueness and originality as other traditional artistic media. He viewed photography, "not as the handmaiden of art, but as a distinctive medium of individual expression." [24] On the uniqueness of photography, Stieglitz quoted Emerson in his essay, "The Photo-Secession." Stieglitz declared that the mechanical beauty of photography was its "nature," and thereby the "retouching"[25] of its optics was unnecessary. This mechanical beauty is most prominent in Stieglitz's 1907 photograph *The Steerage*, in which the spatial perspective is destroyed by the gangplank, which adds to the compression and density of the image, while the stairs, mast, and upper and lower deck separate the composition into different areas. Stieglitz believed photography to be an art that progressed with the times, and *The Steerage* was like a Cubist painting and a represented work of "straight photography." In an age where handheld cameras prevailed, Stieglitz became an advocate for their aesthetics. This marked the beginning of the US Photo-Secession group of the early 20th-century. Other photographers included those led by Frederick Evans, a group who embraced the unique aesthetics of photography and advocated a "pure photography."

Photography modernism can be defined as the artistic awareness of the uniqueness of the medium and a quest for its autonomy. Like other modernist movements at this time, photography is a poetic device capable of awakening one's potentiality in art as the self-consciousness. Stieglitz made the following statement: "I was born in Hoboken. I am an American. Photography is my passion. The search for Truth my obsession."[27] The man with a camera is a "*homo techne*," essentially an artist capable of creating and using tools. Photography is the practice of "individuation," an ontological dimension for the self-consciousness, amid the coexistence of technology and art, altogether conveying the spirit of the times.

The trajectory from Shakespeare via Thomson to modernist photography brings us to the period when Taiwanese modernism started to sprout. It coincided with the era in which the "man with a camera" began to have self-awareness towards the medium. With professional photographers and amateur photographers alike, their works all ask the subjective, self-reflexive question, "Who am I?" The exhibition

Hold the Mirror Up to His Gaze is an attempt to explore the second leitmotif. Through the practice of "individuation" among artists with technology, the curation aims to open the paths of the unique modernization and modernism of Taiwan. In the lens of the likes of Peng Ruei-Lin, Chang Tsai, Hong Kong-Da, Deng Nan-Guang, Lee Ming-Tiao, Long Chin-San, and etc., the first wave of Taiwanese photographers tells identity and how they perceived worlds around them. The practice of photography reveals how the viewing subject develops a social "semi-participation," and how the mechanical gaze turns into images of the times. When Taiwan in the junction of tradition/modernity, relocation/migration, foreign land/home, and colonialism/postcolonialism, photographs capture these fleeting moments, witness shifting social scenes, and write the histories otherwise.

Documents, Memory, and Archive Fever

Photographs are essentially documents. On one hand, each photograph must face its own transformation into an archived document, and on the other hand, it must face the process of becoming a discourse of the other. Photography aims to preserve the vanishing "aura" of people and events. Each photograph's existence involves the quality of time, and as such is an exosomatic memory, which eliminates the quality of immediate reality of people, events, and objects, while at the same time maintaining the record of the temporality. In this respect, photography is the epitome of what Bernard Stieglitz calls "tertiary retention." In its political aspects, photography symbolizes the potential of documentality in witnessing and preserving evidence. The reason photography is able to resist the power of "governmentality" and "biopower" to erase memory lies in the fact that photography is a mechanical art rather than an artificial writing.

In *Archive Fever: A Freudian Impression*,[28] Jacques Derrida proposes the contradictory meaning of archives: "Both in the order of the commencement and in the order of the commandment. The concept of the archive shelters in itself, of course, this memory of the name *Arkhé*. It's sheltered by and from this memory, which comes down to forgetting as well."[29] The word "archive" originates from the Greek word "*Arkhé*," which means commencement, though it held the opposite meaning of "commandment." Derrida's "archive fever" (*Mal d'archive*) finds its ambiguous meaning in these conflicted definitions. Here, archives are not repeated operations under the governing logic of the powers that be, nor various differences, but "différance." "Archive fever" involves the qualities of "location" and "space." In Derrida's analysis, "*arkheion*" referred to the private house of an administrant, a place where documents and archives were stored, persevered, arranged, and protected. It therefore represents the in-between space of private and public spheres. The "domicile" is the place of "domiciliation" of the archives, the original site of "archive fever." In theories of psychoanalysis, the "domicile" is the location where the basic operations of the subconscious are stored; it exists in the primary scene of the Oedipus complex that psychoanalysis emphasizes. Moreover, the word *unheimlich* (uncanny) is pieced together from *un* ("non") and *heimlich* ("home" or "homelike"). The familiar and comfortable home thus becomes uncanny, strange, and eerie.

"Archive fever" is a "contradictory" writing, a concept that Derrida developed from the memory system of writing, cognition, and the (sub)conscious in Sigmund Freud's article "*Notiz Über den Wunderblock*" (Notes on the Wonderpad).[30] The "*wunderblock*" is a children's writing pad that allows repeated writing and erasing; the writing on its first layer is clear, identifiable, and erasable, but the traces of writing is left in the second layer, layered and unrecognizable. In the eyes of Freud, the writing of the "*wunderblock*" reflects how the memory system of perception works and the format of its writing is situated between a blank paper and blackboard. In wunderblock, the traces left behind by writing are preserved, while the operation of the subconscious is to select different memories between forgetting, remembering, and exosomatic memory. This is a sphere invested with "libido," filled with writings

that can be altered, destroyed, and delayed, which the chaotic death drive infused.

In this respect, Aby Warburg's *Mnemosyne Atlas* is precisely an "archive-fever-ish" discourse that reviews human images. In truth, the invention of the technology of photography (exosomatic memory) is the reason Warburg's project was possible. The 63 black display panels showcase densely-packed images of visual evidence, ranging from ancient Greek art to countless pictures from newspapers and magazines. Warburg organized and reassembled the images, juxtaposing the collection with printouts such as maps, photographs, and manuscripts, while each panel presents a visual proposition. Each of the panels of *Mnemosyne Atlas* is numbered according to the themes of the proposition. Through images that are densely arranged and vastly accumulated, *Mnemosyne Atlas* increases the visual intensity of images, which altogether generated a temporality that resembles Benjamin's "messianic time." It's like catching a glimpse of the entirety of history in a single instant; the vastness history is condensed into just one second. As the sequence of time is cut and reversed, its narrative is decided by the structural organization of the archive. The seemingly "chaotic," irrational arrangement hints to the anticipation of the unpredictable catastrophic future, much as Babel the polyglot destroys the completion of the tower.

Derrida's "archive fever" and Warburg's *Mnemosyne Atlas* shows the historicity in visual form, and here we find the third leitmotif of *Hold the Mirror Up to His Gaze*. The exhibition attempts to visualize "messianic time" so that the high-density state of the historicity of the early Taiwan's photography can become visible. Through compressing the diachronic historical narrative into a synchronous display, these photographs reveal the exosomatic memory of this island.

The Supplementation of Artistic Research

Hold the Mirror Up to His Gaze has also invited several new artistic research projects to intervene in the exhibition, where they act as supplements. These supplements function like footnotes, serving as addenda to the exhibition. The nature of art research is its non-replicability, which must emphasize the research and heuristic process. Each invited artist has proposed a specific research proposal by which to intervene into the exhibition and form open-ended discourses. On the one hand, this method displays the discursive ability of art research; on the other hand, it responds to how the uniqueness of areas and cultures are translated into artistic practice that are related to the self and locality. This sets it outside of the standard divisions of the current fields in the humanities (such as sociology, philosophy, political science, art history, and cultural studies) in terms of the discursive methods of "standardization," "measurability," and "methodology." The artistic researches are interspersed throughout the exhibition, placed according to chronology and theme.

Chang Chien-Chi investigates the dimension of desire in John Thomson's photographs. Chang references the images of Asian women that Thomson photographed through his own photographs of foreign brides in contemporary society. Chang's work further reveals changes in the working conditions of professional photographers over the past 150 years, as well as the corresponding changes in regional politics and living standards. Kao Jun-Honn's *Afterimage 1871 (Walking, Snapshotting and Reciting)* is based on Thomson's journal entries during his 16 days in Taiwan and aims to revisit Thomson's journey over the course of a single day. Kao interprets the travels of the Royal Geographical Society member, the route he took in order to "hold the mirror up to nature" and changes in culture and geography over the past 150 years. These observations are then combined with the research trip by local historian and literary scholar You Yung-fu, who will invite exhibition visitors to add their critiques in a live "lecture performance."

Tsao Liang-Pin attempts to respond to *Reminiscence of North Formosa*, an 1895 photo album published by British photographer George Uvedale Price, by adopting methods of textual analysis to grasp the album's commercial and advertising qualities. Tsao's work presents texts and images, which insinuate secret trends in global

industries, focusing specifically on agriculture, ecology, and the economic myth of "Taiwanese Oolong Tea." Liang Ting Yu's *Firearm, Skull, and Bones* investigates portraits of Taiwanese aborigines and other anthropological photographs, and the custom of headhunting during the Japanese Era. This investigation reflects how photography of Taiwan's indigenous people during the Japanese Era (including investigations directed by anthropologists) developed into a "headshot-ology" that relates to head fetishism and a construction of colonial knowledge systems.

In discussing photography's historical development, we must expand the context of Taiwan to also include the photography of Southeast Asia and the development of photographic industries and grass-roots organizations. Zhuang Wubin's *Photography and Chineseness in Southeast Asia* explores the spread of the ethnic Chinese throughout Southeast Asia. Zhuang looks at art circles, photo studios, and grass-roots organizations, such as salon photography associations, and amateur photo clubs and societies. Zhuang gathered massive amounts of family albums from Southeast Asian Chinese families from Vietnam, Thailand, Malaysia, Singapore, and Indonesia. Filipino artist Shireen Seno elaborates on the colonial image in the Philippines through the research project *To Pick a Flower*, which presents the dialectical nature of film and photography in the form of an "essay film." The work contemplates the tension between the dynamic and frozen qualities of the image as it recedes to a state of "it-has-been," as well as the ontology/huantology within.

Chen Chin-Pao's *Vacillation: Peng Ruei-Lin's Two Photographic Approaches* explores the dialectical aspects of painting and photography. Spanning across the works of Baudelaire and Lady Eastlake, as well as Naturalistic and Pictorialist photography, Chen's studies focus on Peng Ruei-Lin, who traveled to study in Japan. Chen spotlights Peng's experience as an official translator for the Japanese army in Guangzhou and as a "Taiwanese," how he "returns the gaze" back towards China and Japan. The project *Nowhere Island Journal* by Huang Ying-Chia and You Cheng-Yan is based on the works of photographer Chang Tsai, novelist and filmmaker Liu Na'ou, and female photographer Chen Li-Hong. The project is an attempt to reconstruct the city of Shanghai, the far-eastern meeting point for colonial empires, and its diaspora of "Japanese-Taiwanese." In doing so, it will retrace identity from the perspective of the other back to the self. Chen Fei-Hao's *Japanese Noh in Taiwan and the Kita Stage* research project rewinds time to the days of the Omura Takeshi Izakaya, which was located in Taipei on Hankou Street in the commercial district of Ximending. There, it reconstructs one of the few Noh training stages in Taiwan of that era. Through the work, Chen explores the context of Taiwanese opera and Noh Theater during the Japanese colonial period and contemplates the rarity of cultural crossover within the traditional arts between the colonializer and the colonized.

The commissioned researches emphasize an integration of artistic practice, historical exhibition, and the production of knowledge. In doing so, these projects bespeak how the current foundations of discourse in the arts—such as the sociology of art, philosophy of art, history of art, cultural studies, and other humanistic schools of thought—may be an integrated part of artistic in an interdisciplinary discourse. These works also respond to how unique regional and cultural elements can be translated into new contexts through the inherent politicality of artistic knowledge, which in turn shows Taiwan's history of photography can only be written from the pluralistic interdisciplinary perspective.

How to Write Taiwan's History of Photography
Just as in 1875, Thomson set out on his journey with the intention of "holding the mirror up to his gaze," our aim is to blaze an intellectual trail by which we can write a history of "Taiwanese photography," and thus attempt to illuminate the dim corners of Taiwan's cultural and colonial history. By following histories of cultural interpretation and technical development, starting from early attempts of photography, the advent of *sheying* in China, and up to our current concept of photography, the exhibition attempts to showcase the untranslatability of cultures

from the 7th century up to the 20th century. This involves an eclectic method complied from the historiography of photography, as well as further contemplating the naming of photography and its aesthetic ideals. Through the problematics of Thomson's writings, the curatorial practice set Taiwanese photography as an object of the colonial gaze between 1850 to 1895. At the same time, it is closely connected to the politics and economy of photography and to the intersubjective relation between the other and the self in the 19th century, an era with explosive intellectual and technological advancements. Taiwanese images is photography's "third generation," much different from previous Daguerreotypes and Talbotypes. When the rise of dry plate process led to changes in the production methods, which in turn improved the knowledge/scientific production, and initiated an increased circulation of media. These historical developments connected to global networks of politics, economics, culture, and military interests can be told from an image, which is no larger than 16 by 20 inches in size.

Of course, to use Hamlet's lines "to hold, as 't were, the mirror up to nature" as a metaphor for the subjective nature of photography is, on the one hand to examine how photography is, like other art forms, a response to nature and an extension of aesthetic theories from Plato's *mimesis* to Romanticism. On the other hand, it invokes photography's artificial or mechanical character, which is tied to art movements from Naturalist photography to Modernism, and their underlying attitudes stretching from self-conscious awareness. In particular, in regards to problems of Taiwan's colonial modernity, this invocation explores how photography can be transformed into a self-conscious inquiry, and through photography's potential for original creation and liberation, to return the gaze of the Big Other, to reconfigure the network of intersubjectivity between self and other, and to create an exhibition that is both self-aware and realized in a visual form. Finally, the curation also conveys photography as archives, a response to the different archival concepts of Foucault, Derrida and Freud's analysis of the *wunderblock*, which is then linked with the high-density image montage of Warburg's *Mnemosyne Atlas*. This is the "hauntological ontology" of images, which also presents the necessity of presenting archives as both a "fever" and a "symptom."

In future research, writing on Taiwanese photography must take into account the existing problematics of "photographic history" and "historical narrative." As researches consider the relevance of these problems, they must break away from established causalities and historical methodologies (such as biographical research and studies of comparative style) to try to develop a multi-deterministic view of history by which to address these problems. And only on this basis, can the history of photography in Taiwan arrive at the possibility of becoming a history that is composed of multiple, complex narratives. Setting out from the standpoint of the history of technology, colonial and postcolonial history, and cultural history, this exhibition looks back on the development of photographic images in Taiwan from the 19th century up through Japanese colonial period, and especially the Japanese colonial period itself, which began in 1895. The colonial policies of Japan were different from the multifaceted aggressions of the Western imperialists. Japanese colonialism operated in the process of the double simulation: on one hand the colonizers had to adapt to Western cultural and political standards, and on the other they were forced to adopt the identity of their colonial subjects.

The Japanese decision to translate "photography" into *sha-shin* (writing of reality) is a particular manifestation of Japanese culture. As the Japanese colonial administration came to understand photography's importance, they regulated the practice through photographic licenses, which only allowed a small number of native Taiwanese to become photographers. The large number of *sha-shin-cho* (photo albums) published during the Japanese colonial period reflects a kind of visual colonialism, which domesticated the other and idealized the self. For the various administrative departments of the Japanese colonial government, including political, cultural, military, and economic departments, photography was rapidly adopted as a

"technology of the visible" to identify and manage the various aspects of this visual colonialism. The paradox here is that this type of visual regime is in fact a reflection of the colonialists' own desires. At the same time, it is at the root of the production of knowledge via publishing, media, and visual governance. We are grapping with the notion of a "return of the gaze" in Taiwan's photographs, we hope to disclose the "conditions of production" under which photography existed within the society. At the same time, we hope to present the social relations (such as those emerging in organically formed photographic organizations) involved in photography relating to its circulation, consumption and distribution. This will enable us to further present photography's dual nature both as an elitist professional activity and as a democratic mass movement.

Writing an introduction to the first exhibition to ever be held at the National Center of Photography and Images, an institution that couldn't arrive soon enough, involves the double meanings of Derrida's "archive fever": it is simultaneously a "commencement" and a "commandment." *Hold the Mirror Up to His Gaze* is an attempt to discuss how we may open Taiwan's photographic archives to the foreseeable future. It is also a "polyphonic" message to the commissioned artists. To open a new discourse in a context that emphasizes its difference from the existing Eurocentric history of photography means we must reflect on the formation of this knowledge system, and at the same time also question and challenge the subject of power. To investigate a new historical causes of the global technologies of photography through photographs in Taiwan will allow us to glimpse the traffic of histories entirety. However we also acknowledge that this exhibition is incapable of comprehensively covering the history of photography in Taiwan in all of its dimensions. Instead, we conceived a Derridean "archive"—the domicile or home—those images which present "Taiwan" as "home" will possess a certain uncanniness, and they will be found in the unintended fascinations of the viewing subject.

At this moment of "commandment" and "commencement," we can say that subsequent research will be necessary in the following areas: first, research on "Taiwanese photography" should at the same time include awareness of synchronic and parallel developments in Southeast Asia and East Asia. Although regional research into photography and film has in the past been hindered by barriers of culture, language, and politics, photography's early history in Asia, especially in regards to historical migrations and conflicted colonial history, there are much shared histories. Example can include Indonesia's Toekang Potret, the Photography Studio established by Japanese migrants in Singapore, or Amoy Photo studio operated by a naturalized French. The list can go on and on, and these subject matters encouraged a distinct research method and model from the Western ones. This will be a central issue encountered by all researchers who uses "nations" as discrete units while embrace a true sense of the "inter-national" history of photography. Second is the problem of the documentary nature of photographs in photography collections. This will entail redefining "archivalization" and "archivability." For example, the photographic archive is built from magazines, newspapers, notes, textbooks, documents, and artifacts, and therefore a single standardized archiving technique cannot be possible. These are tasks that face the first National Center of Photography and Images in Taiwan. This exhibition has endeavored to create the framework of discourse around Taiwan's early photographs, where technology, colonialism, aesthetic ideology, and global cultural history altogether composed their visuality and tell stories which have not been told. The history of photography in Taiwan can only come from the impossibility of writing, which is a future memorandum addressing in the commencement the Photography Center as to curate is to cure the impaired images from the past.

1 See William Shakespeare, *Hamlet*, London: Penguin Books, 2015.

2 Gayatri Chakravorty Spivak, "Can the Subaltern Speak?" *Can the subaltern speak?: Reflections on the History of An Idea*, ed. Morris, Rosalind, New York: Columbia University Press, 2010.

3 Michel Foucault, *The Archaeology of Knowledge and the Discourse on Language*, trans. Sheridan Smith, New York: Pantheon Books, 1972, p. 129.

4 This concept was brought forth by Pierre Bourdieu in *Photography: A Middle-Brow Art*. See Pierre Bourdieu et al., Photography: A Middle-Brow Art, trans. Shaun Whiteside, Stanford, CA: Stanford University Press, [1965]1996.

5 Beautmont Newhall, ed., *Photography, Essays and Images: Illustrated Reading in the History of Photography*, New York: The Museum of Modern Art, 1980.

6 See Newhall, *The History of Photography*, New York: The Museum of Modern Art, 1982.

7 Water Benjamin, "The Work of Art in the Age of Mechanical Reproduction," *Illuminations: Essays and Reflection*, trans. Harry Zorn, New York: Schocken Books, 1968, p. 234.

8 Benjamin, "The Work of Art in the Age of Mechanical Reproduction," p. 241.

9 The article also points out how reproduction technologies destruct unique social states. See Walter Benjamin, "Little History of Photography," *Selected Writings, Vol. 2: 1927–1934*, eds. Michael W. Jennings, Howard Eiland, and Gary Smith, trans. Rodney Livingstone et al., Cambridge, MA: Belknap, 1999, p. 519.

10 On the meaning of "common sense," Bourdieu's propositions present traces of Kant's aesthetics. Pierre Bourdieu et al., *Photography: A Middle-Brow Art*, pp. 77–79.

11 The artistic status of photography often becomes a part of cultural legitimacy through non-governmental assemblies. Japanese modernism photography and the development of photography in Taiwan display similar courses. See Bourdieu, *Photography: A Middle-Brow Art*, p. 103.

12 Allan Sekula, "On the Invention of Photographic Meaning," *Photography in Print: Writing from 1816 to the Present*, ed. Vicki Goldberg, New York: Simon and Schuster, 1981, p. 452.

13 Steffen Siegel, ed., *First Exposures: Writings from the Beginning of Photography*, Los Angeles: The J. Paul Getty Museum, 2017, p. 299.

14 Original text as follows: "The little work now presented to the Public is the first attempt to publish a series of plates or pictures wholly executed by the new art of Photogenic Drawing, without any aid whatever from the artist's pencil. The term 'Photography' is now so well known, that any explanation of it is perhaps superfluous." See William Henry Fox Talbot, *The Pencil of Nature*, Gutenberg Ebook, 2010, p. 1, http://www.gutenberg.org/ebooks/33447, accessed August 1 2020.

15 According to the research of Bruce T. Ericson, so far, four of the remaining Daguerreotype left from the fire are in Japan, and one is within the collection of Bernice Pauahi Bishop Museum. See Bruce T. Ericson, "BROWN JR., ELIPHALET Hannavy," *Encyclopedia of Nineteenth-Century Photography*, ed. John Hannavy, London: Routledge, 2013, pp. 223–224.

16 The appendix includes a chart on Taiwanese indigenous languages. See John Thomson, *The Straits of Malacca Indo-China and China, or Ten Years' Travels, Adventures, and Residence Aboard*, London: Sampson Low, 1875, pp. 543–544.

17 See Thomson, *The Straits of Malacca Indo-China and China, or Ten Years' Travels, Adventures, and Residence Aboard*, V.

18 In truth, viewfinders did not exist then; photography compositions were done using mirrors.

19 Thomson, *The Straits of Malacca Indo-China and China, or Ten Years' Travels, Adventures, and Residence Aboard*, V.

20 John Thomson and Adolphe Smith, *Street Life in London*, London: Sampson Low, Marston, Searle and Rivington, 1877.

21 Jacques Lacan, *The Four Fundamental Concepts of Psycho-Analysis*, trans. Alan Sheridan, New York: W. W. Norton & Company, 1977, p. 140.

22 Thomas Theye, *Der geraubte Schatten. Eine Weltreise im Spiegel der ethnographischen Photographie*, Berlin: Bucher C.J., 1998.

23 See Peter Henry Emerson, *The Death of Naturalistic Photography*, 1891, p. 197.

24 Alfred Stieglitz, "The Photo-Secession," *Bausch and Lomb Lens Souvenir*, Rochester, New York: Bausch and Lomb Optical, 1903; reprinted in Richard Whelan, ed., *Stieglitz on Photography: His Selected Essays and Notes*, New York: Aperture, 2000, p. 154.

25 Original text: "Retouching," says Dr. Emerson, "is the process by which a good, bad, or indifferent photograph is converted into a bad drawing or painting." It was invariably inartistic, generally destructive of values, an always unphotographic, and has to-day almost disappeared.

26 See Alfred Stieglitz, "The Photo-Secession," reprinted in Richard Whelan, ed., *Stieglitz on Photography: His Selected Essays and Notes*, p. 154.

27 Alfred Stieglitz, *An Exhibition of Photography by Alfred Stieglitz: 145 prints, over 128 of which have never been publicly shown, dating from 1886–1921*, New York: Anderson Galleries, 1921.

28 Jacques Derrida, *Archive Fever: A Freudian Impression*, trans. Eric Prenowitz, Chicago: University of Chicago Press, 1996.

29 See Derrida, *Archive Fever: A Freudian Impression*, p. 1.

30 Sigmund Freud, "Notiz über den Wunderblock," *Gesammelte Werke: XIV: Werke aus den Jahren 1925–1931*, 1991, pp. 3–8.

◆ ◆ ◆ ◆
The Refracted Desire
of the Imperial Gaze

In the mid-19th century, with the development of the technological reproduction of images, photography began with the invention of the daguerreotype (1839), the calotype (1841), and collodion wet plate photography. The linguistic roots of the word "photography" mean to "write with light." In 1860, wet plate photography replaced indoor portraits made using silver plates. This liberated photography from the restriction of taking place exclusively in an indoor photography studio and allowed for the photographic documentation of architecture, nature, people, and scenes of war. Although wet plates required more than ten seconds of exposure to light and needed to be developed in a darkroom, their invention led to the spread of photography worldwide. With the invention of the wet plate process, the first photo studios outside America, Europe, and Australia were found in Hong Kong, Singapore, Macau, and Manila. Photographers began to take photographs of places around the world that had never before been photographed. At the time, Australian city Sydney was one of the photographic glass plates' centers. Along with earlier processes such as etching and photogravure, photography allowed for the dissemination of images globally. More broadly speaking, the progress of photography was deeply bounded with modernization and the development of colonialism.

In 1860s, various western photographers became interested and started to take pictures in Formosa. These included photographic projects by St. Julian Hugh Edwards, John Thomson, and S. Sidney. Their photographs not only represented an external gaze onto Taiwan, but also showed how an empire revealed its desire to the island. These photographers entered Taiwan from Takao (Kaohsiung), Jilong (Keelung), and other ports. They included photographers who had spent years photographing China and Southeast Asia, such as John Thomson. Together with the medical missionary James Laidlaw Maxwell they visited Lau-long and Baksa taking images of indigenous peoples and natural environment. 19th century political figures such as Charles W. Le Gendre and William A. Pickering asserted in their writings that making the extension of the imperial military and political power by claiming they owned the knowledge of the area. The Sino-French War in 1884 saw photography used to document warfare, with photographs taken of prisoners of war. Consequently, during this period, photography began to be used for its military value. With the rise of global trade, photography was also used for commercial purposes. John Dodd began to grow Oolong tea in Taiwan, and took photos of the tea production process. His photo collections documenting this process were used as commercial advertisement for exporting tea to the West.

As such, the images of 19th century Taiwan are marked with colonial power and capitalism. At the same time, because of the expansion of imperial power, there are strong ties between the photographic histories of Taiwan, Southeast Asia, East Asia, Hong Kong, Singapore, Indonesia, and the Philippines. What is archived in photographs is not only the trace of power and the deployment of bio-politics, but also a fixed image of then natural conditions and social customs of a place. These photographs provide clues for understanding Taiwan's history and material culture, particularly regarding the history of Taiwan's indigenous and the Pingpu tribes. Such photographs serve as a valuable archive for understanding history and therefore to unveil the future.

At Dawn: Thoughts on Early Photographers in Taiwan [1]

Hsiao Yong-Sheng

◆

An old photograph, *Image Point, Kelung Harbour, Formosa*, [2] (fig. 1) was published in the book titled *On the Coasts of Cathay & Cipango Forty Years Ago*.[3] Next to it is the topographic and hydrographic map of the Keelung Harbor drawn by William Blakeney between June 20 and 24, 1958.

The photo is taken from the site of Cape Waimushan, on the entrance to the west side of the Keelung Harbor. The islets in the harbor are on the upper-left of the drawing, and a strangely shaped weathered stone can be seen in the foreground.

The Taiwan Voyages of the *Inflexible*

On May 28, 1858, William Blakeney, an assistant surveyor on the survey ship Actaeon was ordered to Hong Kong where he was to join the crew of a military vessel, the *Inflexible*. The ship would take him onwards to Taiwan, and its movements weave an interesting thread through the Chinese history of this period. During the second Opium War, a fleet of English and French ships attacked Xiamen, Guangzhou on December 30, 1857. The following day, December 31, the inspector-general of Guangzhou, Bo Guei, surrendered the city to the invading forces. On January 4, 1858, the governor of Guangzhou and Guangxi, Ye Ming-Chen, who was also a cabinet scholar and imperial minister, was captured by the British and French forces after a search of the city.

Imperial Minister Ye was detained aboard the *Inflexible*, and on January 5 the ship sailed for Hong Kong, anchoring there for 48 days. While Ye was imprisoned onboard, one of the ship's officers, Colonel Crealock, took a photo of him. This portrait became the prototype for the "Portrait of Ye Ming-Chen", a photo later produced by the Yuegu Painting Studio in Guangzhou.

On February 23, the *Inflexible*, with Ye still aboard, sailed for the British colony of India, arriving at Calcutta on March 12, 1858. There, Ye was imprisoned at Fort William and died there a year later as the result of a hunger strike in protest of his captivity in a faraway land. In 1859, the British returned Ye's body to Guangzhou. The Inflexible then set out for Taiwan. Under orders from British Indian Ocean naval commander Michael Seymour, the ship was dispatched to search for survivors of a shipwrecked British vessel, the *Kelpie*, and undertake a mission of scientific exploration. Crew members included the well-known naturalist Robert Swinhoe, who was eventually to take up a post in Taiwan as the first British consul, and Charles Wilford of the Royal Botanic Gardens.

Swinhoe had just left his position as an interpreter for British High Commissioner and Plenipotentiary in China and the Far East, Lord Elgin, whom he assisted in his 1858 negotiations with the Qing court in Tianjin to revise the treaties between China and Britain. He then was transferred to serve as translator at the British Consulate in Xiamen. Although the *Inflexible*'s official mission to Taiwan was scientific exploration and a search and rescue operations for the crew of a vessel that had been lost at sea ten years previously, the true purpose of this voyage was likely to examine the feasibility of opening up trade ports in Taiwan. [4]

The *Inflexible* sailed for Taiwan on June 8, setting off from Xiamen, Guangzhou and arriving at Guosheng Harbor in the Taiwanese city of Tainan. From there, the ship sailed south and circumnavigated Taiwan, traveling in a counter-clockwise direction around the island. The ship returned to Tainan on June 29 and from there returned to China, passing the Penghu archipelago on June 30 and landing at Xiamen on July 1.

It was a rare event for a foreign warship to travel around Taiwan. The *Inflexible* recorded stops at Zeelandia, Anping, Takao, Fangliao, Checheng, Lanyu, Green Island, Suao, Keelung, Heping Island, and Tamsui. The ship's longest stay of anchorage was in Keelung Harbor. Blakeney spent five days producing a highly detailed map of Keelung's Harbor and environs. According to his record of the mission in *On the Coasts of Cathay & Cipango Forty Years Ago*, this map was published independently in October 1858 (fig. 2).

While Blakeney was surveying the harbor, Swinhoe and others set off inland. They scouted Coal Harbour in Badouzi for coal and traveled as far as Jinbaoli by foot, traversing Qixing Mountain and entering Taipei via Beitou. They then took small boats down the Keelung River to Xizhi and Qidu.

In June 1858, the *Inflexible* completed its voyage around Taiwan. Blakeney drew a map of the Keelung Harbor and conducted detailed measurements of Keelung. The detailed hydrology map of the harbor was more accurate and detailed than the one completed by the American navy four years prior, with key locations on the map being Image Point, Palm Island, and Coal Harbour, following international practices and using the name of the previous drawing.

The Origins of Image Point: The Perry Fleet

An important document tells [5] us that Image Point at Keelung

Harbour was named by American naval surveyor Captain George H. Preble and Naval Academy graduate Warrant Officer Walter F. Jones. The document, titled *The Official Narrative of the Expedition* recorded Perry's expedition. [6]

In 1852, American naval officer Commodore Matthew Calbraith Perry was appointed as commander of the American navy for East India, China, and Japan. The same year, Perry set off to assume his command aboard the steamship Mississippi, which took him from Virginia to Hong Kong. There, Perry assembled his fleet of five American naval vessels and dispatched them to Shanghai, Guangzhou, Macau, and the Yangtze River with different tasks. One of these ships, the Saratoga, was sent to Macau to pick up chief naval translator Samuel Wells Williams and his Chinese classics teacher, Sie Yong-Chuan. [7]

From Perry's diaries, we can see that in 1852 he read a number of books on imperial China. Impressed with Williams's knowledge of Chinese culture, Perry was highly attentive to Williams's counsel,[8] and in 1853, made Williams his chief interpreter. According to Perry's diary, Sie died on the voyage owing to his habit of smoking opium. As a result the fleet lacked a Chinese interpreter, so Williams was forced to search for a new interpreter in Shanghai.

Why did Williams, the chief translator of Perry's fleet, need Chinese tutors to assist him? According to Perry's diary, Williams could interpret spoken Chinese but was not skilled at written Chinese, which was the medium for diplomatic exchanges between America, the Ryukyu Kingdom, and the Japanese shogunate. The American Navy also lacked interpreters for Japanese, and Japan lacked English interpreters. Communication thus required the use of Dutch and Chinese. This necessity for the use of third languages is a particular historical phenomenon. In Shanghai, Williams eventually found a replacement Chinese tutor, Luo Sen, a native of Guangdong. In early 1854, the two men then set out to re-join Perry's fleet and assist with translation.

In a great number of historical writings, including Chinese photography written in the 1980s up to scholarly works on the origin of "Taiwanese photography" in the 2010s, Luo Sen's role in the voyage has been mistakenly attributed as assistant to the fleet's photographer, Eliphalet Brown Jr. Luo Sen's primary role was however that of translator. He was a highly erudite Chinese literati skilled in painting and calligraphy and who engaged in academic research on the West.

The Perry Fleet's Photographer:
Early Daguerreotypes and Prints

We may next turn to the photographer of the Perry Fleet, Eliphalet Brown Jr. In joining the Perry Fleet, Brown gave up a profitable photographic practice in New York, where he produced daguerreotypes. He was one of two artists selected for the expedition from many who applied.

In the list of images in *The Official Narrative of the Expedition* includes separate lists for lithographs and woodcuts. Photographic printing was still not practical at scale, so books often used handmade prints created after original photographs. For each print in this volume, the name, place, artist, page number, and origin of the print is clearly indicated. Images originally drawn from a daguerreotype are indicated as such. In examining the list of prints, we find that Brown provided at least thirty daguerreotypes to the New York lithograph workshops Sarony and Ackerman and to the woodcut workshop Richardson. We also find several references to "DAG", "Dag", and "From a Dag" on the edges of the prints (fig. 3), giving indirect evidence of the existence of dozens of daguerreotypes used for reference for these prints.

Brown produced hundreds of daguerreotypes between 1853 and 1854, more than 400 according to some researchers. Only six survive today, three of which were rediscovered in 1965 by Japanese scholar Shibuya Shiro and are currently in the collection of the Hokkaido Museum. These correspond to two surviving lithographs and one woodcut (fig. 4, fig. 5).

The fourth remaining daguerreotype taken by Brown was a portrait of his Japanese translator, Gohachiro Namura, in Yokohama. This photograph was discovered in June 1982 in a Hawaii museum. Gohachiro appears in the first volume of *The Official Narrative* in a wood engraving of two people titled, "Gohachiro, Third Translator, Yokohama." At the bottom right of the engraving is the inscription, "E. BROWN. DAG."

In the list of images, Brown is credited as the author of this image, but the list gives no indication that the woodcut is from a daguerreotype. Brown took multiple photos of members of the Japanese shogunate. Some were used as presents to those photographed, while others were kept for future use.

The fifth remaining daguerreotype of Brown was taken in 1854 in Japan. It is a personal portrait taken by Brown at Shimoda Port on behalf of Uraga Yuli, a local guard, and Tanaka Kogi. This portrait was made public by Tanaka's descendants in October, 1983. There have been no new discoveries of Brown's daguerreotypes since then. The sixth surviving photograph is a daguerreotype of Kuroda Yoshibei, the overseer of the Port of Shimoda. It was discovered in 2007 and is currently stored at the Nihon University of the Arts. [9]

These six surviving photographs served as the basis for dozens of later images produced as lithographs, woodcuts, and pencil drawings. The nature of such reproductions suggests questions for further research, such as the relationship between original images and their reproductions via light boxes and various forms graphic printing. How an image may change through reproduction in painting, engraving or various print processes is certainly an interesting issue.

C. Imbault-Huart's *L' île Formose Histoire et Description*

Only a limited number of vintage prints of Taiwan from the 19th century still survive. These are dispersed in private and public collections around the world, including both public and private libraries and the collections of private individuals. National Taiwan Library's Taiwan Study Research Center has a collection of "Taiwan ko shashincho", which includes a

IMAGE POINT, KELUNG HARBOUR, FORMOSA.

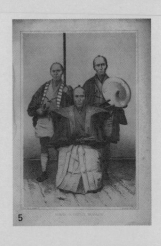

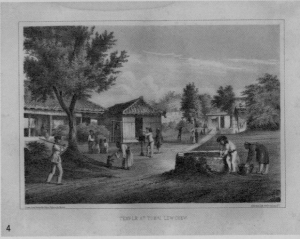

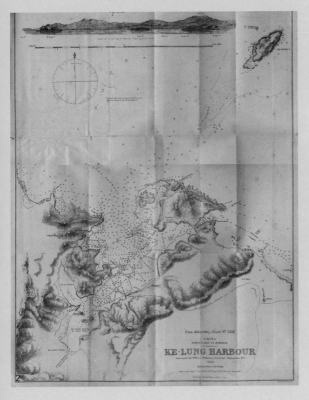

TEMPLE AT TUMAI LEW CHEW.

1 IMAGE POINT, KELUNG HARBOUR, FORMOSA. Courtesy of National Taiwan Library ｜ 2 The topographic and hydrographic map of the Keelung Harbor, drawn by William Blakeney in 1958. Courtesy of National Taiwan Library ｜ 3 The Regent of the Ryukyu Kingdom and his financial officers. Lithograph drawn by Eliphalet Brown Jr. in 1853 based on his daguerreotype. Courtesy of National Taiwan Library ｜ 4 Eliphalet Brown, Jr. preparing to take a daguerreotype portrait in Temple at Tumai, June 1853. Lithograph by Ackerman Studio. Courtesy of National Taiwan Library ｜ 5 Endo Matazaemon and his attendants, 1856. Lithograph based on Eliphalet Brown Jr.'s daguerreotype. Courtesy of National Taiwan Library

total of 39 portraits purchased by the Governor-General's Office in 1942 (fig. 6, fig. 7). [10]

A number of prints can be found in the French National Library in the manuscript for the book *L' île Formose Histoire et Description*, [11] which was published by C. Imbault-Huart in 1885.

This book proves of great importance in the history of Taiwanese photography, but it has been misread in previous research, as the author wishes to point these out. First, some of the photographs were provided by St. Julian Hugh Edwards, but we can't conclude on this basis that Edwards necessarily took those photographs. Imbault-Huart states in the preface, "Of course, these photos of Taiwan's natural scenery are very rare, in publishing them here, we must thank Mr. Edwards from Xiamen for the photos that he provided." [12]

Imbault-Huart was thanking Edwards for providing the photos, but not necessarily crediting him for taking them. These likely include both photographs that Edwards collected and some that he took himself, but we cannot assume that he himself took all of these photographs.

The book contains 17 photogravure images for which no photographer is credited and 11 prints. As printing technology was still quite limited at this time, photographic printing was highly resource-intensive. So many photographs were disseminated instead in the form of photo prints. On these 11 prints, some are annotated as derived from photographs (*d'après une photographie*) or bear the signatures of individuals, such as "Ch. Emonts" and others. Included in the 28 photographs provided by Edwards are two photographs by John Thomson.

Another question raised in research surrounding this book concerns 12 photographs bearing the annotation, "Phot. Berthaud, Paris". These 12 photos were provided by the Berthaud Studios in Amiens and Paris, but some researchers have mistakenly concluded that Berthaud is a person's name. There is however no mention of Berthaud in the text of *L' île Formose Histoire et Description*. [13] The book only mentions that in 1874, the imperial commissioner Shen Bao-Zhen accepted a blueprint similar to the fortresses surrounding Paris from a Frenchman, M. Berthault, in the process of constructing a Chinese fortress located one and a half kilometers from Anping in order to control the bay.

In two previous studies, Wang Ya-Lun's *French Photos Between 1850 and 1920 of Early Taiwan* [14] and Chen Jheng-San's "Who Took Taiwan's First Photo?," [15] it is supposed that this engineer, M. Berthault, and the photographer credited as "Phot. Berthaud, Paris" was the same person—an engineer who took photos as a hobby. But other scholars' works, including several masters theses, suggested that the photographer who took these images might be Felice Beato. Beato indeed took photos of China during the Second Opium War and of the Japanese shogunate, and of course he could not be the photographer who took these pictures.

Among these 12 photos of questionable attribution is the full-length portrait of Syu Run-Jhih, a photograph taken by William Saunders in Macau and published in the Yokohama news journal, *The Far East* in its August 1876 issue, on page 38.

Imbault-Huart's *L' île Formose Histoire et Description* labels Syu Run-Jhih as Shen Bao-Zhen, creating further issues for research. [16]

Notes of Travel in Formosa

American-French diplomat Charles W. Le Gendre has proved a controversial figure in 19th century diplomacy related to Taiwan. The Waseda University Library collection in Japan has a well-preserved collection of vintage prints of Taiwan collected by Le Gendre's in a volume entitled, *Notes of travel in Formosa: Plates*. It was only in 1865 that Taiwan began to open up treaty ports. The following year, Le Gendre took up the position as American consul in Xiamen, China, and as a result also took responsibility over four ports in Taiwan. In addition to his role as a diplomat, Le Gendre collected photographs of Taiwan, and this collection has made him a key figure in research on early photographs of Taiwan. Many of his photographs and documents are now collected in the Manuscript Division at the Library of Congress in the US.

The photographs collected at the Waseda University Library include photographs given by Le Gendre to high-ranking Japanese officials as a gifts. [17] These include photographs of Taiwan's tea farms, petroleum oil, and of Formosan aborigines—images of political, economic, and military value. *Notes of travel in Formosa: Plates*, which bears the stamp of Okuma on the front cover, includes 42 photos taken by John Thomson in southern Taiwan in 1871. These are Thomson's original prints and are genuine antique photographs, not modern reproductions. In all, the album contains 89 albumen photographic prints. These are certainly not all of the photos that Le Gendre brought to Japan, but this photo album is indeed an extremely important collection of historical materials for Taiwan studies.

Le Gendre served as American consul in Xiamen between 1866 and 1872. [18] In March 1867, an American barque, the *Rover*, struck the Qixingyan coral reef off Pingtung in southern Taiwan, and the passengers who made it ashore were killed by nearby aboriginal tribes. The incident brought Le Gendre to Taiwan for the first time to coordinate with military and civil officials in their dealings with leaders of the aboriginal tribes. Le Gendre was frequently accompanied by photographers on his visits to Taiwan.

In 1869 visit to Taiwan, Le Gendre was accompanied by John Dodd [19] and W.A. Pickering, [20] in an expedition between northern and southern Taiwan, which produced a quantity of valuable photographs (fig. 8, fig. 9, fig. 10). In the spring of 1872, Le Gendre's final trip to Taiwan was to Sheliao, Pingtung. In 1874, Le Gendre published *Notes of Travel in Formosa*, which refers that his accompanies of this trip were photographer Lee Khong Tek of the Yuanfa Commercial Company of Xiamen along with two assistants and 27 coolies. [21]

In October 1872, Le Gendre encountered a setback in his diplomatic career. The Meiji government had come to power in Japan, and he had proposed that the Japanese establish colonies along Taiwan's southeastern coast. In support of this project, he delivered several maps of Taiwan to the Japanese cabinet, along with several memorandums and high quality

albumen photographic prints of Taiwan.

At the same time, Le Gendre accepted from the Japanese foreign ministry a 12,000 yuan annual salary and second-order official position. He further introduced American military officers to assist the Japanese military, violating provisions of American law and the Treaty of Tianjin. Samuel Wells Williams, the American acting consul in Beijing, believed that Le Gendre and lieutenant commander Douglas Cassel were aiding the Japanese in ways that violated agreements between China and the United States.

In August 1874, Le Gendre returned to Xiamen, where he first served as a consul, and planned to travel to Taiwan to assist the Japanese army. The American consul-general in Shanghai, George F. Seward, learned of this and sent a telegraph to Xiamen consul J. J. Henderson, who arrested Le Gendre. Henderson was both consul and had the judicial authority in the American navy to arrest Le Gendre. Friends of Le Gendre sought to raise the funds for his bail in Xiamen, but he was later sent to Shanghai. Although Le Gendre was eventually released, he never returned to Taiwan. Le Gendre can however be seen as a shadow figure behind the dispatch of Japanese troops to Taiwan in 1874.

In 1874, Okuma Shigenobu, an official in the Meiji government, became the recipient of 89 photos that were originally Le Gendre's.[22] Okuma was born in Saga, Kyushu, and in his youth undertook studies in Dutch in Nagasaki. After the Perry Fleet forced Japan to open to western trade, he went to study Britain.

There are different historical assessments of Okuma. In 1869, he held key positions in the Japanese government related to diplomacy and financial administration. The following year, he took on a position as a high ranking advisor. During the 1873 Seikanron debate, which involved calls for a punitive expedition against Korea, he played a key role in the Meiji government.

When an incident occurred in Taiwan that would draw Japan into conflict with China over the island, Okuma was a key figure. The incident, known as the Mudan Incident, took place in February 1874, when 54 shipwrecked Japanese were murdered by Taiwanese aborigines on Taiwan's southeast coast.

At the time, a faction in Japan led by the samurai Saigo Takamori was already calling for a punitive mission to Korea, which refused to recognize the Meiji as the legitimate government of Japan. A conflict with Korea was never realized, but in order to appease Saigo, the Meiji government allowed his brother Saigo Judo to lead troops to Taiwan. Saigo Judo was thus named the Commander-in-chief of Taiwan Affairs, a position similar to that of the commander-in-chief of a military expedition. At the same time, Okuma took up a position as Director-General of Taiwan Affairs and thus took responsibility over administration of Taiwan related issues and finances. As the person in charge, Le Gendre sent his photos to Okuma.

In a section of a letter from Le Gendre to Okuma bearing the heading "Views on Administration and Military Suppression", we can see that Le Gendre is frank in his discussions with the Japanese. He introduces America's naval officers, secretaries, and translators and raises questions regarding rewards and annual salary.[23]

Okuma was one of the architects of modern Japan. Those who criticize him view him as a proponent towards Japan militarism. We can see Japan's ambitions toward China from the 21 demands that he, in 1915 as Japanese prime minister, sent to the Chinese government, then called the Beiyang government. Domestically, Okuma's notable accomplishments include the opening of the first railway in Japan between Shimbashi and Yokohama in 1872 and the establishment of Waseda University (previously known as Tokyo Senmon Gakko) in 1882.

After Okuma's death, his family donated 12,000 of his letters and private documents to the Waseda University archives, with donations coming between 1922 an 1950. Among these holdings are the photographs gifted by Le Gendre.

Photographs of Mudan Incident

Japan's occupation of Taiwan began in 1895, but one can trace the origins of the Japanese occupation back to the Mudan Incident, two decades earlier. In December 1871, officials from the island of Miyakojima were en route to the Ryukyus to pay their annual tribute, when storms blew them off the route to the southeastern coast of Taiwan. As they came ashore, they were killed by aborigines of the Paiwan tribe.

This incident served as a pretext for the Japanese to send troops to Taiwan in 1874. The Japanese army brought with them military photographer Matsuzaki Shinji. Only one of his pictures survived, a small black and white photograph entitled *Taiwan Island Mudan Girl, Twelve Years Old*, an uncomfortable photo which conveys a strong sense of intrusion.

Research on Matsuzaki Shinji only began from the fall of 1992, when the Tokyo-based scholar Udaka Kasei compiled a Taiwan Journal from his own collection so that it would be known to later generations of scholars.[24] Research on Matsuzaki was then taken up by Naoyuki Kinoshita, a professor from the University of Tokyo and Morita Mineko, the head of the Morita Historical Photo Archives. We might read two entries from Matsuzaki's diary here. From September 7, 1874: "It is said that an Italian photographer was ordered by the king of his country to obtain permission from the Japanese foreign ministry; he then took the Kanagawa-maru here."

And from June 6th: "I was called on to take photos of Commander-in-chief Saigo Judo and others. There were issues with the chemicals and it was windy, the photos were not successful. I felt very unsettled. I tried again the next day, but the quality of the water was bad, so it did not go smoothly. Taiwan is really not very suited for photography. The road conditions are very poor, and it's unsteady trying to balance a camera on the coast. Just a bit of wind will cause the camera bellows to start moving. There's no way to take good photographs. The wind blows so strong that the darkroom tent is full of sand and glass plates are smudged. Taiwan is a cruel environment for photographing."

6

8

9

Catamaran ou radeau en usage sur les côtes.

7

10

6 An image of a bamboo raft from an antique Taiwanese photography. There is a Yellow Dragon Flag of the Qing Dynasty at the end of the raft. Inside the barrel sits a foreign customs inspector. There are also three law enforcement officers with the words "Taiwan Prefecture (or Taiwanfu)" embroidered on the left chests. This photo could be taken after the establishment of Taiwan Prefecture Customs in 1865 if the location is Tainan Prefecture. Photo print size: 19 x 26 cm. Courtesy of National Taiwan Library | 7 A printmaking collected in C. Imbault-Huart's L' île Formose Histoire et Description. Courtesy of National Taiwan Library | 8 The camphor barrel on the left side attaches a piece of paper written "J. Dodd Petroleum Springs April 1865" (l Todd was at the oil spring in April 1865). Courtesy of National Taiwan Library | 9 From the left of the photo, Todd, three spear guards, Le Gendre, and the other three. Collection of the Special Reference Room, Waseda University Library, Japan | 10 Under a banyan tree in southern Taiwan, with Le Gendre, Pickering and Todd. Collection of the Special Reference Room, Waseda University Library, Japan

Although the technical difficulties, one photo of Matsuzaki on Taiwan survived. The girl in the photo was forced and fixed by a reaching hand outside of the frame, in order to allow Matsuzaki to take the photo. This twelve-year-old girl was named Otai, and she had been chosen by Judo for a program in assimilation into Japanese culture. She was sent to Tokyo for half a year to learn to read and write Japanese and for training in Japanese etiquette, or *shitsuke*. As a captive, she, in a Japanese kimono, was brought to a Japanese photographic studio to have her photo taken. This photo was published in 1875 in an English language news magazine in Yokohama, *The Far East*, where it was placed on the same page as a photo of a member of Okinawan royalty who was similarly sent to Japan and was published on page 204 of volume 6 of *The Far East* in 1875.

Had Le Gendre been able to travel to Taiwan to assist the Japanese arm with a photographer, considering his passion for collecting photos and his experiences of working with the region's leading photographers—Edwards in Xiamen, S. Sidney in Xiamen and Fuzhou, Thomson in Hong Kong and Singapore, and Lee Khong Tek in Xiamen—we might have more photos related the Mudan Incident today.

Conclusion

Research on the origins of photography in Taiwan as much as that of paintings can always be a challenging topic. Taiwan's research on photography is still under construction. Both in Taiwan and abroad, there are a great number of historical documents, photographs and artefacts to dig through. Be it a wet plate collodion, an albumen print, an album of vintage prints, a photo book of early collotype prints, a journal of photography enthusiasts' works, or a wooden panoramic camera used in early photographic studios, every discovery-- either by an individual or a public institution, preservation, exhibition, research, writing or publication of a photography-enriches the material culture and its history in Taiwan.

A recent finding, *Notes on the Island of Formosa*, by Robert Swinhoe published in 1863. There is a black-and-white albumen photographic print on page 113. This can be well surmised as the oldest photograph related to Taiwan, since the picture could be taken between 1858 and 1862.

1 This essay was edited from two essays originally published in the *Voices of Photography* series, "History of Photography in Taiwan". These essays, both by Hsiao Yong-Sheng, are "Beginning from an Old Photograph," and "The History of Old Photo Books: Evaluating Old Photos of Taiwan in the 1860s." They were respectively published in *Voices of Photography*, volume 8, March-April 2013, pp. 66-73, and volume 9, May-June 2013, pp. 72-79.

2 On January 14, 2006, Taiwanese history researcher Chen Zheng-San published "Who Took Taiwan's First Photograph?" in the United Daily News. He conjectured that this photograph may be from June 1858. The author has different views.

3 William Blakeney, *On the Coasts of Cathay & Cipango Forty Years Ago*, London: Elliot Stock, 1902.

4 Taiwan's harbors were opened up for trade as a provision of the Treaty of Tianjin. American plenipotentiary ambassador William B. Reed and the Grand Secretariat Gui Liang signed the treaty in Tianjin on June 18th, 1858. Outside of the five existing treaty ports, Shantou and Taiwan were among the new treaty ports added. With the signing of the Treaty of Tianjin on June 26th between Britain and China, Taiwan, Niuzhuang, Dengzhou, Chaozhou, and Qiongzhou were opened as treaty ports to the British. On June 27th, China and France signed the Treaty of Tianjin, opening Taiwan, Tamsui, Qiongzhou, Chaozhou, Dengzhou, and Jiangning as treaty ports to the French. China had twelve treaty ports after the two Opium Wars. Of the original five treaty ports, Guangzhou was jointly occupied by the British and French.

5 See Narrative of the *Expedition of an American Squadron to the China Seas and Japan, Performed in the Years 1852, 1853, and 1854, under the Command of Commodore M. C. Perry, United States Navy, by Order of the Government of the United States*, volume 3, chapter 2, p.159. The first two volumes are titled *Narrative of the Expedition of an American Squadron to the China Seas and Japan, Performed in the Years 1852, 1853, and 1854, under the Command of Commodore M. C. Perry, United States Navy, by Order of the Government of the United States*. Perry wrote the preface to the first volume on January 1, 1856 and the preface to the second volume on June 10th, 1857. The third volume is titled *Observations on the Zodiacal Light, from April 2, 1853, to April 22, 1855, Made Chiefly on Board the United States Steam-frigate Mississippi, during Her Late Cruise Eastern Seas, and Her Voyage Homeward: with Conclusion from the Data thus Obtained*. The three volumes were published by the US Congress. The first volume was published in 1856, the second volume in 1858, and the third volume in 1857.

6 *The Official Narrative of the Expedition* is divided into three volumes. The first volume consulted the diaries of the naval officers in the fleets, with artistic sketches by the authors, rough sketches of silver photos as the basis for prints, and 89 heavy-colored lithograph prints. It is recorded that one of Perry's ships, the *Southampton*, passed by Taiwan on October 29, 1853, at which time it observed an undersea volcanic eruption at a distance of ten nautical miles. The second volume contains detailed scientific drawings of birds, fish, shellfish, flowers and plants. It also contains official correspondence between Perry and ship commanders, official orders, reports on coal mining surveys, and the English translation of Luo Sen's "Japan Diary". In July 1854, the ship *Macedonian* surveyed the prospects for coal mining in Keelung. George Jones, who was in charge of the survey, produced two reports. Perry and ship captain Joel Abbot exchanged many letters. The editor of the third volume was George Jones, the ship's priest and a Master of Arts. It contains a number of large-scale charts, astrological diagrams, ship's coordinates, and maps of waterways. The large-scale map of the Keelung Harbor drawn by Preble and Jones is in this volume.

7 Samuel Wells Williams (1813-1884) was sent to Guangdong by the American Board of Commissioners for Foreign Mission at the age of 21. He served as editor for *The Chinese Repository*, an English language journal on China published out of Hong Kong. *The Chinese Repository*, which was published between May 1832 and 1851, provides important historical documentation for researching China and the historical relationship between China and America. Williams became editor-in-chief of the publication in 1848, having become known as a China expert after publishing *The Middle Kingdom* in New York. Participating in the 1855 expedition was a major accomplishment for Williams. In 1855, he joined the US diplomatic corps and was appointed Secretary of the United States Legation to China. In his later years, he became pioneering Sinologist as the first Professor of Chinese language and literature in the United States at Yale University. During the signing of the Treaty of Tianjin, he served as the deputy envoy of William B. Reed, the plenipotentiary of the United States. In the Treaty of Tianjin, Taiwan (Tainan Prefecture) was listed for the first time on the list of open ports.

8 See Matthew C. Perry, *The Japan Expedition 1852-1854: The Personal Journal of Commodore Matthew C. Perry*, ed. Roger Pineau, Smithsonian Institution Press, 1968, first book, Guangdong chapter.

9 Iizawa Kōtarō 飯沢耕太郎 , "Shashin-tekina mono no mikata to nihonjin no shigaku taiken," 真的な物の見方と日本人の視学体験 *Kikan dezain No. 15*, Tokushū shashin toshi, p100. Toriumi Saki 鳥海早喜 , "Hajimete da-ge teo taipu ni utsusa reta Nihon," 初めてダげレオタイプに された日本 *Renzu ga tora reta gaikoku hito kameraman no mita bakumatsu nihon'ichi* レンズが撮られた外国人カメラマンの見た幕末日本一 , Tokyo: Yamakawa Shuppansha 東京：山川出版 , 2014, p. 125.

10 *Taiwan gu xiezhen tie* [Old Photo Album of Taiwan], with 39 vintage prints, 19 x 26 cm.

11 C. Imbault-Huart, *L'île Formose Histoire et Description*, trans. Li Lie, Taipei: Taiwan Institute of Economic Research, 1958.

12 Originally written in 1885. See C. Imbault-Huart 's preface to *L'île Formose Histoire et Description*, p. xiii.

13 C. Imbault-Huart , *L'île Formose Histoire et Description*, p.178.

14 Wang Ya-Lun, *1950-1920 Faguo zhencang zaoqi taiwan yingxiang* [French Photos Between 1850 and 1920 of Early Taiwan], Taipei: Lion Art, 1997.

15 Chen Jheng-San , "Who Took Taiwan's First Photo?" *United Daily News*, Jan.14 2006, A15.

16 Tung Shen, "Shen Bao-Zhen tu xiang kao lun: Zhuixun zuxian de rongyan" [On Controversy of Shen Bao-Zhen Portrait: In Search of the True Face of an Ancestor], *Taiwan Historical Research*, Academia Sinica, Vol. 24, No. 2, June 2017, pp. 33-81.

17 *Notes of travel in Formosa: Plates are collected in Waseda's Notes of Travel in Formosa collection of photo plates*. There are a total of 63 pages and the book is 39.3 x 31 cm.

18 Although Taiwan and Tamsui became treaty ports respectively in 1859 and 1860, and various countries sent troops to maintain military garrisons, it was stipulated in the Treaty of Tianjin that trade could not be opened without a consulate. As such, Taiwan's situation was unusual. Western powers wished to exploit Taiwan for material benefits, but in the early years trade was slow to develop. Britain sent a young translator, Robert Swinhoe, to Taiwan in 1861. As he was only deputy consul, he was not allowed to meet with the Taiwan prefectural governor, or Taotai, and could only conduct exchanges with the Taiwan prefectural magistrate. Diplomatic communications were all sent through the British consulate in Fuzhou and he could not directly communicate with the British consulate in Beijing. See Yeh Chen-Huei, *Qing ji taiwan kai bu zhi yanjiu [Research on the Treaty Ports in Taiwan]*, Taipei: Shuijhun Bookstore, 1985, pp. 125-127. After years of Swinhoe's efforts, a consulate was set up in Takao in February, 1865. Swinhoe was promoted to consul. British Presbyterian priest James Laidlaw Maxwell was a missionary, who spread the gospel in southern Taiwan. Treaty ports were only fully established in Taiwan in 1865, with the opening of ports in Keelung, Tamsui, Taiwan Prefecture, and Takao. America was busy fighting the American Civil War in 1861 and so did not have time to focus on developing treaty ports. In 1866, Charles Le Gendre, who had assisted the Union during the Civil War, was appointed as the consul of Xiamen and took control of the four ports on Taiwan.

19 John Dodd, who was Scottish, was active in the opium, camphor, and tea industries in Taiwan between 1864 and 1890. He served as the representative for many western trading houses in Taiwan, establishing Dodd & Co. He hired Lee Chun-Sheng as a comprador, setting up stores in Bangka, Tuatutia (Dadaocheng), Tamsui, Keelung, Xiamen, and Shanghai. In 1865, Dodd discovered oil Miaoli. In 1869, he found success marketing Taiwanese oolong tea to the United States. Between 1868 and 1874, he served as the American deputy consul in Tamsui and was continually in private correspondence with Charles Le Gendre. Between 1884 and 1885, he published accounts of the Sino-French War in the *Hong Kong Daily Press*.

20 W.A. Pickering, a Scotsman, joined the Chinese customs office as an inspector in 1862, taking up responsibilities in Fuzhou, China covering the administration of Takao and Taiwan Province. Between 1864 and 1870, he worked in the customs house as an intermediary between Western traders and indigenous villages. Owing to his skill with languages, he assisted Le Gendre in negotiating an agreement with Hengchun village- Lonckjau leader Tauketok regarding the protection of sailors shipwrecked on Taiwan. Trade rights and the implementation of customs led to the outbreak of the Camphor War in 1867. As a result, Pickering was dismissed from his customs post owing to objections by the Qing court.

21 The original footnote was published in the 2012 publication of *Notes of Travel in Formosa* by the National Taiwan Museum in chapter 23, p.311. The book contains two essays by Douglas Fix, a long-time researcher on Charles Le Gendre: "An Annotated Listing of Photographs in Notes of Travel in Formosa," pp. 418-425, and "Photographic Views in Notes of Travel in Formosa," pp. xxxv-xlix.

22 Okuma Shigenobu (1838-1922) was a Japanese politician and educator. He was an important reformer during the Meiji Restoration. He served as prime minister twice and established Waseda University.

23 This is a letter from Charles Le Gendre to Okuma dated March 13, 1874. The *Okuma Letter* served as a memorandum from Le Gendre to Okuma. *Okuma Letter*, Tokyo: Waseda University, Graduate School of Social Sciences, 1957.

24 The period documented in *Notes of Travel in Formosa* was between April 22, 1874 and October 18, 1874.

Archival Inscription: John Thomson's Image of Formosa in 1871 [1]

Chou Yu-Ling

◆

In 1985, Huang Ming-Chuan collected the materials accumulated during his studies in the US and published a brief photographic history of Taiwan. This was the first systematic writing on the history of Taiwanese photography. The text mentions that around 1985, photographs of Taiwan were discovered in great quantities, noting: "This is proof that there is a thirst for historical images in Taiwan, a thirst born amidst the breakage of Taiwanese history. Owing to trends such as literary movements, political movements, and academic research on folklore, these photographs may finally enter the spotlight as historical evidence." [2] Owing to the reconstruction of social memory that commenced around the end of Taiwan's period of Martial Law, collecting historical photographs gained urgency as a form of cultural output and formed the basis for constructing a revised pictorial memory. *Photography Taiwan* and *Photography China*, published by Lion Art even earlier in 1979, attempted to bear witness to this historical shift. Despite the fact that these two publications focused on architecture and the daily lives of ordinary people, during the editing process Lion Art was raided multiple times by the Garrison Command. At that time, the production and interpretation of non-official historical images was especially difficult. As Hsu Chi-Lin stated, owing to political considerations, it was not until the 1980s that Taiwan finally had the necessary conditions to produce a local history of photography. [3]

At the same time, Wu Jia-Bao in May 1985 chaired the research project "The Coordination of a Hundred Years' Photographic History of Taiwan," organized by the Council for Cultural Affairs, Executive Yuan. The question "Who was the first to capture images of Taiwan?" [4] set the tone for a new history and was frequently discussed as the early history of photography in Taiwan was compiled. However, during the mid-1980s, a time when many historical facts were still to be discovered, most hypotheses could only be based on written records. [5] The search for the beginning of a photographic history, as Geoffrey Batchen stated, is more than an abstract act, but also a political one, as the idea of an origin is usually bundled with concepts of nationalism and the structures we impose on history. And on this basis, the selection of a starting point is also a declaration of intention. Batchen refers to historian Michel Frizot's *A New History of Photography* as an example. The work focuses on the technological production of photographic images, and in it, the definition of "photography"

and the nature of photography takes on utmost importance, transforming the history of photography into a history of "technology" and "production." This history excludes various practices of photography and photographic practices outside Europe—locations removed from the origin of the technology—such as Africa, Asia, and Latin America. Therefore, the question of the genesis of photography encompasses more than "where" it all began, but also includes "how" it all began. The question of "how" further serves to frame any origin story within the politics and worldview of a certain historical construct. [6]

By asking, "Who was the first to capture images of Taiwan?" or "How was Taiwan captured through photography?" the origins of Taiwan's photographic history have become entwined with the stories of "those who were photographed." In early research, which looked at the power relationships of seeing and being seen, John Thomson's photographs quickly came to be identified as marking year zero for photography in Taiwan. [7] Some scholars of 19th-century history even regard Thomson's 1871 photographs of southern Taiwan as a historical dividing point. Those who've examined the pre-Thomson history question whether there is any firm evidence, such as references in textual records. [8] However, new historical evidence suggests that the first incidence of photography in Taiwan took place between 1865 and 1874 when St. Julian Hugh Edwards documented his travels between Xiamen and Formosa with photographs. Edwards held multiple professional identities. He was the owner of a photography studio in Xiamen, held a position at the Spanish embassy there, and was once arrested by Charles W. Le Gendre for smuggling laborers. He viewed photography as paid work and a means of earning a living and never identified himself as an auteur photographer, i.e. one who self-consciously documents and presents his own photographic oeuvre. As a result, Edwards's photographs were scattered. When published, they were often presented without the name of the photographer. It is often impossible to definitively identify Edwards' photographs as being taken by him. [9]

From 1985 onward, scholars working to construct a history of photography were no longer satisfied with viewing photographs as mere historical footnotes or evidence, which urged viewers to regard photographs from the narrative viewpoint of a succession of historical eras. It was proposed that "photography needs a historical trajectory of its own," [10] a sentiment which conveyed an urge of questioning its ontological starting point. Despite the fact that photography has an innate

ability to "capture reality," it has limitations as "self-evidence." In his "Little History of Photography," Walter Benjamin relates the vital role of inscription in photography, thus, "the lessons inherent in the authenticity of photographs to follow the ability of capturing reality. This is where an inscription must come into play without which all photographic construction must remain arrested in the approximate." [11] The reason Thomson's work was recognized as the genesis of Taiwan photography in 1985, when the urge for tracing the origin began, was mainly due to the fact that he was able to leave behind textual records alongside his photographs, which enabled categorization and identification. These captions enable precise identification to his photographs and save researchers on 19th-century photography in Taiwan from the difficulty of having "images and no texts,"[12] which makes it impossible to date photographs or identify the photographer, or else "texts and no images." An example of this latter case came in 1854, when Commodore Matthew Perry commanded Joel Abbot, captain of the *Macedonian*, to explore coalmines on Taiwan's northern coast, along with another ship, the *Supply*. Photographers were probably on board the ships, but no photographs have ever been discovered. [13]

Thomson's textual inscriptions can be separated onto two levels: one is his notes written directly on the plates; the second is his later publication and public presentation of photographs of his travels after returning from Asia to Britain. In the former, Thomson carefully wrote the location, subject, and year onto the glass negative. In 1921, before selling his entire oeuvre to the Wellcome Collection, he wrote the location and year of the photographs using materials that resembled paper tape, and also carefully numbered the glass negative, archiving the images.[14] As for publishing, after Thomson in 1872 completed his five-year journey through China and Formosa, he published five travel books on the expedition. [15] As a member of the Royal Geographical Society and Ethnological Society of London,[16] Thomson continued to present talks on his journeys in Formosa from the perspective of geographical exploration and anthropological research (for example, Thomson published *Notes of a Journey in Southern Formosa* at the Royal Geographical Society in 1873). Thomson's textual inscriptions, whether written on the glass plate or in published materials, which have allowed Thomson's photographs to be easily recognized and incorporated as photographic heritage. Therefore, compared with other 19th-century photographers who traveled to Formosa but did not take detailed notes of images or had no intention of wide distribution, Thomson had an astute awareness regarding the messages that images convey. For instance, in his 1891 article, "Photography and Exploration," Thomson states that he wishes "to show the growing importance of photography in its application to science, notably to geography; also to urge explorers to avail themselves more fully of the great advantages which knowledge of photography secures, in enabling them to illustrate their route and register their observations." [17] To ensure the knowledge that photography secures, Thomson's act of making detailed notes on his photographic subjects echoes the power-knowledge-subject trinity, which was behind 19th-century policies for

colonialism and imperial expansion.

As the construction of the history of photography is intimately linked with the techniques of inscription and interpretation, apart from Thomson's 19th-century techniques of documentary inscriptions, which led him to swiftly become a notable pioneering figure in the history of Taiwan photography, as mentioned at the beginning of this paper, the methods that Thomson implemented to contribute to the imperial archive economy of the 19th century through this inscription technique will be elaborated. In the following chapters, I will account for the reason for Thomson's travel to Asia and his attempts to publish his work following his return.

John Thomson's Travel in Asia

John Thomson (1837-1921) was born in Edinburgh, Scotland. His father was a successful tobacconist. Edinburgh was then important in the optical and scientific instrument trade in the 19th century.[18] Between the years of 1851 and 1861, Thomson was apprenticed as an optician, and was also admitted as a member of the Royal Scottish Society of Arts. During his apprenticeship, he was exposed to microphotography.[19] In 1859, Thomson's older brother moved to Singapore and started a business as a watchmaker and photographer. In 1862, the 25-year-old Thomson decided to travel to Singapore to assist his brother in his photographic studio, mainly taking portraits of European merchants and producing *cartes de visite*. Earnings from the photography studio funded his subsequent four years of traveling throughout Southeast Asia.[20] During his time in Singapore, Thomson trained two Chinese assistants: Akum and Ahong. The two became Thomson's important travel companions on his voyage through Asia.[21] After settling in Singapore, geographical convenience led Thomson to travel to various locations in Malacca, Sumatra, and Penang.

In 1864, John Murray publishing company published a translation of French author Henri Mouhit's *Travels in the Central Parts of Indo-China (Siam), Cambodia and Laos During the Years 1858, 1859 and 1860*. The book inspired Thomson to visit Siam and Cambodia to take pictures of Angkor Wat. In 1865, Thomson arrived in Bangkok and took photographs of King Mongkut and Thai aristocrats and officials. Thomson was keenly alert of the commercial value of these pictures and his ownership of them, he even asked the King not to show the pictures to other photographers for fear that they might try to duplicate the images.[22] From the perspective of protecting ownership of his photographs and their dissemination, it is evident that Thomson had considerable awareness of his identity as a photographer. During the 19th century, an era in which copyright did not yet exist, it was common to duplicate or copy other people's photographs for commercial purposes. For instance, W. Elwell Goldsborough, US consulate of Xiamen, once wrote to Beijing to appeal for his lawsuit with Julian Edwards, stating that not only was the amount of compensation for Edwards too high, but also that the photographs provided by Edwards were themselves duplicates, and that Edwards was not the photographer of the images.[23] Therefore, Thomson's meticulous inscriptions of the date of his photographs, his

control of their circulation, and documentation of the images by their author, ensure that photographs of Thomson's travels in Asia are very easy to identify.

In June 1866, Thomson returned from Singapore to the UK, staying for a year. Less than two months after arriving, Thomson took a proactive stance in publishing a report of his travels in the East. He first shared his travels at the British Association for the Advancement of Science in Nottingham. On August 16th of the same year, he presented a report on his travels in Cambodia and Siam at the Royal Geographical Society, becoming an official member in November. He further showcased his photographs of Cambodia at a photography exhibition arranged by Edinburgh Photography Association. In 1867, Thomson began publishing his works in the *British Journal of Photography* and *Illustrated London News*. The same year, Thomson published his first photography collection *The Antiquities of Cambodia: A Series of Photographs Taken on the spot* and joined the Ethnological Society of London. As a result of publication, Thomson's travels in the East brought him considerable fame and response from the public. This same model, traveling in the East, taking photographs, and returning to publish one's experiences, was a strategic approach that built his professional reputation through publishing opportunities in various British institutions. After his stay in Britain, Thomson returned to Singapore late that same year and began planning his 1868 voyage to China.

Travels on Formosa

Thomson settled in Hong Kong in 1868. Foreign expeditions were inextricably linked with the actions of Western imperialist forces in China. Treaties signed following the Opium Wars guaranteed Westerners rights of residence, religious missionary work and trade. For example, the Treaty of Nanking (1843), signed after the First Opium War, opened five harbors and led to the cession of Hong Kong to Great Britain. In June 1858, the Ch'ing court signed the Treaty of Tianjin with the US, Britain, and France, which further led to the opening of the Taiwanese ports of Anping and Huwei (now Tamsui). Although the ports of Jióng and Takao (now Keelung and Kaohsiung) were not listed in the treaties, they had a record of foreign trade and there was a coal mine located in Jióng, so the Ch'ing court was demanded by the foreign force to open the ports. As a result, a considerable amount of "treaty-port imagery" of the 19th century has been left to us.

Hong Kong and other trading ports were contact points for foreign powers and were often described as prosperous, orderly, and lively. Thomson believed that electricity was a symbol of modern civilization, and technology such as steamships and telegrams would alter the landscape of China. In particular, electrified Victorian cities served as signposts of the achievements of western civilization.[24] Thomson arrived in Hong Kong in 1868 and set up his studio in the Commercial Bank Building, and part of his income came from taking photographs of tourists. He also began publishing his photographs of Southeast Asia in *The China Magazine*. Between 1868 and 1869, Thomson took short trips to neighboring areas

of Canton and Shanghai. Then in 1870, he decided to leave his studio to spend a year traveling through China. While passing through Xiamen, Thomson visited the Amoy hospital, which was one of the most important missionary outposts in China, and also a crucial contact point for missions to Formosa. It was here that Thomson met doctor James L. Maxwell, who became an important guide in his travels in Formosa. Maxwell had been appointed as a medical missionary to Formosa in 1863. According to *Handbook of the English Presbyterian Mission in South Formosa* (1910),[25] Maxwell received 18 months of language training in Xiamen and arrived at Tai-wan-fu to set up a missionary station in May 1865, accompanied by missionary Carstair Douglas (1830-1877). From that time forward, Western medicine spread through the island with the intention of "curing body and soul."[26]

Maxwell's medical missions throughout Taiwan provided a plan for Thomson's travel route. Thomson took a series of portraits on the *pingpuzu*, all of whom were from Maxwell's parish. When Maxwell began his missionary work in Formosa in 1865, he was faced with substantial hardship and was forced to compare relative chances for success in preaching the gospel to indigenous tribes versus the Han Chinese. In November 1865, Maxwell visited Xingang, Kong-a-nah, and Lau-long with W. A. Pickering, a customs official at Takao. The visits were met with enthusiasm and confirmed Maxwell's thoughts about preaching to the *pingpuzu*. Between 1867 and 1868, Maxwell again joined Pickering for multiple visits to the mountain areas of southern Taiwan, then in 1870 proceeded into regions inhabited by the *pingpu* people, including Baksa, Poah-be, Kong-a-nah, and A-Li. With Maxwell's Pepohoan domestic helpers Nhauh-a and Niu-I assisting with missionary work in Baksa, proselytization went smoothly and the number of believers shot up from 60 to 200 within two months.[27] Local chapels were also established in these areas.

By the time Thomson first arrived in Formosa in 1871, Maxwell had already built over a dozen chapels in the *pingpu* area, with around 1,000 *pingpu* people baptized.[28] Those regions Thomson visited had thus already been exposed to two types of modern technology, photography and Western medicine. Maxwell had been the first missionary of the English Presbyterian Church in Taiwan, so in addition to building missions and engaging in medical work throughout Taiwan, he further assisted in the production of numerous portraits and photographic images of the *pingpuzu*. For example, Professor Douglas L. Fix speculates that the *pingpuzu* portraits in the manuscript of Le Gendre's *Notes of Travel in Formosa* were probably taken between January 1869 and February 1870 by Julian Edwards, with the commission from Le Gendre coming at Maxwell's parish in the company of Le Gendre, Pickering, and John Dodd. Maxwell's *pingpu* domestic helper and pious congregation member Niu-i was captured both as part of a Maxwell family portrait and in a solo portrait captioned "Peppo woman, Baksa" in *Notes of Travel in Formosa*, which has become a representative image of Baksa pingpu women. This early photography in Maxwell's parish was a physical endeavor that required great discipline (exposure

times varied with the amount of available and range from several seconds to one minute) and with the spread of medical missions became a familiar ritual in Formosa. While Thomson encountered distrust and even physical attacks in China, the major challenges he encountered in Formosa were limited to the physical hardships of climbing mountains and crossing rivers. Thomson's photography proceeded smoothly, and in this Maxwell played a key role.

The route of Thomson's travels included Takao (Kaohsiung), Tai-wan-fu (Tainan), Poah-be (Zuojhen), Baksa, Pau-ah-liau (Baolong), Ka-san-po, Lau-long and La-ko-li. Thomson took 61 photographs in total,[30] and the subject of his images can be roughly divided into two categories, the mountain scenery of southern Taiwan and portraits of *pingpuzu*. Thomson also took pictures of their daily lives and the chapels they built. According to Thomson's travel log, he traveled from Xiamen together with Maxwell, arriving at Takao on April 1, 1871. Upon arrival, Thomson first proceeded to Reverend Hugh Ritchie's mission station. On hearing the news of bandits raiding the island, Thomson postponed his plan to visit the "Pepohoans" of southern Taiwan and proceeded to visit the Tai-wan-fu Taotai early on the morning of April 2. When he expressed his wish to see the aborigines of the island, a man who was said to be the nephew of a Taotai warned him in fluent English that he would never be able to go near the locals, and would only be shot with poisonous arrows or lost in the mountains. Thomson's clear wish was to travel deep into "the heart of the island in search of aborigines"[31] to fill the absence of adventures with primitives in his travels in Asia.

After a few days of rest, on April 11 Maxwell and Thomson decided to travel deeper into the mountains. The two wished to visit the more remote missions stations, and Maxwell wanted to add more parishes. After leaving Tai-wan-fu, the first station they reached was Poah-be. Before setting out for the mountains, they hired sedans and coolies to carry photographic equipment. As they moved closer to the mountains, the group braved winding, muddy mountain trails, and upon reaching Poah-be, they were welcomed by the *pingpu* people, who hadn't seen Maxwell for some time. Within the area was a small church run by a *pingpu* believer. The next morning, the group proceeded to Baksa and was again welcomed by many *pingpu* people. After spending one night at the mission station, the group proceeded toward Ka-san-po on April 13, climbing steep, bare cliffs. The group hired six *pingpu* men as porters, and together they enjoyed majestic views of the central mountains range enshrouded in clouds. The group made a brief stop on reaching Kamana, then led by a local church deacon, they left the mission station and proceeded on their arduous journey. Reaching Pau-ah-liau, they stayed with a *pingpu* family named Sin-chun. Thomson described in detail their experience of dining with the tribal members and Maxwell's medical inspection after the meal.

On April 14, they set off toward Ka-san-po and stayed at the home of an elder named A-Tung, an acquaintance of Maxwell. Thomson described the *pingpu* living conditions in great detail and participated in a celebration of song and dance that night. On April 15, the group proceeded eleven miles to Lau-long, passing scenery that Thomson described as offering the most spectacular views he'd encountered in his entire life. As the party was about to enter "savage territory,"[32] A-Tung sent a gun-bearing youth to accompany Thomson. They stopped briefly on this phase of their journey to take photographs of the beautiful scenery. Reaching Lau-long, which was near a large river, they were received by *pingpu* man A-Hung. A-Hung's son served as a guide as they proceeded onwards to La-ko-li and Thomson took pictures of indigenous tribes and scenery along the way. While spending the night in La-ko-li, the group stayed at the residence of an old acquaintance of Maxwell's, and Thomson stayed up late to prepare the silver nitrate solution. On April 17, Thomson spent most of the day traveling back to Baksa and taking photographs, and Maxwell raced back as well to conduct the Sunday service at Baksa chapel the next day. After staying that night in Baksa, on April 18 Maxwell led the service at the chapel and Thomson returned to Takao. Thomson had hoped to explore to visit tribes further south, but due to fighting in that region, he ended his travels in Formosa.

The Publication of the Photography Collection and Archival Desire

After traveling through Formosa, Thomson returned to Hong Kong in April 1871. There, Thomson sold his photo studio in order to procure more photographic equipment and then proceeded on to Shanghai, Hebei, Tianjin, Beijing, Hangkow, Sichuan, Nanjing, and other parts of China. Thomson returned to Hong Kong again in the spring of 1872 to sort through his glass plates, finally narrowing them down 1,200 images to take back to Britain. Upon returning to Britain in the autumn of the same year, Thomson began publishing photographs of his five year voyage through China and Formosa. Thomson divided his photographs of Formosa into three publications: *Illustrations of China and Its People* (1873-1874), *The Straits of Malacca, Indo-China, and China: Or, Ten Years' Travels, Adventures, and Residence Abroad* (1874, hereafter referred to as *Ten Years' Travels*), and *Through China with a Camera* (1898).[33]

Illustrations of China and Its People is Thomson's most acclaimed album of photography. The four-volume work, published by company Sampson Low in 1873 or 1874, contains over 200 photographs along with letterpress-printed captions. An advertisement for the album emphasizes the photographer's observations and personal experience of travel, with text that reads, "Magnificent Work on China: Being photographs from the Author's Negatives, printed in Permanent Pigments by the Autotype Process, and Notes from Personal Observation."[34] The collotype or autotype method used was able to print continuous tones and was an advanced technology at the time.[35] The price of each volume was 3 pounds, 3 shillings, making it rather expensive for such a publication. Thomson's images of Formosa appear in the first and second volumes, with 600 copies printed of each. In the literary

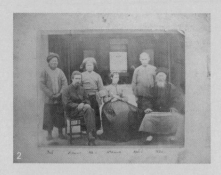

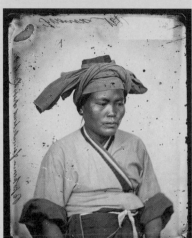

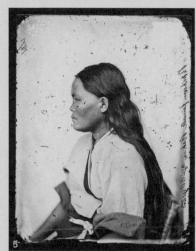

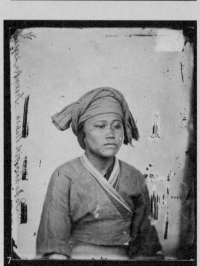

1 Pepohoan dwellings Formosa China Pepohoan house Bak-su, Formosa 1871 Huts Formosa native Pepohoan. 410 Credit: Wellcome Collection. (CC BY 4.0) I 2 In the collections of the School of Oriental and African Studies are preserved the names of those photographed. This photograph is of the Maxwell wife and husband, their pingpu helper and fellow church member Thik Niu-i, their Han helper, and the preacher Wu Wen-Shui, known as Bun. Credit: The School of Oriental and African Studies, Missionary Collections (PCE BOX2, file2) I 3 A photograph by Edwards of a *pingpu* woman in Baksa. This photo was part of photos found in Le Gendre's *Notes of Travel in Formosa*. Collection of National Center of Photography and Images I 4 John Thomson, Pepohoan female, headdress, Baksa, Formosa [Taiwan], 1871. Credit: Wellcome Collection. (CC BY 4.0) I 5 John Thomson, Pepohoan female, Baksa, age 30 years, Formosa [Taiwan], 1871. Credit:Wellcome Collection. (CC BY 4.0) I 6 John Thomson, Old Woman, Canton, Kwangtung Province, 1869. Credit:Wellcome Collection (CC BY 4.0) I 7 John Thomson, Pepohoan Girl, Baksa, Formosa, 20 years old,1871. Credit: Wellcome Collection (CC BY 4.0) I 8 John Thomson, *Illustrations of China and Its People*, Vol.2, plate2. Collection of National Center of Photography and Images

reviews *The Graphic* and *The Athenaeum*, these volumes received high praise. The second volume, which opened with images of Formosa, was the best received of the two. One reviewer wrote, "It is only the testimony of our own eyesight that would convince us that photography was capable of yielding such marvelous effects. There is a softness and delicacy about these illustrations that we should have thought unobtainable by any merely mechanical process…The work is indeed in all ways a perfect miracle of excellence, and Mr. Thomson has every claim to be regarded as a public benefactor."[36] Strictly speaking, *Illustrations of China and Its People* is not a travelogue, but rather a collection of photographs with supplementary descriptive texts. In the first volume, images of Formosa appear in the final chapter, "A Mountain Pass in the Island of Formosa." The left-side pages contain brief passages of population, history and geography of Formosa, the right-side pages contain photographs of the mountain scenery at Ka-san-po and Lau-long. Other chapters on Formosa include "Bamboos of Baksa," "The Natives of Formosa," "A Pepohoan Dwelling," "Types of The Pepohoan," and "A Country Road near Taiwanfu." The texts of this series describe the images in a neutral, reportedly manner. For example, for the photograph *The Natives of Formosa*, the caption states, "The theme of this image is the Pepohoan of Baksa…they are often regarded as the most advanced types of those semi-civilized aborigines." There is a difference here from Thomson's travel notes, which often use the word "savage." These published texts in comparison display a more objective or neutral perspective, while the images are categorized by racial type, which was a prominent method in ethnological photography during the Victorian era. For example, portraits shot either full face or in profile and using a simple neutral background were standard in 19th-century ethnological photography.[37]

Illustrations of China and Its People enjoyed good sales, and as a result, in 1874 another volume of Thomson's China travel notes, *Ten Years' Travels*, was raced to the printers in time for a December 1874 release to coincide with that year's Christmas sales. *Ten Years' Travels* was printed in the octavo format, which is about the size of a modern paperback, and documents Thomson's travels in the Far East. The book includes 60 woodcut prints by J. D. Cooper, which are reproductions of Thomson's photographs. The price for one book was one guinea (£ 1.05). *Ten Years' Travels* also received positive reviews. In 1875, *The Illustrated London News* described the volume as "providing large amounts of entertaining knowledge…[while Thomson's camera is] ever wide open to [China's] scenes and manners, of which he sets before us a lively and truthful series of views."[38] Critics at *The Athenaeum* however opined that the book failed to report anything new.[39] Unlike *Illustrations of China and Its People*, which was principally an album of photography, *Ten Years' Travels* is largely composed of text; it is a lengthy travel narrative written in a lively tone and intended to be entertaining and affecting. Thomson tells of hearing stories of cannibal savages while still on the ocean voyage to Formosa's shores, and upon landing, of his declaration to the Taotai of his wish

to see the aborigines deep in the heart of the island, only to be warned of dangers that would inevitably unfold. Early in the book, Thomson repeatedly describes Formosa as being beyond the rule of law. But as he visits Maxwell's parishes and meets the *pingpuzu*, he begins to describe the natives as of noble character, welcoming and living in harmony. The book describes Thomson's travel routes in great detail, and offers vivid accounts of the scenery and Thomson's encounters along the way. In this book, the prints merely serve as illustrations to the text, and from Thomson's travels in Formosa, only one image of Lau-long and one map of southern Taiwan is included.

Having established his professional reputation in Britain, in 1876 Thomson translated French chemist Gaston Tissandier's *History and Handbook of Photography*, and then in 1877 he co-authored the famous book of photos and text, *Street Life in London*. Thomson was named Instructor of Photography at the Royal Geographical Society, and in 1898 and 1899 produced the volume of text and photos, *Through China with a Camera*, his final book to be published before his death. *Through China with a Camera* was published in a volume of 100 photographs in 1898 by Westminster A. Constable & Co, and then in 1899 in a volume of 114 photographs published by London and New York Harper & Brothers. Despite the slight difference in the selection of images, the texts of the two versions are largely the same as that of *Ten Years' Travels*, though with some minor simplifications. The two books were printed using the process of halftone printing and thus avoid losing any of the detail of the original images.[40] New printing technology had a crucial effect on the publication of books of travel photography. The advantage of halftone printing was its ability to print images and texts on the same page at the same time, thereby lowering printing costs. In regards to Thomson's travels in Formosa, what's special about the 1898 version of *Through China with a Camera* is Thomson's pairing of photographs from China with texts on Formosa. One passage describing his visit to the Taotai courtyard and another offering his observations before leaving Tai-wan-fu of Han Chinese farming in the fields or on village streets are set against images of courtyards and street scenes in China. Evidently, while Thomson was traveling in Formosa in 1871, he was not overly interested in taking photographs of the Han Chinese, and as a result he captured few images of them. However, 27 years later, publishing considerations caused him to attribute images of China to Formosa.

From the three types of publications mentioned above, it is evident that Thomson was skilled at adapting the style of his prose and images to different readerships and markets. His repeated publication of the accounts of his travels shows a "publishing fever" and is like an attempt to resist the fading of memory by using technologies of inscription to preserve these memories as external traces. To some extent, this reflects the nature of media representation during the Victorian era, with photography coming on as a new technology for seeing. This context certainly includes the

calotype process developed by William Henry Fox Talbot, which allowed an unlimited number of photographic prints to be produced from a single negative image. This let readers become accustomed to a mixture of lithography, photography, and narrative fiction as means for observing and understanding colonialism, the exploration of foreign lands, and even class distinctions used to demarcate the Other.[41] So owing to the proliferation of printed matter, Thomson was able to respond to European readers' thirst for visual information and photography's promise to connect the entire world, a process which involves a desire for documentation. Derrida's *Archive Fever* presents an incisive analysis of the principles of the archive. The Greek word *arkheion* refers to the home, residence, and address of a civil administrator, as well as the administrator himself.[42] This administrator's residence is also the site where the archives occur, and is thus an intertwining of topology and legal affairs. The administrative official exercises a power to accumulate, identify, and categorize all that is seen. In the same way, Thomson, upon his return to London, in 1873 presented his collected information and knowledge on Formosa at the Royal Geographical Society. Viewed from the perspective of an intertwining of topology (which in nautical terms refers to navigation rights) and legal affairs, we can imagine the foreign lands that were reached through imperial expansion and navigation rights. Thus in the Victorian era of the 19th-century, "literate people apparently found it irresistible to imagine the Empire itself as an archive." [43] Underneath the enormous house of an empire, by way of documentation, interpretation and accumulation of cultural knowledge of the other, external unknowns are gradually incorporated into a systematic, singular, clear, and ideally-arranged body of documents.

The Type of Primitives

From the 1860s, British anthropologists such as Thomas Henry Huxley and J. H. Lamprey began using photographs as part of a system of scientific measurement, most commonly employing full-face and in-profile photographic portraits. Thomson applied these standardized methods in his photographs taken in Formosa, which not only allowed him to quickly establish relationships with his subjects, but also enabled the public to receive in a familiar visual format about the new Other. With the expansion of the British Empire in the 19th century, subjects and themes of observation grew significantly more diverse, but at the same time modes of understanding became more and more standard. In other words, the creators and viewers of images co-existed in the same social and cultural space, and that visual information deemed familiar or acceptable became increasingly homogeneous. Hence, the anthropological style of photographic portraits became a kind of general visual grammar for determining cultural differences, by which new figures and faces were presented according to a familiar formula.

Thomson took both full face and profile photographs of Pepohoans standing in front of white walls or walls decorated with bamboo ink paint. He also took photographs of women before and after removing their headscarves. The portraits that Thomson took in China were very different. For instance, in his *Illustrations of China and its People*, the chapter "Types of the Labouring class" records the social background and names of his subjects and endows them with personality. To offer one example, Thomson writes, "Joan …the old woman still busies herself in the lighter domestic duties: she is skilled with her needle, and invaluable as a nurse in time of sickness."[44] In his photograph of Joan, who is posed in profile, Thomson breaks through anthropological conventions. He captures her neat, tidy hairstyle, and allows the subject to pose in a contemplative manner, lightly touching her chin with her right hand and supporting her elbow with her left hand. The closeup of the wrinkles on Joan's hand hints at manual labour and social status. Photographs from Formosa of the *pingpuzu*, on the other hand, generally adhere to anthropological conventions; they only mention the subject's gender and age. For example, the inscription on one glass plate reads, "Pepohoan girl Baksa Formosa 20 years old," thus classifying the photographic subject by her tribe and presenting an anthropological taxonomy of clothing, hairstyle, and facial features. In a chapter titled "The Natives of Formosa" in *Illustrations of China and its People*, Thomson writes, "The illustrations Nos. 2, 3, 4 and 5 are female, while Nos. 6 and 7 are male heads of Pepohoans."[45] The subject's identities are replaced with "heads of Pepohoans" and anthropological readings of their facial features. If Thomson's photographic portraits from China exhibit the markings of social class, the photographic types from Formosa are only identified by their primitive status, recalling perhaps Thomson's desire to search for "savages on the strange island."[46] In Thomson's Asian travels, Formosa became a necessary element to add to his collection on account of its "primitive" character. But this conception of Formosa as "primitive" was only able to form after Formosa finally encountered modernity and was put on a spectrum ranging from the modern to the pre-modern. Within Thomson's photographic oeuvre, China appears in the process of modernization and illuminated by the "light of civilization," [47] while Formosa's primitiveness is presented in terms of natural mountain scenery and portraits of its indigenous people. What's more, these kinds of imagined ideas became Thomson's reference value for a "classic type of primitive," which he later used to describe Gypsies living in the streets of London. Thomson writes, "In his savage state, whether inhabiting the marshes of Equatorial Africa, or the mountain ranges of Formosa, man is fain to wander…" [48] Formosa's primitivism thus appeared as a defining factor of nomadic urban types in his famous *Street Life in London*.

Secret Agreement/ Inscription/ Heritage/ The-to-be-looked-at-ness

After Thomson exposed and developed his photographic plates, he used an edged tool to write inscriptions on the glass. These inscriptions allow the photographs to resist ambiguous interpretation. Once Thomson returned to Britain, he energetically published and promoted his works. Before his death, he sought out a safe repository in which to preserve his photographic negatives. All of this indicates Thomson's desire

that his work not be forgotten and that it to be preserved for posterity. The legacy of his images has influenced Taiwan's recognition of its own identity within the history of photography in Taiwan. However, as Hsu Chi-Lin points out, if one is to write a photographic history of Taiwan in which Taiwan is defined solely as a geographic territory, one must confront a common myth, namely the desire to discover an authentic, local, and non-foreign gaze. Creating a self-identity by viewing the self through the eyes of one's own kind seems to be a necessary task in the production of a national consciousness.[49] However, I believe this type of self-identification is missing an important layer of history, namely the experience of being looked at, which occurs in the context of colonialism. To-be-looked-at-ness is a concept developed by Rey Chow that aims to break through the moral dilemma of anthropology by attempting to construct a fortress between the dualism of Us (the viewed object) and Them (the viewing subject) within the western anthropological tradition, a tradition which documents the lives of the other but is incapable of considering the power dynamic that is involved.[50] We must be aware that to-be-looked-at-ness will very likely become a part of subjective identification, as the space in front of the photograph we look upon has already been occupied by the gaze of the photographer. As we interpret the history of photography, there will be consideration of the past for objectifying the "to-be-look-at-ness."

Thomson's lens has indeed influenced Taiwan's perspective towards its own self-representation, which is a kind of imagined geography of otherness. In "The Indistinct Exposure: A Brief History of Photography in Taiwan" Huang Ming-Chuan once stated, "In the world history of photography, Taiwan is a non-existent geographical entity. Unlike Japan and the coastal regions of China, where contact with the West, and conflicts precipitated by political interests and cultural differences, attracted Western photographers…. In the eyes of Westerners of the Qing Dynasty, [Taiwan] was only a place filled with Manchus, Han Chinese, Pepohoans and rumors of bloodthirsty savages."[51] Viewing Taiwan according to the Western gaze has nevertheless offered clues toward an understanding of differences and distinctions, such that Taiwan can be seen for its otherness relative to China and Japan. Moreover, in our contemporary era, "to-be-looked-at-ness" has transformed into a desire to be seen by others. "Owing to Thomson's fame in the history of photography... his photographs of Taiwan from 1871 brought Taiwan's photographic history into larger history of world photography. "[52] Whether the history of photography in Taiwan was truly brought into the history of world photography is an issue that will require further examination. However, the implication here is that the "to-be-looked-at-ness" of the 19th century has now been transformed into a desire to be seen through the lens of documentary images. The complex relationship of viewing and projecting one's views is in fact touched upon in Thomson's *Ten Years' Travels*, when he declares that to travel through Asia with a camera is "to hold the mirror up to his [the reader's] gaze, that it may present to him, if not always an agreeable, yet at least a faithful, impression of China and its inhabitants." [53] Taking the mirror as a metaphor, its reflection may not only reveal a faithful representation of the sights and peoples of some foreign land, but also the mutual gaze between the mirror holder (the viewer) and oneself. This mutual entanglement points towards a kind of visual discourse, which "saw the world before I did and will go on seeing it after I see no longer." [54]

1 This paper has been revised numerous times; part of the content is revised from MA dissertation by Chou Yu-Ling. Chou Yu-Ling, "Archival Inscription – John Thomson's image archive of Formosa in 1871," MA Thesis, London: The London Consortium, 2008.

2 Huang Ming-Chuan, "The Indistinct Exposure: The Brief Taiwan Photographic History," *Lion Art*, no. 175, September 1985, pp. 158–168.

3 Hsu Chi-Lin, "Photography in Taiwan and Preliminary Research of Symbol of China," *The Realms of the Other: Cultural Identities and Politics of Representation*, ed. Joyce Chi-Hui Liu, Taipei: Rye Field Publishing, 2001, p. 136.

4 Huang Ming-Chuan, "The Indistinct Exposure: The Brief Taiwan Photographic History," p. 165.

5 For instance, Huang Ming-Chuan presumed that the import of photography was probably no later than 1852, since Matthew C. Perry, commodore of the United States Navy who's administration included East India, China, and Japan, traveled southward from Ryukyu to Jilong to investigate the coal mine in the stratum surrounding Jilong. Two daguerreotype experts were among the crew, but it is unsure whether they took photographs.

6 Geoffrey Batchen, "Origins Without End," *Photography and its Origins*, New York: Routledge, 2015, pp. 68–71. Judith Balmer, "Introduction," *Thomson's China: Travels and Adventures of a Nineteenth-century Photographer*, Hong Kong, Oxford, New York: Oxford University Press, 1993, p. x.

7 Wu Jia-bao, "Brief Photography history in Taiwan," http://www.fotosoft.com.tw/book/papers/library-1-1005.htm, accessed August 21 2015. Hsiao Yong-Seng, "The Genealogy of Taiwanese Realistic Photography," *Modern Art*, No.74, October 1997, pp. 19–27. Chang Chao-Tang, "Light and Footstep: A Report of Development of Taiwan Documentary Photography," June 1992, *Annual of Photography in Taiwan*, Taipei: Yuan Yi Art Gallery, 1998, pp. 33–48. Chuang Shu-Hui, "Requiring More Development and Ploughing: The Developmental Trajectory and Current State of Artistic Development in Taiwan's Photography Art," *Artco*, No.61, October 1997, pp. 219–224.

8 Lin Chi-Ming, "19th Century Images of Taiwan: New Clues and Interpretations," *Eye of the Times: Centennial Images of Taiwan*, Taipei: Taipei Fine Arts Museum, 2011, pp. 25–35.

9 Among research on Julian Edwards, the most thorough is Douglas L. Fix's "Shots from the shadows: The Formosan images of St. Julian Hugh Edwards," *Notes of Travel in Formosa*, ed. Fix and John Shufelt, which compares and identifies 30 (9 of which were "probably" taken by Edwards) photographs by Julian Edwards. In addition, the book also provides a rare glimpse of the overview of the works of Edwards. Douglas L. Fix and John Shufelt, eds., *Charles W. Le Gendre: Notes of Travel in Formosa*, Taipei: National Museum of Taiwan History, 2013.

10 Huang Ming-Chuan, "Photography Visual and Taiwan Phenomenon," *Lion Art*, May 1986, p. 86.

11 Walter Benjamin, *Selected Writings, Volume 2, Part 2, 1931–1934*, trans. Rodney Livingstone and others, eds. Michael W. Jennings, Howard Eiland and Gary Smith, Cambridge, Mass., London: Belknap Press of Harvard University Press, 1999, p. 527.

12 Wang Ya-Lun, "Discussion about the Necessity of Instituting an Image Archive— Take the Collection of French National Library as the Starting Point," *Old Photographs as a Fundamental Part of Culture Patrimony: An International Seminar*, Taipei: National Digital Archives Program Taiwan, 2006.

13 Kao Chih-Chuan, "Photography Pioneers of 19th Century Taiwan," *In Sight*, Taichung: National Taiwan Museum of Fine Arts, 2010, p. 32.

14 Liu Chia-Chi, "Developing the images of Formosa in 1871— Landscape issues in John Thomson's Photography in Taiwan," Master's degree dissertation, Taipei: National Taiwan Normal University, 2008.

15 Listed as follows: *Foochow and the River Min, 1873; Illustrations of China and Its People*, 1873–1874; *The Straits of Malacca, Indo-China, and China: Or, Ten Years' Travels, Adventures, and Residence Abroad*, 1874; *The Land and People of China*, 1876; and *Through China with Camera*, 1898.

16 Elliott S. Parker, "John Thomson 1837–1921 RGS Instructor in Photography," *Geographical Journal*, vol. 144, 1978, p. 456.

17 John Thomson, "Photography and Exploration," *Proceedings of the Royal Geographical Society and Monthly Series*, vol. 13, no. 11, November 1891, pp. 669–675.

18 Judith Balmer, "Introduction," *Thomson's China: Travels and Adventures of a Nineteenth-century Photographer*, Hong Kong, Oxford, New York: Oxford University Press, 1993, p. x.

19 Gaston Tissandier, *A History and Handbook of Photography*, trans. John Thomson F.R.G.S, London: Sampson, Low, Marston, Low & Searle, 1876. Also see Joel Montague and Jim Mizerski, *John Thomson: the early years in search of the Orient*, Bangkok: White Lotus, 2014, p. 2.

20 Balmer, "Introduction," p. xi.

21 Stephen White, *John Thomson: A Window to the Orient*, New York: Thames and Hudson, 1986, p. 10.

22 Letter from King Mongkut to John Thomson, May 13, 1866. From a copy of the original handwritten letter made available by Stephen White. Also see: Montague and Mizerski, *John Thomson: The Early Years—In Search of the Orient*, Thailand: White Lotus Press, 2014, pp.18–35.

23 Terence Bennett, *History of Photography in China: Western Photographers 1861–1879*, trans. Hsu Ting, Beijing: China Photography Press, 2013, pp. 180–181.

24 John Thomson, "Introduction," *Illustrations of China and its people*, London: Sampson Low, Marston, Low and Searle, 1874, Vol. I.

25 Rev. William Campbell, *Handbook of the English Presbyterian Mission in South Formosa*, London, Edinburgh, New York: F. J. Parsons, LTD, 1910, p. xiii.

26 Li Shang-jen, "In the Crevice between Rumors and Empire: Missionary Medicine and Conflicts between Locals and Religion in Early Taiwan," *400 Years of Taiwan Medicine*, Taipei: Rhythms Monthly, 2006, pp. 52–57.

27 Home worship, March 1st, 1870, quoted from Lambert van der Aalsvoort's *Leaf in the Wind*, Taipei: Rhythms Monthly, 2003, p. 141.

28 Rev. William Campbell, *Handbook of the English Presbyterian*, p. xiv.

29 Douglas L. Fix, "Shots from the Shadows: The Formosan Images of St. Julian Hugh Edwards," Taiwan Studies in the US and New Research on Taiwan History Conference (II) and 2007 Lin Ben Yuan Culture and Education Foundation, 2007, pp. 19–21.

30 Hsiao Yong-Seng, "The History in Antique Photo Albums: Investigation of Taiwanese Photographs in 1860s," *Voices of Photography*, no. 9, May 2013, pp. 72–79.

31 John Thomson, "The Straits of Malacca, Indo-China, and China: Or, Ten Years' Travels, Adventures, and Residence Abroad," *Formosa from the Earth and from the Air 1871–2006*, trans. Huang Shih-Han, France: Pigeonnier Publishing, 2006, p. 90

32 Quoted from the text in John Thomson, "Ten Years' Travels: The Straits of Malacca, China, and Indo-China," *Formosa from the Earth and from the Air 1871–2006*, trans. Huang Shih-Han, ed. Yen Hsiang Ju, Taipei: Librairie Le Pigeonnier, 2006, p. 64.

33 Despite the fact that *The Land and People of China*, 1876, is a book that was published for the promotion of Christian knowledge, it includes a few woodcut prints edited from Thomson's works. *The Land and People of China* analyzes China's condition in topics including geography, history, and religion, but rarely mentions Formosa and does not include images of Formosa, and therefore is not inspected in this article. John Thomson, *The Land and People of China*, https://archive.org/details/landpeopleofchin00thomrich, accessed September 16 2015.

34 Richard Ovenden, *John Thomson 1837–1921*, London: The Stationary Office, 1997, p. 32.

35 John Hannavy, *Encyclopedia of Nineteenth-Century Photography Volume 1*, New York, London: Taylor & Francis Group, 2008, pp. 190–191.

36 Ovenden, *John Thomson 1837–1921*, p. 32.

37 Mary Warner Marien, *Photography a cultural history*, New York: Harry N. Abramas, 2002, p. 39.

38 *The Illustrated London News*, vol. 66, London, England, Saturday, January 16 1875.

39 Ovenden, *John Thomson 1837–1921*, p. 42.

40 Thomson, "Introduction," p. 245.

41 Nancy Armstrong, *Fiction in the Age of Photography—The Legacy of British Realism*, Cambridge, MA: Harvard University, 2002, p. 77.

42 Jacques Derrida, Archive Fever: A Freudian Impression, trans. Eric Prenowitz, Chicago, London: The University of Chicago Press, 1996.

43 Armstrong, *Fiction in the Age of Photography-The Legacy of British Realism*, p.14.

44 Thomson, *Illustrations of China and Its People*, Plate XI.

45 Thomson, *Illustrations of China and Its People*, Plate XXIV.

46 Thomson, *Ten Years' Travels, 2006*, p. 80.

47 'the light of civilization seems indeed to have dawned in the distant East; ···.and already penetrating to the edges of the great Chinese continent.' John Thomson, Preface, "The Straits of Malacca Indo-China and China," 2006, p. 80.

48 John Thomson, *Victorian London Street Life in Historic Photographs*, New York: Dover Publications, 1994, p. 1.

49 Hsu, "Photography in Taiwan and Preliminary Research of Symbol of China," p. 142.

50 Rey Chow, *Primitive Passions: Visually, Sexuality, Ethnography and Contemporary China Cinema*, New York: Columbia University Press, 1995, p. 20.

51 Huang, "The Indistinct Exposure: The Brief Taiwan Photographic History," p. 142.

52 Liu, *Developing the images of Formosa in 1871 — Landscape issues in John Thomson's Photography in Taiwan*, 2008.

53 I would like to express my gratitude to curator Lin Hong-John for providing the following reference: Thomas Prasch, "Mirror Images: John Thomson's Photographs of East Asia," *A Century of Travels in China: Critical Essays on Travel Writing from the 1840s to the 1940s*, Hong Kong: Hong Kong University Press, 2007, pp. 53–61.

54 Norman Bryson, "The Gaze in the Expanded Field," *Vision and Visuality-Discussions in Contemporary Culture*, ed. Hal Foster, New York: Dia Art Foundation, 1988, p. 92.

St. Julian Hugh Edwards (1838-1903, Xiamen) was born in Malacca, then a British colonial possession. His mother was of Spanish descent but on account of his father, an African-American, he was able to claim American citizenship. After moving to Xiamen in 1862, he engaged in various trades and activities. He ran a photo studio, rented a house to the American consul, and acted as an agent for the Spanish consulate. In 1867, he was arrested in connection with illegal smuggling of coolie laborers by the American consul in Xiamen, Charles W. Le Gendre.

Edwards took photographic commissions from the British consulate stationed in Taiwan, Robert Swinhoe as well as from Le Gendre, American zoologist Joseph Steere, and others. He left behind a valuable photographic record and was one of the first photographers to document Taiwan. According to Swinhoe's memoirs, in 1865, he and Edwards photographed indigenous peoples of the Paiwan Tribe in Wanjinzhuang (today the mountain village of Wanjin in Pingtung). In 1869, Edwards accompanied Le Gendre on his travels around Formosa to gather information on social customs and geography.

After many years of research, Le Gendre, who worked in the Meiji government's "Bureau of Formosa Aborigine Affairs," put together a collection of maps, photographs (including Edwards' works), charts, and manuscripts as *Notes of Travel in Formosa*. He meant to present this volume to Okuma Shigenobu to help facilitate strategic planning for Japan's annexation of Taiwan. In 1874, Edwards sent many of his photos from Xiamen and Formosa to Swinhoe, including reproductions of the Sinkang Manuscripts.

Aside from taking portrait photographs, Edwards in 1877 took out advertisements in *The Far East* to advertise his various photographic offerings. These included his landscape photographs of Xiamen and Formosa and his photographs of Han and indigenous people. Edwards' photography was one of his many side occupations, and his photographs appeared in various 19th century publications, including in Camille Imbault-Huart's *L'ile Formose, Histoire et Description* (1885).

◆ ◆◆◆

St. Julian Hugh Edwards

St. Julian Hugh Edwards, A Mango Tree Planted by a Dutchman 300 Years ago, Tainan, 1870, Albumen Print, 25.8 × 21.5 cm, Collection of National Center of Photography and Images

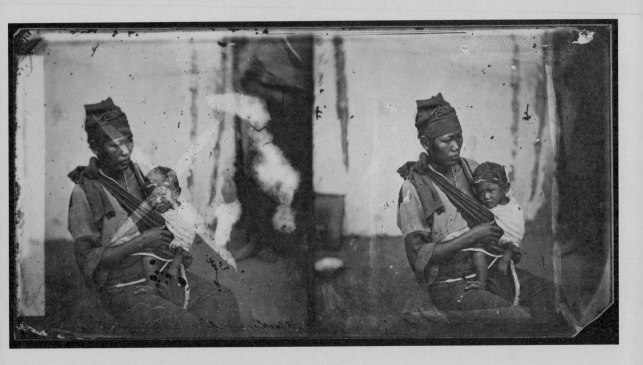

John Thomson (1837-1921) was born in Edinburgh, Scotland, in 1837. As a youth, he served as an apprentice at an optics company, while also taking night classes at the Watt Institution and School of Arts. In 1862, Thomson traveled to Singapore, where his brother had set up a company manufacturing clocks, and the two of them established a photo studio.

Thomson availed himself of the opportunity to travel around Southeast Asia. In 1865, he traveled to Siam and Cambodia. Arriving in Bangkok, he took a portrait of King Mongkut—also known as Rama IV—and his family. The next year, he returned briefly to England and there published his photographs from Siam and Cambodia. The same year, he was accepted as a member of the Royal Geographical Society.

In 1868, Thomson moved to Hong Kong to set up a photo studio. In 1870, he decided to close his portrait studio to focus his energies on publishing his photographs and writings in preparation for a career following his eventual return to England. Thomson traveled through China. He passed through Xiamen in 1871 and met the first missionary sent to Formosa, James Laidlaw Maxwell, who later came to act as a guide for Thomson in his travels in Formosa. Owing to his strong interest in photographing Taiwan's indigenous peoples, he traveled with Maxwell to photograph Formosan plains aborigines on a voyage that included Takao (Kaohsiung), Tai-wan-fu (Tainan), Poah-be Puh-b (Zuojhen), Baksa, Pau-ah-liau (Baolong), Ka-san-po, Lau-long, La-ko-li, and other places.

Thomson took a total of 61 wet-collodion plates in Taiwan. These primarily consist of photos of landscapes and portraits of *pingpuzu*. Although the wet-plate method required Thomson to carry a heavy camera and travel with a darkroom, this helped him produce brilliant and exquisite works.

When Thomson's outstanding photographs were published as photo books, they made major waves in Europe. His pictures of Formosa were published in several volumes, including *Illustrations of China and Its People* (1873-1874), *The Straits of Malacca, Indo-china, and China Or, Ten Years' Travels, Adventures, and Residence Abroad* (1874), and *Through China with a Camera* (1898).

After returning to London, he published *Street Life in London* in collaboration with Adolphe Smith, using photographs to document the streets of London and marginalized groups on the edges of everyday life. This book also came to occupy an important place in the history of photography. Before his death, Thomson sold his collected glass plates to British pharmaceutical entrepreneur Sir Henry Solomon Wellcome. As a result, they are now part of the Wellcome Collection.

◆ ◆ ◆◆

John Thomson

John Thomson, A Mother and Child in Morning Dress, Baksa, Formosa [Taiwan], 1871. Epson Giclée Print on Baryta Photo Paper, 10.5 × 21.5 cm. Credit: Wellcome Collection. (CC BY 4.0)

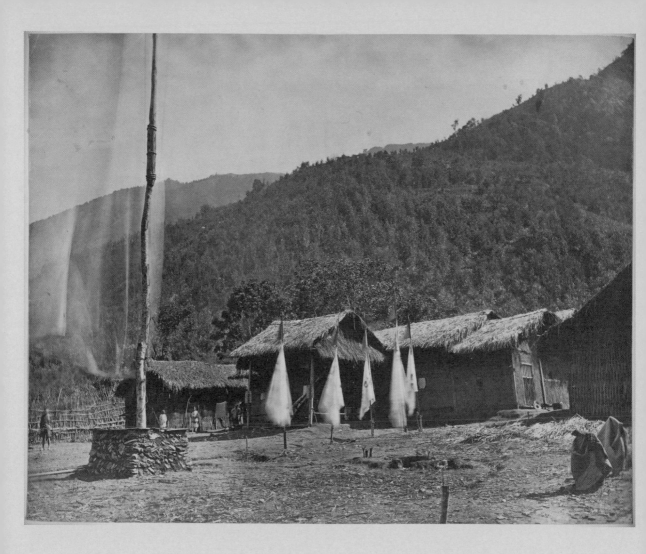

Lai Afong (1839-1890), also known as Li Fang, began working as photographer in Hong Kong from the age of 21. According to records from that time, between 1865 and 1867, he started out as an apprentice in the photo studio of a Western resident of Hong Kong, José Joaquim Alves de Silveira, on Queen's Road Central.

Advertisements in the *Hong Kong Daily Press* show that around 1870, he opened his own photo studio. Apart from taking photographs of the cartes de visite, he also sold scenic photos of various locations in China, including the Min River and Fujian Province.

The photography business in Hong Kong of 1870 was fairly competitive, and Lai was relatively well known. His competitor, the photographer John Thomson in his book *The Straits of Malacca, Indo-china, and China Or, Ten Years' Travels, Adventures, and Residence Abroad* praised Lai Afong's images as "extremely well-executed, remarkable for their artistic choice of position" Lai also hired western photographers such as Emil Riisfeldt and David Griffith to work for him in order to attract Western clients who might not trust the skills of a Chinese photographer.

In 1875, Lai traveled to Formosa, and brought back a series of photographs. We can learn from the Nov 25 edition of the *North-China Herald* that while in Formosa, he photographed "mountains, rivers, and lakes never before photographed...and the residents of beautiful Kulangsu."

Lai's studio maintained its prestige and took photographs of a number of famous personages who visited Hong Kong, including Russian Grand Duke Alexei Alexandrovich and foreign dignitaries visiting Beijing. Lai's photographs could be seen in foreign newspapers, such as the *London and China Telegraph*. His photo studio continued operating for a half century after his death up until 1940.

◆◆ ◆ ◆

Lai
Afong

Lai Afong, Puli Settlement, Nantou, 1875
Albumen Print, 27.3 × 21.5 cm. Collection of
National Center of Photography and Images

PLATE V.

ALONG the streets of TUATUTIA there floated that quaint sound, a sort of half grunt and half groan, with which the coolie accompanies each step as he staggers along under his load.

PLATE IV.

RIVER and Road hummed with tea being borne along to the Market Town, and the now deserted Lekin Station was then a busy, bustling scene.

♦♦♦ ♦

Reminiscences of North Formosa

Along the street of Tuatutia there floated that quaint sound, a sort of half grunt and half groan, with which the coolie accompanies each step as he staggers along under his road. (Short text of Plate V from *Reminiscences of North Formosa*)
River and Road hummed with tea being borne along to the Market Town, and the now deserted Lekin Station was then a busy, bustling scene. (Short text of Plate V from *Reminiscences of North Formosa*)

Reminiscences of North Formosa was published in 1985 as a photo book, documenting the tea industry in Tamsui as operated by Han residents of Taiwan. The book was printed in collotype and its photo was taken by British photographer George Uvedale Price and captions explaining the photographs. It is the first known photo book published with "Formosa" in its title.

The book contains photos of women sitting together in narrow alleyways as they engage in the tea manufacturing process. Some of these women are rubbing tea leaves in their hands, though from the static positions of their arms, it seems that they are not actually working together, but holding a pose, perhaps at the orders of Price, the photographer.

Similar images appear throughout this book. Examples include photos of men carrying baskets filled with tea leaves, of women wearing particular costumes for packing tea, or squatting together in tea gardens on hillsides. They gaze profoundly into the lens, looking directly into the eyes of the book's reader. The role of the photographer is supremely apparent here. From these photos, we can also see that one purpose in publishing *Reminiscences of North Formosa* was as a form of advertising in the global tea market of that era.

You Watch Me Watch You

Chang Chien-Chi

Artistic Research | Single-channel video, 25 mins | 2021

Chang Chien-Chi, Screenshot of *You Watch Me Watch You,* based on John Thomson's Portraits, 2020. Courtesy of the artist
Chang Chien-Chi, *Double Happiness,* Ho Chi Minh City, 2006 (2006015W003). Courtesy of the artist

I wonder if John Thomson ever asked his sitters out on a date. I have been a stranger in strange lands for my entire adult life, crisscrossing the globe to make images. By coincidence, I have traveled to almost—if not all—the places in Asia where John Thomson visited and photographed in the late 19th century.

Thomson's expeditions, to put it lightly, were insanely brave, done with insurmountable passion. Traveling with a cumbersome and bulky wooden camera, large and fragile glass plates, background materials and potentially explosive chemicals was challenging beyond description back then. No matter how extensive his entourage was, his travels alone made him a pioneer. The imagery made him a legend.

Thomson could well be the first photographer who explored those regions in Asia— including remote, unpopulated areas far inland—to document the people and landscapes. His subjects varied enormously, but I am particularly interested in and in awe of how he photographed "the exotic, oriental women." His images are either observant/voyeuristic or provocative. They are also highly convincing and human—and contemplatively intimate. So what might have gone through the mind of that photographer behind a dark curtain and those sitters, who were seeing and posing, for possibly the first and only time in their lives, for a bearded, white man in a top hat?

A hundred and fifty years later, image-capturing devices are readily available and affordable, but some things remain unchanged in the image-making processes: There have always been the expectations and tension, the mysterious power play before, during and after a formal or even an informal portrait is made.

How a photographer sees his or her subject, how the subject sees himself or herself, how the subject wishes to be viewed and photographed and how the photographer is able to use the language of photography to interpret and translate his or her vision. Nowadays, even if the image is made with a mobile device, the scenario remains the same.

The photographer almost always possesses the power of interpretation, but what if the silent and emotional gaze between the photographer and the sitter went overboard while Thomson's wet plate was still drying up? Was he drowned in desire as she was fixzedly gazing back at him? You are watching me watch you; I am watching you watch me.

After reviewing a large number of Thomson's portraits of women, I am convinced that they were made not only with

absolute professionalism but perhaps also with infatuation or impulse, or perhaps love at first sight during Thomson's perilous voyages.

John Thomson never made it to Irina Jaya (West Papua), Indonesia, but I wonder how he would have travelled and photographed had he been there. In 1999, I was on assignment for Der Spiegel to document Irina Jaya. I traveled with a German reporter, a guide, a cook and eight barefooted porters carrying equipment and backpacks for our two weeks in the jungle. It was unlike any terrain I had ever seen before. We either climbed or crawled. Deep in the jungle, it was either humid with scorching 40 plus degrees Celsius or raining non-stop. Two of my three cameras were kaput. There was no way to retreat, only to move forward, painfully. How would Thomson have managed to trek and photograph under such harsh conditions?

During the perilous trekking, we passed by villages to recuperate. We might have been the first outsiders these people had ever encountered. The men in the villages wore nothing but penis gourds and women were bare breasted with straw skirts from the waist down. The penis gourds always stay 60 degrees up, but the topless women, firm or saggy, proved the divine power of gravity. We never let our guard down, because ritual cannibalism had been reported as recently as the early 1980s. I was wondering why the villagers sniffed around the German reporter. It dawned on me that it was the smell of cheese! Did Thomson ever fear for his life? What did he eat on the road when he missed English home cooking?

Thomson's portraits, formal or seemingly casual, were made under exceptionally technical situations. Yet they are poised, and some are almost documentary. The portrait of "Old Woman, Canton, Kwangtung Province" is as contemporary as today's portraiture. Among all those physically challenging expeditions, I wonder how he managed when he encountered setbacks. Also, did he, like me, ever have insomnia, restlessness or throbbing headaches? Did he miss his home? Did Thomson ever feel lonely? What if there was the moaning and screaming of a couple in ecstasy ululating through a crumbling wall?

When reviewing Thomson's images, I am often reminded of the young, shy Vietnamese women I photographed in Ho Chi Minh City while working on my *Double Happiness* project in the mid 2000s. I made seven trips to Vietnam to document the process as Taiwanese men selected wives. It was extremely demeaning to women, like being on a speedy assembly line. Marriage brokers would recruit young Vietnamese women from the country to come to Ho Chi Minh City, where they are viewed by groups of Taiwanese men. Each of the men pays a fee to pick a suitable bride from the lineup. Within days of meeting, the couples are married! I and both the Taiwanese and Vietnamese brokers saw and photographed probably a thousand young Vietnamese women during the seven trips. Before long, the eyes got tired, dazed and confused as the heart was sometimes pounding harder. At the end of each day, we were entertained at local karaoke bars, mingling with more experienced Vietnamese women. Was Thomson ever homesick during those expeditions? For me, being on the road means not being at home. I feel sometimes like a kite with a broken string. After many years of being away and in a foreign state, physically and mentally lagging, half awake or half asleep and full of many strange nights and nightmares, eventually screen-to-screen chats cannot make up for skin-to-skin contact at home.

I wonder if John Thomson ever asked his sitters out on a date. I don't know. But I myself certainly contemplated it.

Chang Chien-Chi, born in Taichung, Taiwan in 1961. Chang earned his BA from Soochow University in 1984 and an MA from Indiana University in 1990. In 1995, Chang was elected to join Magnum Photos. In his work, Chang makes manifest the abstract concepts of alienation and connection. Chang's investigation of the ties that bind one person to another draws on his own deeply divided immigrant experience, first in the United States and later in Austria. Chang has had steady history of solo and group exhibitions: *The Chain* was exhibited at La Biennale di Venezia (2001) and São Paulo Bienal (2002) and International Center of Photography Triennial, New York (2003). National Museum of Singapore held a mid-career survey exhibition for Chang, entitled *Doubleness* in 2008. ●

Afterimage 1871
(Walking, Snapshotting and Reciting)
Kao Jun-Honn
Artistic Research I Workshop and video I 2021

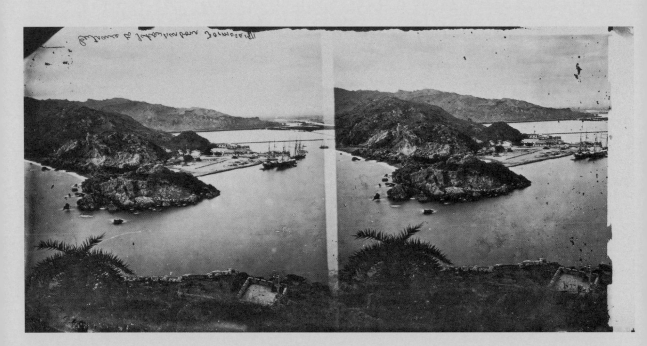

This work is based on sections about Taiwan in *The Straits of Malacca, Indo-China and China, or, Ten Years' Travels, Adventures, and Residence Aboard*, 1875 by John Thomson, member of UK's Royal Geographical Society. Thomson's text is integrated with the work of local Jiasian researcher You Yung-Fu, whose research focused on "The Thomson Route." You Yong-Fu planned a field inspection retracing the route that Thomson embarked upon in April 1871, a trail regarded as "forbidden land" one century ago. Using the perspectives of modernology (study of modern society and life) and critical geography to view the afterimage of Thomson's photographic oeuvre, participants took snapshots with their phones along the trail and were invited to reinterpret Thomson's texts at specific locations in the form of performative lectures.

Born in 1973, Taiwan, Kao Jun-Honn is an artist and cultural theorist. Kao has a PhD from Tainan National University of the Arts and is currently an adjunct associate professor at the Taipei National University of the Arts. Kao makes use of the human body, moving images, planned actions, and textual discourse as the media of his artistic creation. The artist is a longtime observer of issues related to history, war, bio-politics, Neoliberalism, East Asia, and indigenous peoples. Kao has held several solo and group exhibitions, participated in biennales both domestic and abroad since 1995, and has completed residency projects in locations including Hong Kong, France, and the UK. Kao's works have been shortlisted and awarded in the Taishin Arts Award on numerous accounts, and his publications include *Bubble Love*, *The Home Project*, *The Road Project*, *The Three-Mirror Lens of the Archipelagic Art Series*, and *Llyong Topa* (tentative). Kao won awards including Best Non-Fiction Book and Book of the Year at the 2016 Golden Tripod Awards, and his documentary *Llyong Topa* was shortlisted for the 12th Taiwan International Documentary Festival. ●

John Thomson, Takao harbour, Formosa [Taiwan], 1871. Credit: Wellcome Collection. (CC BY 4.0)

Paging Through the
Reminiscences of North Formosa
Tsao Liang-Pin

Artistic Research | Single-channel video, approx. 20 mins | 2021

After a brief research on the archives of the National Center of Photography and Images, I chose *Reminiscences of North Formosa*, a photobook by George Uvedale Price, as the subject of my research project and a starting point for my artwork.

Published in 1895, *Reminiscences of North Formosa* consisted of a foreword, 12 calotype photographs, 12 introductory texts, and an afterword. The photos recorded the planting, picking, processing, transporting, sorting, drying and preserving of tea in Taiwan. They were taken primarily in tea plantations, farmhouses, markets, verandas, and tea houses around Tamsui and Dadaocheng.

Aside from recording the history and the culture of tea in Taiwan, the thin book actually probes into certain complex topics. As such, this research project attempts to problematize Price's photobook, and to group the dilemmas I have encountered in the process of reading into a few key words: Book, Archive, Classification, Collection, Value, Parallax, etc., which are then represented and transformed in the form of a video. With this project, I hope to create interactions, kindle imagination, and inspire co-creations among viewers, the book, and the institution.

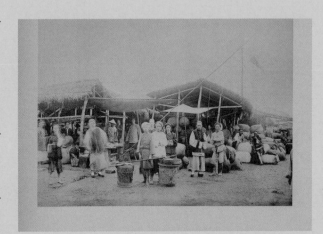

Born and raised in Taiwan, Tsao Liang-Pin is an artist based in Taipei, Taiwan. He holds an MFA degree from Pratt Institute, and his works have been exhibited internationally. Liang is the recipient of a Fulbright Taiwan grant, New York Residency Program sponsored by the Ministry of Culture Taiwan, and Pratt Institute scholarship among others. His recent project, *Becoming / Taiwanese*, investigates the relational tension between national history, transitional justice and value awareness in Taiwan, exploring its socio-cultural significance. Liang also devotes himself to public service and community development, and has given lectures, conducted workshops and curated exhibitions at various cultural institutions and universities. In 2015, he published his first photobook, *Sojourn*, and has initiated a symposium project, *Photo Talks*, to help promote contemporary photography in Taiwan. In 2016, he established Lightbox Photo Library, a non-for-profit organization, as a way to preserve and promote cultural autonomy, intellectual freedom and diversity in Taiwanese photography community. ●

George Uvedale Price, *Reminiscences of North Formosa*, 1895, Collotype, 29 × 40 cm. Collection of National Center of Photography and Images

Japanese Colonialism and the Governance of Images

With the commercial success of the gelatin dry plate in the West in the 1870s, the dry plate gradually came to replace the wet plate in photography. This new photographic technology produced a separation between the exposing of film and the developing of photographs, which were now completely standard processes. Exposure time was also reduced to around one second, compared with twenty seconds for a wet plate. As a result, it became easier and more convenient to use photography to capture objects or people in the moment. Following the daguerreotype of the 1830s-40s and wet-collodion process of the 1850s-60s, the gelatin silver plate came as a third generation of advances in photographic technologies. A further development was Edward Muybridge's photographs of movement through fast sequential shuttering, a necessary precondition for the development of his zoopraxiscope, a forerunner to the motion picture. It was with gelatin dry plate photography that George Eastman's camera company was able to grow and expand in the 1890s. Not only did Eastman's company hold the patent to the dry plate, but it also invented the film roll in 1894. With the advertising slogan, "You press the button, we do the rest," Eastman promoted cheap, handheld cameras. This led to his establishment of the Kodak Company in 1892. With the development of the half-tone photographic printing techniques, photographs for the first time began to be extensively used in mass media. For the general public, photography has always been parts of visual expression and memory ever since.

Third-generation photography entered Taiwan during the Japanese colonial period. Matsuzaki Shinji took photos of events of military significance such as the Mudan Incident. In 1896, Ogawa Kazumasa published *Souvenirs de Formose et des Îles Pescadores*. The Japanese translated "photography" by inventing a new word "shashin", literally "writing reality," which connoted the sinicized aesthetics of portraiture from the Taika Reforms of the 7th century. We can see this not only in Japan's management of the production of photographic equipment, materials, and the regulations regarding obtaining licenses and certificates, but also in the Japanese government's control over the circulation, distribution, and transmission of photographs and photographic technologies. The circulation of images took place under the control of the state apparatus, and this was important in defining the power relations between the colonizers and the colonized. For example, the photographic projects of anthropologists Ino Kanori and Torii Ryuzo aimed not only to gather specimens for research but also assisted in the colonial governance of Taiwan's indigenous tribes in telling clear distinctions between "self" and "other."

During the period, state regulation and control of images could be observed in photos, portraits, paintings, postcards, and the official decrees of the Japanese government. These practices were techniques of control that had developed after the Meiji Restoration and had become the ideal method to practice the theory of *Datsu-A Ron* (Leaving Asia for Europe). We can clearly see how an image of the "colonized" was constructed through the colonial administrative system through the visual governance. Therefore an image also preserved the trace of powers as an archive. In other words, these images offer proof of the existence of the colonized and also provide the return gaze of the colonized subject. The silent resistance of the colonized subject can be seen as something that could not be photogenic. Yet through "modern" and "contemporary" techniques of photography, we are able to unveil messages hidden inside the archives of colonial history.

Picturing Gentlemen: Japanese Portrait Photography in Colonial Taiwan [1]

Joseph R. Allen

¤

On a surprisingly cool summer day in 1899, a group of men from the club are gathered on the lawn of the Governor-General's residence in downtown Taihoku, Taiwan, for a round of croquet. Croquet has recently come to the island along with many other accoutrements of international colonial culture. The local photographer Arita Shunkō (有田春香) is in the group. His photographic studio, which is just a few blocks away on North Gate Street, is filled with the latest professional equipment and materials, but today he is carrying his new hand-held Kodak that he bought from the Tenshōdō store in Hiroshima. He turns his camera on the Governor-General, Kodama Gentarō (兒玉源太郎). Kodama obliges with a playful pose in his jaunty togs and Mona Lisa-like smile (see fig. 1): a pose startlingly unlike any other of him (and there are many) in the colonial photographic record, where he always appears deadly serious in his medal-laden military uniform (cf. fig. 4, 10). Although the photographer is a professional and the print is produced by the prestigious K. Ogawa Printing Factory, in its casual occasionality this image clearly is influenced by the genre of the snapshot that is beginning to make its way through popular culture around the globe. The pose, especially the smile, looks forward to the age of the "Kodak moment."

The question of the existential condition of the photographic image has long been debated. Is the image an index of the photographed subject, a fingerprint made in light and salts? Or is it a manufactured icon, a likeness produced only within specific cultural codes, as with other portraiture media? The intersection of the invention of the photographic image and the rise of modern science (represented by the daguerreotype, which fixed the image from a camera obscura in light-sensitive chemicals on metal media) first aligned photography with the evidential world. It was proof of its subject's existence at a given moment in time, and in the world of the daguerreotype, that subject was primarily the human portrait. Yet, as the technology became widespread, manipulated, divergent, and theorized, its indexical nature was challenged. This is, in part, the result of what Roland Barthes calls the "connotation procedures" of photography: trick effects, pose, objects, photogenia, syntax, and aestheticism.[2] But more important is the power of the surrounding discourse to bring the image into specific significance, most obviously seen in the authority of the caption to control the meaning of the image but more subtly seen in the way the photograph is broadly embedded in social discourses, from evidentiality to aestheticism. To move a photograph from one discursive system to another is to change the representation of the image. This is as true for portraiture as it is for other genres.

Responding in part to Barthes's postulation of the "evidential force" of photography in his *Camera Lucida*,[3] John Tagg[4] argues rather for photography's contingent nature. Tagg identifies the second half of the nineteenth century as a time when an ideology of surveillance intersected with the flourishing photographic medium, implicating the technology into the institutions of state administration, law enforcement, and social policy, primarily in Europe and the United States. In this disciplinary world, grandfather's portrait became his mug shot. In a similar but broader vein, James R. Ryan[5] explicates the photographic construction of the British Empire, exploring the military, anthropological, recreational, and educational applications of the medium to the imperial project. As might be expected, many of the practices surveyed by Tagg and Ryan are also found in the photographic culture of Meiji Japan, which overlaps with European institutional conditions both temporally and ideologically; yet there are also distinguishing contingencies of photography in Japan and of Japanese photography in the colony. Some of those contingencies are clearly evident in its colonial portrait photography and studio system.

The Historical Frame

In the early years of photography, technical and economic contingencies kept the medium deployed in a relatively narrow range of applications. But by the end of the nineteenth century, photographic practice had become widely embedded in fields of inquiry and in mundane social lives. Lemagny and Rouillé[6] write:

> During the last decades of the nineteenth century, as the new fields of anthropology, experimental medicine, psychology and sociology were institutionalized, photography assumed a greater role in recording the diversity of human behavior, customs, and life styles. In the realm of studio portraiture, the middle and upper classes continued to memorialise their bustles and top hats, although the fluted column and ornate papier-mâché of the Second Empire and mid-Victorian period yielded to the cardboard canoes,

bicycles and rustic fences considered chic by an age that re-established the Olympic Games.

It is this turn-of-the-century photographic technology and outlook that Japan brought to its early colonial project in Taiwan.

The timely convergence of Japan's colonization of Taiwan and the development of "third-generation" photographic materials and processes, especially the introduction of celluloid film and the perfection of the halftone printing process, gave the medium a position in the Japanese colonial effort that exceeded its significance in early British, French, and German colonial regimes.[7] This is especially evident when one considers the conditions of portraiture, which had been photography's driving economic force since its inception. Early portrait photography, especially the daguerreotype, quickly overwhelmed and extended the work of the portrait artist working in watercolors and oils. Although the technology was not available to all, a wide variety of people, from royalty to unnamed cousins, could sit for these portraits—all it took was twenty-five cents and fifteen minutes at the daguerreotype studio.[8] Yet, like the painted portrait, daguerreotypes were unique, non-reproducible images: one sitting, one long exposure, one image. The calotype (talbotype) paper negative liberated the photographer from the studio and allowed reproduction of a positive image, but the long exposure times and grainy medium limited the subjects largely to inanimate objects; the calotype portraits by David Octavius Hill were an important exception.[9] Only with the perfection of the collodion wet-plate process, which produced both speed and a very printable negative, could more animated images be made and circulated. At last one could smile for the camera and send copies to family and friends. In the world of portraiture, this potential became highly commercialized through the *carte de visite*, which generated a craze in the 1860s and led to the creation of the first photographic albums. This was the portrait technology that first made substantial inroads in Japan.[10] Toward the end of the century, the photographic experience was not only shared by many but also produced far from the studio and darkroom. Very fast dry-plate and film media gave photography new mobility and ease; the formal portrait moved toward the snapshot.

Although the earliest Japanese photographs of Taiwan, by Matsuzaki Shinji (松崎晋二), who accompanied the 1874 Meiji military expedition to the east coast of the island, were made with cumbersome wet-plate techniques that required an on-site darkroom, the photography from the colonial period proper was produced with high-speed dry-plate or film media and was reproduced widely by halftone printing in the typeset pages of books and newspapers.[11] Regarding the improved technology of the 1890s, Beaumont Newhall[12] wrote:

This important invention [halftone printing] was perfected at precisely the time that the technical revolution in photography was taking place. Dry plates, flexible film, anastigmat lenses and hand cameras made it possible to produce negatives more quickly, more easily, and of a greater variety of subjects than ever before. The halftone enabled these photographs to be produced in limitless quantities in books, magazines, and newspapers.

This Western technology reached Japan, and then Taiwan, with little delay. The first transfer took place largely through the agency of the influential photographer and printer Ogawa Kazuma (小川一真). Ogawa studied in Boston from 1882 to 1884 and returned to Japan with the materials and training to open a series of photographic establishments. In 1889, he founded the K. Ogawa Printing Factory (Ogawa Shashin Seihanjo) in Tokyo, which produced photochemical plates using both the deluxe collotype and the more common halftone processes.[13]

Obviously, the European colonial powers also had this technology by the turn of the twentieth century, but since their initial colonial efforts had come decades, if not centuries, earlier, the seminal conditions of their colonies were only partially recorded, if at all. This is true for portraiture: the royal family and the colonial native were principal subjects of the *carte de visite* craze, but this came toward the end of the British colonial effort. This is one essential difference between European and Japanese colonial photographies: for Japan, colonization and third-generation photography were full partners from the very beginning of its imperialistic project. In fact, Karen Fraser[14] argues that photography in Japan was linked from the beginning with Meiji modernity and cultural change. Whether by imitation or by an internal logic, early Japanese photographers had their equivalents of the royal family and the local "type." The celebrated portraiture of the Meiji Emperor was at the elevated end of that spectrum; at the other end was the aboriginal "type" in Japan and Taiwan, which was grounded in early anthropological study.[15] Yet the Japanese extended their pool of portrait subjects far beyond these predictable figures, quickly populating social space between the imperial and the indigenous. Photographic portraiture of the upper and middle ranks of the colonial population, both ruler and subject, has a special position in the early ideological machinery of the Japanese colony, for this is where the photographic image most clearly demonstrates its constitutive power.

The Japanese Colonial Photographic Industry

Since there is no sustained description of the photographic industry in Taiwan during the Japanese colonial period, either contemporaneous with or subsequent to it, we must rely on a range of primary materials for this investigation.[16] The materials used here are found primarily in the holdings of the Taiwan Study Research Center (Taiwan Ziliao Yanjiu Zhongxin) of the National Taiwan Library, which includes approximately 160,000 volumes transferred from the Japanese Colonial Library (Taiwan Sōtokufu Toshokan) in 1946. There are several types of photographic records in that collection.

For our purposes, the most important are the photo albums (*shashinchō*) and the various commercial directories and listings (*meikan* or *meiroku*), both of which contain portraits and other photographs, as well as textual materials such as narratives, notes, and commercial advertisements. Newspapers and other contemporaneous documentary materials provide supplementary information.

The photographic industry in early colonial Taiwan was dominated by Japanese nationals and was closely tied to that of the homeland, about which we do have extensive information.[17] For example, the earliest extant photo album that takes the island as its subject, *Taiwan gun gaisen kinen shashinchō* (Album commemorating the military triumph in Taiwan), was produced in 1896 by the well-known Endō Photographic Studio of Sendai. The photographic plates in this album were produced by the famous K. Ogawa Printing Factory mentioned above— Ogawa is listed in the publication information, and the name "K. Ogawa" appears in Latin letters on several important images in the album.[18] Given the relatively undeveloped technological conditions in the early colony, it is not surprising that this and other early albums were produced wholly or in part in the homeland; yet, as early as 1899, some production had already moved to the island. Not only was *Taiwan meisho shashinchō* (Album of famous sites in Taiwan) issued by Taiwan shōpō (Taiwan Commercial News), but its principal photographer was Ishikawa Genchirō (石河源一郎) of Taihoku (Taipei) City, the island's colonial capital; plate production and printing were still done in Japan by the K. Ogawa firm, however. Advertisements in this commercially oriented album offer more evidence of the island's widening photographic world: for example, ads for five other photographic studios appear beside Ishikawa's (three in Taihoku, two in Kiryō [Jilong]), as well as an ad for another album of photographs of the island. By 1901, a similar album, *Taiwan miyage shashinchō* (Album of Taiwan souvenirs), was issued as an entirely Taiwan-based production, albeit by Japanese nationals, suggesting the rapid development of an island-based photographic industry. These and other publications of the time allow us to begin to map the early photography studio system in Taihoku.

The 1900 *Taiwan shishō meikan* (Directory of political and business figures in Taiwan)[19] is in two volumes: volume 1 includes 178 portraits and listings for colonial administrative and business personnel, and volume 2 is a directory of businesses in Taihoku, along with some advertisements for the same. Before discussing the portraits themselves, I want to mine the commercial listings and advertisements for data to help map photographic establishments in the city. The directory is organized geographically by commercial address without any topical or name indices, which are common in later directories; this means that locating a type of business or a certain establishment requires scanning the entire listing of about 130 pages, with the contents of a page ranging from twelve individual listings to a single advertisement. Thus, this is a passive, cartographic account of commerce in the city rather than a functional directory. A search for establishments directly related to the photographic industry yields at least twelve, including photographers, portrait studios, photography businesses, and supply houses (nos. 1–12 in table 1). In addition, the 1899 *Taiwan*

meisho album contains advertisements for two other Taihoku studios (A and B in table 1). Contemporaneous newspaper advertisements for local photographic equipment stores expand table 1 to include C and D.[20] Together this yields a listing of sixteen establishments in the city at the turn of the century (see fig. 2 for corresponding map).

This should be considered a substantial but no doubt incomplete representation of the photographic enterprise in the capital circa 1900. This industry was dominated by Japanese nationals and was minuscule compared to that of the homeland.[21] And in keeping with Japanese settlement patterns of the time, these establishments were concentrated in the central and northwestern part of the intramural city, although several businesses were further dispersed into the Chinese settlement areas: one in Mengjia and three in Dadaocheng, the latter of which had a significant European population.

Early colonial newspapers help plot the workings of the early photographic industry in Taiwan in other, more tangential ways. For example, a small advertisement from 1898 for the Era Studio in the Bunbubyō (Wenwumiao) ward (listed in table 1 as A) says that its photographer was trained in Hong Kong;[22] elsewhere[23] mention is made of a photographer named Era Sandai (惠良三太), presumably the person referred to here. Hong Kong was the center of the early photographic industry in China, and there was a good deal of cultural commerce with Japan.[24] A month later, the newspaper carried an advertisement for photographic equipment offered by the large retail store Tenshōdō in Hiroshima, which includes an illustration of the recently released Kodak handheld camera with rolled film, suggesting an emerging clientele of amateur photographers on the island.[25] That local audience is referred to explicitly in a 1900 advertisement for the Kashimura Store (C in table 1) that touts equipment designed for the amateur (*shirōtoyō*).[26] Unfortunately, given the vicissitudes of these early years, very little evidence of that world of early snapshot photography exists for Taiwan. There will be occasions, however, when the quality of the snapshot makes its presence felt in the formal portraits produced by the studio system during these early years.

Halftone printing technology allowed for the efficient reproduction of photographs in newspapers beginning in the late 1890s, which was first seen in Japan in 1904.[27] Again, this technology made its way quickly to Taiwan: the first halftone photograph to appear in a Taiwan newspaper, a relatively candid photograph of Governor-General Kodama Gentarō with his military advisers, was on the front page of the May 3, 1905, edition of *Taiwan nichinichi shimpō*.[28] And on July 1, the newspaper published its first halftone-printed formal portrait, that of Suzuki Sōgen (鈴木宗言), head of the court of appeals; theretofore all portraits in the newspaper appear to be engravings, albeit often derived from photographs. Within five years, *Taiwan nichinichi shimpō* was filled with photographs, including numerous portraits. The ubiquity, size, and style of these newspaper photographs were intertwined with the changing nature of portraiture in Taiwan.

Although the dearth of contemporaneous records makes

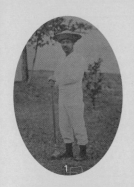

Listing Type	Business/Owner Names	Listing/Ad Pages	Location Ward/Number
城內			
1. 寫真業	蘭昌堂/有田春香	149, 150	北門街 3/5
2. 寫真業	二雁館/齊藤南總	153	北門街 1/35
3. 寫真店	遠藤寫真館/遠藤寬哉	167, 166	府前街 3/11
4. 寫真店	淺井寫真店/淺井魁一	167, 165	府前街 3/9
5. 藥種商	資生堂藥館/中田銀三郎	174, 172	府前街 4/5
6. 寫真業	中島寫真店/中島喬木	181, 181	府中街 3/12
7. 寫真業	相川寫真館/相川清水	199, 200	文武街 1/39
8. 小間物, 雜貨	寫真攝影商/臼井兵吉	211	書院街 2/25
A. 寫真	惠良寫真店事：南進館	n.p.	文武廟街 56.
B. 寫真	有田春香	n.p.	北門街，cho 1
C. 寫真器械	樫村支店	1900/3/7, 6	北門街，cho 2
D. 寫真原料品	資生堂寫真部	1900/4/3, 8	府前街，cho 1
艋甲			
9. 寫真業	吉富吉次	221	西門外街 1/57
大稻埕			
10. 寫真業	增田寫真館/增田儔太郎	332	草店尾街 63
11. 寫真師	淺井寫真館/窪田洋平	343	義重橋街 35
12. 寫真業	有馬寫真館/有馬磯吉	343	義重橋街 36

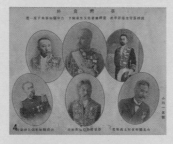

Table. List of photographic enterprises in Taihoku City, 1900 ǀ 1 Governor General Kodama Gentarō, summer, 1899. Source: *Shashin kuragubu* (1901). Courtesy of National Taiwan Library ǀ 2 Map showing location of photographic establishments in Taihoku, 1900. Map source: detail of Taihoku shigai kaisei zenzu, 1901, with author's annotations (nos. 10, 11, 12, approximate location). Original map courtesy of SMC Publishing ǀ 3 Portrait of Endō Makoto, owner of the Endō Photographic Studio in Taihoku, 1900. Source: *Taiwan shishō meikan* (1900). Courtesy of National Taiwan Library ǀ 4 Opening portrait gallery of Governor-General Kodama Gentarō (top center) and his civil officials. Source: *Taiwan meisho shashinchō* (1899). Courtesy of National Taiwan Library ǀ 5 Portraits of Meiji Emperor and heir apparent (the future Taishō Emperor). Source: *Taiwan gun gaisen kinen shashinchō* (1896). Courtesy of National Taiwan Library ǀ 6 Portrait of Liu Yong-Fu, Qing military commander, relabeled in the Japanese album as "Ex Governor-General Ru-You-Foo." Source: *Taiwan gun gaisen kinen shashinchō* (1896). Courtesy of National Taiwan Library ǀ 7 Portraits of president, editor-in-chief, reporter, and editor of the Taiwan nichinichi shimpō (clockwise from upper left). Source: *Shashin kurabu* (1901). Courtesy of National Taiwan Library ǀ 8 Group portrait of Taihoku Club members led by Gotō Shimpei on tour in southern China, 1899. Source: *Shashin kurabu* (1901). Courtesy of National Taiwan Library ǀ 9 Portrait of Soeda Juichirō as a gentleman hunter in a studio photograph captioned "Dr. Soeda on a Hunting Trip." Source: *Shashin kurabu* (1901). Courtesy of National Taiwan Library ǀ 10 Portraits of colonial leaders: Civil Administrator Gotō Shimpei, Governor General Kodama Gentarō, Taihoku District Chief Kinoshita Shǔichi, and Taichū District Chief Murakami Giyū; by photographers Endo, Asai, Era, Nakashima (clockwise from upper left). Source: *Shashin kurabu* (1901). Courtesy of National Taiwan Library

it difficult to probe deeply into the commercial activities of these individual establishments, some gleanings are possible. For example, the activities of the Endō studios in Taiwan (the Taihoku branch is no. 3 in table 1) were foreshadowed by an impressive array of work produced by the original studio in Sendai, established in 1878. This work ranged from its founder, Endō Rikurō (遠藤陸郎 , 1845–1914), acting as official photographer for government expeditions to the Kurile Islands in 1891, to his younger brother, Endō Makoto (遠藤誠), photographing the Meiji Emperor and Empress in 1892, and then acting as military photographer for the expedition to occupy Taiwan in 1895, producing the illustrations for the 1896 *Taiwan gun gaisen* album. Another brother, Endō Hiroya (遠藤 寛哉), was a military photographer for the 1894 expedition against Qing forces in China.[29] The studio's pedigree is further clarified in the full-page advertisement in the 1900 directory and in the biographical note for Hiroya in the 1912 Taiwan *jitsugyō meikan*.[30] The 1900 advertisement lists the Sendai studio as the home office and three branches: in Taihoku, Tainan, and China.[31] According to his biographical note, Endō Hiroya, who had been a military photographer since the beginning of the Sino-Japanese War, arrived in Taiwan in August 1895 and went on to Tainan (perhaps joining Makoto there). Hiroya stayed on in Tainan until May 1896, when he returned to Japan with the army. He went back to Taiwan in December of that year, however, to open a photographic studio in Tainan, and then founded the Taihoku branch in 1899. Although the 1900 business listing for the Taihoku branch is under the name Endō Hiroya,[32] a photograph in the directory's portrait gallery presents Endō Makoto as the proprietor (*kanshū*) (see fig. 3), suggesting that Makoto joined Hiroya to run the Taihoku studio. According to Fu Yue'an,[33] Makoto died in Tainan in 1903. Another source says that the eldest sibling, Endō Rikurō, followed Hiroya and Makoto to Taiwan and joined the studio in Tainan in 1902—this is perhaps why Makoto was in Tainan when he passed away.[34] Subsequently, the 1911 Taiwan *shōkōjin meiroku* lists Endō Kokki (遠藤克已 , presumably Hiroya's son) as proprietor of the Taihoku branch, with Hiroya still owner; Endō Shun (遠藤俊), otherwise unknown, is listed under the Tainan studio.[35]

The Endō studio in Taihoku was closely connected to the colonial authorities. When the Taiwan Shinto Shrine (Taiwan Jinja) was established in 1901, the studio was its official photographer, as it was for the military expeditions against the Taiwan aboriginal peoples that commenced in 1910. A Mr. Endō (either Makoto or Hiroya) is also on record for one of the earliest portraits (1899) of the very famous Gotō Shimpei (後藤新平), civil administrator of the colonial government (1898–1906) (see fig. 10). Moreover, the Endō studio was very long lived. The Taihoku branch was still active under the ownership of Endō Kokki as late as 1937, one of over fifty photographic businesses and branches in the city, but the only one also listed in the original directory of 1900.[36] Needless to say, these isolated points of reference hardly provide a full understanding of the Endō studio and its role in colonial society, but they offer a glimpse of its integration into the machinery of colonial politics and a sense of the vitality of the studio and industry over time.

The Portrait Gallery

The most visible manifestation of the photographic studio system in Taiwan during these early colonial years is the formal portraits that are often arrayed at the front of various contemporaneous publications — what I call a "portrait gallery." The 1896 illustrated account of the Japanese military expedition on the island, *Taiwan gun gaisen kinen shashinchō*, established this convention. As would be expected, the portraits there are of military personnel, beginning with the military commander of the expedition, Prince Kitashirakawa Yoshihisa (北白川宮能久親王 , followed by other commanders and their officers, for a total of twenty-five images in seven pages. This type of gallery is repeated in a truncated form in the 1899 travel guide *Taiwan meisho shashinchō*, which has one page of portraits of the colonial governor-general and his civil officials (see fig. 4). Broadly speaking, there is nothing unusual in either of these galleries. Most portraits follow the widely shared conventions of the time: either half or three-quarter body shots of uniformed, medal-laden figures, serious in demeanor, and with heads turned slightly away from the camera, approaching the three-quarter profile. There are some exceptions in the 1896 album, however. In the opening images, the Meiji Emperor and his heir apparent (the future Taishō Emperor) stare directly, nearly menacingly, at the camera, as if challenging its authority with their own (see fig. 5). This pose remains the one most associated with the Meiji Emperor, and set the tone for much of modern Japanese portraiture.[37] Another exception is the group portrait of military figures taken in the field after the attack on the Penghu islands; the poses of some of the figures adhere more closely to the conventions of the traditional East Asian "ancestor portrait"—face front, full body, seated with legs spread, which is seen in early portraiture in China as well.[38] Later in the album, that pose is formally represented in the portrait of one of the important Taiwanese military leaders of the resistance against the Japanese, Liu Yong-Fu (劉永福), who sits stiffly in his official robes (see fig. 6). Although this is an Ogawa print and reveals some of the conventional three-quarter profile of modern portraiture, the picture must be from an earlier time: the calligraphy colophon, titled "Commemorative Verse on the Portrait of Commander-in-Chief Liu Yong-Fu," praises Liu as a pillar of the Qing nation for his military exploits against the French in Vietnam during the 1870s and 1880s, which is likely the time and place the portrait was taken. The Japanese recaptioned the photo "Ex-Governor-General Ru-You-Foo," demoting Liu to his conquered, colonial position. Such vestiges of earlier portrait styles remain in the mix throughout most of the colonial period, but there was also a steady march toward a new, very modern look.

The portrait gallery takes an extravagantly elaborated form in the 1901 album *Shashin kurabu: Ichimei Taiwan jinbutsu shashinchō* (Photographing the club: Album of famous people in Taiwan). Here we have portraits of approximately ninety-six individuals,

primarily four to a page, with short introductions and biographies provided on the versos. With one exception, all subjects are either Japanese bureaucrats or businessmen who belonged to this social and recreational club.[39] The portraits themselves are largely the expected sort, although there are a number of striking photographs that open the album.

As expected, the gallery begins with the top-ranking military and civilian officials; here again are Governor-General Kodama and Civilian Administrator Gotō, along with the heads of Taihoku and Taichō counties (see fig. 10). The following pages trace in detail the various levels of elite colonial society, depicting men in a variety of formal poses. For example, three-quarters of the way through this gallery, as we work our way through the colonial commercial world, are the portraits of members of the most important newspaper of the day, *Taiwan nichinichi shimpō*: the president, the editor-in-chief, an editor, and a reporter (see fig. 7). Two of these portraits are standard bust views with a blank background (the lower half tastefully vignetted); another is a mid-range shot with a vague studio background. Except for the portrait on the lower right (to which I will return below), these all represent different versions of the standard photographic portrait at the turn of the twentieth century; they are remarkable only in their full participation in the conventions of colonial representation seen throughout the world.

The array of portraits in the club album provides a survey of colonial power at the time and, with scrutiny, would certainly yield a wealth of information (biographical, social, and ideological), yet here I would like to turn to the set of six rather unusual, full-page photographs that prefaces the portrait gallery. Three are group photographs that document club activities, the most formal of which shows some of the club's most elite members on tour in southern China as part of a delegation led by Gotō Shimpei (see fig. 8). Mimicking the pose of military leaders on campaign, the club members, centered by Gotō, pose on the steps of the Nanputuo Temple in Xiamen (Amoy) in May 1899. The shot offers a graduated display of colonial power: top hats and uniforms dominating the front; suits and derbies in the middle; and finally, in the back, the robes of the local hosts, a delegation of "islanders" (*hontōjin*), presumably Taiwanese living in Xiamen at the time. Two individuals at the far ends of this spectrum deviate from the standard pose. In the front row, second from right, a distinguished gentleman in a derby and white trousers gazes off camera, up and to his left, as if watching birds in flight. The pose seems as purposeful as that of the others, who stare sternly into the camera. In the far background, a man in monk's robes smiles brightly, as if unable to contain his natural mirth. Perhaps he does not know the protocol of the portrait, or perhaps his position in the religious community releases him from the grip of the standards of colonial modernity. In any case, seeing this lone smile in the sea of dour expressions, not only in this photograph but also in the album as a whole, reinforces, by counterpoint, the somber nature of the portrait genre at this time.

The other full-page photographs offer glimpses into the

lives of individual club members. The images also suggest the presence of the photographer and his craft in colonial life. The last of these photographs, captioned "Dr. Soeda on a Hunting Trip," shows Soeda Juichirō (添田壽一郎), doctor of law and head of the Taiwan Bank, in a most club-like pose: the gentleman hunter with his springer spaniel, shotgun, and bag of birds (see fig. 9). Although we have no direct evidence, this Dr. Soeda appears to be the same figure in the front row of the group photo at the Xiamen temple who is gazing skyward, perhaps contemplating such a diversion.[40] Hunting and other sports were part of modern life in Japan, just as in other colonial societies.[41] James Ryan [42] has noted that the photograph of a hunter "posed with a gun beside his recently killed prey" is a common representation of an "archetypal colonial figure." That certainly fits the depiction of Dr. Soeda, even though this is a studio photograph with rather puny prey.

The first two photographs in the album are, as might be expected, of Kodama Gentarō and Gotō Shimpei, but these diverge widely from their gallery portraits here and elsewhere. In these photographs, the two are pictured as full participants in the "club culture." Gotō Shimpei's photograph is not entirely unusual. The photograph was taken at the time of his delegation's visit to the temple in Xiamen, and he is his typical dapper self, with top hat, double-breasted coat, and walking cane. But the photograph of Kodama, which I introduce in the anecdote that opens the essay, is remarkable in its deviation from the norm set by his formal portraits.

The Photographers

The *Shashin kurabu* album is not only dominated by studio-produced portraits; the photographers from those studios also have a marked presence throughout the album. Of the ninety-six photographs, sixty-seven are attributed to a specific photographer or studio. Some portraits also carry other attributions and incidental information. The photograph of Kodama as a croquet player is most fully documented, with not only a caption and attributions to the photographer and printer but also details of the occasion recorded at the end of the biographical note: "This photograph was taken by Arita Shunkō on a summer day in 1899 while sporting on the recreation grounds at the Governor-General's residence"—it is from that note that I have created the anecdote. In contrast, the Governor-General's formal portrait is attributed to another photographer and is much simpler, labeled just "Mr. Asai." This should be Asai Kai'ichi (淺井魁一, no. 4 in table 1), who also photographed Soeda Juichirō as a hunter and produced seven other portraits in the album. All told, the album contains attributions to five different Taihoku photographers in fifty-two portraits and three advertisements. The remaining thirteen attributions are to photographers in Japan. The opening page of the gallery (see fig. 10) gives a sense of this range, with four different photographers named Asai, Endō, Era, and Nakashima (presumably 4, 3, A, and 6, respectively, in table 1). Of the five Taihoku photographers, two dominate the album: Arita Shunkō, with fifteen attributions, including one advertisement, and Nakashima Kyōboko (中島喬木),

with sixteen portraits and two advertisements. The close association of these two photographers with the club is attested not only in the number of attributions each holds but also in the album's closing image.

The album's elaborate portrait gallery closes with a composite photograph that offers a somewhat perplexing montage (see fig. 11). At the center of the photograph is a "posed snapshot" of two colonial figures, the architect Tamura Satarō（田村佐太郎, left）and his companion from Japan, the novelist Murakami Namiroku（村上波六）, being propelled by local laborers on a rail pushcart outside the Taihoku city wall.[43] The image is purely "colonial" in the sense that it represents the local subject bearing the burden, literally, of the colonial ruler—equivalent to the many colonial photographs of sedan chairs and porters transporting the foreigner and his bags across exotic landscapes. The two gentlemen have donned their "local" hats to protect them from the tropical sun but are otherwise similarly "in uniform." There seem to be gradations in their sartorial markings, however. The attire of Murakami, the visitor from the homeland, is relatively elegant and pristine (white shirt and tie, polished boots, etc.) compared to that of the local homelander, Tamura, whose outfit looks somewhat the worse for wear under colonial conditions. It is as if Murakami has not been sullied by the visit and remains the more perfect modern man from Tokyo. One supposes that is why there is no information on him in the verso note: he is not "of the island." Needless to say, there is no information on the two laborers either, but for very different reasons.

This central photograph is flanked by portraits of the photographers, Arita Shunkō and Nakashima Kyōboko. These are standard studio portraits, copies of which were published in the 1900 directory discussed below, although with slightly different treatments (see fig. 13, upper left for Nakashima). According to the short biographies, Nakashima came to Taiwan in 1896, first worked at the Asai studio, and then set up his own shop (no. 6 in table 1); similarly, Arita came to the island in 1897 and set up shop in 1898. The relationship of the photographers to the center snapshot is unclear, however—there are no attributions or clarifying notes. Is this meant to represent their work? If so, it is an interesting choice, suggesting the future of their craft: outdoor "action" photography that was the hallmark of the new small cameras, although this photograph is clearly posed. Moreover, the transparent manipulative treatment of the materials, Barthes's [44] so-called connotation procedures, announces the presence of the photographer and his craft in graphic ways. In the end, this composite self-portrait (if that is what is being represented here) poses more questions than answers about the photographers and their profession, questions that must await another line of inquiry. What continues to be evident is the overwhelming product of their labors: the public portraits of colonial gentlemen.

The Businessman Style

We now return to the *Taiwan shishō meikan* business directory of 1900 and consider its portraiture, along with other visual contents. The 178 portraits in forty-five pages range widely in both subject and style. The directory opens again with a full-page photograph of Governor-General Kodama and his colonial leadership—although the photograph is new, in pose and style it is almost an exact copy of the portrait in the 1899 album (see fig. 3)—and concludes with something quite new: photograph depicting three Taiwanese figures, a civic leader and two businessmen (see fig. 12). The civic leader, Huang Yujie（黃玉階）, was the first doctor of Chinese medicine licensed by the colonial authorities and the head of a civic improvement society, Tenran Zukai（天然足會）. He appears here in local dress and with what appears to be a Manchu-style queue, which was de rigueur for Chinese men. The two Taiwanese businessmen contrast starkly with each other, representing two reactions to the colonial world. Rong Qinian（容棋年, lower left）was photographed casually outside in local attire and also sporting a queue; he stares into the camera with seemingly little accommodation of the modern despite his position in a Western firm (*yōkō*). In contrast, the formal studio portrait of Wang Zhitang（王志堂 lower right）shows him in fully modern colonial attire, including a modest collection of medals, looking away from the camera, as if toward a future of colonial modernity into which he hopes to be remade.

Happenstance, it would seem, led to the inclusion of the portrait of Wang's Japanese counterpart on this page (upper right): Saitō Shigetomo（齋藤重友）from Danshui (Tamsui) is listed without title or profession, as if he were closer to the Taiwanese in his diminished colonial status. However, a comparison of Saitō and his Taiwanese companions reveals a number of status and ethnic markers in their portraits. This is obviously so with Huang and Rong, but even the mimic man Wang cannot fully embody Saitō's colonial modernity. Although almost identical in clothing, pose, and even male-pattern baldness, Saitō's full mustache establishes his racial and colonial position. Throughout the early portrait galleries, Japanese colonial leaders sport a variety of beards: for example, the twenty-three individuals in the portrait gallery of the 1896 *Taiwan gun gaisen* expedition album and the six on the first page of the 1899 *Taiwan meisho* travel guide *all* have either mustaches or beards (see fig. 4 for the latter). And even with a much wider cross-section of the elite in the 1901 club album, including a number of very young men, more than two-thirds (and almost all the top-ranked officials) display some type of facial hair. This was true for their European colonial counterparts and may be seen as Japanese mimicry of the European colonial image (the uniform for the face), but we should remember that the bearded hero was also prominent in Japanese samurai culture, at least before the Edo period. For the majority of Chinese colonial subjects, their raciality makes this one form of mimicry that they could not easily affect, even if they wanted to. They could cut off their queues, dress in a variety of colonial uniforms, and outfit themselves with other modern paraphernalia, but they seldom could grow the Japanese- and European-style beards, even in adult maturity. Their beardlessness made them appear

as "children" of the Japanese patriarchs of the colony. I will return to this question of mimicry and the colonial beard in the final section of the essay.

The style of portraiture throughout the 1900 directory is largely uniform and in line with standards seen in the other albums, yet I would like to note some deviations, both residual and innovative, remembering that they are a small minority in a sea of convention. One element in some of these portraits is the staging that anachronistically echoes the conventions of old daguerreotype and other long-exposure technologies, a phenomenon that Walter Benjamin[45] sharply criticized as a crass commercialization of the old portrait style, which he considered to possess "aura" and dignity. In first-generation photography, extended exposure time meant that both camera and subject had to remain immobile for the duration of the session, which, in the beginning, lasted several minutes. This was easy enough for the camera and the inanimate subject, but for portraits, various mechanical devices were employed to brace the very animate human body. Chairs with arms were the most practical, especially when outfitted with an invisible head brace; this often led to a certain throne-like pose that coincidentally echoes the formal East Asian ancestral portrait. The table and short pillar upon which the subject could lean also provided stability and allowed for the introduction of other atmospheric props, such as books, vases, and the like. And of course there could be no smiling, for ideological as well as practical reasons. Remnants of those conventions are evident in some of the portraits shown here, even though the speed of the film did not require them—one twenty-fifth of a second being a common shutter speed by this time. The once necessary had become the fashionable (see fig. 3 for an example). On the side of innovation, there are several forward-looking props and poses. There is a studio shot of a businessman in his sporting outfit and with a pet dog, as seen in the club album's photograph of Dr. Soeda. In addition, there is an interesting form of self-representation in a page dedicated to owners and employees of several photography studios, seen especially in the highly innovative depiction of a contemplative Tanaka Minezuki (田中嶺月) in full profile (see fig. 13, lower right). Finally, although colonial attire dominates, a number of figures in the directory wear the traditional Japanese kimono, a statement of Japanese ethnicity within the world of colonial mimicry. It is difficult to say whether this was a residual or innovative effect within the context of the early photography. The kimono could be residual in the sense of quoting a tradition but innovative in the insertion of Japaneseness into the representation of the modern nation.

As the colonial regime moved inevitably toward the modern, the Japanese kimono was reserved more and more for special occasions marked by either formality or Japaneseness, most notably any event with Shintō connotations. This is true not only for the Japanese population of the island, however; a significant portion of the colonized population, especially the urban elite, and among them especially women, adopted the kimono for special occasions. One of the most stunning examples of this mimicry is the 1917 wedding portrait of the Taiwanese intellectual leader Lin Maosheng (林茂生) and his wife (see fig. 14). Although such occasions can project the ambivalence of mimicry that Homi Bhabha discusses in the world of South Asian and African colonial regimes, here, there is an element that marks the mimicry as particularly East Asian. This is related directly to the question of racial difference and the effectiveness of the mask. Bhabha[46] observes that colonial mimicry "is the desire for a reformed, recognizable Other, *as a subject of difference that is almost the same, but not quite*"[47] He adds "but not quite" in part because of the highly racialized worlds of European colonialism, leading him to the revision "almost the same but not white"[48]. Race and ethnicity also played a decisive role in Japanese colonial policy, including brutal acts of oppression and terror, especially against the Taiwan aboriginal people, yet Japanese colonial rhetoric of the so-called East Asian *dōbun* (shared script) and *dōka* (shared culture) policies also downplayed racial difference.[49] This racial blurring seems to find visual form in some of the photography of urban elite populations. Although the Taiwanese could never actually "become Japanese," in the still and mute frame of the photograph, they could sometimes "be as Japanese." Cultural knowledge may or may not allow us to decipher Lin Maosheng's ethnicity, but the challenge is stronger when we try to parse the ethnicity of his bride. Is she Tomoko or Ling? Only the caption will let us know.

This racial ambiguity and colonial mimicry sometimes assumed odd configurations in Taiwan. One figure in the 1900 directory reverses the standard colonial conventions of representation: the *Taiwan nichinichi shimpō* reporter Tochiuchi Seiroku (栃内正六) appears in the silk robes and cap of a traditional Chinese scholar, a veritable mandarin staring directly at the camera (see fig. 15). This is a most peculiar form of self-presentation. Other colonial photographies provide examples of this type of reverse mimicry, such as Jean Geiser's 1870 "Couple Européen en costume Algérien".[50] There, however, the Europeans seem to suggest a mock ethnographic photograph filled with irony—they are very much "playing pretend." In other settings, this reverse mimicry can take on a suggestion of espionage, as when the colonial figure seeks to pass as his subject in order to make clandestine entry into that society; Sir Richard Burton, British colonial author and adventurer, was notorious for his success with this type of mimicry. The Tochiuchi photograph, however, seems to be an example of reverse colonial mimicry without irony or subterfuge. How can that be?

Elsewhere I have written on the possible ambiguous cultural relationship between the colonial ruler and his subject in Taiwan when the subject (Han Taiwanese) has command over highly valued cultural capital that members of the ruling colonial elite want to possess, especially as manifested in Chinese literati culture, which enjoyed considerable esteem and symbolic value in Japan.[51] I would argue here that the portrait of Tochiuchi Seiroku might be seen as a visualization of this cultural ambiguity. Although we can never retrieve Tochiuchi's intent, there seems to be a remarkable blurring of colonial distinctions in this image. First, he apparently chose

11 Composite photograph, with architect Tamura Satarō center left, and novelist Murakami Namiroku center right; photographers Arita Shunkō upper right, Nakashima Kyōboko lower left. Source: *Shashin kurabu* (1901). Courtesy of National Taiwan Library | 12 Concluding portrait page of 1900 directory, *Taiwan shishōmeikan*: Civic leader Huang Yu-Jie, Tamsui resident Saitō Shigetomo, businessman Wang Zhi-Tang, and businessman Rong Qinian (clockwise from upper left). Courtesy of National Taiwan Library | 13 Portraits of photographers/owners and technicians of photography studios in Taihoku: photographer Nakashima Kyōboko upper left, technician Tanaka Minezuki lower right. Source: *Taiwan shishōmeikan* (1900). Courtesy of National Taiwan Library | 14 A 1917 wedding photograph of Lin Mao-Sheng and his wife in traditional Japanese dress. Source: XIE Senzhan, ed., 1993, *Daoguo xianying [Images of an island nation]*, Taipei: Chuangyili wenhua. Courtesy of Lin Zong-Ren | 15 Taiwan nichinichi shimpō reporter Tochiuchi Seiroku in silk robes and cap of a traditional Chinese scholar. *Taiwan shishōmeikan* (1900). Courtesy of National Taiwan Library | 16 Photograph of studio owner Endō Hiroya; the two other profiles show the use of the name card in place of the photograph. Source: *Taiwan jitsugyōmeikan* (1912). Courtesy of National Taiwan Library | 17 Listings of Taiwanese with the surname Chen. Source: *Taiwan jitsugyōmeikan* (1912). Courtesy of National Taiwan Library | 18 Listings of Taiwanese with the surname Lin. Source: *Taiwan jitsugyōmeikan* (1912). Courtesy of National Taiwan Library | 19 Portraits from 1934 and 1937 of jurist Ou Qingshi. Sources: *Taiwan jinshi kan* (1934), (1937). Courtesy of National Taiwan Library | 20 Japanese and Taiwanese gentlemen: Misters Hashimoto, Kondō, Chen, and Hong. Source: *Taiwan jinshi kan* (1934). Courtesy of National Taiwan Library

this portrait as a form of self-representation in a formal colonial document of record. Second, there is nothing in the pose that suggests a playful stance: his choice of costume seems to be in earnest. Moreover, this also applies, perhaps even more strongly, to his 1901 club album portrait (see fig. 7, lower right), in which he again poses as a Chinese gentleman, both in clothing and posture: head-to-toe in mandarin robe, cap, and boots, in a full-body, spread-leg "ancestral pose." And in both photographs, Tochiuchi is not bearing the most prominent racial marker of the Japanese ruling elite: a beard or a mustache. [52]

In both portraits of Tochiuchi Seiroku the racial and cultural lines are clearly blurred, and in particularly East Asian ways. Viewers may claim to be able to decipher Tochiuchi's ethnicity, but the line of distinction between the colonial ruler and the subject is nothing like that seen in European colonial photography. Tochiuchi *could* be taken for Wang, although seldom could Jones be taken for either Wang or Gupta. A particularly clear example of this is in the similar sartorial habits of the Jesuits in China who also wore Chinese robes, but their "big noses and beards" clearly distinguished them from the Chinese population . Throughout the colonial period, this racial and cultural blurring follows several trajectories, the most important of which is the one in which portraiture of the Taiwanese subject and the Japanese ruler becomes closer in kind by moving toward a new standard of the modern male identity. These changes are clearly visible in the evolution of business directories over the next thirty years.

The Evolution of the Business Directory

As photographic albums proliferated throughout the colonial period, the prominence of the formal portrait gallery diminished markedly. At the same time, directories of businessmen and other professionals grew in stature and complexity, introducing several innovative variations. These directories provide important social documentation of the period. Among much other data, they offer a diachronic record of public portraiture of an elite and middle-elite segment of the population. The National Taiwan Library's Sōtokufu collection holds at least thirteen such directories for Taihoku (or Taiwan with a Taihoku section) subsequent to the 1900 directory: 1911, 1912, 1919, 1927, 1933, 1934 (two), 1936, 1937 (two), 1938, and 1943 (two).

The ten years between the first Taiwan business directory and the next two (from 1911 and 1912) brought dramatic changes in both the content and the form of the genre. First, these two directories are populated with a wide range of Taiwanese figures: for example, the Taihoku section of the 1912 *Taiwan jitsugyō meikan* lists more than 200 Taiwanese, compared to approximately 300 Japanese. This directory is again organized generally by locale (Taihoku, Giran [Yilan], Tōgen [Taoyuan], etc.), but the listing under each locale is by individual, rather than by address as in the 1900 directory. Although the Japanese residents (*naijin*) are listed separately from the Taiwanese (*hontōjin*), all individual listings are arranged by kana pronunciation of last names, including the Chinese names. The Japanese reading of Chinese names is a marker of

the unusual linguistic complications of the two populations, as well as a clear sign of colonial hierarchy. In contrast, the 1911 directory, *Taiwan shōkōjin meiroku*, is organized first by profession and then by locale and individual, with Japanese and Taiwanese listed together. For example, professional photographers have a mixed listing of thirty-four island-wide, with nine in the Taihoku-Kiryō area. [54] Thus, both directories are much more searchable (in different ways) than the 1900 one.

For our purposes, the 1912 directory is a particularly revealing document. As a listing of individuals that includes personal data and images, it compares well with volume 2 the 1900 directory and with the 1901 club album, despite its much wider subject pool. The structure and content of its listings are quite uniform, typically composed of a photograph of the individual and basic information (place of birth, age, profession, business address, and telephone number), usually supplemented by a short biographical note similar to those in the club album. If there is no photograph, the space is occupied by a basic "name card" (see fig. 16). By this time, portrait studios were widespread on the island, and portraiture was readily available to the elite and middle-elite populations, both Japanese and Taiwanese. Despite this shared accessibility, images often still retain clear ethnic distinctions. Members of the Japanese elite were photographed almost exclusively in suits and ties (occasionally in uniforms or traditional attire) in half-body or bust poses. Some Taiwanese figures are also pictured in this style, but more often the clothing and poses are older in style and more "Chinese," that is, traditional clothing and full-body pose, sometimes still in the old "ancestral portrait" style. Sample pages from the Chen and Lin sections of the directory show this range (see fig. 17, 18). The rapidly expanding subject pool partly accounts for the range of sartorial styles in the Taiwanese portraits: these were members of the local merchant class who were largely elided from early albums and directories. The wider range of representation also reflects the spreading presence of the photographic industry across the island, and captures noteworthy cultural and social phenomena.

One of the most remarkable aspects of the 1912 *Taiwan jitsugyō meikan* is the relative density of portraiture for the Taiwanese figures compared to that for the Japanese. For example, of the 228 "islanders" listed for the Taihoku area, 137 (60 percent) have portraits, yet for the 372 Japanese listings, only 160 (43 percent) include portraits. This trend is even more pronounced beyond the Taihoku area. In total, the album lists more than twice as many Japanese as Taiwanese (1,054 vs. 427), but the latter are twice as likely to have a portrait with their listing: 284 (67 percent) of the Taiwanese have portraits instead of just a name card, while only 322 (31 percent) of the Japanese do. On the surface, this means that while the professional photographic enterprise remained firmly (albeit not exclusively) in the hands of the Japanese, the studios' clientele was increasingly Taiwanese. [55] And if the statistics for this formal portraiture hold for other products of the photographic industry, such as wedding and family photographs, school portraits, and the like, that increase would

be even more substantial, given the popularity of those genres during the later years of the colony.

What might be made of this data? The high proportion of photographic representation of the Taiwanese subject so early in the colonial project is obviously a special condition of Japanese colonialism: the technology and industry were available to allow it to happen. Yet one wonders what drew the Taiwanese elite into the photographic studio in such numbers. Was the prestige value of the portrait especially significant for members of the Taiwanese business elite who wanted to be included in the colonial commercial system? Or was there an inherent cultural or class disparity in the two subject pools that yielded the results—that is, did Taiwanese individuals represent a much thinner slice of the upper echelons of their society and therefore have the resources for investing in these portraits? Or were the Taiwanese just interested in "looking Japanese"? Even if that were the rationale, these early portraits are still filled with socially constructed signs of ethnicity, whether or not they were meant to be.

Later Colonial Trends

The general format of the Taiwan business directory remains largely stable through the subsequent decades, but its specific content reflects changes in the colonial social structure. This is seen, for example, in the demographics of photographers on the island. Whereas in 1911, of nine photographic studios or stores in the Taihoku area, none was Taiwanese-owned, in 1927, five of twenty-two were owned by Taiwanese, and in 1936, at the peak of colonial photographic culture, fifteen of fifty-one listings in Taihoku were designated as Taiwanese-owned.[56] Data from the 1937 directory is slightly less Taiwanese-dense (fourteen of fifty-four establishments are Taiwanese), but here we find a first-time listing for the photographer Zhang Cai (張才) and his studio in the Dadaocheng area.[57] Zhang became one of the famous "three musketeers" of photographers who transitioned from the colonial to the postwar period, helping maintain an indigenous photographic community in Taiwan after the coming of Chinese Kuomintang rule in 1945. That transition was not without its disruptions, however. During the height of the Pacific War, a 1943 directory lists only nine photographic studios in the city, and none was Taiwanese.[58] Wartime austerity obviously was changing the local economy, particularly in the areas of luxury and leisure. That austerity is even more dramatically evident in a companion volume of biographical listings, the 1943 reissue of the 1934 Taiwan *jinshi kan* in which all entries consist merely of names and other printed information, with no images.

Other developments in the conventions of public portraiture can be traced from the early directories into the following decades. First is the increasing presence of Taiwanese business and civic leaders, with a continued high percentage of their portraiture; for example, of the ninety-three listings for the surname Chen in the 1934 *Taiwan jinshi kan*, eighty-one (87 percent) of them have portraits, while only twenty-one (54 percent) of the first thirty-nine Japanese listings have portraits. The significant ethnic markings and older

conventions of the portraiture in the early directories diminish over the years, such that by the 1930s, almost all portraits, of both Japanese and Taiwanese, are uniform in presentation and styling: most men are dressed in coat and tie, and the image is waist- or bust-high with a frontal gaze. Although some mustaches remain, the extravagant full colonial beard, which so distinguished colonial rulers in the early decades, has largely disappeared. This convention of the clean-shaven gentleman follows a worldwide phenomenon that arose with the invention of the safety razor by Gillette in 1901 and the spreading fashionableness of the clean-shaven face, with its link to youth and modernity, in the following decades, especially after World War I. The collateral effect of this practice in colonial Taiwan was to move the Taiwanese and Japanese male populations closer together in representational terms. It might be said that this leads to the apparent Japanese mimicry of the Taiwanese, in the sense that the Taiwanese were always more "clean shaven" and the Japanese became increasingly so. In addition, there are no full-body poses in these later albums, either of the East Asian or daguerreotype style; even half-body poses are rare. The images are more and more truncated.

This truncation of the portrait reaches its near limit in the 1937 *Taiwan jinshi kan*, in which most portraits are reduced to a shoulder-and-head shot, as the image approaches "mug shot" material, diminishing even further any possible sartorial markers of ethnicity. This is evident in the portraits of jurist Ou Qing-Shi (歐清石) between 1934 and 1937, as the same photograph is used but is significantly cropped in the latter (see fig. 19). This also seems to be aligned with a changing perception of what makes identity, moving away from the somatic and sartorial to the psychological and internal, with the face, especially the eyes, becoming the primary site of the individual. This is parallel to (if not intertwined with) the emerging filmic attention to the extreme close-up, which was becoming the shot for conveying emotion and intimacy. In effect, portrait photography had transitioned from a dramatic representation, in which identity is projected from the "stage" with one's whole body, to a filmic representation. The increasing use of the portrait in newspapers of the time reinforces this trend. In early examples, the newspaper portrait photograph is usually quite large in format, sometimes an eighth of a page, but the proliferation of images in later years necessitated reducing their size, most often to no more than the width or height of the standard newspaper column. For the portrait, this meant more and more focus on the head shot.

In these later directories, there are still some bows toward ethnicity, especially with older Taiwanese men who appear occasionally in a Chinese silk jacket, although sometimes adorned with colonial medals and topped off with a derby.[59] There is also occasionally just the opposite: Xie Quanzai (謝權在), a young Taiwanese man from Pingdong, wears a Japanese kimono and has a pencil mustache.[60] And finally, a few portraits of women begin to appear in these listings: Chen Jin (陳進), a Tokyo-educated artist, is presented in a kimono, while her contemporary Chen née Shi Man (陳石氏滿), a Tokyo-educated physician

practicing ophthalmology in Taihoku, appears in a Western-style blouse. [61]

Despite the obvious real-world divisions that persist between the Japanese colonialists and their Taiwanese subjects throughout the colonial period, in terms of visual representation, at least in public portraiture, an unusual form of colonial mimicry evolved. This is mimicry of a "third kind," in which the two populations accept the model of "another other" for their own: the image of a young, clean-shaven man of modernity wearing a Western suit in a mug-shot presentation. Combined with the relatively ambiguous racial differences in the populations, this moves the portrait toward a model that in effect draws Hashimoto, Kondō, Chen, and Hong into one image; they are indeed "the same" (see fig. 20). In the end, Chen could never become Hashimoto, no more than Hashimoto could become Jones, but in some ways, Chen and Hashimoto could become mutually equal mimic men of Jones. Although there were other markers that maintained colonial identities and divisions, such as personal names and spoken language, this visual ambiguity of the photographic portrait conspires with other social convergences, such as those involved in literary and calligraphic arts, to further confuse cultural distinctions that are the base of colonial rule. In fact, during the *kominka* (making of imperial subjects) movement of the late colonial period, policies sought to blur these distinctions even further with the displacement of Chinese names, language, and religion for those of the metropole (so Chen *could* become Hashimoto, at least "in name"). Homi Bhabha[62] argues that colonial mimicry is "at once resemblance and menace," by which I understand him to mean that a subversive menace emerges from the final difference ("excess/slippage") that is produced in mimicry: it is the "not quite" that mocks the arbitrariness of colonial power. In Taiwan's public portraiture, this menace seems to come from another quarter. In the shared mimicry of "another other," the Taiwanese colonial subject was able to claim an authenticity that achieves parity with that of his colonial rulers. They are both "not quite" in the same way.

Acknowledgments

Research for this article was conducted under a Taiwan Studies Fellowship from the Ministry of Education, ROC, Taiwan. I express my gratitude to that office and to the Culture Center at the Taipei Economic and Cultural Office in Chicago.

1 In this essay, citations of Japanese photo albums and directories held by the Taiwan Research Materials Center, National Taiwan Library (NTL), are listed by their romanized Japanese names and include call numbers. Translated titles that are part of an original publication are treated in headline style, while those added here are treated in sentence style. Chinese and Japanese names of authors are included if the publication is in the vernacular.

2 Roland Barthes, "The Photographic Message," *Image, Music, Text*, trans. Stephen Heath, New York: Hill and Wang, 1977, pp. 20–25.

3 Roland Barthes, *Camera Lucida: Reflections on Photography*, trans. Richard Howard, New York: Hill and Wang, 1981.

4 John Tagg, *The Burden of Representation: Essays on Photographies and Histories*, Minneapolis: University of Minnesota Press, 1993, pp. 1–5.

5 James R. Ryan, *Picturing Empire: Photography and the Visualization of the British Empire*, Chicago: University of Chicago Press, 1997.

6 Jean-Claude Lemagny and André Rouillé, *A History of Photography: Social and Cultural Perspectives*, trans. Janet Lloyd, Cambridge: Cambridge University Press, 1987, p. 62.

7 I use the term "third-generation" technology to distinguish dry plate and film from the wet-glass (collodion) plates, which had replaced the first-phase media of the daguerreotype and calotype. Dry-plate techniques were developed in the late 1860s, although sufficient speed was not reached until around 1890; modern celluloid film was invented by Kodak in 1889. The halftone process was invented in the 1880s, finding its way into newspapers in the late 1890s. See Beaumont Newhall, *The History of Photography*, New York: Museum of Modern Art, 1964, pp. 86, 89, 139, 175–77. The early deployment of this technology is further explored in my "Colonial Itineraries: Japanese Photography in Taiwan," *Japanese Taiwan: Colonial Rule and Its Legacy*, ed. Andrew W. Morris, London: Bloomsbury, 2015, pp. 25–48.

8 Ben Maddow, *Faces: A Narrative History of the Portrait in Photography*, Boston: New York Graphic Society, 1977, pp. 16–31 and Newhall, *The History of Photography*, chap. 4.

9 Newhall, *The History of Photography*, pp. 36–37.

10 Karen M. Fraser, *Photography and Japan*, London: Reaktion Books, 2011, p. 10.

11 Naoyuki Kinoshita, "The Early Years of Japanese Photography," *The History of Japanese Photography*, eds. Anne Tucker et al., New Haven, Conn.: Yale University Press, 2003, p. 33. Kinoshita mentions Matsuzaki Shinji's work but says "his photographs of Taiwan have never been found." There are, however, a small set of reproductions from his expedition in the 1915 photo album, *Taiwan shashinchō*, and in James Wheeler Davidson, *The Island of Formosa Past and Present: History, People, Resources, and Commercial Prospects: Tea, Camphor, Sugar, Coal, Sulfur, Economical Plants, and Other Productions*, London: Macmillan & Company, 1903, facing p. 127. There is no direct evidence regarding the equipment Matsuzaki used on the Taiwan expedition, but on an expedition a year later, he produced collodion prints (see Kinoshita, "The Early Years of Japanese Photography," p. 33, fig. 8), so one could assume that he also used wet-plate technology in Taiwan.

12 Newhall, *The History of Photography*, p. 175.

13 Ogawa Kazuma's influential role in the history of Japanese photography is reviewed in Kinoshita, "The Early Years of Japanese Photography," pp. 34–35 and Fraser, *Photography and Japan*, pp. 33–34; for details regarding technical information on the printing processes that Ogawa used, along with his extensive list of publications, see George C. Baxley, "Kazumasa Ogawa: Japanese Photographer," BaxleyStamps.com, http://www.baxleystamps.com/litho/ogawa.shtml, accessed July 22, 2014.

14 Fraser, *Photography and Japan*, p. 9.

15 Anthropological "type" photography of Taiwan has received a good deal of academic attention, such as by Xu Jin-Fa and Wei De-Wen. Ka F. Wong describes the seminal position that anthropologist and photographer Torii Ryūzō holds in the history of modern ethnography with his photographs of Taiwan's aborigine types. James Ryan has written on the anthropologically informed descriptions of colonized people in the British Empire; see his chapter "Photographing the Native." Above references see Xu Jin-Fa （許進發）and Wei De-Wen （魏德文）, "Rizhi shidai Taiwan yuanzhumin yingxiang [xiezhen] jilu gaishu" [Overview of the images of Taiwan aboriginal people during the Japanese period], *Taiwan shiliao yanjiu* [Taiwan Historical Materials Studies], 1996: 7, pp. 19–44; Ka F. Wong, "Entanglements of Ethnographic Images: Torii Ryūzō's Photographic Record of Taiwan Aborigines (1896-1900)," *Japanese Studies*, 2004: 24(3), pp. 283–99; Torii Ryūzō （鳥居龍藏）, *Etudes Anthropologiques: Les Aborigènes de Formosa*, Tokyo: Tokyo University, 1910. NTL call no. 0762 3; Torii Ryūzō, *The Torii Ryūzō Photographic Record of East Asian Photography, Parts I-IV*, Tokyo: University of Tokyo, 1990; and Ryan, *Picturing Empire: Photography and the Visualization of the British Empire*.

16 Essays by Huang Ming-Chuan (1985), Chang Chao-Tang (1992), and Chou Wen (1999) take passing notice of early colonial photography in Taiwan. Above references see Huang Ming-Chuan （黃明川）, "Yiduan mohu de puguang: Taiwan sheyingshi jianlun" [A Brief Dim Exposure: Introduction to the History of Taiwan Photography], *Xiongshi Meishu*, 1985, iss. 175, pp. 159–68; Chang Chao-Tang （張照堂）, "Guangying yu jiaobu: Taiwan xieshi baodao sheyingde fazhan shiji" [Image and step: The historical traces of Taiwan's realist reportage photography], in *Yingxiang yu shidai: Zhonghua minguo guoji sheying yishuguan sheying yishu yanjiu taohui lunwen zhuanji* [Image and time: Taipei International Exhibition of Photographic Art: 1992 ROC: The collection of papers from the symposium on photography art], Taichung: Shengli meishuguan, 1992, pp. 11–25; and Chou Wen （周文）, "Taiwan sheying de fazhan yi lishi yanguang niaokan" [The development of Taiwan photography from a historical bird's eye perspective], *Taiwan meishu*, 1999, iss. 44, pp. 74–82.

17 Kinoshita, "The Early Years of Japanese Photography."

18 These may also have been produced with the higher-quality Meisenbach halftone printing process, for which Ogawa was well known: see Baxley, "Kazumasa Ogawa: Japanese Photographer." Ogawa never visited Taiwan, as he did China, but he did produce a Taiwan album, also in 1896, the *Souvenirs de Formose et des Iles Pescadores*; for those images, which have no overlap here, see Thomas H. Hahn, "Taiwan 1896," *Thomas H. Hahn Docu-Images*, 2009, http://hahn.zenfolio.com/p554924562 and accessed July 23, 2014.

19 *Taiwan Shishō Meikan*, Taihoku: Nihitakasha, 1900. NTL call no. 0743-1.

20 *Taiwan Nichinichi Shimpō* [Taiwan Daily News], 1900a, March 7, p. 6; 1900b, April 3, p. 8.

21 By contrast, in 1877, Tokyo already had listings for 116 professional photographers and fourteen supply houses (See Kinoshita, "The Early Years of Japanese Photography," p. 24). The only two exceptions to the uniform Japanese presence in the early industry is in Taizhong, where Lin Cao （林草）established a studio in 1901 after apprenticing to a Japanese military photographer, and in Lugang, Zhanhua, where Shih Chiang （施強）opened another studio in the same year. See Chang Tsang-Sang （張蒼松）, *Lin xiezhenguan: Bainian zuji chongxian: Lin Zao yu Lin xiezhenguan sumiao* [Revealing traces of one hundred years: A Sketch of Lin Zao and the Lin Photographic Studio], Taichung: Taichung wenhuaju, ed. 2003, p. 86; and Lin Huan Sheng, "Taiwan Zaoqi Sheying Fazhan Guochenzhonde Lugang Erwo Xiezhenguan" [Lugang's "Erwo" Studio in the Early Development of Taiwan's Photogrpahy], *Tawian she ying nian jing zong lan: Taiwan nai nian she ying-1997* [Annual of Photography in Taiwan], Taipei: Yuanyi, 1998, pp. 1-92-1-103.

22 *Taiwan Nichinichi Shimpō*. 1898, May 17, p.6.

23 *Shashin Kurabu: Ichimei Taiwan Jimbutsu Shashinchō* [Photographing the Club: Album of Famous People in Taiwan], Taihoku: Taiwan shimminpōsha, 1901. NTL call no. 0743.3.

24 Claire Roberts, *Photography and China*, London: Reaktion Books, 2013, p. 27.

25 *Taiwan Nichinichi Shimpō*, 1898, June 15, p. 8.

26 *Taiwan Nichinichi Shimpō*, 1900, March 7, p. 6.

27 On the history of the newspaper halftone print in the West, see Lemagny and Rouillé, *A History of Photography: Social and Cultural Perspectives*, pp. 76–79 and Newhall, *The History of Photography*, pp. 176–77. For Japan, see Kaneko Ryuichi, "Realism and Propaganda: The Photographer's Eye Trained on Society," p. 187.

28 *Taiwan Nichinichi Shimpō*, 1905, May 3.

29 Activities of the Sendai studio are described in an advertisement at the back of the 1896 *Taiwan gun gaisen* album. Makoto is listed as the photographer on the album's title page. The biography for Hiroya in the 1912 *Taiwan jitsugyō meikan* details his work with the Japanese military during the Sino-Japanese War of 1894–95, including his travel to

Taiwan. See *Taiwan jitsugyō meikan* [Directory of Individuals by Profession in Taiwan], Taihoku: Taiwan nichinichi shimpō sha. NTL call no. 0743-6a, p. 99, fig. 19.

30　*Taiwan jitsugyō meikan*, p. 99.

31　*Taiwan jitsugyō meikan*, p. 166.

32　*Taiwan jitsugyō meikan*, p. 167.

33　Fu Yue'an (傅月庵), "Yiwei zhanshe yingxiang shiliao pandushang de yixie wenti" [Some questions regarding the interpretation of historical materials related to images from the 1895 war], *Taiwan shiliao yanjiu* [Taiwan Historical Materials Studies], 1996, p. 46.

34　This information is from Anne Tucker, but she says that Rikurō opened the studio in 1902. I am assuming he took control of it. See Anne Tucker, Izawa Kōtarō, and Kinoshita Naoyuki, *The History of Japanese Photography*, New Haven, Conn.: Yale University Press, eds. 2003, p. 316.

35　*Taiwan Shōkōjin Meiroku*, Taihoku: Taiwan shōkōjin meiroku insatsujo, 1911, p. 265. NTL call no. 07901-23.

36　*Taihokushi shōkōjin meiroku* [Directory of Taipei Business and Industrial Leaders], Taihoku: Taihokushi yakusho, 1937, pp. 217–19. NTL call no. 07901/28a.

37　The taking and circulation of the Meiji Emperor's portrait is closely associated with the Restoration's bid for modernity and parity in the international world (see Fraser, Photography and Japan, pp. 37–40; Morris Low, *Japan on Display: Photography and the Emperor*, London: Routledge, 2006, pp. 10–15). The first and most famous of these portraits was by Uchida Kuichi in 1873. The one reproduced here is similar but presumably by the Endō studio and also widely reproduced. As for this portrait of the heir apparent, I have not seen it reproduced in any other source.

38　Wu Hung has described the problematic nature of this "Chinese pose" as it was manufactured in a binary of East/West, old/modern discourse that came from descriptions by Western photographs in early China. Particularly intriguing is how it was used to create "ancestral portraits" of contemporary Chinese in the 1860s and 70s by Milton Miller. Above references see Wu Hung, "Inventing a 'Chinese' Portrait Style in Early Photography: The Case of Milton Miller," *Brushes and Shutter: Early Photography in China*, eds. Jeffrey W. Cody and Frances Terpak, Los Angeles: Getty Research Institute, 2011, pp. 69–89; and Roberts, *Photography and China*, p. 14 et passim.

39　I assume that this is the club known elsewhere as the Taihoku Club (Taihoku Kurabu). See Joseph R. Allen, *Taipei: City of Displacements*, Seattle: University of Washington Press, 2012, pp. 96–101.

40　In a display of another side of his cultured life, Soeda's cursive calligraphy adorns the album's frontispiece with the classical Chinese verse *Qingfeng guren lai* (清風故人來 A fresh breeze brings old friends) from a poem by Du Mu (杜牧, 803–852).

41　Note that newspapers and other publications of this time often carried advertisements for hunting rifles and equipment. The 1906 album *Kodama Sōtoku gaisen* has photographs of skeet-shooting competitions associated with the club.

42　Ryan, *Picturing Empire: Photography and the Visualization of the British Empire*, p. 99.

43　Murakami (1865–1944) is designated by his pen name, Chimenoura Namiroku ちめの浦 浪六 . My thanks to Professor Maki Isaka for this identification.

44　Barthes, "The Photographic Message."

45　Walter Benjamin, "Little History of Photography," *Walter Benjamin: Selected Writings, Volume 2 (1927-1934)*, ed. Michael W. Jennings, Cambridge, Mass.: Harvard University Press, 1999, p. 515.

46　Homi Bhabha, "Of Mimicry and Man," *The Location of Culture*, London: Routledge, 1994, pp. 85–92.

47　Bhabha, "Of Mimicry and Man," p. 86. Italics in original.

48　Bhabha, "Of Mimicry and Man," p. 87.

49　These policies, with their duplicity and inherent contradictions, are fully explored by Ching, Leo, *Becoming "Japanese": Colonial Taiwan and the Politics of Identity Formation*, Durham, N.C.: Duke University Press, 2001.

50　Mounira Khemir, *L'Orientalisme: l'Orient des photographes au XIXe siècle* [Orientalism: Nineteenth century photographs of the Orient], Paris: Centre national de la photographie, eds. 1994, pp. 24–25.

51　Allen, *Taipei: City of Displacements*, pp. 102–103.

52　Of the 178 portraits in this gallery, only about fifty individuals (and almost none of the colonial leadership) are clean-shaven.

53　Cf. Roberts, *Photography and China*, pp. 13–14, fig. 3; Wu, "Inventing a 'Chinese' Portrait Style in Early Photography: The Case of Milton Miller," p. 86, fig. 18.

54　*Taiwan Shōkōjin Meiroku*, pp. 265–267

55　Island-wide, seven of thirty-three listings are Taiwanese-owned studios. Six of these were in the Taichu (Taichung) area, which is probably the effect of the early and prestigious photographic studio of Lin Cao (see Chang, *Lin xiezhenguan: Bainian zuji chongxian: Lin Zao yu Lin xiezhenguan sumiao*).

56　*Taiwan Shōkōjin Meiroku*, pp. 265–266; *Taiwan Shōkō Meiroku* [Listing of Business and Industrial Figures], Taiwan busan kyōkai, 1927, pp. 842–843. NTL call no. 07901-24b; *Taihokushi Shōkōjin Meiroku*, pp. 223–225.

57　*Taihokushi Shōkōjin Meiroku*, p. 217.

58　*Taihokushi Shōkōjin Meiroku*, pp. 202–3. One wonders what sort of demographic censorship might have been at work during the height of the kominka period. Perhaps some of the Taiwanese photographers had changed their names to Japanese forms by this time.

59　*Taiwan Jinshi Kan* [Listing of Individuals in Taiwan], Taihoku: Taiwan shimminpōsha, 1934, pp. 11–12. NTL call no. RT 733.7 4307/1934.

60　*Taiwan Jinshi Kan*, p. 85.

61　*Taiwan Jinshi Kan*, pp. 127, 139.

62　Bhabha, "Of Mimicry and Man," p. 86.

Souvenirs de Formose et des Îles Pescadores was published in 1896 by Japanese landscape photography pioneer Ogawa Kazumasa and consists of a number of postcard photographs. The names of the photographers of these images are not given, but the book specifies that they were taken between October and November 1896.

Ogawa studied photography in America and began publishing portraits and other photographs in 1890 for an audience of Western viewers. Annotations for his works are all in Western languages. *Souvenirs de Formose et des Îles Pescadores* was compiled, edited, and printed for a French audience.

The year before *Souvenirs de Formose et des Îles Pescadores* was published, the modern Japanese military used the First Sino-Japanese War as pretext to invade Taiwan. Taiwan was incorporated into a group of countries administered by Japan that it sought to modernize. This explains why the book begins with photos of high-ranking military officers that were awarded medals during the Sino-Japanese War and why photos of neatly uniformed troops periodically appear among the photographs.

At that point in time, the Japanese government did not yet completely control Taiwan. As a result, the postcards primarily depict Taiwan as it looked under the Qing Dynasty. For example, one photo depicts a Han farmer driving an ox to plough a field. Other photos show the ferry crossings and streets in Tamsui. The anonymous photographer is not a member of the Japanese military, so military activities are not the main focus of the photographs. Likewise, they do not aim to document colonial reconstruction. Consequently, a particular characteristic of this photo book is its depictions of the daily lives of Han people during this period.

¤ ¤¤¤¤¤¤¤¤¤

Souvenirs de Formose et des Îles Pescadores

Ogawa Kazumasa (publisher), *Souvenirs de Formose et des Îles Pescadores (Memories from Formosa and the Pescadores Islands)*, 1896, Collotype, 26.9 x 38.4 cm. Collection of National Center of Photography and Images

（陛下春仮と番童） 徒生校學公人番萊芒、士佛高萊芒、務勤の旅ンワイバ
Supon, Kusukusu. Savage School Children.

なとこるす視視の挺士く知の部西島水は地ひれ居し恤な育教通善し涙な的教人地内け設る校學に地番等此りる時當の置設署姐海
其し用採に手勒の校學は又地査過なとし出な生業卒のく番に恤て以なるたし恤な育教し與な校學り狀て針方的極機はく多に驚く
效蠢番に的対欵とん給來以年九十三治明は盛教橋高の個な央中盛蒿りありのるるた、率な科學の等蒿ぐ盛注倫はのしるな等遵の
のし知の神事るす服欵人番の近閇りあいつり取な賴教に校學公人番社ンマス府下目り常に在の育

Taiwan Photo Album was a periodical published during the Japanese Colonial Era by the Taiwan Photographic Society (*Taiwan Shashin Kai*), which was established to document Taiwan's culture and natural beauty. From November 1914, *Taiwan Photo Album* was published monthly and mainly contained photographs of Taiwan's natural scenery accompanied by explanatory texts. The preface to the first issue stated the publication's objective as the promotion of tourism and facilitation of national education. The preface also compared Taiwan's unique geography to the landscape of Switzerland and stated that "although policies to pacify the savage tribes, which have gained attention from the West, have encountered much adversity, the completion of the crusades in Truku [Taroko] is worthy of praise… During this period, completion of these endeavors may be possible owing to divine gifts, allowing for development and a perfect resolution in international relations." Since the periodical began publication following the Truku War of 1914, its purposes included propaganda related to the pacification of Taiwan's aborigines, as well ask promotion of Taiwan's natural beauty and modern development. For instance, the first photograph in the first issue showed the Temple Plaque of Wu Feng Yuan-Huei Temple, which was issued by Taiwan Governor-General, Sakuma Samata, when he commissioned the temple's renovation of the temple. It was inscribed, "Embracing Death to Achieve Benevolence." The first image published in *Taiwan Photo Album* was thus a reiteration of the Governor-General's policies for "ruling savage tribes" and spread the story of Wu Feng extensively across Taiwan. *Taiwan Photo Album* also featured images of Baguashan in Changhua, Taichung Park, Chikan Tower, and other scenic destinations to promote tourism.

□ □ □□□□□□□□
Taiwan Photo Album

Taiwan Shashin Kai, *Taiwan Photo Album Vol. 3*, 1914-1915, Paper, 22 x 30 cm. Collection of National Center of Photography and Images

Taisho III Crusade Photo Album is a military-themed photography journal that mostly contains images related to military campaigns. These include photographs of soldiers visiting shrines, scenes of victorious returns from military campaigns, and views of the Tainan Training Ground. According to dates given in notations, the album is most likely documentation of the Truku War, which took place in the Taroko area between May and August of the third year of the Taisho Period (1914). The war began when the Government-General of Taiwan launched the attack on the Truku Tribe and enabled the Japanese to gain further control over eastern Taiwan.

The Truku War of 1914 was initiated by Imperial Japan with the objective of taking total control over lands inhabited by Taiwan's indigenous tribes. The aim was to establish authority and then exploit natural resources of those areas such as camphor, wood, and minerals. The series of planned attacks came as the final incidents in the long-running conflicts between the Truku Tribe and the Japanese military. The tension could be traced back to December, 1896 when Japanese soldiers of the Xincheng unit in the Karenko (Hualien) Garrison sexually assaulted Truku women, after which several Japanese soldiers were killed by the tribesmen by way of retaliation. In 1906, a conflict over the extraction of camphor led to increased tensions between the Japanese and the Truku people and finally resulted in the Weili Incident, in which the Truku killed a number of Japanese citizens and officials, including Oyama Juro. In 1909, members of the Amis Tribe from Cikasuan, who had joined with the Japanese to fight the Truku as part of a Japanese military tactic of "governing savages with their own people," also rebelled and were suppressed. The incident was later known as the Cikasuan Incident.

The Truku War was the most extensive military campaign for the suppression of indigenous peoples in Taiwan's mountain areas during the Japanese Colonial Period. Pre-war preparations took as long as two years and involved comprehensive exploration, observation, and the drafting of maps. The Truku War also involved the greatest numbers of military and police force personnel, military conscripts, military supplies, and the longest supply line. The war itself lasted for three months and ended when the Japanese army used their military advantage to force the Truku Tribe to surrender. After the war, the Japanese government set up the Xincheng and Inner-Truku subprefectures as part of the Karenko Prefecture (now Hualien), while a squadron of infantry was stationed at Haishu Shan, allowing the Japanese further control of Eastern Taiwan. The surviving Truku people were relocated in groups to the plains and scattered in different areas, including some who were forced to relocate to Han-settled regions. All of these measures were attempts to destroy the social structure and traditional culture of the Truku Tribe. Schools for the children of indigenous peoples were established to teach Japanese culture. At the same time, the Japanese government encouraged farming on fixed plots of land and established institutes for cultivation of silk, ramie, and general agriculture. These were intended as means of dismantling the traditional economy and lifestyle of the Truku Tribe.

□□ □ □□□□□□□□

Taisho III Crusade Photo Album

Photographer Unknown, *Taisho III Crusade Photo Album*, 1914, Gelatin Silver Print, Paper, 13 x 18.7 cm. Collection of National Center of Photography and Images

Reference:
1 Lin Jin-Fa, *The Developmental History of Taiwan*, Taipei City: People's Opinion Publishing, 1936, pp. 178-215.
2 Pan Jih-Daw, "The Truku Incident," *Newsletter of Taiwan Studies*, issue 72, October 2012, pp. 14-15.
3 Dai Bao-Cun, "The Centennial of the Truku War," *Newsletter of Taiwan Studies*, issue 82, July 2014, pp. 9-11.

Text by Tseng Lin-Yi, Collection's Interpretative Research Project, National Center of Photography and Images, 2020.

(二ノ三) 姿英御上馬

On April 16, 1923, the 12th year of the Taisho period, Crown Prince Hirohito of Japan arrived in Taiwan on the imperial cruiser Kongo for a twelve-day "East Palace Visit." The purpose of this trip was to generate propaganda highlighting Japan's achievements in governing Taiwan and promote Japan's investment into Taiwan. Since the start of the Japanese Colonial Period in 1895, Taiwan's native inhabitants had seen members of the Japanese imperial family visit Taiwan on several occasions, but this was the first ever visit by a crown prince regent. His appearances were highly-ritualized and for the native onlookers possessed the function of constructing a vision of the imperial image and reinforcing the hierarchy of the ruling class. In addition, the visit was a significant event for the Governor-General of Taiwan.

The crown prince's visit included stops in Taiwan's major cities. After arriving in Keelung, his entourage proceeded to tour through Taipei, Hsinchu, Taichung, Tainan, Kaohsiung, Pingtung, and Penghu, visiting prefecture halls, schools, military institutions, industrial production bureaus, and factories for manufacturing sugar and salt. There were 62 destinations in total and numerous celebrations and festivities were conducted along the way. *Photo Album of the Crown Prince's Visit* was published by Taipei City Hall (Taipei Shiyakusho) and its photographs offer detailed documentation of Crown Prince Hirohito's itinerary. The album captures the majesty of constructions specifically built for the visit, such as the torii, or ceremonial arches, erected in front of each of the Crown Prince's lodgings. It also depicts the Crown Prince's enthusiastic welcome by crowds in the streets, as well as of a meeting, held at 4:50 pm on April 18, 1923, with 500 male and female members of Taiwan's various indigenous tribes. Photographs capture the moment when tribal leaders paid their respects to the Crown Prince according to the guidance of the head of the Division of Aboriginal Affairs of the Police Administration Bureau. The visual signals sent by these images of ceremonies and processions were intended to convey the regal stance of the imperial court and the adoration and awe of the Taiwanese populace. *Photo Album of the Crown Prince's Visit to Tainan*, which is displayed as part of this exhibition, only shows parts of the Crown Prince's visit to Tainan. It includes visits to the Tainan Prefecture Hall, the Kitashirakawa Goisekisho in Nanmen Cho, the Test-site for Salt Water Aquaculture of the Industrial Production Bureau of the Governor-General's Office, and Taiwan's Second Garrison Command.

□□□ □ □□□□□□
Photo Album of the Crown Prince's Visit to Tainan

Photographer Unknown, *Photo Album of the Crown Prince's Visit to Tainan*, 1923, Gelatin Silver Print, Paper, 18.4 × 26.5 x 3.5 cm. Collection of National Center of Photography and Images

Reference Guo Shuang-Fu, Wang Zuo-Rong, *Photo Album of the Crown Prince's Visit to Taiwan*, 1923, Taipei: dersturm publisher, 2019.

Firearm, Skull, and Bones

Liang Ting-Yu

Artistic Research | Video, 23 mins | 2021

Indigenous traditional hunting practices reflect certain rites of life and an ecological point of view in the culture and world view of indigenous people. But during the early part of the Japanese colonial period, photographers carefully composed their shots of Taiwan's aborigines, setting up the objects that appear in the photographs and the poses of the sitters. This led to the creation of images that reflected imperial desire. Meanwhile, in order to emphasize the image of barbarism, photographic compositions featured "staged" figures, objects and skulls. The video work, *Firearm, Skull, and Bones* and the text, "The Gaze into the Abyss: Images of the Japanese Colonial Period's Indigenous Skeletons, Skulls, and Headhunting" delve into this topic through a reexamination of colonial images. This project operates as an attempt to break free from the visual language and textual descriptions of the colonizers and aims to return to a more life-centered and affective approach to the reading of these images.

The project takes its departure point from an anecdote of Japanese anthropologists Mori Ushinosuke and Torii Ryūzū, who stole bones from Taiwan's indigenous tribes. It connects their desire to take bones as specimens to the manipulation of images of indigenous headhunting practices to create barbarized representations, using close-ups of indigenous skulls obtained in mountain warfare between Japanese troops and Taiwan's aborigines. The process of obtaining, transforming, measuring, archiving and specimen-izing skulls and bones served as a "production line" for Japanese research into Taiwan's indigenous peoples. This project rethinks the connections between militaristic governance and the anthropological production of knowledge.

On one hand, these photos of indigenous skulls allow one to distinguish the faces and skulls of the deceased. But the blank gazes of men and women, young and old, with the eyelids peeled back, seem to be gazing yet not gazing. The neck fractures and abnormal wounds evoke images of the horrific experiences of the recently deceased and invoke criticisms of colonial anthropological photography. Yet at the same time, records from the period also show that members of the Japanese police and military were decapitated or wounded or killed by gunshots. It is worth noting that photographs of casualties are generally those of Taiwan's aborigines killed by Japanese troops. Why was this the focus, but not the other way around? What does it mean to focus on the dead or decapitated bodies of Japanese troops killed by aboriginal

Taiwanese? This is the starting point of my research. Can the photographs of indigenous skulls, through the juxtaposing and analyzing the pathological research of the craniums, skull images and specimens, push for re-imaginations of their owners' lives? Photos of dead Japanese troops can be seen either as a form of imperial humiliation or of those who sacrificed their lives for their country. But can we reveal a more complex historical point of view through these images? These are the questions that this project aims to address.

Liang Ting-Yu obtained his MA in Interdisciplinary Art Research from the Taipei National University of the Arts. His practice integrates fieldwork and research. Through actions and various media, his project-based works delve into conceptions of ghosts and spirits and how these are entangled with ideas from geography, history, memory and ethnic relations. At present, his projects involve collections of images, the study of death and the paranormal, the drafting of images, and writing. His research has variously been presented through academic conferences, workshops, and essays in academic journals in the fields of cultural studies, history, and anthropology. ●

Liang Ting-Yu, *Firearm, Skull and Bones*, 2021, video, 23 mins. Courtesy of the artist

Japanese Noh in Taiwan and the Kita Stage

Chen Fei-Hao

Artistic Research | Single-channel video,
approx. 20 mins | 2021

There's an old building from the Japanese colonial period that remains near the edge of Taipei's Ximending commercial district on Hankou Rd. The name of the building is the Omura Takeshi Building, and today it is an *izakaya*, or Japanese style restaurant. Omura Takeshi was part of a Noh theatrical troupe during the Japanese colonial period and once owned the building. There, he established one of the few Noh stages and Noh schools in Taiwan. It was then known as the Kita Stage. [1]

During the Japanese colonial period, Noh theater had only a low-key presence in Taiwan. Noh was then one of Japan's major traditional forms of performing arts, and Japanese living in Taiwan held a natural appreciation for it. Although Noh has aesthetic value in its own right, it also has certain traditional connections to Japanese politics. Noh is very different both from the traditional Chinese plays watched by Taiwan's majority Han population and from modern theater. Interest in Noh was primarily limited to Japanese residents of Taiwan, and as a result the existence of these Noh theaters in Taiwan is wrapped in mystery. How should we view the cultural context of these Japanese traditional arts that has almost been forgotten in the history of Taiwan? How should we evaluate these arts in connection to colonialism? This project aims to open a dialogue about this through exploring the history of the Kita Stage.

This project focuses on a historical novel by Nishikawa Mitsuru, *The Taiwan Cross-Island Railway*. It tells the story of Takebe Chikurei, a Noh-ga artist—Noh-ga is a style of paintings of Noh theater—who was also an actor. In the story, Takebe is selected for Taiwan's first exhibition of Noh-ga. In 1895, at the handover ceremony organised during the Japan's conflict with the armed forces of the Republic of Formosa, he performs the Noh play, Yashima, a type of Noh performance referred to as the Shimai. From this performance, one can see links between Noh theater and the Japanese military, namely the modern army that came to into being following the Meiji Restoration. Although Noh was limited in its function of "civilizing" Taiwanese, Noh performances were held during national ceremonies and dedications of shrines and exhibitions, and it stood as a cultural signifier of the Japanese political regime.

Another key point is that Taiwan was very distant from Japan and allowed different gender compositions in the Noh theater. In Japan, Noh was predominantly male, and female actors were generally only considered as amateurs. But in Taiwan, female actors had more opportunities to perform. The group of female performers in the Kita Women Group included a young girl named Yasuko Miyake, who acted in the Noh play, *Gekyuden*, at the dedication of the Kenkou Shinto Shrine in Taipei in 1929. After Japan's defeat in World War II, all Japanese in Taiwan were repatriated to Japan. The Kita Stage eventually became the izakaya in today's Omura Takeshi Building. But in 2020, a New Kita Group was established in Taiwan by Okabe Chie, who is descended from a family of Japanese born in Taiwan. Most members of the New Kita Group are women. When they performed at the Omura Takeshi Izakaya on Feb 9, 2020, it marked the first time that a Noh performance had taken place there since 1945.

With this project, I hope to invite the New Kita Group to perform *Yashima* at Taiwan Provincial Administration Hall of the Taipei Botanical Garden, where the handover ceremony of Taiwan to Japan took place; and *Gekyuden* at the National Taiwan Arts Education Center, which is the former location of the Kenkou Shinto Shrine. We hope to use female performers to subvert the male-dominated art of Noh and its links to masculine imperialist history. We further hope to establish a trans-colonial history and new ways of imagining local memory and sexual identity. These are the key issues we hope to address with this project.

1 The stage had basic Noh stage functions and was mainly used for rehearsal, but sometimes served as a facility for small performances.

Chen Fei-Hao, born in 1985, holds an advanced degree from the Graduate Institute of Trans-disciplinary Arts of the Taipei National University of the Arts and a BA in Journalism from Mingchuan University. Chen employs writing and conceptual photography and moving images to examine history, culture, and social change. He often combines images with installations, videos, and texts to probe the possibilities for convergence among different media. He was a participating artist in the 2016 Taipei Biennale as well as the recent exhibitions *Jodori Khiang–Community Artfest* at Taipei Artist Village (2017), *Yao-Chi City: Taiwan Paranormal Literature and Contemporary Art Exhibition* at Taiwan Contemporary Culture Lab, *Shattered Sanctity* at the Museum of Contemporary Art Taipei and *We Are Bound To Meet* at Loop Alt Space in Seoul, Korea. Chen currently works and lives in Taipei, Taiwan. ●

Takebe Chikurei's Nouga work "Dojo-ji", Historical Archive and Print, 30 x 30 cm (with frame). Courtesy of the artist

Visual Culture from Shashin to Hip-siòng

With the reproducibility of images used as a tool of colonial administration during the Japanese colonial period, the regulation of photographic equipment, photographic plates, and photographic paper was tightly controlled by the colonial authorities. It was difficult for a native Taiwanese to open a photo studio. During World War II, photographers had to register with the intelligence agency. This led the everyday use of photography to come under severe restrictions. Through tax records from the Japanese colonial period, we can see that the majority of photo studios in Taiwan were set up by Japanese, and the turnover of the Taiwanese studio was less than 10% of the Japanese's. With the Japanese government seeking to promote immigration, vocational schools that taught photography were set up in Japan and there was a large number of Japanese who set up photo studios in Southeast Asia.

The use of techniques for reproducing sounds and images were heavily regulated by Japanese colonial authorities, but this still could not suppress the democratic potentialities of these technologies. Pierre Bourdieu's ideas are elucidating regarding the notion of "Middle-brow Art," regarding how this concept was constructed in the choice of what is photographed, as well as how photography itself can form a social relation, and become a cultural index in observing everyday life. During the Japanese colonial period, many Taiwanese photographers learnt their skills as apprentices working in the Japanese studios. The Erwo Photo Studio, the Lin Photo Studio, the Chang Photo Studio, the Jin-Miao Photo Studio, the Mingliang Photo Studio, and others not only document Taiwanese modernization, but can be understood as having been a part of the development of photography as a mid-brow art. In this period, photography became a public sphere with the formation of photography societies and organizations. "Shashin" in Japanese can mean "portrait," but it can also mean "photography" and it is a loose translation of the notion "written by light." This reflects the close relationship between portraits and photography in Japanese culture. In schools of portraiture, taking portraits and using lighting was a large part of the curriculum. By contrast, the term "hip-siòng" used in Taiwanese dialect was derived from "xi," meaning to "intake" the image into the machine, just like how the camera does when taking pictures. When Taiwanese people set up photo studios, the standard business included portraits, wedding photos, exterior shots, and group photos. Techniques for using light in darkrooms played an important role in the development of visual culture in Taiwan. After the Nationalist government came to Taiwan, photos were required for identification documents. This also led to a fashion of several people taking close up photos together.

Just as the double simulation of colonial images reached its apex, one saw the universalization of photographic equipment, allowing regular people to treat photography as a hobby. Under the refracted colonial gaze, Taiwan's modernization was documented through photography. But one can also see how Taiwan's sense of identity gradually transitioned toward its modern liberation through examining photographs from this period.

Between Resemblance and Reality:
Early Portrait Photo Studios [1] and the Making of
Visual Traditions in Taiwan's Local Society (1895-1940)

Ma Kuo-An

Chang Chiuhai is employed to paint my portraiture. His way of painting is different from Pan Chunyuan's. Chunyuan painted from my photograph, and Tsai Peihuo considers the painting un-artistic. Qiuhai is not like Chunyuan, he paints from actual subject, and the result bears greater resemblance.

— Lin Xiantang, 1931 [2]

In 1931, for the celebration of Lin Xiantang's (1881–1956) 51st birthday, Tokyo Art School student Chang Chiuhai (1898–1988) was commissioned to paint a portraiture for the head of this wealthy and powerful family from Wufung (a Han settlement since late Qing in central Taiwan). Considering that having a commissioned portrait painter was already a luxury, Lin Xiantang had two painters paint his portrait for the same occasion. The employment of both painters was undertakings of his friends Tsai Peihuo (1889–1983) and Yang Chaojia (1892–1976). [3] As stated in his diary, the commissioning of the second painter Chang Chiuhai was due mainly to his friends' dissatisfaction with the "artistic" (*meishude*) quality of the first painting by painter Pan Chunyuan (1891–1972), which was basically a painted copy of his photograph. Although it has been common practice among portrait painters at the time to base portrait paintings on photographs, Lin Xiantang considered the painter who can "paint from actual subject" more trustworthy, even though he had not yet seen the finished work. For Lin and his friends, the style of this portrait painting could not compare with that of a portrait photograph, a "non-artistic" piece of image. In their minds, there exists at the same time an established way of judging portrait photographs and ideal portraiture. This standard appeared to have ruled out the influence of photo portraits; at least, in the eyes of Lin Xiantang, a painting copied from a photograph was considered neither artistic nor bearing the highest level of resemblance (*xiang*).

Lin and his friends' discussions over the "level of resemblance" and "artistic values" of photo and painted portraits are rooted in the cultural discourses for visual reproductions in the early 1930s. Globally, photo studios were emerging to be a major means of visualization for the growing middle class, and the relationship between patrons or customers and studio masters had increasingly became a common experience shared by all. In the past decade, studies of visual culture and history that focus on photo and painted portraits are also beginning to receive growing interest among scholars of interdisciplinary researches on modern East Asia. A mixed type of visual medium by nature, "portrait photography"—with "portrait" as its genre and "photography" as the medium—opened up a new field for analysis into the intertwined relationship between identities and visuality, while bringing forth new questions for scholarship of modern East Asian cultural history. To begin with, portrait photography embodies the process when photography and traditional portrait painting—as two systems of visual identification—interwove, thus obscuring the boundaries between "tradition" and "modern." The case presented above, as shall be elaborated below, provides a vivid example of the ways in which concepts for "traditional" and "modern" surfaced in the search for pictorial "reality."

The early portrait/photo studios in Taiwan used to have close ties with their predecessors and peers in the mainland at the turn of twentieth century, as these early generations of painters and photographers were mostly settlers and immigrants from China's southeast coastal regions. Pan Chunyuan, the portrait painter mentioned in Lin Xiantang's diary, studied portraiture at an Art School across the strait, and painters' templates popularized since late Qing such as *Jieziyuan Huazhuan* (Paintings from the Mustard-seed Garden) should have also been a common resource for a painter like him. [4] Mostly self-taught with occasional exchanges with teachers from the mainland, Pan was actually a widely-respected painter and local crafts master for temple paintings, famous but not as a portrait painter. When working as a portrait painter, Pan was like most of his colleagues—that is, commercial portrait producers—who had to survive the challenges brought by the new century. They were challenged, on the one hand, by the Japanese photographic technology and aesthetics that seemed to have come to dominate popular media with the colonial rule. On the other hand, however, they were much more seriously challenged by their customers like Lin Xiantang, who were also looking for new and better ways to represent images of the self in a transforming local society.

The first photographic portrait studio operated by Taiwanese opened in 1901, and the application of techniques for producing portrait photography, or charcoal portraits mimicking the effects of photography, was already on the list of services they offered. The "Lin Photo Studio (Shashinkan)"

opened in 1901, and the "Erwo Studio" began to offer portrait and photographic services in the late 1910s. Both were regarded, in terms of production techniques and style, as imports or extensions of portrait studio business from the "mainlands:" the "Lin Shashinkan" of Taichung owned by Lin Tsao (1881–1953)[5] from mainland Japan (opened in 1901); and the "Erwo Studio" (Me and Myself Studio) in Lugang (opened circa 1920), Zhanghua operated by Shih Chiang (1876–1943) from mainland China (some documents in the Japanese Colonial Period also refer to China as 內地). [6] The city of Taichung is where Lin Xiantang's families, one of the most powerful regional lineages reside; on the other hand, the small town of Lugang, with its once prominent port of "Lugang," has been home to some of the most successful family businesses in Taiwan since the nineteenth century. In a diary entry by Taiwanese literati and appointed yasumasa Chang Lijun (style name Shengsan, 1868–1941), he praises Shih Chiang's portrait painting for another literati friend's birthday, "It resembles in spirit (jingshen) and excels in painting skill. If compared to painters of [Fujian] Shanghang, his technique is equally good." [7] Using the title "painters of Shanghang" (Shanghang huashih) as a standard for ideal portrait painters, Chang's comment suggests he was fully aware of the quality and style of portrait painting popularized in southeast China,[8] and viewed Shih Chiang's painting not necessarily as an independent piece of (art) work, but rather as more of a local replica of the practice for portrait studios within the cultural space of Chinese visual experience. Being a customer of "Lin Shashinkan" at the same time, Chang offered no such comments on Lin's work in his diary. As per his descriptions, instead of portraits comparable with those produced by Fujian painters, Lin's studio specialized in photographs—thus had to be evaluated according to a completely different standard for "photographic" portraits. Thus, the two studios became the place in which changing conceptions toward different ways of visualization as well as systems of signification began to take shape, and in the process, helped to shape the complicated relationship between local ways of perception and forms of visual representation.

In other words, when the traditions of Chinese portrait-making practices were being inherited by practitioners settled in the immigrant society of Taiwan, it was also the time when the Japanese colonial rule brought in discourses for "modern" styles of visual production. This is not to say, however, that the "traditions of Chinese portrait-making practice" were not being transformed when encountering "modern" technologies for visualization, and it would also be useful to acknowledge that parallel processes were occurring on both sides of the straits. Recent scholarship on modern Chinese visual culture has demonstrated that the dynamics shaping "visual modernity" in modern China could not be fully understood without further analysis into China's portrait-making culture. Literary historian Shengqing Wu's studies of the "poems on photographs of the self" (ziti xiaozhao) has shown that modern Chinese intellectuals' visual encounters with the "self" were not only encounters with the "other," or Western modernity, but also reiterations of Chinese literary culture.[9] The visuality of photography in modern China, from the aspect of portraiture, could not be considered without the accompanying texts, and the text/image duality embedded within the cultural and socioeconomic contexts in which portrait photography were produced. Thus, as researchers began to realize the significance of portrait photography to studies of visual culture, explorations into the economic and social relations surrounding the production, distribution and reception of studio photography have increasingly become the undertakings of new projects that re-examine its different mediating natures. [10]

Re-considering portrait photography as a medium that mediates between text and image, visual and cultural historians not only problematized the "tradition vs. modern" or "East vs. West" binary in understanding visual cultures, but also came to recognize the transnational aspect of visual productions. Because as a visual medium, portrait photography was the product of a process that involved interactions between people playing different roles—or constructing multiple subjectivities—through the platform of photo (portrait) studios. These studios, also the subject of analysis for this paper, usually were expected to bear certain "local" characters and cultural functions for customers, but their decisive roles in framing the visual medium have constantly been ignored. In early twentieth century Taiwan, as shall be demonstrated in this paper, portrait studios were transformed into a whole new industry of image-making in the network of cultural communities molded by the changing local society. But what was this process for portrait studios to be integrated into local narratives for "locality" and "tradition," while becoming an enterprise that developed with the popularization of visual media? Moreover, under Chinese and Japanese influence, in what way did portrait studios in Taiwan struggled to survive while becoming an everyday base for local literati and intellectuals to building an agency facing colonial rule? By "agency," I am not referring only to the increasingly multi-faceted role photographic medium plays in a print culture negotiating with forces of globalization but also to the way in which customers of commercial studios create their own self-images within a globalizing local space by interacting with studio masters. As studio masters and their customers explored the ways in which photographic techniques re-frame visualized identities by representing "reality" in customized personal images, together, they shaped each other's visual consciousness.

This paper discusses the relationship between formations of identities and the practice of photographic portrait-making within the network of local literati and photo studios in 1930s Taiwan by looking at stories of some of the more prominent studio masters and their customers. Besides a concise overview of the histories for Chinese style portrait and how the genre evolved in the twentieth century, this paper also addresses questions surrounding the power relations within local societies that shaped and were shaped by portrait studios. As the medium that challenges

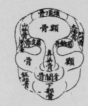

五嶽虛染圖

十五骨節虛染圖

五岳人人皆有惟其凹凸少不同。
蒼者顯而易見。嫩者澹以蒿工。

是分位渾元

皮肉　明備。骨節　暗全。

2　六〇

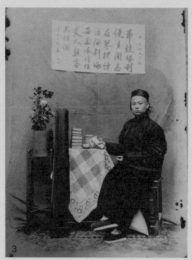

the boundary between "tradition" and "modernity," what were the reasons that made portrait photography different or similar to traditional portraiture? And if it served as a visual medium, what was it mediating? Also, what kind of new perspectives could we acquire by reconsidering and returning the portrait studios to the public spaces that they helped to build? Finally, examined from a transnational aspect that reviews cultural exchanges under colonial rule from a new light, this study should help further studies into how the formations of ideas and concepts for "identity" were both an individual, and communal act.

The first section of this paper gives a short survey of the development of portrait studios in modern East Asia and observes the entanglements of practices for image-making between the local societies reacting to while actively creating "traditions" of their own. The second part looks at the case of the Erwo Studio and its intimate relationship with local lineages of the Lugang area. The third offers an analysis of the Lin Studio and the ways in which it both adapted to and defined discourses for the "modernization" of portrait-making in local society. This paper thus proposes, that photo portraits are material objects, medium for personal memories as well as records for individual's explorations for subjectivity(ies) and selfhood all at the same time. Portrait studios, based on these arguments, are the unique space where people, objects and memories converge—a space that connects resemblance and reality.

Portrait Studios across Modern East Asia

In China, different regions have their own styles for portrait paintings, and the process in which they came to be viewed as a kind of pictorial tradition roughly began from the Qing dynasty. By the late Qing dynasty, portrait painting was possibly the most commonly shared experience in visual production among people from upper to lower classes. With the professionalization of commercial painters and development of lithography, the craftsmanship of creating portrait paintings was enjoying unprecedented prevalence and level of standardization. The *Xiezhen Mijue* (Secret Handbook of Portraiture), previously a small pamphlet for disciples of portrait paintings with only textual descriptions, was included in the fourth volume of the publicly circulated *Jieziyuan Huazhuan* in the early nineteenth century. In 1897, accompanied by illustrations of portrait sketches from various picture books, this handbook was reprinted as part of the *Jieziyuan Huazhuan* using lithography.[11] Whereas the custom-made "birthday portraiture" (shouxian) and "ancestral portraiture" (zuxianxiang) remained a luxury that most of the time only cultural elites and wealthy families could afford, publications such as *Jieziyuan Huazhuan* revealed that the visual economy of portraiture did not necessarily register as an exclusive upper-class experience. On the one hand, the technique for portrait painting was made more easily accessible. For those unable to afford a fully customized portraiture, painters prepared "template" paintings as cheaper options (fig. 1). These templates contained mostly only the body, fully dressed, and the background of the portraiture. Customer could pick

one template based on the painted subject's social standing and aesthetic taste and then ask the painter to fill in the only part left blank in the picture – the face. With instructions for facial drawings printed in the *Jieziyuan Huazhuan*, the cost and required training for the completion of a template painting became much lower because it became possible for a painter to learn the skills of the trade independently without being constrained by the system of apprenticeship (fig. 2). On the other hand, as the technical aspects of commercial portraiture, as opposed to the literati portraits (*wenrenhua*) made by elite painters, came to bear standards for evaluation, portraiture became not only a symbol of social commemoration embedded in traditional social structures and domestic relations but also a commercial product that could be reproduced visually within the public sphere, open for mass circulation and comparison with other visual reproductions, namely, those more "modern," or more "realistic." [12]

In other words, the so-called traditional practices for Chinese portraiture were already beginning to acquire certain characteristics of "modern" commercial culture. Besides the popularization of print industry, these developments toward modernization also required transformations of techniques and tools for making sketches, and more importantly, new ways of recognizing images of the self for literati and intellectual communities, namely, a transforming local society. The application of photographic technique in the process of making portraits, seen from this light, was one of the results when local communities began negotiating the "truthfulness," or "realness" for personal images. By the 1900s, photographic portraits in China, especially in developing cities such as Shanghai, had already become multi-functional products that could be circulated in the public space or collected as personal tokens, and this development of new visual medium has been viewed as a significant emblem of China's "visual modernity."[13] While history of Chinese portrait studios' accommodation of photographic technique has been understood primarily as a significant aspect of transforming visual culture in China's period of modernization, the process by which this accommodation took place, or the "pre-modern" story of this trade has seldom received careful examination within the scope of these analyses. This historical rupture could be attributed to the lack of data and sources on the proprietors or masters of earliest portrait studios that offered photographic services. In China, the adoption of photography as a technique for visual representation and reproduction first occurred in the circle of cultural literati and Qing court, but it was the commercial studios, most famously those in the treaty ports and Hong Kong, that introduced the practice of photography to the public.

The Erwo Studio and Legacy of the "Public" among Lugang Lineages

This space for formations of the visual culture evolving around the making and reception of portraiture did not exist in Taiwan until the early twentieth century. By the time Lin Tsao and Shih Chiang started their careers as portrait

studio masters, quite a few photographic studios have already been in business in Taipei city owned and run by Japanese photographers. Namely, Shih Chiang's Erwo studio might very well have been the first generation of portrait studios offering Chinese-style portraiture, while Lin Tsao's Lin studio being the first generation of portrait studios providing photographic services operated by local Taiwanese.

The story of Shih Chiang's Erwo studio is said to have begun from a trip to Hong Kong with his friend and patron Chen Huaicheng (1877–1940), a member of the prominent Chen lineage of Lugang. Shih's uncle was a portrait painter and was trained as a portrait painter before the opening of Erwo studio. He allegedly picked up photographer skills in Hong Kong and returned to start his business as a Chinese portrait painter and photographer circa 1916. The name "Erwo" was suggested by Chen Huaicheng, but it was not his invention, as there already existed photographic studios with the very same name in China.[14] Although it is unclear whether it was Chen's intention, the full name of the studio "Erwo Xiezhenguan (Chinese)/shashinkan (Japanese)," written in Chinese characters (or *kanji*), could be interpreted as a Chinese-style portrait studio and a photographic studio at the same time. The term "erwo" could have either originated from the genre of traditional Chinese portraiture called "erwo tu" (image of me and myself) or a famous saying by Matteo Ricci that was mistakenly passed on by the public to serve as a refined way for addressing photography.[15] With its double meanings, Shih Chiang's portrait studio also had double functions. For customers ordering portrait paintings, he offered works that could "compare to those by painters from Shanghang;" for others asking for photographs, he had the studio backdrops and props that were imported in part from China. Nicknamed "Qiangxian" (literally "Qiang-immortal"), Shih Chiang soon became one of the most sought-after studio masters in Lugang-Tainan cultural society by the 1920s, when the convenience of the just-built railway system allowed for greater mobility. While Shih's professional technique for photography made him one of the pioneers among portrait masters in Taiwan, a large part of his success can be attributed to his connection with mid/south Taiwan literati communities. In fact, Shih was also admitted into the circle of cultural elites. He was a frequent guest in many of the cultural events hosted by Lin Xiantang, and his friend Chen Huaicheng, as an esteemed local cultural activist, belongs to the famous Lugang family business Chingchanghang, owned and operated by the Chen family lineage, once the most successful in southern Taiwan.[16]

The double functions of the "Erwo Studio" in early twentieth century Taiwan made visible not only the nuanced relationship between painted and photographic portraiture but also the shifting of cultural traditions for portrait images in local communities. Thanks to Chen Huaicheng's priviledges as a local gentry head, Shih was able to occupy the side rooms of the Guandi Temple (part of the Wenwu Temple, the cultural and social center for local activities) when the studio first opened.[17] Although one reason for this arrangement

could be Shih's uncle, said to be a popular painter often employed by the literati visiting the Temple to work on the temple decorations as well as birthday portraitures until the time Shih opened the Erwo Studio, the functions of this space became much more complicated under the colonial governing system.[18] The space of the Guandi Temple in the first decade of colonial rule was characterized by an awkward in-betweenness. As part of the "Wenwu Temple" complex that consisted of a Wenchang Temple and a "shuyuan" (academy) sponsored by local literati, the entire temple complex and academy were shut down by the Japanese army and its original social functions were thus suspended temporarily. On the one hand, the *shuyuan* or Wenkai Academy could no longer operate as a Chinese academy because the colonial government strongly discouraged the teaching of Chinese traditional curriculum. On the other hand, previously a hub for local business communities' social events and religious gatherings, the Guandi Temple under Japanese supervision became a public space neither strictly religious nor cultural. Nonetheless, transforming the garden outside the temple into his outdoor studio background, inside the darkroom, Shih Chiang and his sponsor Chen Huaicheng temporarily relieved the place of colonial surveillance by the establishment of a portrait studio. For the customers of Erwo Studio, the environment of Guandi Temple was not at all inappropriate but instead created a unique setting with elements of Chinese, if not local, cultural symbols.

It is difficult to say whether Shih was driven by commercial pressure or personal interest to start offering photographic service because this pursuit for changing visual traditions was rooted in the transforming cultural environment of Lugang.[19] It was not a coincidence that the establishment of the Erwo studio was intimately connected with the cultural communities surrounding the Wenwu Temple. As the first and the only portrait and photographic studio located in a local religious and cultural center in Taiwan, the Erwo Studio was a product of transforming local visual culture. By eschewing the common pattern of business shared by earliest photographic studios in southeast China, the Erwo Studio did not appeal to its customers through the novelty of photography or a Western origin of the master's techniques. Compared with photographic studios in Hong Kong, where Shih learned the craft, pictures by Erwo Studio did not appear to be in the latest "fashion," either. Whereas a photographic portrait made by a Hong Kong studio in the same period featured glamorous three-dimensional painting using domestic space as backdrop, the earlier works by Erwo attached calligraphy to the backdrop instead (fig. 3,4).[20] A visual style also seen in works by early Chinese photographic studios, the photographic portraiture was certainly not the only one with such way of presentation by Erwo, as it was very likely early Lugang gentry's favorite personal style. In Figures 3 and 4, the two pictures of one couple were presented similar to literati paintings rather than photographic images. In Chen Tsaoyun's picture, a sentence in the calligraphy attached read "My passion lies in playing guqin, chess, and wine," and a set of

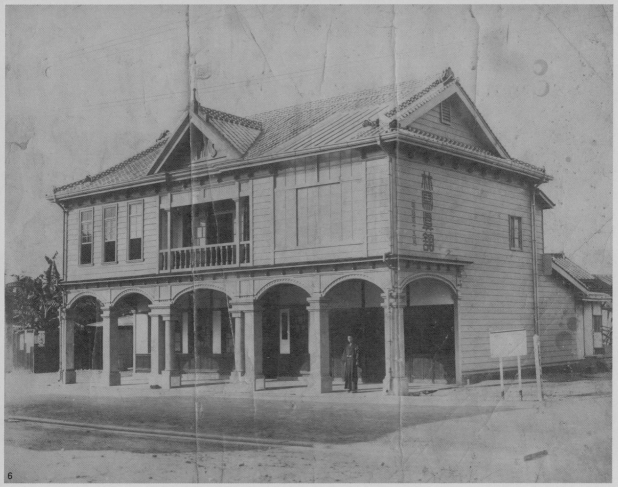

5 Chen Chi. From Li Chao-Jung, "A Study on Shihyilou Chi Chen and His Descendants," *Chung-Hsing Journal of History*, vol.29, 2014.12, p.36. I 6 Lin Photo Studio circa 1918, by Lin Tsao. Courtesy of Mr. Lin Chuan-Hsiu I 7 Lin Tsao. Courtesy of Mr. Lin Chuan-Hsiu

guqin was placed in the front; in the picture for his wife, the calligraphic work states that "A maid serves and adds incense to the burner," and standing beside her, with an incense burner on the table, was indeed a young maid with unbound bare feet, rather than her child, which is a much more commonly seen subject for Chinese portraiture. The images were visual realizations, even faithful "documentation," not of a cultural elite's real life, but of his ideal lifestyle or state of mind. The medium of photography, for Chen Tsaoyun, took the place of portrait painting and "conveyed the spirit" through a visual symbolic system transported from the world of literati painting to photography.

Judging from the carefully arranged props that fit with every detail described in the poems hanging in the photographs, the setting of the photographs' background should have been Chen Tsaoyun's own design. Chen's inspiration for the "poetry photography" could have originated in part from the style of literati painting, but it was his father Chen Chi (1842–1893), another Lugang businessman, also Chen Huaicheng's half-brother, who first took a portrait photograph with scrolls of poem hanging in the background (fig. 5). Born in the businessmen's family of Chingchanghang, Chen Tsaoyun was, like his father, neither a scholar-official recognized by the imperial examination system nor productive in classical literature, as his only literary works left were the two poems attached in the background of the two photographs. However, both father and son placed great value on their friendship with the society of literati and were eager to demonstrate these connections. Chen Chihung a set of calligraphy by Huang Yiji (1850–1900, *jinshi* from Fujian) in the only photograph of him still kept by his offspring. Chen Tsaoyun asked Cheng Hongyo (1856–1920), local *shengyuan*, teacher at Wenkai Academy who also made a living selling his writings, to write the poems used as the literary idealization and commentaries for his own image in the portrait photographs.

For the cultural elites asking Shih for photographic portraits, it was this sense of trust, based not only on Shih's skills in the practice of portrait-painting, but also on his social and cultural network, that brought them to this first local photographic studio. Whereas Shih's career of portrait production was an inherited family business from his uncle who was known to have based most of his activities in the Wenwu Temple, Shih also became in-laws with the teacher of the Wenkai Academy, Cai Dexuan and was directly related with the Academy's sponsors.[21] However, in the eyes of Shi and his "customers," whether they considered the Erwo studio a "business" is doubtful. Based on Shih family's collection of Shih Chiang's works, most of the images made by the Erwo studio until the mid-1920s were ordered either by Shih's friends or relatives. As a highly praised master (shifu, or "saifu" in Minnan dialect) of portrait painting by training, Shih's contribution to the local community was certainly not limited to individual or family portrait-making. Frequented by the most respected literati and head of commercial organizations in the Lugang area, the Wenwu Temple never

lost its importance as the center for literati activities even under colonial surveillance. Shih's studio served a particular role when the Lugang literati society attempted to rescue it from Japanese control. In 1914, appeals made by the Chen family and some Lugang gentry to the Japanese officials resulted in the renovation of the entire temple structure and the Wenkai Academy being able to accept students again. Thus, walking into the Wenwu Temple by the early 1920s, one would be able to see Lugang scholar Cheng Hongyo teaching calligraphy on one side of the temple and Shih Chiang working on portrait images in the rooms on the other side. By 1920, both Cheng and Shih became long-term residents of the temple's side rooms. [22] One of the few photographs of the Wenkai Academy operating under the colonial government was also produced by Shih Chiang. In this space exclusively kept for the purposes of preserving traditional means and system for knowledge transmission and exchange, Shih and his studio became a recorder and witness to Lugang gentry's accommodation and struggles toward transforming practices for self-representation by the production of their portrait images, mostly in the format of photography.

Thus, by juxtaposing calligraphic works by famous intellectuals with their own images in the photographs, the Chens were not only able to create the effects of inscribed literati paintings for the images; in the eyes of Chen Tsaoyun, the deliberate setting of the content within the images was meant to construct for themselves a lifestyle of the Chinese/local literati through a staged visual reproduction. Literati portraiture, a kind of "wenrenhua" as mentioned earlier, with texts written on the side describing the subject's state of mind or self-appointed cultural identities, has been a genre established since the seventeenth century in China and is commonly practiced among the circle of elites. When the painting style is copied in Chen's photographic portraits, the images served to mediate between the subjectivities from the world of Chinese pictorial symbolism, that of photographic realism in twentieth century Lugang, and the individual to an emerging public space being increasingly defined by the "modern" system of visualization. Exploring methods of self-representation through the medium of photographic portraiture, Shih and his client began to utilize photography as a record and symbol of photographed subjects' cultural, social, and economic status vis-à-vis an increasingly globalized practice of portrait photography in the format of *carte-de-visite*. This "literati painting style" photographic portraiture thus, like those practiced in portrait studios of mainland China, became a kind of "collaborative visual projects" produced by both his customers and master of the Erwo Studio, suggesting the way in which local society's established conceptions toward means of visual representation contributed to the shaping of image-making at the dawn of photographic production in colonial Taiwan.

Experimenting with Modern Self-Portraits in the Lin Shashinkan

By the late 1930s, "Erwo-style" portrait studios were gradually

being replaced by the first generation of "modern" photographic studios, and the value or function of photographic portraits, as demonstrated in the poem, was also being re-defined. Unlike Shih Chiang and his Erwo Studio, the owner of the Lin Shashinkan, Lin Tsao, had no background in traditional portrait painting but he did have a wealthy patron, Lin Xiantang. Raised as an adopted child in the Lin family, Lin Tsao had Lin Xiantang and his friends as the early group of clients when he took over his Japanese master's business and started to run his own studio in 1901.[23] In the first decade of the studio's operation, Lin Tsao seemed more like a family photographer for the Lin family, because most of his works left from this period are of the Lin family members and the famous "Lin family garden." Nevertheless, by 1917, as he moved the studio into a new house designed particularly to mimic a Japanese-style photographic studio, it became apparent that the Lin Shashinkan was capable of appealing to clients other than the Lin family members. Lin's studio in 1917 was a two-floor building, with western-style arcade and skylight on the roof and very different from the environment of the Erwo studio (fig. 6). Using "light" as the "brush," Lin Tsao envisioned the Lin studio to be the basis for creating new visual experiences with the modern technology of photography.[24] By the 1920s, Lin Tsao became a rather successful entrepreneur, and began to invest in newly emerging types of businesses such as coach services and cane sugar manufacture while owning over fifty acres of sugar cane field in the Nantou area.[25] Viewed in every aspect, the Lin Shashinkan, as opposed to the Erwo studio, was supposed to be a business that provided products comparable to those offered by Japanese photographic studios. In 1921, Taichung literati Chang Lijun, also a member of the major poetry society "Lishe" (society of oak) wrote in his diary that for the carte de visite requested by the poetry society to be printed in its collection of poems, he had to make a trip to the Lin Shashinkan.[26] The other visit to the studio with a special purpose, as recorded by Chang in his diary, was in 1911 when he needed an identity photograph for the permit to travel to Mainland China.[27] Although no records to indicate Lin's photo studio's popularity among Japanese clients exist, it would be reasonable to assume that his services should have been comparable with those offered by his Japanese colleagues. It could be said that the services offered by the Lin Shashinkan relied more upon Lin's "guarantee of quality" versus the sense of "trust" based on inter-personal relations shared by Shih Chiang's clients; for the locals visiting the Lin Shashinkan, works by Lin Tsao could be guaranteed to meet the standards for modern-style imagery. "Image of me and myself" (fig. 7), a double exposure photomontage of Lin's own portrait, was one sample photograph Lin created for advertisement, demonstrating to his clients how a photographic studio could serve as a means for transforming an established theme for traditional portraiture into a piece of modern-style photography. Documenting the most "photographable" even confident moments of his client's lives, Lin introduced to his clients a "modernized" way of visually "reproducing" one's perception of individual images.

Moreover, with the discovery of some of Lin studio's early images, it turns out that the role Lin Tsao played in the local society of 1910s could have been much more complicated than that of a successful entrepreneur.[28] Figures 8 to 10 are photographs of Japanese soldiers and aborigines traveling in the mountain and what appears to be a group of Truku people with a barefoot Japanese, Lin himself could be found in this image (fig. 8). Based on Lin's grandchildren, Lin was actually involved with colonial government's projects for expeditions into the mountains, and that he was specially commissioned by colonial officials as the photographer for several of these trips that took place in the period between 1911 and 1914. Compared with the photo albums housed in the archives of Japan's Imperial House Agency on these expeditions, Lin's photographs were shot with similar angles. Working under governmental commission with Japanese troops and inspection teams lead by Governor-General Samata Sakuma (1844–1915), Lin would have been one among the very few Taiwanese photographers who received such assignments from the colonial government.[29] As visual evidence of Japanese military's success and legitimacy of Japanese conquests into indigenous tribes, these official photographic assignments were part and parcel of the colonial discourses on the "civilizational" function of photography as a tool and a witness to colonial rule's disciplinary power.

No available records on the process or necessary qualifications for a commissioned photographer can be found, but it would be reasonable to assume that for a non-governmental photographer, such as Lin Tsao, the "discipline" for ways of making visual documentation would have been a prerequisite for taking up governmental assignments, and the process by which Lin was "trained" to produce images per colonial standards becomes another issue. One of the possible sources for Lin to receive such "training" could have been his Japanese master Morimoto, who traveled with Japanese troops to Taiwan in 1895.[30] In most of these photo albums made to submit to the Imperial collections which might have been published on sights of aborigines, conquests, or scenery, the perspective adapted did not differ much, as each photo album was supposed to be visual "documents" of successful dominance under the Emperor's watch. Between the role of commissioned photographer and owner of commercial studio, Lin Tsao was able to establish a thriving "modern" photographic studio; compared to Shih Chiang, he was the photographer "of a new generation," the generation when "modernity" or "modern" became a buzzword for cultural elites in Taiwan's local societies. In other words, the key to the success of Lin Shashinkan, contrary to the Erwo studio, lies in the way in which photographic portraits could "convey the spirits" of the subjects by a departure from the pictorial or visual tradition established by the Chinese system for signification, with the narrative for a "modern" way of viewing or visual documentation based on "scientific" standards.

By the "modern way of viewing," I am not only referring to the effects that colonial institutions established for image archives had on local practitioners of photographic production, but also the way in which the modern episteme for visual

8 Lin Tsao and companions. Courtesy of Lin Chuan-Hsiu l 9 Japanese troop, by Lin Tsao. Courtesy of Lin Chuan-Hsiu l 10 Troop on the road, by Lin Tsao. Courtesy of Lin Chuan-Hsiu

realism entered and began to shape local practice for portrait-making. Being a kind of "technology," the colonial archive for visual documentation of the natives has exerted its disciplinary function on studio masters such as Lin Tsao, but this certainly does not mean that the technology utilized in photographic studios was the same as that implemented by the colonial archive. For clients of commercial studios in the early twentieth century Taiwan, "technology" was viewed as a major driving force behind the transforming styles for image production, but what was really at stake for them was the way in which a new kind of narrative could be conceived and used to offer symbolic or ritualistic aspects for the new visual format. As painted portraiture quickly lost its popularity, by the late 1930s, for most studio clientele, it was "shashinkan" rather than "xiezhen guan" that they would be ordering pictures from.

Conclusion

While visual production in colonialism appears to be automatically part of colonial visual economy, in the case of colonial Taiwan, taking a step back from the Foucauldian approach is necessary to engage colonial imagery as the basis for the formation of colonial archive, both as a "technology" and as a result of governmentality. [31] In the studies of the two photo studios presented in this paper, the Lin photo studio in Taichung and the Erwo studio in Lugang are interpreted as two cases that represent the two paths of development for photographic production in colonial Taiwan. However, what this paper intends to establish is not necessarily the argument for "modern versus traditional" binary but the way in which the "modern" way of viewing was being articulated through contests, appropriations, and challenges not only for visual medium but for discourses of "technology" as well. Sharing a largely overlapping clientele, the Lin photographic studio and the Erwo studio were more than just two different choices of photographic formats for their clients. Both with powerful patrons and good connections in local communities, the Erwo studio was regarded as part of the ritualistic space of Wenwu temple, whereas Lin Tsao's photographic studio offered the service that only became necessary under the colonial governance system. The service for portraiture provided by master Shih of the Erwo studio is based on a set of shared pictorial standards that used to be regarded as the highest achievable form of reality. Some aspects of this world of visual symbolism were preserved in Shih's photographic works "custom-made" for his clients. On the other hand, operating with a Western (Japanese) set of visual symbolism, the Lin photographic studio should have been viewed as a site that generates mechanically produced reality "more real" than painted ones, according to an emerging visual realism. The kind of "social currency" embodied in these different forms of visual productions acquired its values from modern Chinese as well as emerging colonial Taiwan discourses on transforming epistemes of the early twentieth century.

1 Lin Xian-Tang, "Mr. Guan Yuan's Diary: November 26th, 1931," Institute of Taiwan History, Academia Sinica, Taiwanese Diary Archive, http://taco.ith.sinica.edu.tw/tdk/ 灌園先生日記 /1931-11-26, accessed February 20 2019.

2 Lin, "Mr. Guan Yuan's Diary: November 26th, 1931."

3 Luke Gartlan and Roberta Wue, eds., "Introductions," *Portraiture and Early Studio Photography in China and Japan*, London: Routledge, 2017, pp. 1–14.

4 Xie Shi-Ying, "Tuoxie de xiandai xing: Ri zhi shiqi chuantong miaoyu caihui shi panchunyuan" (Compromising with Modernity: Pan Chunyuan, A Painter of Traditional Temples During the Japanese Colonial Period), *Journal of Art Studies*, vol. 3, May 2008, pp. 131–169.

5 Lin Tsao also known as Lin Cao, the former is Hanyu pinyin used in this article, the latter is Tongyong pinyin used in the rest of the reader.

6 The "Portrait" in the "Erwo Portrait Studio", is a term derived from Japanese, but is not co term completely Japanese either. From the late Qing, there was no Chinese word that completely captured portraits, photography, and film, and no term corresponding to what we refer to as photography today. Originally, the term was used to refer to painted portraiture, but with the development of photography and its importation into Japan in the 19th century, the term was used to refer to photography as well. The term then disseminated to China. The term is the same as the modern term for photography in Japan, "shashin", and, in this way, it can be seen as a transnational term. When this essay uses the term "Portrait Studio", it refers to a studio that offers both photographic and portrait services, a term not used in the present. See Yi Gu, "What's in a Name? Photography and the Reinvention of Visual Truth in China 1840-1911," *The Art Bulletin*, vol. 95, no. 1, March 2013, pp. 120–138.

7 Zhang Lijun, "Shuizhu Resident's Diary, January 23rd, 1908," Institute of Taiwan History, Academia Sinica, Taiwanese Diary Archive, http://taco.ith.sinica.edu.tw/tdk/ 水竹居主人日記 /1908-01-23, accessed February 20 2019.

8 Charcoal portrait painting, also known as brush painting, emerged after photography was introduced to China. At the start of the 20th century, portrait studios sprung up across China. The appearance of these studios stimulated the demand of the people for commemorative images, but other forms of technology were more expensive, leading to the development of charcoal portrait painting, and its popularization. See: "Zhongguo minjian xiaoxianghua" (Chinese Portraiture and Painting), *Han sheng zazhi* (Hansheng Magazine), vol. 63, 64, April 1994.

9 Regarding the textual format of "poems on photographs of the self," including combining images with lyrical traditions in Chinese literature, and the modernity constructed through Chinese tradition, see Wu Sheng-qing, "Zhongceng de ziwo ying-xiang: Shuqing chuantong yu xiandai meijie" (Multi-Layered Personal Images: Chinese Lyrical Poetry and Modern Media), *Bulletin of the Department of Chinese Literature, National Cheng Chi University*, vol. 26, December 2016, pp. 31-74. Also see: Wu Sheng-qing, Xiangsi zhi ying: Qingmo ming chu zhaoxiang wenhua zhong de qinggan ditu" (The Shadow of Yearning: The Emotional Map of Portrait Culture Since the Qing). Also see: Wu Sheng-qing ed., *Luxing de tu xiang yu wenben: Xiandai huayu yu jing zhong de meijie hudong* (Traveling Images and Texts: Media Interaction in Context of Modern Chinese), Shanghai: Fudan University Press, 2016, pp. 127-158.

10 Gartlan and Wue, eds., *Portraiture and Early Studio Photography in China and Japan*. See also Katherine R. Tsiang and Wu Hung, eds., *Body and Face in Chinese Visual Culture*, Cambridge: Harvard University Asia Center, Distributed by Harvard University Press, 2005.

11 Wang Gai, ed., *Jie Zi Yuan Hua Zhuan: Chao Xun Lin Ben* [The Mustard Seed Garden Painting Manual], Beijing: People's Fine Arts Publishing House, 1960.

12 Technically not a genre of portrait painting, *wenrenhua* or "literati painting" could have landscape, flowers, or people as its subjects. Developed in the Song dynasty, "literati painting" is a genre of painting that involved mainly the participation of literati painters or patrons, and an ideal "literati painting" is supposed to express the inner character and state of self-cultivation of its painter and/or the painted subject. In the Yuan dynasty, as the professionalization of portrait painting began to develop outside of the circle of literati as well as court painters, gradually, portrait painting became no longer considered as a type of "literati painting." See Chen Hao-xing, Museu de Arte de Macau, et al., eds., *Xiang Ying Shen Quan: Ming Qing Ren Wu Xiao Xiang Hua Te Ji* [Spirits Alive: Figures and Portraits from the Ming and Qing Dynasties], Aomen: Museu de Arte de Macau, 2008.

13 The term China's "visual modernity" is borrowed from Laikwan Pang, *Distorting Mirror: Visual Modernity in China*, Honolulu: University of Hawaii Press, 2007, and by bringing up this analytical framework, I adopt her emphasis on the materiality of images, and the "social relations" between these objects and the subjects who look at, while wanting to be part of, the material world constructed by these image-objects. This concept for the "social nature of vision" was also borrowed by Pang from Deborah Poole, and I appreciate Pang's careful way of contextualizing the emergence of different mass visual media and their historical and cultural implications in modern China. Her proposal of modern Chinese print culture's "realist desire" has been one of the theoretic bases for this paper. However, my interest here lies less on the discursive boundaries between "modern" and "traditional" visual cultures, and more on the historical context of colonial cultural propaganda and the ways in which this materiality of the image-object generated in mainland's print culture served different roles and functions in 1930s Taiwan. See also Deborah Poole, *Vision, Race, Modernity: A Visual Economy of the Andean Image World*, Princeton, N.J.: Princeton University Press, 1997.

14 Most notably the "Erwo Xuan" (Me and Myself Studio) in Hangzhou. See Claire Roberts, *Photography and China*, Hong Kong: Hong Kong University Press, c. 2013.

15 "Image of me and myself," or "Er-wo tu" is a type of "painting-within-painting" (*huazhonghua*) more commonly seen after literati portraiture became a popular theme among the Song literati. Within such paintings, a painting of the subject's portraiture is hung on the screen, while the subject rests in front of the painting. Some of the most renowned paintings that feature "image of me and myself" include Liu Guandao's *Whiling Away the Summer* (*Hsiao-hsia t'u*, Nelson-Atkins Museum of Art) and *Scholar* by anonymous painter produced in the Song dynasty (National Palace Museum, Taipei). See Li Lin-tsan, "shìh yi shìh èr tú hé song rén jhuó sè rén wù" [The Double Portrait of Ch'ien-lung and Sung], *National Palace Museum Bulletin*, vol. 6, no. 5, November–December 1972, pp. 11–12. Recent scholarship on history of photography in modern China has also noticed the unique genre of "erwo tu" in portrait photographs, and argue for the uncanny effects photographic doubles have on modern visual culture, see H. Tiffany Lee, "One, and the Same: The Photographic Double in Republican China," *Portraiture and Early Studio Photography in China and Japan*, pp. 140–155. For the Chinese misinterpretation of Matteo Ricci's text, see Fang Hao's "Banwo Yu Erwo" in the epilogue for *Fanghao Liushi Zidinggao 2*, Taipei: Student Book Co., Ltd., 1969, p. 1270.

16 For a detailed study of the "Chingchanghang" and Lugang Chen family, see *Li Zhaorong, Lugang Yi Lou: Qing Chang Hang Jia Zu Shi Xu Tan* [Studies on the History of the Chigchanghang Family], Taichung: Morning Star, 2011.

17 *Simiao Taizhang, Zhanghua Jun, Lugang Jie* [Temple Records and Accounts of Zhanghua County, Vol. 5, Lugang Region I], pp. 538–539. Special collection of the Institute of Ethnology, Academia Sinica.

18 For a brief introduction of Shih's uncle, see *Li Zhaorong, Yi Lou Ju Yue Yi Lou Chun: Lugang Chingchang Jia Zu Xu Tan* [Yi Lou Ju Yue Yi Lou Chun: Further Studies into the History of the Chingchanghang Family], pp. 121-124.

19 According to new sources provided by Lin Tsao's grandchild, Mr. Lin Chuan-hsiu, the reason for Shi to first took up the practice of photography was also related to Chen Huaicheng (and a group of Lugang gentry), who wished to have visual records of the historic sites and heritage, as the colonial government implemented more and more control over the practice of local cultural traditions in a historic local society such as Lugang.

20 Lin Huan-Sheng, "Taiwan Zaoqi Sheying Fazhan Guochengzhongde Lugang Erwo Xiezhenguan,"[Lugang's "Erwo" Studio in the Early Development of Taiwan's Photography], *Taiwan she ying nian jian zong lan: Taiwan bai nian she ying 1997* [Annual of photography in Taiwan], Taipei: Yuanyi, 1998, pp. 1-92–1-103.

21 Lin, *Taiwan Zaoqi Sheying Fazhan Guochengzhongde Lugang Erwo Xiezhenguan*, pp. 1-99–1-100.

22 *Temple Records and Accounts of Zhanghua County, Vol. 5, Lugang Region I*, pp. 538–539.

23 "Lin Tsao," *Taiwan Jitsugyōka Meikan*, Taipei: Taiwan Magazine, 1912.

24 Based on Mr. Lin Chuan-Hsiu's recollection of his grandfather's career.

25 Zhang, Cang-Song, *Bai Nian Zu Ji Chong Xian: Lin Tsao Yu Lin Xie Zhen Guan Su Miao* [Tracing Hundred Years' Footsteps: Lin Tsao and the Lin Photographic Studio], Taichung: Cultural Affairs Bureau, Taichung City Government, 2003.

26 Chang Li-Jun, "Diaries of the Lishui Residence Owner: 25th August 1921."

27 Chang Li-Jun, "Diaries of the Lishui Residence Owner: 5th April 1911."

28 Based on some new resources provided by Lin's grandchild Lin Chuan-Hsiu, it could be said that Lin Tsao was not only a much sought-after professional studio photographer at that time, he also played an important role in local society of Taichung.

29 For the photo album on Japanese war with Musha aborigines published in 1931, the photographer was a "Lin Defu" from another "Lin photographic studio."

30 "Lin Tsao," *Taiwan Jitsugyōka Meikan*, Taipei: Taiwan Magazine.

31 See for instance, Foucault's discussion in his lectures on "Technologies of the Self." Michel Foucault, "Technologies of the Self." Lectures at University of Vermont Oct. 1982, in *Technologies of the Self*, Univ. of Massachusets Press, 1988, pp. 16-49.

¤¤¤¤ ¤ ¤¤¤¤¤

Shih Chiang
Erwo Photo Studio

Shih Chiang / Erwo Photo Studio, Portrait of
Woman, Lukang ca.1901, Gelatin Silver Print,
Paper, 5.3 × 3.6 cm. Collection of National
Center of Photography and Images

Shih Chiang (1876-1943) was a very active photographer in Lukang, Changhua, and was
probably one of the first Taiwanese to open a photo studio during the Japanese Period. He
learned portraiture from his uncle while young, and later became acquainted with Chen
Huai-Cheng of the Chen Qing-Chang family. In 1890, he encountered photography for
the first time while in Hong Kong. After learning photography by himself, Shih in 1901 set
up the Erwo Photo Studio in a side room of the Wenkai Academy in the Wen-Wu Temple.
The exterior garden was also used as a backdrop for photographs.

The name "Erwo" literally means "double selves" and refers to the exterior "self"
which exists within the world and the other "self" that can be seen through the camera
lens. The clients of the photo studio were not only members of the gentry in Taichung,
they also included literati and other locals. The photographic studio left a deep impression
on the local people. In 1944, with the deaths of both Shih Chiang and his son, the Erwo
Photo Studio ceased operations.

With his experience in painted portraits, Shih Chiang was able to combine
commercial photography with traditional folk portraiture, giving special care to the
aesthetics of the composition. Many of his photographs show literati amidst the grandeur
of their homes. During the Second World War, when many people feared dying and being
forgotten, they went to photo studios to have their photographs taken. In this way, the
Erwo Photo Studio created a significant documentary record of the area's local residents.

Lin Cao
Lin Photo Studio

Lin Cao, Daily Life of Lin Family- Lin Cheng-Tang (center) at a Commercially Produced Play, Wufeng, 1905-1910, Epson Giclée Print on Baryta Photo Paper. Courtesy of Lin Ming-Hong

During the Meiji Period, Lin Cao (1881-1953), became one of the first Taiwanese to run a photographic studio. As a young man, Lin became acquainted with Ogi Shinmachi, owner of the Morimoto Photo Studio, from whom he learned to take photographs, develop film, and touch up photos. Eventually, he succeeded Ogi as head of the Morimoto Photo Studio and in 1901 changed the studio's name to the Lin Photo Studio. Apart from the photo studio, Lin Cao also operated a bus service and ran a sugar factory.

Lin primarily took photos using a glass plate camera with bellows. From 1905 onward, he became the unofficial photographer of the Lin family in Wufeng, Taichung, and continued to take photographs of Lin Xian-Tang and others for close to thirty years. In 1907, the Lin Photo Studio built a new location, perhaps the most beautiful photo studio of its time. A portable daylight cover was set up to allow for photography in natural light, and double exposure photographs and other specialty services were offered to customers. As a result, the Lin Photo Studio had the most business of any Taiwanese-run studio of its time and also paid the most tax.

During the early Meiji period, only Japanese officials or members of the Taiwanese gentry would visit a photo studio to have their photos taken. Lin was the first official photographer of the Taichung Prefectural Hall, for which he took photographs of political activities, folk celebrations, and other events. Among those Lin photographed were the Japanese governor-general of Taiwan. With these experiences, the negatives Lin left behind record varied subjects.

Chang Chao-Mu
Chang Photo Studio

Chang Chao-Mu / Chang Photo Studio, A
Character of Sin Jin Yun Taiwanese Opera
Troupe, Location Unknown, Ca.1932, Epson
Giclée Print on Baryta Photo Paper, 16.5 ×
11.9 cm. Collection of National Center of
Photography and Images

Chang Chao-Mu (1895-1964) was a photographer who worked in Fengyuan, Taichung during the Meiji period. In 1925, he studied abroad at the Tokyo College of Photography (Shashin). Upon returning to Taiwan, he set up the Chang Photo Studio in Fengyuan. He left behind 80 glass plates. His most representative work is his photographic series of actors from the Sinjinyun Nanguan theatrical group, which were taken around 1932.

The Sinjinyun group was active around Taichung in the 1930s, performing in the nanguan style. This series of Chang include photos taken of the actors performing on stage and photos of the actors taken in his studio. The bellows cameras used during that time were not very mobile and required one full second of exposure, so actors would need to assume a fixed pose before the camera could take their picture. Even in the 1930s, these early Taiwanese theatrical images were extremely rare in "photography series" taken by local photographers at that time.

□□□□□□ □ □□□

Wu Jin-Miao
Jinmiao Photo Studio

Wu Jin-Miao, Wu Ming-Jhu portrait (Wu Jin-miao's younger sister), Yangmei, 1935-1950, Epson Giclée Print on Baryta Photo Paper, Collection of National Center of Photography and Images
Wu Jin-Miao, Wu Jin-Miao self-portrait, Yangmei, 1935-1950, Epson Giclée Print on Baryta Photo Paper. Collection of National Center of Photography and Images

Wu Jin-Miao, the Jinmiao Photo Studio, located in Yangmei, Taoyuan, obtained its operating license in 1935. The two key staff members were the older brother Wu Jin-Miao, who was responsible for taking photographs and hand tinting prints, and the younger brother Wu Jin-Rong, who handled darkroom work. The younger sister Wu Min-Jhu, father Wu A-Chang, and mother Wu Chong-Duan also helped with the studio work.

As the manager of the photo studio, Wu Jin-Miao was hailed as the "father of photography in Yangmei." Every year, before and after the Lunar New Year, local residents made arrangements to have their pictures taken. The Jinmiao Photo Studio was especially good at taking photos using props, stage sets, and lighting arrangements, and shooting photographic subjects in a variety of different poses.

Wu Jin-Miao often carried his heavy photography equipment to photograph the scenery around Yangmei. In this way, the Jinmiao Photo Studio captured images of daily life in Yangmei during the Meiji period, including those from the Kominka movement, farewell parties before military campaigns, group photos, wedding ceremonies, and Hakka life, leaving behind a considerable number of photos of historical values.

metallic photo

□□□□□□□ □ □□

Wu Chi-Jhang
Mingliang Photo Studio

Wu Chi-Jhang / Mingliang Photo Studio, A Silver-
haired Old Man, Kaohsiung Meinong, 1940-1950
Gelatin Silver Print, Glass Plate, 16.5 × 12 cm.
Collection of National Center of Photography
and Images

Wu Chi-Jhang (1916-2001)/Mingliang Photo Studio, was the first photographer from Meinong, Kaohsiung to graduate from the Tokyo College of Photography (Shashin). Wu originally studied portraiture from Wu Chao-Hua, while also learning to take photographs, work in a darkroom, and develop film. Wu left Taiwan for the Tokyo College of Photography in 1936. While there, he won first place in a university competition. After returning to Taiwan, he opened the Mingliang Photo Studio and only retired in 1980.

Compared to other early Taiwanese photographers, Wu Chi-Jhang was highly proficient in the art of charcoal painting, a sensibility that can also be seen in his photography. Since it was only possible to produce black-and-white photographs in the 1930s, Wu won awards during his time at the Tokyo College of Photography for his skill at increasing tints in photographs. The "silver portraits" developed by Wu were even referred to as "metalphotos", a technique which placed silver-coated paper behind a glass positive to simulate the effect of a silver-plate photograph.

Although Wu only rarely produced portrait paintings after opening his studio, his photography continued to be influenced by various traditions of portraiture. The majority of his photographs use a simple composition, which focuses on the photographic subject, without a strong emphasis on the arrangement of the background. Later in his career, Wu broke from this tendency to only take direct frontal portraits, attempting to record the particularity of his subject's character or disposition, while also capturing images of the daily life of his family members.

Huang Yu-Jhu
Guanghua Photo Studio

Huang Yu-Jhu / Guanghua Photo Studio, Seated Woman (Hand Coloring Process), Kaohsiung Fengshan, 1945-1955, Gelatin Silver Print with Hand-Painted Color, Paper, 30.3 × 25.6 cm. Collection of National Center of Photography and Images

Huang Yu-Jhu (1920-)/Guanghua Photo Studio is a photographer who has been working in Fengshan, Kaohsiung for a very long time. Like many other Taiwanese photographers, his artistic training began from charcoal painting. He learned photography from Huang Ding-Jin, who had learned the trade working in Japanese photo studios. Later on, he studied at the Ishibashi Photo Studio's under the owner, Mr. Ishibashi.

At the age of 20, Huang went to Tokyo to study at the East Asian School of Photography, where he learned a great number of photographic techniques. He graduated in 1941 as part of the twentieth class of the school. After the start of the Pacific War, he returned to Taiwan and set up the Nankei Photo Studio with Chen Lian-Ke in Nantou. At the same time, he also worked at the Japanese-owned Mary Photo Studio and the Ishibashi Photo Studio, taking and retouching photographs. In 1946, he set up the Guanghua Photo Studio in Fengshan, which is still in operation today in 2021.

During the Meiji Period, photo studios found their main business in taking portraits and wedding photos. During photography's early years, the taking of a photograph was seen as a significant lifetime event, and sitters would wear their most fashionable clothing. Some would even dress in theater costumes. As Huang's background was in painting, in the days before color photography, Huang was able to specialize in tinting black-and-white photographs with color.

¤ ¤ ¤ ¤ ¤ ¤ ¤ ¤ ¤ ¤

Lin Shou-Yi
Lin Photo Studio

Lin Shou-Yi / Lin Photo Studio, Female
Portraiture, Taoyuan, 1930-1939, Gelatin Silver
Print, Paper, 4.2 × 9 cm. Collection of National
Center of Photography and Images

Lin Shou-Yi (1916-2011)/Lin Photo Studio, Taoyaun was a photographer active in
Taoyuan. Unlike many other photographers in Taiwan, he came from a poor family
and had to work to supplement his family's income. In 1929, upon public school
graduation, he took up an apprenticeship at the Syu Ci-Yuan Photo Studio, which
was run by his cousin. He learned how to take photographs, work with a charcoal
pencil, powder colors, watercolors, and other techniques. In 1931, he traveled between
Keelung and Hualien, taking photographs and making portraits of local residents.

Realizing that Taiwan still lagged far behind Japan when it came to photographic
techniques, in 1934, Lin decided to travel to Tokyo to become a student at the Hi
no Hatsu Photography Limited Company in Ginza, Tokyo. After studying various
photographic techniques there, he became one of the few Taiwanese to work in a
Japanese photography company. In 1937, after returning to Taiwan, he set up the Lin
Photo Studio in Taoyuan. Lin was skilled at photographic portraits and specialized
in lighting arrangements and the use of artificial colors. His photographs excelled at
revealing the personal characteristics of the sitter.

Due to heavy competition between Taiwan's different photo studios and in order
to secure job opportunities, Lin continued to learn new techniques and how to use new
photographic equipment. Following the end of World War II, he continued to run his
photo studio and was an active participant in local photography groups and competitions.

To Pick A Flower
Shireen Seno
Artistic Research | Video | 2021

My mother used to tell me that our dining table was as old as I am. I wonder how old the tree was when it was cut down and turned into our table. I am fascinated by such processes of transmutation from the natural world to the human realm, and how a tree takes on new lives long after it has been cut down.

I would like to propose a video essay incorporating archival photographs from the American Colonial Era in the Philippines (1898–1946), exploring the sticky relationship between humans and nature and its entanglements with empire.

During my research, I came across a photograph of a young bride posing for an outdoor portrait, but in place of a groom there was a potted plant. An air of uncertainty abounds. Could it be that her groom is running late or has failed to show up? Is she hesitant to enter into marriage with him, or at all? Or perhaps she is just so uncomfortable and just can't wait for this photograph to be taken? I imagine it was very hot at the time, and here she is under the sun in a heavy, tight-waisted wedding dress.

Later on, I found a similar photograph of another woman posing outdoors next to a potted plant. I'm not sure if she is a bride, but she is wearing formal attire. This time, the woman is not looking at the camera. She is slightly turned to the side, and her gaze is downward to the dirt road at her feet. Her face is not very clear, but she appears to be in some discomfort. Her left-hand rests on the leaves of the small potted plant at her side, which is almost like a pet or a companion, definitely an object of comfort to her.

There's a tension to image-making that makes it so interesting—to keep moments of life with you, but in doing so, perhaps you also take something away from them. As a friend once said to me, it's kind of like picking a flower: it's beautiful and you want to take it, but you're killing it at the same time. The camera enables us to straddle that fine line between life and death.

Taking plants and trees as a starting point, this work aims to explore the roots and growth of photography and capitalism in the Philippines.

Shireen Seno is an artist and filmmaker whose work addresses memory, history, and image-making, often in relation to the idea of home. She is a recipient of the 2018 Thirteen Artists Award from the Cultural Center of the Philippines. She started out in film, shooting stills for Filipino director Lav Diaz before going on to direct her debut feature, *Big Boy* (2012). Shot entirely on Super 8, the film is about a boy whose parents believe the taller he is, the better. Her second film, *Nervous Translation* (2018), about a girl who finds out about a pen that can translate the thoughts and feelings of nervous people, won several awards and screened at MoMA as part of New Directors / New Films, at the Tate Modern as part of their Artists' Cinema program, and at the Tokyo Photographic Art Museum as part of the Yebisu International Festival for Art & Alternative Visions. Her curatorial projects include Christian Tablazon's solo exhibition *And the World Thickens with Texture Instead of History*; Takahiko Iimura's *Circle+Square* in Manila with Merv Espina; *INSTRUCTIONS: a video without video exhibit* for PABLO Gallery's 10th anniversary; and The Kalampag Tracking Agency, a program of experimental film and video from the Philippines over the past 30 years. She and John Torres run Los Otros, a Manila-based studio and platform dedicated to the intersections of film and art. They recently had their first solo exhibition together, a collaborative installation and screening program called *Cloudy with a chance of coconuts* at Portikus in Frankfurt. She is also part of Tito & Tita, a film and art collective whose work spans installation, film, photography and collective action. Seno is currently a visiting faculty member at the Philippine High School for the Arts. ●

Man picking coconuts from tree. Courtesy of Philippine Photographs Digital Archive, Special Collections Research Center, University of Michigan

Modernist Photography

By 1949, photography in Taiwan had become a specialized professional field. This was not only because photo studios opened up across Taiwan, but also because a culture of photography was developing among individuals who had studied photography in Japan or elsewhere. With the mass circulation of magazines and newspapers, photography was now in high demand. Photography's popularization led in turn to its democratization. Photographic clubs were formed by amateur photographers and professionals alike. A new body of writing on photography not only focused on photographic techniques but also on aesthetic ideas. From the 1920s, with the popularization of 35mm cameras that used rolls of film, gelatin silver prints took over the photographic mainstream, and the portable camera became a tool for capturing social transformation. Photography had now become professionalized and democratized. Images in print media such as newspapers, magazines, and books were now accessible. These developments allow us to understand the first-generation of photographers in Taiwan.

Compared to their counterparts in the West or Japan, these early Taiwanese photographers produced pictures that one can compare to the Pictorialist photographs of Western 19th-century photography salons. But their images also led to the development of modern photography in Taiwan, both in terms of machine aesthetics and abstraction. Social change could now be captured by the methods of "straight photography" and "photojournalism" advocated by Alfred Stieglitz. Politics could disappear into aesthetics by way of avant-gardism or structuralism, but their visual language revealed the boundaries that existed at the time. Between pictorialism and modernism of photography in Taiwan, identity is asserted through the act of making pictures. As such, the "Photo Eye" became the "Photo I". The self-consciously creative works of this period went on to ask the classic modernist question, "Who am I?" And from there, the question became, "Who photographs?", "Who is being photographed?", and "Why photograph?" In the context of Taiwan, this led to interest in photographs of local character, tradition, and ceremonial gatherings. Even what was being photographed was not Taiwan, there is a self-consciousness caught in between modernization and colonialism, which is the exclusive property of the local. In the photography of Peng Ruei-Lin, Chang Tsai, Hong Kong-Da, Deng Nan-Guang, Lee Ming-Tiao and other first-generation photographers in Taiwan, one can observe the subject as the "man with the camera". These photographers operated in the territory between "observer" and "participant", and from this "in between" position, they cast their cool gaze upon images of the times.

*
This is (Not) Photography:
An Assignment Given by Peng Ruei-Lin

Guo Jau-Lan

*

What's the value of silence today? Or the value of something that is untitled, and does not ask to be named? ...Silence, and its subsequent ambiguity, may be something sorely missing today, with the onslaught of noise that dominates the information sphere. [1]

Foreword: Yuanli and Tongsiao

Just five minutes away from Yuanli is the site of Peng Ruei-Lin's former Chinese medical practice, but I never heard his name when I lived there. Peng was a pioneering photographer of the Japanese colonial period, who later became a practitioner of Chinese medicine, living near Yuanli into the 1970s. Yet I never heard anyone from my grandparents' generation mentioning the name Peng, either in Mandarin or in the Taiwanese dialect, in which it is pronounced "Suī Lîn." [2]

Around 2006, I started asking around my relatives and father's friends, "Who are artists from Yuanli?" I wanted to meet people who had made art as part of their everyday lives in my hometown.

I was taken into Ciou Jin-Lian's home in Tongsiao. In 1932 and 1933, Ciou's work was selected for the Taiten (*Taiwan Fine Arts Exhibition*), a major art exhibition organized by the Japanese colonial government. After the 1930s, however, she perhaps never again picked up a brush. In Ciou's old house, a photograph of Ciou and my grandparents hung on the wall, showing their camaraderie as former classmates. It is in this way that art from that era has disappeared without anyone's notice. All that remains are a few forgotten photographs.

In 2014, when I realized that Peng's Tongsiao residence was five-minute drive from my hometown, like Ciou, his story took on a symbolic importance for me. In Taiwanese art history, both Peng and Ciou are classified as "Taiwanese pioneers" from the Japanese colonial period. But just as Ciou has been forgotten and receded into family history, so too, Peng's name is rarely mentioned. [3]

The reason that I have been pondering over why I never encountered the work of Peng while I was young is not because I regret discovering him late in life. Instead, I have been trying to understand the meaning of silence represented both by a phase in Peng's life and also by his account in Taiwanese art history. I look at this as two different aspects of what I call Peng's "non-photography." What does this uncertainty tell us? And what stories can these silences tell us?

Peng's Photography Did (Not) End: Disappearance and Reappearance

For a long time, we have viewed Peng's photographic works from 1928 to 1940 as "art photography." But as with Ciou Jin-Lian, in post-war Taiwan, he no longer had any opportunity to exhibit work publicly. From this disappearance of Peng as a photographer, what should we conclude? Is this the withdrawal of an individual artist? A dead end in art history? Or is this the absence of the history of Taiwanese photography itself?

What, then, is the recent driving force behind Peng's reappearance in the art scene? How should we now look at Peng and his photographs, which paid witness to his era? What does the reappearance of Peng have to say to us, at the end of the day? Research into Peng touches upon questions, which concern the history of art in Taiwan as a whole. Peng is not simply an object of research, but offers lessons in research methodology as well. Even during elementary school, I knew the name of amateur artists like Hong Tong. Hong Tong's name has been lionized in the media, and we have constructed a social imagination of him.

In this way, we can perhaps try and differentiate between the "the imagination of Peng" and "Peng and his photography." We might try to take these as two separate things and bypass the labels, which have been attached to Peng in the official discourse of the art history of Taiwan.

Peng came to be forgotten after a long and seemingly interminable war. From this, we can perhaps see the constitutive absences of Taiwanese art history in the art education of Taiwan. Unlike the first generation painters that traveled to Japan to learn Western art history, later served as a member of the provincial exhibition jury and were influential during their lifetime both inside and outside of the academy, the practice of photography art in the Japanese colonial period gained little attention in the later prosperous art market. The collection of its historical materials was not legitimized in the historiography of art until around the lifting of Martial Law, when the early narratives of arts came to be regarded as a strand of wider historical retrieval.

The "Not-Photographing" of Peng Ruei-Lin in Taiwanese Art History

Lin Chien-Yu: He never took photos again after the war. Do you think there was any particular reason for that?

Peng Liang-Min: No.

Lin Chien-Yu: Because he closed his photo studio and returned to Hsinchu. From what you mentioned, he'd still touch up some photos. But he no longer took any photos for anyone?

Peng Liang-Min: No, he did not.

Lin Chien-Yu: And he didn't create any more personal work.

Peng Liang-Min: He didn't have any equipment. He didn't have a darkroom nor anything related to photography anymore. [4]

In recent years, research into Peng oeuvre has seen a resurgence, with two important new works on Peng. In 2017, Lin Chien-Yu produced her Master's thesis "Peng Ru[e]i-Lin: Between Photography and Paintings in Modern Taiwan" in the National Taiwan University of Arts' Art History department. In 2018, *Photographers of Taiwan: Peng Ruey-Lin* by Ma Guo-An was published by the National Taiwan Museum of Fine Arts as part of a publishing project by the National Center of Photography and Images.

The latter work is primarily biographical, detailing Peng's transition from painting to photography, his studies in Japan, the awards he won there, his conscription into the Japanese army, and his later career in Chinese medicine.

By comparison, Lin Chien-Yu's work closely examines Peng's roots in painting, detailing how Peng developed his art in the midst of the Japanese trend of Pictorialist photography. Lin offers a reevaluation of how Peng developed as a painter and as a photographer simultaneously. Lin declares Peng to be "at the intersection of painting and photography."

Ma's biography ends with Peng's draft paper "A Primer on Photographic Printing Techniques," discussing the changes in imaginative vocabulary brought about by this technological development. Lin's research meanwhile gives us greater sense of historical perspective. Due to limits on length here, I will take my point of departure from Lin's discussion of Peng's "not-photographing" and its meaning for the history of art in Taiwan. [5]

I believe that Peng's "not-photographing" reflects: 1) his disappearance from photography right after the World War II, and 2) in the rediscovery of Peng's photography, the indistinct image that Peng represents.

In interview transcripts from Lin's thesis, Lin asks Peng's son, Peng Liang-Min, and his wife, "If your father didn't continue with any photography after World War II, how did people find out about him?" Peng Liang-Min replies, "Council for Cultural Affairs was recruiting for 'The Coordination of a Hundred Years' Photographic History of Taiwan,'...I saw this and thought that my father had a place in the history of Taiwanese photography." [6]

Peng Liang-Min first learned about Wu Jia-Bao's commissioned research from Council for Cultural Affairs,

"The Coordination of a Hundred Years' Photographic History of Taiwan," by reading about it in a newspaper. [7] Subsequently, he contacted the council through his older brother Peng Liang-Kun.

As a result, information about Peng was incorporated into the history of Taiwanese photography. [8] In February 1989, Wu Jia-Bao's magazine *China Photography Weekly* published the article "Taiwan's Forgotten Photographer: Peng Ruei-Lin." Hsiao Yong-Seng followed up five years later in *Taiwan Photography Quarterly* with another article, "Peng Ruei-Lin: On the Desolate Roads of an Era, The Portraits of a Taiwanese Photographer."

Lin's thesis only follows Peng up until 1945, at which point her research stops. Appended to the thesis is a timeline of major events in the history of Taiwanese photography and Peng's life. The timeline ends in 1945, the second year following the closure of the Apollo Photo Studio. Her thesis focuses on the establishment of Peng's photo studio and as such excludes his family photographs from the post-war period from the parameters of her research. The end point of 1945 further reflects how the author's definition of the photographic history and culture during the Meiji period reflects a form of essentialism:

In looking at the years during which Peng published photographic works, once Peng returned to Taiwan [from the battlefield in Guangdong] at the end of 1938, he didn't have many photos apart from family photos. According to the *Business Records* from that time, from the 14th year of the Shōwa period (1939) onward, the operator of the Apollo Photographic Studio was Chen De-Ming, and Peng gradually withdrew from its operations. [9]

Peng's "not-photographing" isn't the central research question of Lin's thesis, but rather the limit of its scope. Nevertheless, the author still tries many times to deduce the reasons as to why Peng stopped taking photographs.

For Peng, leaving the Apollo Photo Studio and traveling to China as an interpreter was a turning point in his career as a photographer. According to Peng Liang-Min, Peng's experiences of war may be one reason as to why he stopped photography. On the other hand, from the interview, we know that Peng began to study Chinese medicine before World War II. After the end of the war, he took the exam to be accredited in the practice of Chinese medicine. Outside of practicing Chinese medicine together with his son, Peng Liang-Min, he published research on Chinese medicine, so it's possible that his interests shifted from photography to Chinese medicine. Likewise, during the course of the war, Japanese authorities regulated photography more heavily, requiring photographic studios to be registered from 1942 to 1945. Only registered photographers were

大東亞戰初、アポロの裸像
になつたらしい。
外來語だ、といふ理由で
漢字に書き替えた、此
これから、縁喜がよくなつたと言はれた。
「瑞光」になつてから

昭和十年六月十日前後に
取り拆にあつた。

招牌最初是阿波羅的裸像。其次
改為日文片假名，被指為外來語
而改為漢字，以後又被指為和音
字，改為「瑞光」。

此店於昭和二十年六月十日前後拆除，作為防空
空地。

大東亞戰爭爆發後，為了加強防空設施，在櫥窗
上張貼紙條。這是攝影剛開業時最早的櫥窗。左
上方相片中富戶上的紙條，也是當時所貼。

翻譯提供：彭良岷

2

1 Peng Ruei-Lin's private photo album, *Reflections on Photography*, 1945, 28 cm x 39 cm. Courtesy of Peng Liang-Min, Peng Ya-Lun ｜ 2 Chinese translation of Peng Ruei-Lin's private photo album, *Reflections on Photography*. Translation courtesy of Peng Liang-Min [13] ｜ 3 Peng making sketches. Catalogue number M4A9p98, in the historical research materials M4A5-A10, No. 4 drawer. Courtesy of Peng Liang-Min, Peng Ya-Lun ｜ 4 Postcard from Ni Jhiang-Huai (Dingli), Apollo Photo Studio Era, Collection of Peng Ruei-Lin Historical Archive, file number M7RR1C2-1v82. Courtesy of Peng Liang-Min, Peng Ya-Lun. On the postcard writes Ni Chiang-Huai: Keelung City, Peng Ruei-Lin: Taiwan, Taipei City, Taipingding, Erdingmu, Apollo Photo Studio Era. The message on the postcard can be translated as follows: "Our respects, we are indebted to your care. Thank you for your poem and drumming. Please come this Sunday afternoon (the 6th) and Monday afternoon (the 7th) if you have time. We would be honored by your presence. We await your response. 4th December" Translation courtesy of Peng Ruei-Lin Historical Archive

allowed to take photos in public spaces, which led to limitations on photographic activities. This may have been another reason as to why Peng stopped taking photos. [10]

The war, the wartime regulation of photography studios, or a shift in personal interests could be all possible causes for Peng's discontinuation of his photographic practice. Apart from these reasons given in interviews, we cannot come up with a clear answer due to the limitations of the historical materials available. Different explanations also reflect researchers' disparate views on the meanings of Peng's photography and "not-photographing" in the methods and interpretation of art history.

In a 1994 article, Hsiao Yong-Seng had already perceived that this proposition was an important one. He wrote, "Peng abruptly stopped his photography in 1938. This is an issue worth contemplating for research, whether in terms of the history of Taiwanese photography, or Peng's biographical history. Peng's true passion could be always painting. He had a reserved attitude towards whether photography was truly an artistic undertaking. Strictly speaking, Peng's practice of photography stopped after he produced a series of landscape photographs.[11] Hsiao's interpretation lays the foundation for my discussions of Peng's "not-photographing"; meanwhile his text indirectly excludes Peng's photography practice at the photo studio in Jhudong.

In terms of historical materials, Peng's private photo album of 1945, *Reflections on Photography* provides some evidence as to why he left the photo studio, providing historical evidence that he may have closed the studio for economic reasons (fig. 1, fig. 2). In it he wrote:

"In operating the photo studio, the most painful periods are the cruel summer and the Spring Festival. I want to open a hospital as a remedy for the painful summer period...I was thinking that if I had a house in Shilin, apart from just the Apollo Photo Studio, I could set up a Chinese medicine clinic, an X-ray clinic, and a craft store." [12]

Regarding Peng's "non-photography," Hsiao Yong-Seng points out, "After the war, he was unemployed. The KMT came to Taiwan and he was arrested without proper cause. His sworn brother was murdered after the 228 Massacre. In order to raise his seven children and provide them with an education, he lived in poverty until the end of his years." [14]

Peng Liang-Min further clarified this in a 2016 interview: "My father never did anything for money. He didn't learn Chinese medicine for the sake of making money."[15] In other words, Peng Liang-Min believed that his father may have stopped his photographic practice due to economic pressure, but doesn't believe that his father changed careers to Chinese medicine for the sake of money. Neither did he believe that his career change to Chinese medicine was a key reason for his father giving up photography.

Lastly, Lin Shou-Yi, who ran the Lin Photo Studio during this time, makes similar statements in Chien Yun-Ping's *In Sight: Tracing the Photography Studio Images of the Japanese Period in Taiwan*. He suggests that Peng's giving up photography was related to his recruitment by the Japanese army. "My mentor, Syu Ci-Yuan [who ran a photo studio in Taoyuan in the 1920s, but is now deceased] was one of the earliest to participate in this study. According to their descriptions of Taipei at the time, amongst Taiwanese in the photographic trade, 'Apollo' was not only the most expensive, but the most accomplished photo studio. The Apollo Photographic Studio was known throughout Southeast Asia for its new and original photographic techniques and its scientific knowledge, so many engaged in the study of photography were eager to learn from it. This included amateurs, as well as experts, but after Peng was sent to Guangdong by the Japanese army as a Hakka interpreter, it was such a pity that Taiwan lost an outstanding photographer. [16]

The Limits of Individual Freedom and Individual Representation

After returning to Taiwan from Guangdong, Peng took up a post as the director of the Taipei District Photography Guild in 1940. Then in 1941, he took up a post as the vice president of the Taiwan Photographic Industry Alliance. Even if he returned to Jhudong in 1945, Peng still ran the Apollo Photo Studio, and traveled around Taiwan teaching students how to retouch photos. After returning to Jhudong, he worked managing a sugarcane field and later became a teacher, finally retiring in 1970.

Peng wrote six articles in the Japanese magazine, *Chinese Clinic*, and these were published in 1967, 1968, 1975, 1980, and 1981. Examining Peng's "non-photography" from the standpoint of his interest or decision to focus on Chinese medicine offers the risk of viewing Peng's photography as merely a career option or a personal hobby, and thus prevents us from seeing the broader cultural context underlying specific photographic practices.

According to the biographical explanations for Peng's "not-photographing," if we treat photography as a "hobby," what conclusions do we reach if we assume that "Chinese medicine" replaced "photography" as Peng's primary interest?

Aside from external influences like war or economic hardship, individual interest or choice is often used to explain decisions by artists. For example, Ma Guo-An compares Peng's photographic practice to his practice of Chinese medicine as follows: "Photographer Peng may have lost a better stage, but in the field of Chinese medicine, he was persistent and later became a significant author. After the KMT came to Taiwan, Peng published numerous articles in Japanese research journals on the study of Chinese medicine." [17]

Lin Chien-Yu makes "Peng Ruei-Lin's choice" the conclusion of her thesis. The "choice" here resonates with the topic of her thesis—Peng's choice between painting and photography. Lin describes how Peng, before he went to Japan, had close interaction with Ishikawa Kinichiro, and through Ishikawa's recommendation, he went to study at the Tokyo Specialist School of Photography. When Peng

returned to Taipei, the Japanese Pictorialist photography he had studied was being gradually replaced by Shinko Shashin (New Photography).[18] Later, although Peng held a solo exhibition at the Nichinichi Newspaper in 1931, participated in the Jhudong Education Exhibition in the same year and presented his works at the Apollo Photo Studio in 1934, Lin Chien-Yu argues, "There aren't many works left from the trend in Pictorialism in Taiwan from the time, and there aren't any landscape that were created as the output of artistic practices."[19] The "choice" in Lin Chien-Yu's thesis title actually implies that Peng had no choice, so under the conditions of being unable to decide, his decision is a choice with no other options.

Taiwan Photo-History Still Needs Pioneers

If artistic practice leads to recognition within a system of standards, or achieves meaning and value in life, we can see Peng have withdrawn photography as a photographic career being cut short. But what would be Peng's engagement by not photographing ?

Peng Liang-Min stated that before Wu Jia-Bao visited the Pengs for his research, "My father frequently spoke of painting, but rarely discussed photography."[20] Aside from Shitsuki Shashin (lacquerware photography) and Silver-Powder-Snowy-Landscape Technique (銀粉雪景技術), a technique he planned for Lan Yin-Ding to assist in promoting but failed. [21] Peng Liang-Min's wife also mentioned that after Peng settled in Tongsiao, "He often painted on the third and fourth floors." As a record, we have this image of him working on a still life. (fig. 3) [22]

Lin Chien-Yu also reminds us that, apart from his close relationship with Ishikawa Kinichiro, Peng also associated with members of the first generation of Modern artists in Taiwan, such as Ni Jhiang-Huai (fig. 4), Hong Ruei-Lin, Lee Shih-Ciao, and Lan Yin-Ding. Later on, Peng had fewer opportunities to keep in contact with artist friends like Lee Shih-Ciao and Lan Yin-Ding. But, after settling in Tongsiao, Peng still paid several visits to Li Mei-Shu and bought works from Hong.[23] With Peng's private archives opened to the public, Peng could be seen in a photo taken at Hong's 1979 exhibition, *Hong Ruei-Lin: Thirty-five Years of Mining Shapes*, at the Spring Fine Arts Gallery (fig. 5). Peng also kept a newspaper clipping of the exhibition (fig. 6).

Some recent archival documents on Peng's life support Lin's positioning of Peng as "in-between the intersections of photography and paintings." Peng collected postcards from Imperial Expos of 1930, 1933, 1934, and 1935, the 11th, 14th, 15th, and 16th such exhibitions. Likewise, he kept postcards from an exhibition in which Lee Shih-Ciao was chosen as a special selection by the Second Department of Fine Arts; and from the 13th Chunyang Association Exhibition of 1935; the 16th Independent Fine Arts Exhibition of 1936; the 17th Nika Association exhibition of 1930, and the 21st Nika Association exhibition of 1934. Between 1936 to 1941, Peng published a total of five essays in the Japanese magazine *Landscape*. These essays also included landscape paintings and photographs by him.[24] After Peng was conscripted in 1938 as an interpreter in the Japanese army and sent to Guangdong, he left a sketch of a Guangdong landscape in a notebook gifted by Yoshioka Shazo.

This brings us back to the historical context of Japanese Pictorialism and our understanding of aesthetics shared by both painting and photography. For a photographer like Peng, his relationship with a number of painters equalizes the connection of his photography with the society. This connection not only explicates on Peng's relationship with Ishikawa and paintings before he went to Japan but also the fact that he leaned toward Japanese Pictorialism during its contending for influence with the Shinko Shashin in Japan during the 1930s. But there are risks if we look at Peng's photography in isolation from his painting. In the 1930s, it was still being debated in the Museum of Modern Art in New York as to whether photography was art. It was only in 1939 that the MoMA became the first museum to establish a department of photography. The Tokyo Photographic Art Museum was only established in 1990.

If Peng made his choice on the advice of Ishikawa Kinichiro, who suggested that Peng take up photography rather than painting, since "Taiwan still lacked photographers," rather than ask the question of whether Peng took up photography as a matter of personal interest, do we instead move to ask whether Peng's interests reflect the circulation of art between Japan and Taiwan? And following the end of the war, what shifts took place in the field of art?

Wang Siou-Syong, in "The Conservatism and Authority of First Generation Taiwanese Painters and Their Influence on Taiwan's Post-War Western Paintings" asserts that the majority of Taiwan's first generation artists to paint in a Western style did not experience major stylistic shifts over the years.[25] Taking up long-term teaching positions or serving as provincial exhibition examiners, they however left a large influence. These artists were contemporaries of Peng. Putting aside questions of photographic technique and developments in consuming photography, pictorialism of photography could still experience a decline with the development of newer photographic techniques despite getting through other external factors. Another question that Peng's "not-photographing" drove us to ask was: did the artists who continued to produce works really "paint"?

Again, in the context of the 1930s, photography wasn't accorded the respected position within museums or other institutions that it is given today. Whether painting or photography, the relation of the two was caught within that between the art systems of Japan and Taiwan. Peng's photography could thus not escape the domination of the structural force of "what Taiwan lacks."

After the end of the war, while many of the painters of the Japanese colonial period were, under the new political conditions, able to establish their authority as artists, Peng disappeared from the stage. His production of paintings, which was even forgotten in the name of photography might have been the silent voice of anti-authoritarianism.

5 Photo taken in 1979 at the Spring Fine Arts Gallery exhibition "Hong Ruei-Lin: Thirty-five Years of Mining Shapes" while Peng was there. Collection of Peng Ruei-Lin Historical Archive, file number: A9p84-A9p89. (Order goes upper left, center left, bottom left, upper right, center right, bottom right.) Courtesy of Peng Liang-Min, Peng Ya-Lun | 6 Subterranean Spirit–Discussing Hong Ruei-Lin's works, newspaper clipping, *China Times*, thirteenth edition, 26th June1979. Collection of Peng Ruei-Lin Historical Archive. Courtesy of Peng Liang-Min, Peng Ya-Lun | 7 After being conscripted as a translator in Guangdong by the Japanese army in 1938, he drew this landscape of Xihu in Huizhou in Guangdong. Collection of Peng Ruei-Lin Historical Archive. Courtesy of Peng Liang-Min, Peng Ya-Lun | 8 After being conscripted as a translator in Guangdong by the Japanese army in 1938, he drew this landscape of Xihu in Huizhou in Guangdong. On the left side of the sketch, the Sizhou Pagoda in Xihu is visible. Collection of Peng Ruei-Lin Historical Archive. Courtesy of Peng Liang-Min, Peng Ya-Lun | 9 Peng Ruei-Lin, "Street View of Min-style Architecture", Blue Sketch Series. Collection of Peng Ruei-Lin Historical Archive. Courtesy of Peng Liang-Min, Peng Ya-Lun

These paintings developed under the aesthetic conditions of colonialism and shared the aesthetic standards of Peng's pictorialist photography. However, they were regarded as "non-photographying" in the later medium-centric system of categorization. This "non-photographying" was previously thought of only as an end to Peng's career as a photographer, but may also be understood as an index of the photographer's technical skills and physical memory.

If artistic practice can be described by art history, then an artist's not-practicing should also be an object of concern. Through examining the historical conditions by which art and photography were produced, we can understand the shared living conditions of the time. This does not only add to our understanding, but also reflects the conditions that allow artists to continue to produce work, and under what conditions they must stop. It could provide us answer to the past that we cannot experience directly. In the name of time and through an anthropological point of view regarding artists, what of the trivial lives that this covers over? Where this is concerned, we must seek to avoid historically exploiting art history, even if some level of historical exploitation is impossible.

The Value and Transmission of Silence

Consequently, Peng's "not-photographing" raises more issues than just those concerning photography. As much as my eager to learn from others on this topic on which the contemporary research of photo-history based, we may ask, what will be the narrative structure of photography now and then *differance* from each other? And how does the cultural translation shift?

The question at stake is to understand cultural production of a particular artist without risking the ignorance of his or her personal life experience. If we would have not acknowledged Peng's story coming from a faraway place, we can understand Peng and his artistic endeavor. As such, can Peng avoid being identified merely as a mediator, which in fact is widely regarded by the public as a part of historical homogenous construction?

If we can refrain from building the myth of Peng on the heroism of martyrdom and from general survey of photography history, a true attention of Peng's life is required in telling the entire story of his art. Rendering his life to political meaning can only be necessary in understanding of his silence of "not-photographing," a forever missing piece from the puzzle of Taiwan photo-history.

1 Chiara Ianeselli, Reader #4: Silence, https://www.e-flux.com/announcements/324464/e-flux-reader-silence, accessed on May 28 2020.

2 Only later on did I learn that Peng was Hakka from Erchong, Jhudong. If he had a nickname, it may not have been in Taiwanese.

3 Ciou Jin-Lian learned gouache painting while in high school at the Third Girl's High School from Gobara Koto. She likely gave up painting to take care of her children and assist her husband.

4 Lin Chien-Yu, "Peng Ru[e]i-Lin: Between Photography and Paintings in Modern Taiwan," Master's Thesis, Department of Art History, National Taiwan University of Arts, 2017, p. 140.

5 Ma Guo-An, "Perhaps Peng Ruei-Lin was searching for something between photography as an art and as scientific observation, hoping to see how many sides to the world there were!" *Photographers of Taiwan: Peng Ruei-Lin*, Taipei: National Taiwan Museum, 2018, p. 154.

6 Lin, "Peng Ru[e]i-Lin: Between Photography and Paintings in Modern Taiwan," p. 144.

7 The full name of this project was the "The Coordination of a Hundred Years' Photographic History of Taiwan," which was headed by Wu Jia-Bao. It began in 1985. In February 1989, Wu Jia-Bao's "Taiwan's Forgotten Photographic Pioneer: Peng Ruei-Lin" was published in *China Photography Weekly*.

8 According to Wu Jia-Bao's description: "In 1986, I initiated 'The Coordination of a Hundred Years' Photographic History of Taiwan' based on the investigation, research, and construction of a Taiwanese photography history. This project was continuing large-scale projects undertaken in the last five years. Later on, because of pointless political reasons, we couldn't obtain financial assistance for the government, so we were forced to stop after one year." See Wu Jia-Bao, "Taiwanese Photographic Education from 1930 to 1998," *Fotosoft*, https://www.tofotosoft.com/about-us/ 視丘線上圖書館 /wujiabao-articles/65- 台灣的攝影教育 -1930-1998.html, accessed May 10 2020.

9 Hsiao Yong-Seng, "Peng Ruei-Lin: On the Desolate Roads of an Era, the Portraits of a Taiwanese Photographer," *Taiwan Photography Quarterly*, vol. 3, April 1994, pp. 8–11.

10 Lin, "Peng Ru[e]i-Lin: Between Photography and Paintings in Modern Taiwan," pp. 63–64.

11 Hsiao, "Peng Ruei-Lin: On the Desolate Roads of an Era, the Portraits of a Taiwanese Photographer," p. 8.

12 Peng Ruei-Lin: "Reflections on Portraiture," private photo book. Collections of his family members.

13 The translated text was revised in the exhibition, "Exploding Map of a Rotating History Compilation Method," curated by the author at the Galerie Nichido in Taipei on September 7, 2019.

14 Hsiao, "Peng Ruei-Lin: On the Desolate Roads of an Era, the Portraits of a Taiwanese Photographer," p. 8.

15 Lin, "Peng Ru[e]i-Lin: Between Photography and Paintings in Modern Taiwan," p. 134.

16 Lin Shou-Yi, "The World of Photography Before the Restoration," see Chien Yun-Ping ed., *In Sight : Tracing the Photography Studio Images of the Japanese Period in Tai-wan*, Taipei: Xialuyuan International Limited Company, 2010, p. 178.

17 Ma, "Photographers of Taiwan: Peng Ruei-Lin," p. 154.

18 Shinko Shashin is a trend of photography in the 1930s Japan. Different from Japanese Pictorialism, Shinko Shashin doesn't pursue the aesthetics of paintings and instead emphasize the mechanicalness of camera, through which the photographers create unique visual experiences.

19 Lin, "Peng Ru[e]i-Lin: Between Photography and Paintings in Modern Taiwan," p. 68.

20 Lin, "Peng Ru[e]i-Lin: Between Photography and Paintings in Modern Taiwan," p. 133

21 Hsiao, "Peng Ruei-Lin: On the Desolate Roads of an Era, the Portraits of a Taiwanese Photographer," p. 259.

22 Peng Liang-Min brought up in the interview transcripts with Lin Chien-Yu that he recorded his father's creative process with a V8 camera. Lin, "Peng Ru[e]i-Lin: Between Photography and Paintings in Modern Taiwan," p. 150.

23 Lin, "Peng Ru[e]i-Lin: Between Photography and Paintings in Modern Taiwan," pp.147–149.

24 This was published in July 1940 in the Japanese magazine, Landscape as "Old Temples in Xinhui" and in 1939 in the same magazine as "Xihu, Huizhou." This book can be found in the publicly accessible Peng Ruei-Lin Historical Archive. Lin Chien-Yu speculated that this scenery may come from photos. See Lin, "Peng Ru[e]i-Lin: Between Photography and Paintings in Modern Taiwan," p. 63. We can't be certain as to whether this sketch was based on a photo.

25 Wang Syu-Siong, "The Conservatism and Authority of First Generation Taiwanese Painters and Their Influence on Taiwan's Post-War Western Paintings," *Thesis on the development of Taiwanese Aesthetics*, Taipei: National Museum of History, 1995, pp. 174–179.

Long Chin-San

Long Chin-San, *Flowery Stream with Salt Wells*, 1938, Gelatin Silver Print, 41.0 × 29.5 cm. Collection of National Taiwan Museum of Fine Arts

Born in the city of Huaiyin in China's Jiangsu Province, Long Chin-San (1892-1995) loved traditional Chinese painting and calligraphy from a young age. When he was 12 years old, he began studying under Li Jhing-Lan in the Shanghai Nanyang Middle School. From Li, he learned the principles of photography and how to develop photographs.

In 1911, Long joined the Shen newspaper company, where he worked in the advertising department. At the same time, he continued photography as a hobby. In 1926, Long joined the *Eastern Times* newspaper company in Shanghai as a photojournalist, becoming the first specialized photojournalist in the history of the Chinese media. In 1931, he founded the Chinsan Photo Studio in Shanghai, specializing in photographic portraiture and photographs for commercial advertisements.

After the Marco Polo Bridge Incident of 1937, Long moved to Sichuan, and subsequently traveled back and forth between Shanghai, Kunming, and Chongqing. He conducted interviews and wrote newspaper reports while continuing to experiment with the techniques of Composite Photography. In 1949, Long came to Taiwan at the invitation of the United States Information Agency as a participant in a photography exhibition, and ended up relocating to Taiwan permanently.

Long was famous for his photographic compositions that combined and altered images. His compositions drew on the spirit of Chinese traditional ink paintings and possessed a lofty literati style. He was also a pioneer as the first photographer of Chinese female nudes, and he photographed numerous important Chinese personages of the time. Long's photographic collages brought about a synthesis of ideas from the Western avant-garde, and in this he was highly unique. In these works, he employed techniques of Western photography while maintaining a traditional Chinese aesthetic, using the camera as his brush. He devoted his life to the camera, mixing Western and traditional Chinese styles to explore new territory.

During his lifetime, Long had frequent exchanges with Western photographers and artists, including the art historian and photography specialist Beaumont Newhall. After settling in Taiwan, Long devoted his energy to writing the history of Chinese photography. He won honors in America, Europe, Southeast Asia, South America, Japan, and Korea and came to occupy an important place in the annals of international photography.

Born during the Meiji period in Shinchiku Prefecture (now Chudong, Hsinchu County), Peng Ruei-Lin (1904-1984)/Apollo Photo Studio graduated from the Taipei Normal School in 1923 and was subsequently sent back to his hometown to take up teaching positions at the Emei Elementary School and the Erchonpu Elementary School. In 1928, Peng entered the Tokyo Specialist School of Photography upon the recommendation of Ishikawa Kinichiro. In 1930, a three-color work of his, Still Life, was included in the publication of the Tokyo Photography Research Association. In 1931, he graduated as valedictorian from the Tokyo Specialist School of Photography, becoming the first ever Taiwanese to obtain a Bachelor's degree in photography in Japan and a member of the Japanese Association of Photography Specialists.

In November of the same year, Peng set up the Apollo Photo Studio in Taipingding in Taipei (now Yanping North Road). The Apollo Photo Studio later changed its name to the Yapulu Photo Studio. The following year, Peng set up the Apollo Photography Research Institute, Taiwan's first specialized institute for photographic training. Drawing students from across Taiwan, over its first three or four years, it produced Taiwan's first crop of natively trained professional photographers. In 1938, Peng was conscripted by the Japanese army and sent to China's Guangdong Province to serve as a translator. He often carried his camera with him. But due to the war, after 14 years of operation, the Apollo Photo Studio closed down. Afterwards, Peng returned to his hometown to study Chinese medicine and became a teacher of the fine arts and Chinese medicine.

Due to the influence of a Japanese education, portraits were Peng's forte. But whether taking portraits, landscapes, still lifes—or even X-rays—Peng's photography bore his own unique style, carrying an atmosphere which is melancholy yet graceful. A firm adherent of experimental methods, Peng, while running the Apollo Photo Studio, sought to combine his specializations in photography, Chinese medicine, and X-rays and run an interdisciplinary institution. Peng's extensive knowledge of photography also included influences from modern photography from the West. In his Scenery series of photographs from 1934, he blurred images to create painterly effects, reminiscent of those in early 20th-century pictorial photography.

For decades, Peng continued to push the boundaries of photography and experimented with the possibilities of various techniques. Just as an avant-garde pioneer, he advanced the field of Taiwanese photography as a whole.

* * ****

Peng Ruei-Lin

Peng Ruei-Lin, Reclining Woman, 1931-1933
Gum Bichromate Print, 10 × 14 cm. Courtesy
of Peng Liang-Min

Deng Nan-Guang (1907-1971) was born in Beipu, Hsinchu County. His birth name was Deng Teng-Huei. At the age of 17, he went to study in Japan, and in 1929 passed the entrance exam for Hosei University's economics department. Upon joining Hosei University's photography club, he encountered the "Shinko Shashin" (New Photography) that was then the trend in Japan.

In 1935, Deng returned to Taipei, settling in Taipei on Kyomachi (now Boai Road), where he established the Nanguang Camera Store as a place for photography hobbyists to gather. In 1945, on account of the war, Deng closed his shop and returned to Beipu. Following the war's end, he however quickly returned to Taipei and reestablished the Nanguang Photographic Equipment Store on Hengyang Road. There he continued his work as a photographer and together with Li Huo-Zeng established the "Leica Club".

Dang was a great organizer among Taipei's photographic community. In 1950, he helped establish the "Taipei Photography Monthly Competition", organized the "Freedom Exhibition", and set up a version of the Photographic Society of China following the retreat to Taiwan by the Chinese Nationalists (KMT). He further helped establish the Photographic Society of Taipei. In 1960, Deng closed his store due to financial difficulties and began working as a medical photographer at the US Naval Medical Research Unit No.2, then headquartered in Taipei.

Deng's photography is plain but precise, his photos often taken as snapshots with small cameras. His photographic oeuvre includes images of World War II, the lives and seasonal activities of farmers in Beipu after WWII, and portraits of women. Deng was also highly concerned with the political upheavals in Taiwan during his lifetime, and these concerns are embedded in his photography. From his photographs of the ruins of WWII, portrait of a man massacred in the 228 Incident, and a photo of the photographer himself with Chiang Kai-Shek, one sees that Deng exhibited a deep concern for the social issues of his time. These images of political resistance further point towards the emergence of Taiwanese local consciousness.

Deng's photographs serve as a faithful record of Taiwan, capturing what Taiwan was like before and after WWII. In trying to expand the visual language of photography, Deng integrated modern photographic trends, political metaphors and social observations into his work, while also documenting historical shifts in Taiwanese society.

** * ***
Deng Nan-Guang

Deng Nan-Guang, Swinging, 1940s, Epson Giclée Print on Baryta Photo Paper, 15.2 × 9.9 cm. Collection of National Center of Photography and Images
Deng Nan-Guang, Sea Women from Boso Peninsula, 1935, Epson Giclée Print on Baryta Photo Paper, 12.5 × 17.5 cm. Collection of National Center of Photography and Images

Hong Kong-Da (1912-2012) was born in Taichung, a doctor of obstetrics and gynecology, who spent extensive amounts of time researching the technology of photography. Although Hong received professional medical training during his early years and later opened his own practice in Taichung, "Hong Obstetrics and Gynecology", he had access to various techniques for developing photographs and film. So in addition to running his medical practice, he was a noted photographer.

Hong's father passed away while he was still young, and the early subjects of Hong's photography were family members, especially his mother and grandmother. In the 1950s, Hong and close acquaintances including Wu He-Song, Lin Chuan-Chu, and Chen Keng-Pin used methods from commercial printing to develop a Dye Transfer Process for developing color photographs. In December 1955, Hong was part of a group of 13 people, who established the Photographic Society of Taichung. They launched the organization with an official ceremony the following year and aimed to encourage the popularization of photography in central Taiwan. However, as a gynecologist, Hong had little interest in photographing young female subjects, which was popular trend at the time.

Hong was best known for his nature photography, which focused on pastoral and natural scenes. Hong spent three years photographing egrets, and was the first in Taiwan to document egrets through photography. Hong also traveled among the Atayal Tribe, which then received little attention, and documented their hunting practices and daily lives.

Chang Tsai (1916-1994) born in Dadaocheng in Taipei, his father died when he was nine years old. The same year, his elder brother established the Singuang Drama Research Institute, and Chang participated in many of the plays that the theatrical troupe put on. In 1934, Chang traveled to study at the Musashino College of Photography in Japan. He later studied at the East Asian College of Photography for half a year, which was how he began his career as a photographer.

In 1936, Chang returned to Taiwan and set up the Yingsin Photo Studio in Taipei on Taiyuan Road. During World War II, Chang moved to Shanghai in order to avoid the draft. Through his travels, he was able to document the rise and fall of Shanghai.

After the war, Zhang returned to Shansuiting (in what is now Taipei's Dadaocheng area) to re-establish the Yingxin Photo Studio. In 1957, he began offering photographic developing services at the Daxin Photography Supply Store on Yanping North Road.

Chang Tsai's photography is moderate and calm. As a stranger with a camera, he captured images of wartime Shanghai. After the Nationalist government fled to Taiwan, he assisted with anthropological research conducted by National Taiwan University, taking photos of Taiwan's indigenous peoples and their religious ceremonies. During this period, Chang also photographed temple celebrations and gezaixi (Taiwanese opera) with a simple yet penetrating gaze. The complicated dynamics of the period are captured in his photography.

In his photographs, Chang takes records of the Taiwanese society, while giving his images a surrealist touch with a sense of calmness and detachment. The influences of Anarchism could thus be seen in the aesthetics of his photography. Through his idiosyncratic practice, decades of Taiwan's important cultural moments have been preserved.

**** * *
Chang Tsai

Chang Tsai, *The Noon is High*, 1947, Gelatin Silver Print, Paper, 37.8 x 28.1 cm. Collection of National Center of Photography and Images

Lee Ming-Tiao (1922-2013) was born in Daxi, Taoyuan County. He entered the Daxi Public School at age seven and studied for six years there. At age 14, Lee's uncle, Liao Liang-Fu, established the Daxi Photographic Studio, where he became an apprentice. There, Lee learned the fundamentals of photography and how to retouch glass plate negatives. When Lee was 15, he continued his apprenticeship at the Fuji Photographic Studio in Taipei.

In 1940, Lee went to study at China's Lingnan Art Private School and later with friends established the Dahe Photographic Studio in Guangzhou. In 1942, he volunteered to enlist in the Imperial Japanese Army and was stationed with the Southern Chinese Expeditionary Army on the outskirts of Guangzhou. The next year, he was transferred to Hong Kong where he took on a position as a Japanese translator in the transportation industry. After Japan was defeated in the war, he and many other Taiwanese were imprisoned in prisoner-of-war-camps. In 1946, Lee was finally able to return to Taiwan on a British-chartered steamship.

At age 25, Lee took up residence in Taipei's Sakaechou Nichoume (now Hengyang Street), and established the Jhongmei Photographic Supply Store, whose name was later changed to the Jhongmei Photographic Equipment Supply Store. The business opened at a time when photo shops were springing up all over Taipei.

In 1950, Lee threw himself into organizing photography associations, lectures, exhibitions, and judging photographic works. In 1951, he organized the first photography magazine in Taiwan, *Taiwan Camera Monthly*. The magazine published the works of many local photographers as well as articles on photographic techniques, critical reviews, and promoted exhibitions and activities by the Photographic Society of Taiwan.

Lee Ming-Tiao's photos were tranquil and profound. His major subject matter was village life, the lives of farmers, and women. In addition to straight documentary photography, he also drew on the aesthetics of Western photography to choreograph certain scenes in order to capture Taiwan's changing eras within his frames.

Lee's concern for his homeland and depiction of the lives of everyday people have been recorded in his images with sincerity and great feeling. In the geometric compositions and light arrangements of his black–and–white photography, including photos of sluices and steel bridges, Lee, on the other hand, captured the development of Taiwan's industrial era.

***** *
Lee Ming-Tiao

Lee Ming-Tiao, Tamsui River Estuary, 1948
Gelatin Silver Print, 60.5 × 50 cm. Collection of
National Center of Photography and Images

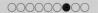

Vacillation:
Peng Ruei-Lin's Two Photographic Approaches

Chen Chin-Pao
Artistic Research | Video | 2021

It is time, then, for [photography] to return to its true duty, which is to be the servant of the sciences and arts—but the very humble servant, like printing or shorthand, which have neither created nor supplemented literature. Let it hasten to enrich the tourist's album and restore to his eye the precision which his memory may lack; let it adorn the naturalist's library, and enlarge microscopic animals; let it even provide information to corroborate the astronomer's hypotheses; in short, let it be the secretary and clerk of whoever needs an absolute factual exactitude in his profession—up to that point nothing could be better.

—Charles Baudelaire [1]

Taiwanese photographer Peng Ruei-Lin entered the Tokyo Specialist School of Photography in 1928 and graduated with honors three years later. As the first Taiwanese to study photography in Japan, his accomplishments are notable. At the Taipei Normal School, he was Ishikawa Kinichiro's favorite pupil, though he also frequently worked on watercolor paintings during this time.

During the Japanese colonial period, he used the "three-color transfer method" to create a color photograph of a still life, which was included in the Kenten gashu (研展画集 Catalogue of the Research Society Exhibition) of the Photography Research Society of Tokyo. At the time, his practice focused on classical portrait photography. His works demonstrated the clear influence of Geijutsu Shashin, an aesthetic trend which originated from the Euro-American Pictorialism and became popular in Japan. Even though Peng had the opportunity to take portraits of the Emperor of Japan in the Japanese Imperial Palace and, after graduating, to travel to America to further pursue photography, he decided to return to Taiwan to set up the Apollo Photo Studio and the Apollo Photography Research Institute.

Peng abruptly cut short his career as a "photographer" following his "Naturalism" series of landscape photography, which he produced in around 1938. He was 34 years old and had also at this time already traveled to Japan to learn the "secret technique" of gold lacquer photography. In 1943, he began studying Chinese medicine, going on to teach traditional healing techniques and write medical theses. In 1950, he became a member of the Japan Society for Oriental Medicine.

Looking at Peng's sudden change of career, aside from the pressure to earn a living following the war, the main reason for this shift might be his thinking on the relationship between painting and photography. He might be one of the first to raise such a question in Taiwan. In the 19th century, the photographic medium only gradually came to be seen as a legitimate form of art and also drew serious criticisms from individuals such as Baudelaire. The first artistic movement in photography, Pictorialism, began in 1885 and borrowed its use of form, artistic vocabulary, and aesthetics from painting.

In response to a letter from Peng in 1933, Ishikawa Kinichiro wrote:

Regarding the question you bring up about 'the artistic value of photography,' I believe that in the end, it returns to the question of how photographers overcome technical problems... photographers could decide whether they want to produce commercial or artistic photography...I suggest that you not worry about the issues mentioned above...

In other words, what troubled Peng was the question of whether photography was merely a commercial process or else a fine art. This question derived from the style of photography he studied in Japan, which was greatly influenced by the European and American stylistic trends of Pictorialism and Naturalism.

Interestingly, during World War II, Peng developed an approach that departed from photography as "fine art." In 1938, he was sent to China's Guangdong Province as a translator for the Japanese Imperial Army. There, he was able "at close range" to take photographs of military maneuvers and the daily life of the Japanese military. His photos included demonstrations against Chiang Kai-Shek and women being carried on trucks by Japanese military personnel.

Peng asked the question of photography's status as art, but had difficulty finding answers. The photos he took in Guangdong between 1938 and 1941 were taken after he had "given up" photography as a creative art form. They were simple snapshots that were not even produced as "artworks". However, these images embody an attitude that has a special place in the history of photography in Taiwan—the gaze of the colonized toward the colonizer.

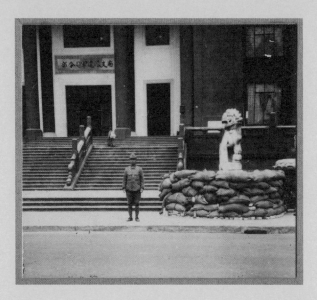

1 Jonathan Mayne, ed. and trans., *The Mirror Of Art: Critical Studies by Charles Baudelaire*, London: Phaidon Press Limited, 1955.

Chen Chin-Pao enrolled in the Department of Photography of School of Visual Arts in New York in 1996, and three years later earned his BFA degree with an award for outstanding achievement. Chen later earned an MFA degree from Taipei National University of the Arts, School of Fine Arts in 2013. As a photographer, he has focused on different aspects of photography since the beginning of his career. He first gained notice from his documentary portrait series *A Moment of Beauty: Betel Nut Girls*. His recent project *Circumgyration* deals with "pseudo memory" by taking fragments of memories from elementary school students and parents, then has the students "reenact" the scenes of memory in dramatic stage presentations. *Heaven on Earth* juxtaposes photographs of shrines, homes, and graves to depict Taiwan as a land shared by gods, humans and ghosts. His latest ongoing project, *Ordinary Household* depicts contemporary Taiwanese domestic life. Chen was awarded The Overseas Photographer Award at The 26th Higashikawa Award in 2008. He lives and works in New Taipei City, Taiwan. ●

Peng Ruei-Lin, A Soldier beside a Stone Lion,1938. Courtesy of Peng Liang-Min, Peng Ya-Lun

Man of the World

Nowhere Island Journal
(Huang Ying-Jia, You Cheng-Yan)

Artistic Research | Video, 5 mins | 2021

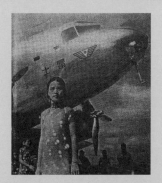

Research on photography generally focuses on "photographers" and their "works." We find several types of photographers during the Japanese period, with two traditional types represented by Chang Tsai, a witness type who offers photographic evidence in his pictures, and Liu Na'ou, an amateur roving photographer. However, here we would like to emphasize the importance of (very seldom researched) photographers like Chen Li-Hong, a representative of the commercial photographers of the photography studios. In particular, we would like to look at Chen's photograph for an airline advertisement, which poses an indigenous woman as the "photographed subject." Such photographs cannot be ignored, and hold important connections to the history of photographic technologies and historical social transformations. In this work, we attempt to use techniques from film, including footage intercut with interview segments, to discuss the people and objects photographed according to their photographic genres and to gain a deeper understanding of the ways we talk about photography itself.

In 1943, in preparation of the entrance exams of the East Asian College of Photography in Japan, Chen Li-Hong went to learned photo retouching in a studio in Taipei. After graduating, she continued her studies at Shochiku Films, observing and studying the skills of taking film stills hoping to eventually set up her own photographic studio. With the start of the war, she returned to Taiwan and took a temporary job at the Xindian District Office.

In 1942, to escape the hostilities of World War II, Chang Tsai left the Yingsin Photo Studio in Dadaocheng and moved his entire family to Shanghai. He owned the latest model cameras from Europe and took photos of Shanghai's international concessions, the architecture of the growing city, and developing disparity between the rich and poor.

In 1940, Liu Na'ou was assassinated in Shanghai. He left behind a silent film, *The Man Who Has a Camera*. The title references Russian director Dziga Vertov's *Man with a Movie Camera*, and the film itself is composed of scenes of the landscapes and locals' daily life in Manchuria, Guangdong, Tokyo, and his home city of Tainan in Taiwan.

This project concerns itself with these three Taiwanese photographers and their work during the Japanese colonial period up until 1949, as divided between the differing attitudes toward photography between these three individuals with their special identities as "Taiwanese during the Japanese colonial period" (日屬臺灣人). Through the eyes and body of a contemporary Taiwanese photographer, viewers will be able to travel back in time, to see as Taiwanese photographers saw during that period and challenge themselves to see how our contemporary world compares to the worlds of Chen Li-Hong, Chang Tsai, and Liu Na'ou. This reflects photography as a global and eternal language and demonstrates its potential to travel in time.

"Man of the world" is a concept Charles Baudelaire took from Edgar Allan Poe, who believed that a person could be an artist, a man of the world, a man of the crowd, and a child at the same time. If you couldn't call yourself a photographer, perhaps you could call yourself a pictorial moralist. Such people see the whole world as their home, and the masses are to them as water is to fish. This kind of person is perpetually dissatisfied with the "not-I" and their world is like a kaleidoscope. They have an innate skill in observation, if they have the ability to express, they could even be seen as geniuses. However, although their spirit, feelings and observations come from the masses, but they are not often accepted by the masses.

Man of the world, if nothing else, is a structural notion derived from patriarchy, and for Baudelaire, referred specifically to a man of the Western world. But this meaning has now expanded into what was once the periphery. In 2021, colonialism and censorship are things of the past. Also, it is no longer prohibitively expensive to engage in photography. In Taiwan, one still sees mixed heritage between indigenous Taiwanese, Han Chinese, and Southeast Asian immigrants. The Taiwanese sense of identity has been complex and the current socio-political situation remains unstable.

Nevertheless, we can be sure of this: The image of the "Taiwanese" has come a long way from the exotic and eroticized images of Taiwanese aboriginal women who appeared during the Japanese colonial period on magazine covers alongside the latest Japanese fighter aircraft. Contemporary photographers may now interrogate Chen Li-Hong, Chang Tsai, and Liu Na'ou and ask, "How do you seek to depict yourself?"

Nowhere Island Journal was started by Huang Ying-Jia in 2017 in collaboration with artists You Cheng-Yan and Gao Deng-Hui with the goals of undertaking research, conducting fieldwork, and producing art projects. In 2017, Nowhere Island Journal's "Three Mice Nakashi Training Camp" produced film screenings in locations around Taipei, including the Fuzhou Wetlands and the forests of Xindian. In 2018, they participated in the Mipaliw Land Art Festival and took an artist residency in Fengbin, Taidong County. Their "Tearfully Struggling" project sought to connect traditional ceremonies with cultural context and was displayed in the Cepo' Art Center, the Kuandu Museum of Fine Arts, the Waley Art Gallery. They were awarded the Outstanding Prize of the School of Fine Arts (Taipei National University of Arts) in 2019. ●

Nowhere Island Journal (Huang Ying-Jia, You Cheng-Yan), *Man of the World*, 2021. Video, 5 mins. Courtesy of the artist

Come out Better:
Photography and Chineseness in Southeast Asia

Zhuang Wubin

Artistic Research | Archival Materials | 2021

The places that would, over time, become Southeast Asia were first opened up for photography through colonialism. The photographers were mostly white men who penetrated the region with or through colonial conquest. The colonial encounters also provided the opportunity for local elites, put off initially by that devilish device of modernity, to take up photography to advance their personal agendas. Taking advantage of the colonial economy, Chinese migrant photographers in the 19th century opened photo studios (照相館) and / or produced picture postcards in the region. By the early twentieth century, they had come to dominate the photo studio trade. According to the anthropologist Karen Strassler, the Cantonese owned many of the studios in Java. While the Cantonese seemed to have dominated the trade across Southeast Asia, there were also examples of Chinese photographers from other dialect groups who owned some of the most prominent photo studios. The most obvious examples

were Luang Anusarnsunthorn (1867—1934; b. Lamphun), a rich merchant of part-Teochew ancestry who opened the first photography shop in Chiang Mai after 1900 or 1901, and K. F. Wong (黃傑夫 b. 1916, Sibu—d. 1998, China), a Henghua (興化) Chinese who opened the famed Anna Studio at Kuching in 1938 (followed by a branch in Sibu in 1941). Wong also became a world-renowned photographer who first made his name through salon photography.

The international movement of Pictorialism, or salon photography (沙龍攝影), impacted the pursuit of art photography in the region. There were two periods of growth, as seen in the proliferation of amateur photo clubs or societies (業餘攝影俱樂部或攝影學會). The first occurred during the 1920s and the 1930s, when these societies were set up under the auspices of the colonial authorities. Foreigners (including some Chinese enthusiasts) and local elites made up the membership of these photo clubs. The second wave occurred during the 1950s

and the 1960s, when the high tide of decolonisation shifted the patronage and leadership of these photo societies to the national elites. However, the club members who most actively participated in salon contests were ethnic Chinese, many of whom had just migrated to Southeast Asia. By winning salon accolades across and beyond the region, they helped to put the newly independent Southeast Asian nations on a global map and inevitably attracted the attention of the national elites. Despite its apolitical veneer, salon photography was a practice through which many ethnic Chinese practitioners got involved, willingly or otherwise, in a bewildering range of political and socio-cultural initiatives directed by the State or its opponents, who proposed competing visions of statehood.

Their reference point was Hong Kong (HK), dubbed the "kingdom of salon" because its photographers had dominated the salon contests around the world since the late 1940s. According to researchers like Wang Meihsiang and Kalen Lee (李泳麒), HK was a strategic space that many people and institutions of different political affiliations exploited to court the overseas Chinese communities during the cultural Cold War. Salon photographers from HK and Southeast Asia were drawn into these initiatives. They contributed to the publication of pictorial periodicals (畫報) and organised regional contests and exhibitions.

Since 2004, I have been writing about the photographic practices of Southeast Asia. Thanks to the generosity of the interviewees, I have procured some materials (such as zines, photobooks, periodicals, catalogues and exhibition brochures) related to my research. However, since 2011, I have been building a small collection of family photographs, photo studio ephemerals (i.e., photo and film envelopes) and periodicals by visiting flea markets and "junk" sellers across Southeast Asia. Over time, I realised that my research and art-making practices have shaped the way I collect these materials. In 2013, at Le Cong Kieu in Saigon, the curator Nguyen Nhu Huy (阮如輝) introduced me to a Teochew seller, who claimed that he had 200kg of old photographs stowed in his attic! He was not joking. When the Hoa (華) and the Viet fled Vietnam after 1975 and during the Third Indochina War (1978-91), they did not bring along their family photographs. That was how these materials ended up in the seller's hands. Dispossession through war made them available on the market.

Though implicated in the violence, my act of buying and repossessing them aims to reimagine the stories that led to the creation of these materials. In the seller's stock, the photographs were not only taken in and during the Republic of Vietnam (1955-75, with Saigon as capital). Many of them were photographed or sent from the rest of Indochina or further afield, as in Malaysia, Singapore, Taiwan, China, the USA or Europe. Of course, tragic displacement is not the only reason why Chinese family photographs ended up in the flea markets. My friends told me that when the Chinese Indonesians abandoned their old houses in Java, some of them would just leave their family photographs in situ, allowing people to scavenge whatever they wanted.

This installation introduces photo-related materials and fieldwork documentation that I have accumulated over the years. I visualise photography and Chineseness as entangled practices that evolved through the colonial period to the decolonising era of nation building. I use the term "Chineseness" to highlight ethnic Chinese involvement in the production, consumption, and circulation of photographic practices and images across and beyond Southeast Asia. At the same time, photographic practices have also been used to produce, address, and confound the desires of Chineseness. I use the phrase "come out better" by the anthropologist Christopher Pinney to foreground the intersecting desires of the photographers and those who are being photographed. Their desires are further imbricated by State imperatives, creating a dynamic of collaboration and resistance that shaped the nation and the photographic practices in Southeast Asia..

Zhuang Wubin is an author, curator, and artist, who focuses, through writing and exhibitions, on photography from Southeast Asia and Hong Kong. His research examines the relationship between photography and "Chineseness", books as a site for the history of photography, and the links between photography and nationalism. In 2010, Zhuang won the Netherland's Prince Claus Award for his achievements. In 2017, he won the Lee Kong Chian fellowship from the National Library of Singapore and in 2019 won the Chinese research plan fellowship from the Robert H.N. Ho Family Foundation. He has been invited to participate in numerous residencies, including the Bandung Institute of Technology, Indonesia (2013), the Asia Art Archive, Hong Kong (2015 and 2018), and the Kuandu Museum of Fine Arts, Taiwan (2017). He serves on the board of the Trans-Asia Photography Review and served as curator for the Chiang Mai Photo Festival in 2015, 2017, and 2020. In 2017, Zhuang began to cooperate with the Lumenvisum photography studio in Hong Kong to organize exhibitions on Southeast Asia. In 2016, he published *Photography In Southeast Asia: A Survey* through the National University of Singapore and in 2018 published *Shifting Currents: Glimpses of a Changing Nation* through the National Library of Singapore. ●

Zhuang Wubin, *Come out Better: Photography and Chineseness in Southeast Asia*, 2021, Archives and Documents. Courtesy of the artist

Hold the Mirror up to His Gaze
the Early History of Photography in Taiwan (1869-1949)

舉起鏡子迎上他的凝視
●臺灣攝影首篇●
一八六九●一九四九

展覽
指導單位｜文化部
主辦單位｜國立臺灣美術館、國家攝影文化中心
總策劃｜梁永斐
副總策劃｜梁晉誌
展覽總監｜蔡昭儀
策展人｜林宏璋
策展助理｜周佩穎、林彥翔、余建勳、鍾昱儂
展覽執行｜周郁齡、賴信宇、劉依盈
展務統籌｜孵一間有限公司
視覺設計｜吳國強
空間設計｜游騰毅、施承毅
影音設計及展場燈光｜牧旦
展場攝影｜徐承誼
秘書室｜劉木鎮
主計室｜周益弘
展覽地點｜國家攝影文化中心臺北館
作品指定輸出｜台灣愛普生科技股份有限公司

專輯
指導單位｜文化部
主辦單位｜國立臺灣美術館、國家攝影文化中心
發行人｜梁永斐
編輯委員｜梁晉誌、汪佳政、蔡昭儀、黃舒屏、蔡雅純、
薛燕玲、林晉仲、曾淑錢、張智傑、陳俊廷、劉木鎮
總編輯｜梁晉誌
編輯主任｜蔡昭儀
主編｜林宏璋
執行編輯｜周郁齡、劉依盈
專文撰稿｜林宏璋、蕭永盛、周郁齡、周文龍（Joseph R.
Allen）、馬國安、郭昭蘭
詮釋資料撰寫｜周郁齡、林彥翔、余建勳
校對｜周郁齡、劉依盈、黃可萱、宓儀、吳欣潔、林羿君
編輯印製｜孵一間有限公司
編輯校對｜陳芳玲
書籍設計｜吳國強
翻譯｜李佳純、丘琦欣、韞藝術工作室
英文編輯｜David Frazier
英文校對｜羅巧芸
出版單位｜國立臺灣美術館、國家攝影文化中心
40359 臺中市西區五權西路一段二號
電話｜04-2372-3552
傳真｜04-2372-1195
製版印刷｜佳信印刷
出版日期｜2021 年 3 月

EXHIBITION
Supervisor I Ministry of Culture
Organizer I National Taiwan Museum of Fine Arts, National
Center of Photography and Images
Commisioner I Liang Yung-Fei
Vice Commisioner I Liang Chin-Chih
Exhibition Director I Tsai Chao-Yi
Curator I Lin Hongjohn
Curatorial Assistants I Patrice Chou, Lin Yan-Xiang,
Yu Chien-Hsun, Chung Yu-Nung
Exhibition Coordinators I Chou Yu-Ling, Lai Shin-Yu, Liu I-Ying
Exhibition Management I Foison Art Studio
Graphic Design I Ralph K.C. Wu
Exhibition Design I Yu Teng-Yi, Shih Cheng-Yi
Technical Executive & Lighting Design I l'atelier muxuan
Photographer I Hsu Cheng-Yi
General Affiairs I Liu Mu-Chun
Accountant I Tseng Shu-Chi
Venue I National Center of Photography and Images, Taipei
Appointed Printing Sponsor I Epson Taiwan Technology &
Trading Ltd.

CATALOGUE
Supervisor I Ministry of Culture
Organizer I National Taiwan Museum of Fine Arts,
National Center of Photography and Images
Director I Liang Yung-Fei
Editorial Committee I Liang Chin-Chih, Wang Chia-Cheng,
Tsai Chao-Yi, Iris Huang Shu-Ping, Tsai Ya-Chun,
Hsueh Yen-Ling, Lin Chin-Chung, Tseng Shu-Chi,
Chang Chih-Chieh, Chen Chun-Ting, Liu Mu-Chun
Chief Editor I Liang Chin-Chih
Managing Editor I Tsai Chao-Yi
Editor I Lin Hongjohn
Executive Editors I Chou Yu-Ling, Liu I-Ying
Contributors I Lin Hongjohn, Hsiao Yong-Seng, Chou Yu-Ling,
Joseph R. Allen, Ma Guo-An, Guo Jau-Lan
Short Texts Contributors I Chou Yu-Ling, Lin Yan-Xiang,
Yu Chien-Hsun
Prooofreading I Chou Yu-Ling, Liu I-Ying, Huang Ke-Hsuan,
Mi I, Wu Hsin-Chieh
Production Coordination I Foison Art Studio
Chinese Editor and Proofreader I Chen Fang-Ling
English Editor I David Frazier
Book Design I Ralph K.C. Wu
Translators I Yun Art Studio, Brian Hioe, Sandy Lee
English Proofreader I Lo Chiao-Yun
Publisher I National Taiwan Museum of Fine Arts,
National Center of Photography and Images
No. 2, Sec. 1, Wu-Chuan W. Road, 40359, Taichung, Taiwan
TEL I +886-4-2372-3552
FAX I +886-4-2372-1195
Printer I Chia Hsin Printing
Publishing Date I March 2021

GPN 1010901965
ISBN 978-986-532-210-6 (平裝)
800 NTD
www.ntmofa.gov.tw

ISBN 978-986-532-210-6